COLLECTION
Eli, Eli, lamma sabacthani?

Volume V

ANIMUS DELENDI – II

(Desire to Destroy)

by

Atila Sinke Guimarães

Translated and Edited

by

Marian Therese Horvat, Ph.D.

ISBN: 0-9672166-8-0

Library of the Congress Number: 2002112860

Printed and bounded in the United States of America

Cover: *The Killing of the Innocents* by Giotto.

TRADITION IN ACTION, INC.
PO Box 23135
Los Angeles, CA 90023
www.TraditionInAction.org

"The evidence singles out the Second Vatican Council as one of the greatest calamities, if not the greatest, in the History of the Church To the scandal of countless souls, the Mystical Body of Christ entered a sinister process of self-destruction, as it were.

"History narrates the innumerable dramas the Church has suffered in the twenty centuries of her existence When, however, has History witnessed an attempted demolition of the Church like the present one?

"From this resulted an immense debacle for the Church and what still remains of Christian civilization."

Plinio Corrêa de Oliveira
Revolution and Counter-Revolution
Part III, Chapter 2, 4A

TABLE OF CONTENTS

CHAPTERS

PART TWO:

NEGATION OF THE UNITY OF THE FAITH AND THE UNICITY OF THE CHURCH; DESTRUCTION OF HER MILITANT AND MISSIONARY CHARACTER; AND AFFIRMATION OF A PAN-RELIGION

CHAPTERS

FOREWORD

by

Marian Therese Horvat. Ph.D.

These are, without a doubt, confusing times. Where is the Church heading? What will happen next? Is the Modern State collapsing? What will replace it? Questions like these persistently afflict Catholics concerned about the inroads of Progressivism in both the spiritual and temporal spheres.

For those who want to know how we got to the distressing place we are in now, as well as for those who would like a glimpse of what is planned for the Church and the State in this nebulous future, the book *Animus Delendi II* (Desire to Destroy) by Atila Sinke Guimarães provides an objective response. It appears on the scene providentially, I would say. For this volume addresses very timely and relevant topics with a keen, original analysis. It is a work that presents facts bound to disturb, but necessary to know if one truly wants to counter and combat the revolution that aims to undermine all that remains of sound Catholic order in secular society and inside the Holy Church.

Animus Delendi II is certainly an eye-opener.

For example, there is much talk today of the new world order. What is rarely spoken of, however, is the important role the Church is playing to reach this revolutionary end. As Mr. Guimarães clearly demonstrates in Part I, those who are promoting the cult of man and the revolutionary world order include renowned progressivist theologians, high Prelates, and, yes, the Popes of the last forty years.

In the name of adaptation to the world, the Church denied to the Catholic State the right of existence and began to champion the principles of liberty, equality, and fraternity that nourished the Modern State. Now that the idol of liberal democracy is starting to tumble, the same Conciliar Church has begun to attack the Capitalist establishment. What does Progressivism intend to raise in its place? The author points to a new formula that the Conciliar Church is defending – a regime that is both anti-Capitalist and trans-Communist – approaching the *synthesis* dreamed of by Marx. This new formula is already

being applied, as in the experimental "Catholic" commune of Nomadelfia (Italy), which has received the blessing and support of John Paul II (Part I, Chapter VI). Or it is assuming an even more radical form of a self-managing neo-tribalism. Aborigenes are held up as models for the man of the future, and their tribal "structure" pointed to by official ecclesiastical organs as an ideal for the society of tomorrow.

Both formulas might have seemed farfetched some few decades ago. Today, as Atila Guimarães shows, even the more radical model is being promoted openly by the Conciliar Church as a "prophetic" way of living. And large numbers of Catholics, acclimated to Pentecostalism, Charismatic movement, and Faith communities, are prepared for this new tribalist "order" of things.

Likewise, there is much talk of a Pan-religion. To achieve this goal, conciliar ecumenism initiated doctrinal accords with heretics and schismatics. They met with failure. So a new kind of ecumenism was activated, in which the bothersome doctrinal points of dispute were laid aside and ignored. It is an ecumenism based on experience and good feelings.

Even more startling is Mr. Guimaraes' description in Part II of the two different pathways the Conciliar Church is treading to achieve this union of all religions. One path would be Buddhism, which is invading the West with the assistance of the Church. The second and more scandalous is the Church's promotion of Judaism as a kind of "mother" religion of all churches, including Catholicism. If this road would be accepted, we would end in a Pan-religion under the hegemony of the Jews.

What exactly is the "Church of Christ" of the Council? This volume shows the reader, in the words of the theologians, conciliar fathers, and Popes themselves, that the progressivist "Church of Christ" is distinct from the Catholic Church. This conciliar "Church of Christ" would encompass not only Catholics and those who improperly are called "Christians" (heretics and schismatics), but also those who believe in one god. Going further, it would also embrace those who believe in a god of some sort, and, finally, even atheists.

While countless conservatives get entangled in the game of hermeneutic acrobatics trying to deny the obvious – that the ecclesiastical authority is promoting the self-

destruction of the Church – the progressivists advance, scandously fooling the innocent.

Animus Delendi II also shows that Vatican II in effect abandoned the militancy of the Catholic Church. The general mood that prevails today is one where enemies of the Faith no longer exist, battles need no longer be fought in the name of the Church, and the combative spirit should be laid aside as a relic of the past. In short, the virtual death of the Church Militant transformed into a Church Tolerant.

Thus the author's conclusion: A deliberate desire to destroy the Holy Catholic Church results from secularization and ecumenism, the two key initiatives of the Council. It is a conclusion that would be difficult to argue against given the superb documentation of this volume, as well as of the other volumes of the Collection launched to date.[1]

Animus Delendi II is directed in a special way to all Catholics who retain a spirit of militancy. At this critical stage when the Revolution seems to be on the verge of taking radical – and perhaps hasty – new steps toward achieving a Pan-religion and the establishment of a new formula for society, it seems very important to keep in mind a weak point of the Revolution. It needs unanimity. Without unanimity it cannot go ahead. Hence, if there is a significant number of Catholics who do not accept secularization and ecumenism and are able to resist them, the Revolution has to stop; and if it stops, it dies.

To achieve their ends unimpeded, progressivists inside the Church have relied more on their indispensable allies,, the blind-conservatives who sincerely or cunningly refuse to acknowledge the reality that an Ecumenical Council could be contrary to Church dogma and tradition. But cracks are beginning to appear in this conservative milieu, as more and more concerned Catholics are questioning Vatican II and the Conciliar Church. It is my hope that *Animus Delendi II* will stimulate this good and healthy resistance to the self-demolition of the Church.

[1] The Collection: Vol. 1, *In the Murky Waters of Vatican II* (MAETA, 1997); *Animus Delendi - I* (TIA, 2000). Special Editions to the Collection: *Quo Vadis, Petre?* (TIA, 1999), *Previews of the New Papacy*, (TIA, 2001).

INTRODUCTION

§ 1 A serious study of the "spirit of the Council" and the progressivist blueprint for the self-destruction of the Church requires consideration of the two principal initiatives that characterize the "conciliar revolution"[1]: secularization and ecumenism, or as they were known originally, *aggiornamento* and dialogue.

§ 2 The much trumpeted *aggiornamento* is characterized by the adaptation of the Church to the modern world, that is to say, to its principles and tendencies that proceed remotely from Humanism, the Renaissance, and Protestantism and, more proximately, from the French Revolution.[2] These principles and tendencies of egalitarianism and liberalism veered broadly on the "evolutionary" path toward Communism[3] and, ultimately, to self-managing tribalism.[4]

[1] For the Reader's convenience, footnote 14, Chap. I, of Vol. IV, *Animus Delendi I* is reproduced here:

The expression "conciliar revolution" was applied to Vatican II by some of its leading protagonists. Cardinal Leo Jozef Suenens said, "The Council is [the Revolution of] 1789 in the Church" (A. Schifferle, *Marcel Lefèbvre – Ärgernis und Besinnung – Fragen an das Traditionsverständnis der Kirche*, Kevelaer: Butzon-Bercker, 1983, p. 190, footnote 579). Suenens used the expression "Copernican revolution" to express the significance of *Lumen gentium* (see Vol. IV, Chap. IV, § 2). Cardinal Yves Congar was referring to the Communist Revolution of 1917 when he affirmed that the Church would "peacefully make its October Revolution" with the Council (*Le concile au jour le jour – Deuxième session*, Paris: Cerf, 1964, p. 115). Fr. Hans Küng affirmed that the Church, by means of "a revolution within the order," had "changed its course in an extraordinary way" (*Veracidade – O futuro da Igreja*, São Paulo: Herder, 1969, p. 131).

[2] About the support of the conciliar Popes, Bishops, and renowned theologians for the ideas of the French Revolution, see Vol. IV, *Animus Delendi I*, Chap. IV, §§ 26-83.

[3] In a work against the socialist and confiscatory land reform in Brazil, Prof. Plinio Corrêa de Oliveira explained how the present day capitalist world, which derives from the French Revolution, tends toward Communism: "The increasingly marked tendency of capitalist and bourgeois society to the philosophical relativism and moral permissiveness linked to the French Revolution was ensured by the In-

dustrial Revolution, which served largely as the vehicle for this. As proof, it suffices to take into account the powerful support of radio and television for the corruption of customs.

"Many developments of contemporary reality - at first sight inexplicable – can be deciphered in light of these considerations. One of them is the enigmatic propensity of so many capitalist milieus toward Communism. What is the explanation for this tendency - which finds no reciprocity whatsoever in the communist camp - given that Capitalism and Communism seem to constitute the great antithesis of our time?

"Without having recourse to fatuous Hegelian explanations on the matter, it suffices to recall that the promoters of the Industrial Revolution are, and always were, at the same time real and strong proponents of Capitalism. Influenced by atheist ideologies remotely originating from the Protestant Pseudo-Reform, these persons find themselves in an intimate ideological symbiosis with the technical and social-economic transformations that they stimulated. From this comes the uniform character of their work, as well as their tendency toward Communism in the long run, even though they may seem to combat it in the immediate term.

"Persons in a Mardi-gras parade, singing and dancing, at times turn their backs toward the destination they aim to reach. But they never for an instant stop moving toward that goal. This fact is illustrative of the inconsistency and vacuity of so many 'anticommunist' bourgeois reactions. It also explains how many of the wealthiest bourgeoisie have taken pro-communist positions" (*No Brasil: a Reforma Agrária leva a miséria ao campo e à cidade*, São Paulo: Vera Cruz, 1986, p. 33).

[4] a. Plinio Corrêa de Oliveira, *Revolution and Counter-Revolution* (New Rochelle, NY: Foundation for a Christian Civilization, 1980), part I, chap. III. 5, part III, chap. III; *Tribalismo indígena, ideal comuno-missionário para o Brasil no século XXI*, (São Paulo: Vera Cruz, 1977); "What does self-managing socialism mean for Communism: A Barrier? Or a Bridgehead?" *The New York Times*, December 13, 1983.

b. Tracing the general lines of what he imagines as the "post-modern society," structured in small groups, American theologian Joseph Holland confirmed this same thesis. He described the genesis of the modern world in this way: "The medieval synthesis of classical Catholic Christendom was disrupted and eventually displaced by the rise of what we call the modern world. This took place over approximately five centuries. The rise of Humanism and the emancipation of science in the Renaissance were an initial sign of the new culture, as the human dimension began to take primacy. The Protestant Reformation further weakened the old culture by heightening the

§ 3 The Council displayed a euphoric enthusiasm for the modern world, particularly evident in a document and a symbolic act. The document was the Constitution *Gaudium et spes*, considered the main girder for *aggiornamento*.[5]

§ 4 The symbolic act was Paul VI's visit to the United Nations to offer the world organization his complete solidarity, as well as that of all the conciliar Fathers.[6]

sense of the individual (private conscience), undercutting the power of the institutional Church, and orienting religious energies more toward History. The American and French Revolutions, along with the general rise of liberal nation states, began a national centralization of diffused communities, weakening the overarching imperial culture tied to the heritage of the Roman Empire and advancing the modern emphasis on progress and freedom. Finally, the Industrial Revolution provided the technological opening, initially through industrial Capitalism and later through industrial Communism

"If there is a key word throughout the rise of the modern world, it has been 'freedom.' This meant historical freedom from the chains of the past for the sake of a better future. Successively it came to mean cultural freedom (Humanism), religious freedom (Protestantism), political freedom (democracy), and economic liberty (Capitalism and later Socialism)

"The modern world stresses the freedom of the individual, and looks suspiciously upon all institutions, seeing them as constraining freedom" ("Linking Social Analysis and Theological Reflection: The Place of Root Metaphors in Social and Religious Experience," in James Hug, *Tracing the Spirit*, Woodstock Theological Center, New York: Paulist Press, 1983, pp. 177-8).

[5] a. Raúl Silva Henríquez, *Memórias* (Santiago, Chile: Ed. Copygraph, 1991), vol. 3, p. 69.

b. Cardinal König confirmed the thesis with this commentary: "At the Council the Church said: we will go down into the world, we will announce the Gospel, we will speak to men. The doors and windows opened. And the world began to ask itself what was happening. With that momentous document which was the pastoral Constitution *Gaudium et spes*, the Church sought to confront the great problems of humanity in order to find the solution for them" (Franz König, "Il Concilio, sorpresa per il mondo," interview by Silvano Stracca, *Avvenire*, October 16, 1992).

[6] Paul VI's visit to the UN took place on October 4, 1965, as the Council was drawing to a close (see full report in *La visita di Paolo VI alle Nazioni Unite*, Libreria Editrice Vaticana, 1966). On the speech the Pontiff gave there, see Part I, Chap. V, §§ 4-18 of this Volume.

The Council ended with the progressivist victory,[7] and the euphoria of the partisans of this current continued. Everywhere in the Church there was evidence of the progressivist *affaire d'amour* with the modern world.

§ 5 This romance, however, was short-lived.

In 1968 the death knell began to toll for the modern world with the student uprisings of the Sorbonne Revolution. "Reason is dead!" "It is prohibited to prohibit!" were cries that were now heard on the same streets of Paris where, two hundred years before, the "goddess Reason" had been carried to Notre Dame Cathedral to be adored by the pioneers of the modern world.[8]

[7] The victory of the progressivist current at Vatican II has already been analyzed in this Collection: Vol. I, *In the Murky Waters of Vatican II*, Chaps. IV, VI, *passim.*

[8] a. This interpretation was confirmed by well-known conciliar theologian Fr. Edward Schillebeeckx: "What an irony of History that Vatican Council II accepted the 'modern era' at the very moment when 'modernity' itself was becoming the focus of universal criticism. A few years after the Council, social criticism began to rear its head all over the world. In this sense, Vatican Council II, compared to the great 'feudal' encyclicals from Leo XIII to Pius XII, is the first great liberal and bourgeois Council. There, for the first time, the Church accepted the rights and ideals of civil society: religious liberty, freedom of conscience, tolerance, an ecumenical attitude. And this took place at the exact moment when secular society began to bitterly criticize the Western abuse of liberal values, especially to the detriment of the poor and the Third World.

"Thus, on one hand, the eruption of the Council could not reach its completion. On the other, the Church saw herself facing entirely new problems that had not been raised in the Council. From this came the ambiguity of Vatican Council II, despite its still positive significance. The effects of the Council, more than the texts taken in their literal sense, remain in force. The 1970s were the years of 'the great fear' about our social well-being. European centralism also came under criticism. The restlessness and alienation of youth in relation to the Council should not be blamed first on Church-related factors, but on the general change of climate in which the Council took place, which could not be greater. We had a world that had just emerged from the chaos of the Second World War, a world radiant with joy over the economic development and perspective of international peace. We find something of this 'naïve optimism' even in the pastoral Constitution *Gaudium et spes*: the role that the Church should play in this grand process leading to universal well being. But in the

§ 6 What was the response of the Conciliar Church – with her *aggiornamento* and secularization – once the modern world engendered a revolution that called for its own death? What would the spirit of the Council adapt itself to now?

§ 7 The Conciliar Church changed its affections.

To the measure that secularization still served the purpose of challenging the prior two-thousand-year old attitude of the Catholic Church toward the world, it continued to preach the necessity for this adaptation. Sensing, however, that death was already embracing the modern world, the Conciliar Church directed its greatest enthusiasm and much of its support to movements inside the Church that echoed the revolutionary aims of the Sorbonne: Liberation Theology, Basic Christian

1970s, the winds of austerity began to blow" (*Gott ist jeden Tag neu - Ein Gespräch*, Mainz: Mathias Grünewald, 1984, pp. 171-2., *apud Orientierung*, January 31, 1985, p. 13).

b. The very notion of "modern man," which until some years ago had been the unquestioned guide-rule regulating everything, began to falter. Commenting on the *Conciliar Catechism*, Cardinal Joseph Ratzinger questioned the very concept of modern man: "The matter of contextuality and attention to the experiences of contemporary man was much discussed in the Bishops' Commission [in charge of the *Catechism*]. We saw that in the collective present many differences exist and contexts as numerous as the persons. The context of a South African miner is different from that of a European university professor, a Vietnamese Christian, or a South American farmer. A 'measure for contemporary man' does not exist." (Joseph Ratzinger, Comments on the conciliar Catechism, *apud* Tommaso Ricci, "Rumo à reta final?" *30 Dias*, August-September 1990, p. 22).

c. Cardinal-Archbishop of Brussels Godfried Danneels expressed much the same opinion about the emptiness of the concept of "modern man." These were his words: "In the 1960s I thought that our pastoral plan should be based on the existence of a totally secularized man, without religious motivations and tranquilly atheist. Almost everyone thought like this, and we were preparing ourselves to find this man in Europe and America. Thirty years have passed, and we see that this man does not exist. Naturally many people continue to live indifferent to any religious form, but the European and American man cannot be considered atheist or simply agnostic. He is neither Catholic nor Christian, but is characterized by a new religious sentiment" (Godfried Danneels, "O inimigo é a Religião," interview by Lucio Brunelli, *30 Dias*, January 1992, p. 36).

Communities, Pentecostal movements, and underground churches. [9]

[9] a. The Western world was still dumbstruck from the anarchy of the student revolution of May 1968 when Paul VI, at the end of August of the same year in the city of Medellin, Colombia, declared his "anguish" over the world's future and launched the groundwork for Liberation Theology. In the next two decades the latter would come to be one of the main scourges of the Capitalist and bourgeois *status quo*.

b. In his opening speech at the Second General Assembly of Latin American Bishops, Paul VI invited them to "a full reflection" on an "anguished" situation: "The future will demand an effort, audacity, and sacrifice that will cause a profound anguish in the Church. We are in a moment of full reflection. An uneasiness that is characteristic of our times overwhelms us, like a powerful wave, especially in those [Latin-American] countries turned toward their full development and agitated by awareness of their economic, social, political, and moral disparities" (*Insegnamenti di Paolo VI*, Tipografia Poliglotta Vaticana, 1968, vol. 6, p. 404).

c. Further on, he showed complaisance toward the new secularized conceptions of the Church: "Let us make, then, an effort of loving intelligence to understand how much good and admissible there is in these disquieting and frequently erroneous forms of interpretation of the Christian message; let us increasingly purify our Christian profession of Faith and direct these spiritual experiences, some that call themselves secular and others charismatic, toward the pathway of the true Church norms" *(ibid.,* p. 409).

d. Finally, although rejecting the way of hatred and violence, he strongly criticized the capitalist social structures in place in Latin America: "While we must support every honest effort to promote the renewal and advancement of those who live in conditions of human and social inferiority, while **we cannot be in solidarity with systems and structures that cover up and favor grave and oppressing inequalities among the classes and citizens of one same country without effecting a concrete plan to remedy the insupportable conditions of inferiority that the less favored populations frequently suffer,** at the same time we again repeat ourselves in this regard: neither hatred nor violence should impel our charity" (*ibid.*, p. 412).

e. Based on these words, the Bishops gathering in Medellin made an official pronouncement in their *Message to the Peoples of Latin America*: "Latin America seems to live under the tragic sign of underdevelopment that not only prevents our brothers from enjoying material goods, but also keeps them from realizing themselves as

human beings. Despite efforts that have been made, hunger and misery walk hand in hand along with disease and infant mortality, illiteracy and marginalization, extreme inequalities of salaries and high tension among the social classes, outbreaks of violence and scant participation of the people in administering for the common good" (Conselho Episcopal Latino-Americano - CELAM, *A Igreja na atual transformação da América Latina à luz do Concílio*, Petrópolis: Vozes, 1980, p. 37).

f. Further on, they made demands that would serve as the seed for Liberation Theology: **"Our peoples aspire to liberation and advancement in humanity through the incorporation and participation of all in the management of the personalizing process. Therefore no one sector should reserve for itself exclusively the political, cultural, economic, and spiritual leadership. Those who possess the power of decision have to exercise it in communion with the desires and choices of the community"** (*ibid.*, p. 38).

g. They also explicated a new task for the Bishops - to act openly in the temporal ambit to stimulate the social-economic transformations: "Our reflections have shed light on the dimensions of other commitments that should be assumed in different ways by all the people of God: To inspire, stimulate, and **press for a new order of justice that incorporates all men in the management of their own communities**; To encourage professional organizations of workers, decisive elements of the social-economic transformation" (*ibid.,* p. 39).

h. The bourgeois and Capitalist establishment should find cause for concern in the *Conclusions of Medellin,* the final document that issued from the same gathering. In chapter 1, which deals with justice, one can read the following "doctrinal foundation" for the new concept of ecclesiastic action:

"The Latin-American Church has a message for all the men on this Continent who 'hunger and thirst for justice.' The same God who created man in His image and likeness created the 'earth and all that it contains for the use of every human being and people. Thus as all men follow justice and unite in charity, created goods should meet the needs of all with equity' (*GS* 69) and empowers him so that he might transform and perfect the world in solidarity with each other (Gen 1; *GS* 34)" (*ibid.*, p. 84).

i. They passed the following judgment on the business establishment: **"The corporate Latin American system and, due to it, the present-day economy, respond to an erroneous concept of the right of property, the means of production, and the final end of the economy"** (*ibid*, p. 50).

j. On the workers' organizations they stated: "In the intermediate professional structure, farm and industrial labor unions in which the workers have rights should acquire adequate strength and presence. **Their associations should have a** solicitous and responsible **power to exercise the right of representation and participation in production and national, continental, and international commerce**" (*ibid.*, p. 51).

k. On transforming rural areas: "While the diversity of situations and resources in the different nations should be considered, there can be no doubt that a common denominator exists for them all: the need for the human advancement of laborers and indigenous populations. **This advancement will not be viable without carrying out an authentic and urgent reform of the agrarian structures and policies**" (*ibid.*, p. 52).

l. On *Basic Christian Communities*: **"It is necessary that small sociological basic communities should develop in order to establish an equilibrium vis-à-vis** minority groups, which are the **power groups**. This can only happen by stimulating these communities by means of their natural components who will act in their respective circles" (*ibid.*, p. 54).

m. In chapter 2, which deals with peace, the Bishops' language became more incendiary: **"Everything that has been said becomes more and more intolerable as the oppressed sectors become increasingly aware of their own situation**. The Holy Father referred to this when he told the workers: 'Today the problem has become more serious because you have become aware of your needs and your sufferings, and **you cannot tolerate these conditions to continue** without seeking some remedy'" (Paul VI, *Speech in Mosquera*, August 23, 1968; *ibid,* p. 57).

Further on, they affirmed: "**The peace in Latin America is not**, therefore, **the simple absence of violence and bloodshed. The oppression exercised by groups of power** can give the impression of maintaining peace and order, but **in reality** this **perpetuates 'the inevitable germ of rebellions and wars'** (Paul VI, Message of January 1, 1968)" (*ibid.*, p. 60).

Finally, they made these inflammatory remarks: Christians "**should see that Latin America** in many parts **finds itself in a situation of injustice that can be called institutionalized violence.** Because of defective structures of industrial and agricultural enterprises, the national and international economy, and the cultural and political life, 'lacking the basic necessities of life, whole nations are under the thumb of others; they cannot act on their own initiative; they cannot exercise personal responsibility. They cannot work toward a higher degree of cultural refinement or a greater participation in social and

political life' (Paul VI, *Populorum progressio*, 30), and therefore their fundamental rights are violated.

"This situation demands global transformations that should be audacious, effective, and profoundly regenerative. We should not be surprised, therefore, to see that a 'temptation to violence' might be born in Latin America. **No one is allowed to abuse the patience of a people who for so many years have endured a condition that anyone with a higher consciousness of human rights could hardly accept"** (*ibid.*, p. 61).

n. Based on these and other teachings of Paul VI and the Bishops gathered in Medellin, a Liberation Theology took form that has shaken the existing social-political structures in Latin-America.

o. Notwithstanding some protests against the more radical expressions of liberation theology, including the famous "condemnation" of Cardinal Ratzinger of "Marxist aspects" of the doctrine of Liberation Theology, this theology has continued to enjoy the strong support of important sectors of the Church (Congregation for the Doctrine of the Faith, *Instruction on some aspects of "Liberation Theology,"* August 6, 1984, São Paulo: Paulinas, 1987, nn. 9-11),

p. How can this statement be proved?

First, because even when the Vatican made a "condemnation," it nonetheless distinguished different "liberation theologies" and condemned only the "Marxist" one. Thus, by "sacrificing" only the extremist wing of Liberation Theology, the Vatican sustained the main body of the new social doctrines that Paul VI and the Bishops launched against the modern world.

Second, because even during the time of the Vatican sanction against Leonardo Boff, one of the leaders of Liberation Theology, the movement nonetheless counted on the decided support of part of the Brazilian Episcopate, notably that of Cardinals Paulo Evaristo Arns and Aloisius Lorscheider. These Cardinals accompanied Boff to Rome to defend him against the so-called "rigorous" measures of Ratzinger. Boff was also openly supported by 18 Bishops who stated their nonconformity with the Vatican or criticized it for its censures (*Folha de São Paulo*, May 10, 11, 13, 14, 20, 1985; *Jornal do Brasil*, May 13, 1985; *O Estado de São Paulo*, May 10, 1985).

Third, because some time later (March 22, 1986), Cardinal Ratzinger himself issued another document, the *Instruction on Christian Liberty and Liberation.* In it he presented the "positive aspects" of the doctrine of Liberation Theology, since he had previously condemned its "negative aspects."

Fourth, because before, during, and after the censure of the Holy See, Liberation Theology continued to receive the support of important ecclesiastics all over the world. An expressive example is a

§ 8 At the same time, the Conciliar Church took a practical attitude of indifferent complacency toward the development of Feminist Theology[10] and Homosexual Theology.[11] Doing this, the Church propitiated the destruction of the same modern world for which just shortly before she had shown such euphoric admiration.

§ 9 This contradictory behavior also generated different interpretations of the term secularization. *Aggiornamento*, a word charged with talismanic meanings,[12] signified the irresistible force of seduction of the world and the outdated position of those who would oppose it. With time, however, this word lost much of its efficacy. Secularization was the word that replaced *aggiornamento*.

§ 10 For a student of History, secularization means the progressive separation of temporal institutions from the sacral in-

statement of the Superior General of the Jesuits, Fr. Hans Peter Kolvenbach, in an interview with the German newspaper *Der Spiegel*. On that occasion, the General of the Society of Jesus affirmed that his powerful Order was "strongly committed" to Liberation Theology. In Latin America where this theology took root, Fr. Kolvenbach affirmed, "people know that the Gospel is not there to encourage the faithful to accept their lot with resignation" (*O Estado de São Paulo*, December 18, 1986, p. 11).

Fifth and most important, the underlying thesis of Liberation Theology, a veritable death sentence for the Capitalist and bourgeois world, found the decisive support of John Paul II in his Encyclical *Sollicitudo rei socialis* of December 30, 1987. Taking an even stronger stance than in his prior anti-Capitalist assertions, the Pontiff criticized the very foundations of Western bourgeois society, which he qualified as "structures of sin." One could call it, therefore, the declaration of a kind of "holy war" against the Capitalist West... For evidence see Part I, Chap. V, § 82.

[10] On the decisive ecclesiastical support to save the Feminism that was passing through a fatal crisis, see Vol. VIII, *Fumus Satanae*, Chap. I, 1. C.

[11] On the "condemnation" of the American Jesuit John McNeill, founder of the organization Dignity and most expressive theologian defending homosexuality, see "The Catholic Church and Homosexuality," appendix to *In the Murky Waters of Vatican II*, § 56, footnote 70.

[12] About "talismanic words" and their use as an artifice to lead the West to Communism, see the work of Plinio Corrêa de Oliveira, *Baldeação Ideológica Inadvertida e Diálogo* (São Paulo: Vera Cruz, 1974), 126 pp.

fluence of the Church that characterized medieval Christendom.[13]

§ 11

To this historical interpretation, the progressivists added two meanings:

First, secularization refers to the adaptation of the Church to the modern world, with its egalitarian philosophical principles and its liberal morals. To fulfill her mission, the Church would need to adapt herself to the world as it is today: de-sacralized and separated from her. Departing from this erroneous premise, the Church should only admit in her own institution what would be acceptable to the world. Secularization would be, in this sense, a phenomenon of internal adaptation of the Church to the world.

Second, secularization came to indicate the change that needed to be made by the Church's initiative in the Modern State itself – in its laws, customs, and institutions – in order to adapt it to the new "sign of the times" that surged in 1968 at the Sorbonne and elsewhere.

§ 12

On one hand, this second meaning contradicts the first. On the other hand, it is a consequence of it. To the measure that the Church has adapted herself to the world, she must help to destroy the points in which the world is still not sufficiently *aggiornato*. Thus, secularization could justify the preaching of Liberation Theology and show complaisance toward Feminist Theology, Homosexual Theology, etc. Each in its own field, these "theologies" aim to abolish the "structures of sin," that is to say, the social-political and moral remnants of a past organic society that still survived in the Capitalist world. This type of secularization serves to steer the revolutionary efforts toward implanting a new Communist world,[14] which is rapidly heading toward a self-managed and tribalist world. In this sense, secularization is an action of the Church upon the world to change it.

§ 13

Secularization is, then, a term that appropriately reflects a whole gamut of relationships that the Conciliar Church has resolved to assume before the modern world. And it is as such that the term will be adopted in this study of the spirit of the Council.

[13] Leo XIII, *Immortale Dei*, n. 28.
[14] See Part I, Chap. IV, Item 3.

§ 14 Ecumenical dialogue is also one of the keynotes of the conciliar spirit.

Initiated with John XXIII's invitation to observers from other religions to assist at the Council, dialogue was vigorously supported under the pontificates of Paul VI and John Paul II.

§ 15 It seems that the first phase of the paradigmatic relationship of dialogue took place with the policy of the Popes toward the Eastern Schism. During the Council, under the pretext of not offending the Russian Schismatic Church,[15] John XXIII and Paul VI exerted all their power to prevent any condemnation of Communism.[16] Representing the Russian Schis-

[15] a. About the preponderant power of the Russian Schismatic Church among all of the so-called Orthodox Churches, see Vol. III, *Animus injuriandi II*, Chap I, Item 3; *30 Dias*, Port. ed., March 1992, pp. 34-37; Maxime Mourin, *Le Vatican et l'URSS*, Paris: Payot, 1965, p. 285; Wilfried Daim, *Le Vatican et les pays de l'Est*, Paris: Fayard, 1971, p. 62; Atila S. Guimarães and Marian T. Horvat, *Previews of the New Papacy*, Los Angeles: TIA, 2001, p.154.

b. About the subservient role of the Russian Schismatic Church to the State from the time the Communists came to power to our days, see the articles of Plinio Corrêa de Oliveira in the *Folha de São Paulo*: "Sobre Pimen," September 12, 1971; "Na I.O.," September 19, 1971; "Autodestruição, instrumento de lavagem cerebral," September 26, 1971; "A I.O. no water shoot," October 3, 1971.

[16] a. The Russian Schismatic Church would have made this a condition to accept John XXIII's invitation to send observers to the Council. Commenting on this agreement, Prof. Corrêa de Oliveira wrote:

"In 1962 the most numerous Council in History assembled at St. Peter's Basilica in Rome. John XXIII had invited observers from all denominations, including the pro-Communist so-called Orthodox Church. It was widely rumored at the time that the condition imposed by this 'Orthodox' Church before it would deign to accept the invitation was an absolute prohibition against any attack on Communism in the conciliar sessions and the demand that Vatican Council II refrain from the mere mention of the word. I do not know of any concrete proof that such demands had actually been made. But the fact is that, with regard to Communism, everything unfolded exactly like this" ("A I.O. no water shoot," *Folha de São Paulo*, November 3, 1971).

b. The concrete proof that Corrêa de Oliveira lacked at the time he wrote that article appeared later on. Today it is known that in 1962 the Vatican and the Russia Schismatic Church made an agreement known as the Pact of Metz. According to its terms, the latter made

the condition for sending observers to Vatican II the demand that there be no condemnation whatsoever of Communism (Ulisse Floridi, *Moscou et le Vatican*, Paris: France-Empire, 1979, pp. 147-8.; Romano Amerio, *Iota Unum*, Milan-Naples: R. Ricciardi, 1985, pp. 65-6.; Ricardo de la Cierva, *Oscura rebelión en la Iglesia*, Barcelona: Plaza & Janes, 1987, pp. 580-2. See also Atila Sinke Guimarães, "O Pacto de Metz," in *Catolicismo*, May 1991, pp. 15-8; "The Pact of Metz," *Catholic Family News*, September 2001, *DailyCatholic.org*, September, 29, 2001; *TraditionInAction.org* /Hot Topics).

c. The trustworthiness of these sources permits no doubt that the Pact of Metz took place. They also lend credibility to other information presented in the "novel" entitled *The Jesuits* by Fr. Malachi Martin, ex-secretary of Cardinal Agostino Bea. Fr. Martin presented very similar details about what happened before, during, and after the Pact of Metz, which was made a few months before the Council opened.

In Malachi Martin's work, the Cardinal Secretary of State, under the pseudonym of *Stato*, tells about the understanding made by the Holy See with the Kremlin from 1942 to our days: "*Stato* reminded his Venerable Colleagues that he had been with the present Holy Father at His Holiness's two meetings with the Soviet negotiator, Anatoly Adamshin, the most recent of which had been earlier this very year of 1981. His Holiness had given the Soviets a guarantee that no word or action, either by His Holiness or the Polish Hierarchy or *Solidarity's* leaders, would violate the Moscow-Vatican Pact of 1962.

"*Stato* did not need to explain to his listeners that in the late spring of 1962, a certain Eugène Cardinal Tisserant had been dispatched by Pope John XXIII to meet with a Russian prelate, one metropolitan Nikodim, representing the Soviet Politburo of Premier Nikita Khrushchev. Pope John ardently desired to know if the Soviet Government would allow two members of the Russian Orthodox church to attend the Second Vatican Council set to open the following October. The meeting between Tisserant and Nikodim took place in the official residence of Paul Joseph Schmitt, then the Bishop of Metz, France. There, Nikodim gave the Soviet answer. His government would agree, provided the Pope would guarantee two things: that his forthcoming Council would issue no condemnation of Soviet Communism or of Marxism, and that the Holy See would make it a rule for the future to abstain from all such official condemnations.

"Nikodin got his guarantees. Matters were orchestrated after that for Pope John by Jesuit Cardinal Augustine Bea until the final agreement was concluded in Moscow, and was carried out in Rome, in that Vatican Council as well as in the policies of the Holy See for nearly two decades since" (Malachi Martin, *The Jesuits - The Society*

matic Church at Vatican II were Vitaly Borovoi and Vladimir Kotliarov, both well-known puppets of the Soviet government[17] working under the orders of the patriarchate of Moscow.

of Jesus and the Betrayal of the Roman Catholic Church, New York: Simon-Schuster, 1987; pp. 85-6).

Further on, Malachi Martin "related" that this Vatican-Moscow pact of 1962 was "merely a renewal of an earlier agreement between the Holy See and Moscow" realized during conversations that took place in 1942 in the pontificate of Pius XII. "It was in that year," he wrote "that Vatican Monsignor Giovanni Battista Montini, who himself later succeeded to the Papacy as Paul VI, talked directly with Joseph Stalin's representative. Those talks were aimed at dimming Pius XII's constant fulminations against the Soviet dictator and Marxism. Stato himself had been privy to those talks. He had also been privy to the conversations between Montini and the Italian Communist Party leader, Palmiro Togliatti, in 1944 *Stato* offered to supply reports from the *Allied Office of Strategic Services* about the matter, beginning, as he recalled, with OSS Report JR-1022 of August 28, 1944" (*Ibid.*, pp. 91-92).

d. When 213 Cardinals, Archbishops, and Bishops asked Paul VI to make a solemn condemnation of Communism, the Russian-Schismatic observers threatened to leave the Council. In an interview with the diocesan paper of Essen, one of them stated resentfully: "The Orthodox always have felt attacked by the Catholic Church. In the Baltic countries, Belarus, and the Ukraine, the Catholic Church has always taken aggressive stands against us. Consequently, while we are further from the Protestant church from the dogmatic point of view, we have good relations with them and unite with them against the common enemy [the Catholic Church]" (Maxime Mourin, *Le Vatican et l'URSS*, pp. 275-6).

e. Regarding Paul VI's response to this request by the 213 conciliar Fathers, see Vol. I, *In the Murky Waters of Vatican II*, Chap. VI, §§ 85-98.

[17] a. Kremlin rulers turned the Schismatic Church into an instrument for their internal and external policies. In his aforementioned work, Maxime Mourin clearly stated that the Russian church was transformed "into an auxiliary of the Soviet government" (*Le Vatican et l'URSS*, pp. 139, 253, 291 *et passim*).

It simply cannot be denied that the two observers sent by the Moscow patriarchate to Vatican II were puppets of the Russian government, which "had judged it in their interest to have Soviet citizens assist at the Council, since it could only gain by this in public opinion. Also, should the Council speak on the topics of Communism, atheism, the Church of Silence, the Uniates, or the Ukrainian Church,

§ 16 Later Paul VI would make multiple efforts to promote dialogue with the Schismatics by means of the Secretariat for the Unity of Christians.[18] A symbolic event that furthered inter-confessional understanding was Paul VI's meeting with patriarch Athenagoras of Constantinople in the Garden of Olives (January 5, 1964), when they embraced and kissed.[19] Nothing like this had taken place since the Schism in the 11th century!

their presence would oblige greater circumspection" (ibid., pp. 253-4).

b. The two Russian observers, professor at the Theological Academy of Leningrad archpriest Vitaly Borovoi and vice-president of the Russian Schismatic mission in Jerusalem Vladmir Kotlyarov, were met at Fiumicino Airport by Msgr. Johannes Willebrands and received in audience the next day by John XXIII (ibid., p. 253).

c. At the synod of Zagorsk (June 6-9, 1988), the Russian Schismatic bishops published a document praising perestroika and the Revolution of 1917. They affirmed that perestroika was "linked to the desire to translate into reality ... the ideas proclaimed by the Great Socialist Revolution of October. As Christians, we participate in these historical transformations and we manifest our support for Gorbachev and his leadership and for the perfecting of Socialist democracy" (30 Giorni, Port. ed., July 1988, p. 71).

[18] On the three ecumenical Secretariats that became Pontifical Councils, see In the Murky Waters of Vatican II, General Information, § 6.

[19] a. Commenting on the meeting of Paul VI with Athenagoras in the Garden of Olives, L'Osservatore Romano noted: "The meeting was very affectionate. The Pope and his guest embraced and kissed Before parting, they exchanged the kiss of peace" (January 7-8, 1964, p. 5).

b. Two decades later, speaking to Schismatics in Constantinople, Cardinal Johannes Willebrands affirmed that there was "a common desire among Catholics for full unity between our Churches." He recalled the kiss of Paul VI and Athenagoras in the Garden of Olives: "These reflections on the significance of our presence here today with you recall a vivid picture of that memorable meeting that took place 20 years ago on January 5, 1964 in the Garden of Olives in Jerusalem between the patriarch Athenagoras I and Pope Paul VI The kiss of peace exchanged by these persons in this place was truly an important advance for the Church. In fact, this kiss was itself an act of reconciliation" (L'Osservatore Romano, December 14, 1983, p. 5).

§ 17 A few months later, during a solemn ceremony on the Island of Patras (September 7, 1964), Cardinal Agostino Bea, in the name of Paul VI, delivered to the Schismatics the head of the Apostle Saint Andrew, which had been conserved in Rome since the 15th century.[20] As always, the aim was to facilitate a *rapprochement* with the Greek Schismatics.

§ 18 Another symbolic step occured at the end of the Council when, in the Brief *Ambulate in dilectione*, Paul VI expressed "great sorrow" for the excommunication launched in 1054 against Michael Cerularius with the intent of annulling it. To confirm this intent, an official supposed annulment was made the next day in a joint statement by Paul VI and Athenagoras.[21] These acts were also intended to rescind the sentence of schism.[22]

[20] M. Mourin, *Le Vatican et l'URSS*, p. 283.

[21] On December 8, 1965, Cardinal J. Willebrands read the joint statement to the conciliar assembly. See photo and details in A. S. Guimarães and M. T. Horvat, *Previews of the New Papacy*, p. 174.

[22] a. The Pontifical Brief *Ambulate in dilectione*, of December 7, 1965, was read in the last conciliar session in the presence of Paul VI by Cardinal Bea, President of the Secretariat for the Unity of Christians. Flanking him were Cardinals P. Marella and F. König, respectively Presidents of the *Secretariats for Non-Christians* and *for Non-Believers* (Boaventura Kloppenburg, *Concílio Vaticano II*, Petrópolis: Vozes, 1966, vol. 5, pp. 488-90).

b. These acts of Paul VI "rescinding" the excommunication of Cerularius and, by extension, the sentence of schism were:

- Doctrinally wrong, since the same errors professed by Cerularius are still avowed today by the ensemble of the Schismatic denominations;
- Symbolically offensive to the militant past of the Catholic Church;
- Juridically empty, since an excommunication ceases with the death of the person and, as such, it made little sense to annul a sentence whose application ended nine centuries ago.
- Without any practical consequences, given that even Athenagora's followers did not acknowledge the annulment, and the principal Schismatic factions did not consider him their representative.

§ 19 Along this path of dialogue with the Schismatics, it is indispensable to mention the unheard-of and humiliating action of Paul VI, who prostrated himself on the ground to kiss the feet of the metropolitan Meliton,[23] "spiritual heir of Athenagoras."[24]

§ 20 During his long pontificate John Paul II has faithfully followed the same road of Paul VI. For example, the joint blessing given by John Paul II and Dimitrios I in the Basilica of St. Peter[25] is symbolic of his line of conduct toward the "Orthodox."[26]

Thus has dialogue with the Schismatics passed through all the various phases needed to subvert the earlier position of the Church:

[23] a. This took place on December 14, 1975. On that occasion, L'Osservatore Romano commented: "It was truly an hour of the Holy Spirit that led the Pope to make an act so similar to that of Christ After his speech, he approached the metropolitan [Meliton] and, before the visibly stunned and moved community, prostrated himself before him and kissed his feet" (Wigand Siebel, Katholisch oder Konziliar - Die Krise der Kirche Heute, München-Wien: Langen Müller, 1978, p. 422).

b. Commenting on this event, Fr. Congar observed that Paul VI had "the sense of expressive gestures that creates new situations: the cordial kiss given to Patriarch Athenagoras in the Mount of Olives, his Geneva visit the preceding year, where he gave his Ring to [Anglican] archbishop Ramsey as he left the Basilica of St. Peter Outside the Walls; the act of kneeling before patriarch Meliton on December 14, 1975 and kissing his feet. For patriarch Dimitrios, all this signified that 'Paul VI transcended the Papacy by associating with the Fathers who founded the Church.' These words are neither flattery nor poetry. The Papacy that Paul VI transcended is the one that the Orthodox and Protestants will never be able to accept" (Paul VI und der Ökumenismus, in L'Osservatore Romano, German ed., September 23, 1977, p. 4).

[24] Informations Catholiques Internationales, August 1972, p. 9.

[25] L'Osservatore Romano, December 7-8, 1987, p. 5.

[26] For more details on ecumenism with the Schismatics, see Atila S. Guimarães, Quo Vadis, Petre? (Los Angeles: TIA, 1999), pp. 51-66; for photos and recent update of data see A. S. Guimarães and M. T. Horvat, Previews of the New Papacy, pp. 153-188.

§ 21 *First*, in opposition to the constant teaching of the Popes[27] it abdicated the fight against Communism.

 Second, without demanding any doctrinal or disciplinary retractions from the Schismatics, "dialogue" skipped over stages of the ecumenical process to reach its final phase, that is, "communion,"[28] symbolized by the kiss in the Garden of Olives.

 Third, Paul VI "repented" and tried to abrogate the sentence of schism, an indisputably clear and appropriate judgment and official teaching of the Church for nine centuries.

 Finally, *fourth*, Paul VI tried to take dialogue to its most radical consequences. Prostrating himself on the ground and kissing the feet of the Schismatic metropolitan Meliton, he symbolically let the faithful understand that this should be the normal attitude of the Catholic Church in face of the Schism...

§ 22 The example of the trajectory followed by the Conciliar Church with the Eastern Schismatics is expressive of its general policies regarding ecumenism. Thus, in this Introduction, I will refrain from describing an analogous process the Conciliar Church has adopted in its inter-confessional relations with each of the multiple false religions.

§ 23 Here it is important to point out that conciliar ecumenism, which was born from dialogue, would soon surpass it to enter into a new phase of *rapprochement* with false religions: that of "communion."

§ 24 The word dialogue, applied to relations of the Catholic Church with other creeds, was used to express the state of spirit of one who had abandoned discussion and polemics based on reasons of Faith, in order to inaugurate an open, unguarded, and tolerant relationship with the other side, until then considered the enemy. Notwithstanding, dialogue still supposes the existence of two opposed parties seeking an understanding. To the measure that this understanding is established, the term loses its utility. In the present phase of ecumenism, the word

[27] Pontifical documents that condemn Communism can be found in Vol. I, *In the Murky Waters of Vatican II*, Chap I, footnote 14c.

[28] About "communion" as the last or next-to-last stage of the process of ecumenism, see Part II of this Volume, Part II,Chap. V, §§ 8-31.

dialogue for the most part is being replaced by "communion,"[29] with the aim of signifying that the obstacles in the way of establishing a universal religion are being overcome.

§ 25 Because the word "ecumenism" encompasses the whole range of conciliar maneuvers of adaptation to the false religions – and not just the first phase – this work will give precedence to this term over the word "dialogue" in the study of the spirit of Vatican II and the plan to destroy the former position of the Holy Church as sole guardian of the treasures of Revelation.[30]

*

§ 26 How do secularization and ecumenism express the *animus delendi*, the progressivist desire to destroy the Holy Catholic Church?

They do so in their very foundations, their means, and their ends.

§ 27 Secularization, in its foundations, supposes abolishing the civilizing missionary action of the Catholic Church, that is, the radiation of her divine mission in the temporal sphere in her efforts to evangelize the entire world (Mk 16:15). Further, the explicit or implicit admission of the philosophical principles of Enlightenment and the "religious" principles of Deism implies the denial of the integrity of the Faith and the Perennial Philosophy of the Church.

In its means, conciliar secularization denies or destroys the formerly prudent and reserved position of the Church toward the world. In its stead, it introduced a lack of vigilance and a tolerance that are opposed to the militant character of the Catholic Church.

[29] This description of how "dialogue" generated "communion" does not mean to imply that "dialogue" has completely lost its usefulness. It is still used in relation to "non-Christians" and "non-believers."

[30] The word ecumenism is being applied here in its general meaning, as it is understood by the common Catholic faithful. This work acknowledges the "technical-official" distinction between ecumenism and dialogue. The former is used only to refer to the relations with Schismatics and Protestants, the latter is reserved for relations with the other false religions.

In its ends, with the marriage of the Church and the ideals of the modern world, secularization assumes the same humanist goals that fostered revolutionary chimeras aimed at depriving God of glory on this earth, the specific end of our Religion.

§ 28

With regard to ecumenism, one can see that it follows an analogous pattern.

In its foundations, when it admits the existence of sanctifying grace in other religions and recognizes them as a means to attain eternal salvation, it denies the divine foundations of the Holy Church, established as the sole intermediary institution between God and man and the exclusive heir to the treasures of Revelation. Further, by claiming that the Catholic Faith could somehow benefit from dialogue with the false religions, ecumenism destroys the unity of the Faith and, as a consequence, the permanent character of dogma.

In its means, conciliar ecumenism abolishes the traditional Catholic missionary action that strives to convert Schismatics, heretics, Jews, and pagans. It also destroys the militant character of the Church, which considers the followers of false religions enemies of the Catholic name.

In its ends, finally, ecumenism clashes with the objectives of the Holy Catholic Church, which are to reflect the glory of God and to offer men eternal salvation. According to the ecumenical thinking, however, the glory of God would no longer be reflected in the Catholic Church, but in a strange amalgam of confessions that would make up a universal religion, a pantheon of all the idols.

Demonstrating these points constitutes the principal objective of this Volume.

* * *

Part I

SECULARIZATION:

A PROGRESSIVIST *NEW LOOK* OF THE MISSION OF THE CHURCH THAT IMPLIES THE DESTRUCTION OF HER FORMER POSITION TOWARD THE MODERN WORLD

PREMISES

§ 1 Openness to the modern world, secularization, laiciza-
tion, and *aggiornamento* are all expressions that refer to one
same phenomenon, a maneuver that originated in Vatican
Council II and aimed at the destruction of the Church's mission
regarding the temporal order.

Based on conciliar documents, the progressivists al-
leged that the Church must permanently adapt herself to the
modern world.[1] Otherwise, they argued, her voice no longer
would be able to move modern day men and she would be un-
able to fulfill her mission. Thus, they claimed, what moved
them was a pastoral concern: the desire to bring peoples and
individuals into the bosom of the Catholic Church.

The root of this supposed zeal is found in *Gaudium et
spes*, which, inspired by a similar concern, was given the title
"pastoral Constitution." For this reason as well, Vatican II was
initially proposed as a pastoral Council.[2]

§ 2 When, however, one studies the basis for this apostolic
zeal that would justify such an adaptation to the world, one
sees that it clearly constitutes a singular innovation that con-
flicts with the 2,000-year-old conduct of the Holy Church.

Throughout her existence and wherever she established
herself, the Catholic Church has faced persecutions, hostilities,
and difficulties. These persecutions and trials have been docu-
mented and studied by Church historians.

§ 3 The tragic cycle of the ten religious persecutions by the
Roman Emperors, for example, found the Holy Church un-
swerving in her adherence to the principles of the Faith, exas-
perating as they were to pagan idolatry. These persecutions
crowned the nascent Church with glory and allowed millions of

[1] Pastoral Constitution *Gaudium et spes*, Decree *Inter mirifica,* and
Declaration *Dignitatis humanae.* Some points of *Gaudium et spes*
recommending adaptation to the modern world are transcribed in
Premise 2, §§ 5,6.

[2] About the aims of the Council and its status as pastoral or dog-
matic, see Vol. I, *In the Murky Waters of Vatican II*, Chap. VI, §§ 34-
64.

Catholics to bear witness to their Faith through martyrdom. What would have become of the Church if the first Christians had resolved to apply the policy of *aggiornamento,* or an "opening" to the errors of the Roman world? Compare the glory of the Church of the Martyrs with the mantle of shame that covered the *lapsi,*[3] and the answer appears. She most probably would be remembered now only as a spurious church of cowards, lost in the disdain of History.

§ 4 On the contrary, by fearlessly confessing her Faith and standing against the pagan errors, she gave an unforgettable example of Catholic courage and *panache* that will ever serve as an example for the faithful in their adversities.

§ 5 What were the fruits of this "policy" of intrepid heroism for the Church? It was not long before the Roman establishment was shaken with insecurity by the great attraction the people felt for the Church, and multitudes flocked to join her ranks. The flaming words of Tertullian to the Roman magistrates during the persecution of Septimus Severus offer proof of this:

"How ready and courageous to fight we would have been, despite our unequal numbers, we who have allowed our heads to roll so easily, if only our religion would not have obliged us to die rather than to kill! Even without taking up arms, even without revolting openly, we could deal you an ignominious defeat simply by separating ourselves from you. If this immense multitude should only desert you and retire to some faraway region, the loss of so many citizens from every social class and profession would discredit and shame your government and punish you very much. Without a doubt, stunned by your solitude, the failure of your administration and the stupor of the whole world, like one mortally wounded, you would seek out someone to rule, yet you would be left with more enemies than citizens."[4]

§ 6 In 313 Constantine officially declared *de jure* the freedom of the Church, which, given her vigor and number of her

[3] *Lapsi*: the Catholics in the early centuries who denied their Faith out of fear of martyrdom. "Adapting" themselves to the vices and errors of the Roman world, they offered some kind of worship to the pagan idols to save their lives or positions.

[4] Tertullian, *Apologetica*, chap. 37, PL 1, cols. 525-7.

followers, had already been for some time a *de facto* reality, especially in the West.

§ 7 The Church's way of acting in hostile ambiences never changed throughout her History. This did not prevent her from developing a missionary action both tactful and sensitive to circumstances, adapting wisely her methods to the needs of peoples. Taking advantage of the positive aspects of the culture and customs of the peoples evangelized, she stimulated and cultivated what was according to natural law. Studying their best tendencies, she screened and developed them in the line of virtue and civilization.

Showing a truly supernatural equilibrium, the Catholic Church was always most pure and holy in the defense and preaching of the Faith and Morals inherited from her Divine Founder, never admitting the least transgression insofar as they were concerned. At the same time, she always showed herself benign, receptive, and protective toward the legitimate values of the peoples and cultures she addressed.

§ 8 It is this age-old attitude of the Church, and even more, the Catholic Faith itself, that are being challenged by the peculiar "apostolic zeal" alleged by the progressivists as a pretext to justify the "opening" to the modern world.

*

First Premise

THE TRADITIONAL TEACHING OF THE CHURCH
REGARDING THE MODERN WORLD

§ 1 The opposition between the principles of the Faith and those of the modern world is such that it could not be more complete.

§ 2 What characterizes the modern world is the transposition of the principles that oriented the French Revolution to the formation of States, and to the domains of law, social relations, customs, culture, and the arts. These principles, in their turn, stemmed from the Rationalism, Enlightenment, and Deism of the philosophers, and are trainbearers of the utopian dreams for a secular, egalitarian, and liberal society. Just as the Encyclopedia generated the French Revolution, this Revolution spawned the modern world.

§ 3 "Modern world" is the expression used to signify the revolutionary attempt to establish in the West a "civilization" and "culture" diametrically opposed to the true civilization and true culture that characterized Christendom.[1]

[1] On Catholic culture and civilization, see the principles expounded by Plinio Corrêa de Oliveira in *Cruzada do Século XX* (*Catolicismo*, January 1951). Later, he summarized them in his well-known work *Revolution and Counter-Revolution*:

"From all these facts it is easy to infer that Catholic culture and civilization are culture *par excellence* and civilization *par excellence*. It must be added that they cannot exist except in Catholic peoples. For even though man may know the principles of Natural Law by his own reason, a people cannot durably maintain the knowledge of all of them without the Magisterium of the Church (Vatican Council I, ses. 3, chap. 2, D. 1786). For this reason a people who do not profess the true Religion cannot durably practice all the Commandments (Council of Trent, ses. 6, chaps. 1-2, D. 793-4; canons 1-2, D. 811-2).

"Given these conditions and since Christian social order cannot exist without the knowledge and observance of the law of God, civilization and culture *par excellence* are possible only in the bosom of the Holy Church. In accordance with the words of St. Pius X on civilization, it 'is all the more true, all the more durable, all the more fecund in pre-

§ 4 The complete opposition between the foundations and goals of the modern world, on the one hand, and the aims of Holy Church with her beneficial, civilizing, and edifying work on the other, was what compelled the Sovereign Pontiffs to condemn the errors that characterize the modern world.[2]

§ 5 Gregory XVI taught this general principle, applied directly to the modern world: "It is the proud, or rather foolish, men who examine the mysteries of Faith which surpass all understanding with the faculties of the human mind, and rely on human reason, which is weak and infirm by the condition of man's fallen nature."[3]

§ 6 With strong, conclusive words, Pius IX, in his Encyclical *Qui pluribus*, referred to the destructive work carried out by the modern world and its agents. He condemned their philosophical pretensions, at the same time rationalistic and enamored with progress:

"It is no secret to you, Venerable Brethren, that in these our calamitous times a very bitter and fearsome war against the whole Catholic commonwealth is being stirred up by men bound together in a lawless alliance. These men do not preserve sound doctrine, but turn their hearing from the truth and eagerly attempt to produce from their darkness all sorts of perverse beliefs, and then to magnify them with all their strength, and to publish them and spread them among ordinary people. We are horrified and our heart suffers bitter pain when we reflect on all their monstrous errors and the many artifices, plots,

cious fruits the more purely Christian it is; it is all the more decadent, to the great misfortune of society, the farther removed it is from the Christian ideal. For this reason, by the intrinsic force of things, the Church becomes in fact the guardian and protector also of Christian civilization' (Encyclical *Il fermo proposito*, June 11, 1905, Paris: Bonne Presse, vol. 2, p. 92)," (*Revolution and Counter-Revolution*, New Rochelle, NY: Foundation for a Christian Civilization, 1983, part I, chap. VII.2.D).

[2] For the pontifical document condemning the principles of the revolutionary triad liberty-equality-fraternity, the foundation stones of the modern world, see *In the Murky Waters of Vatican II*, Chap. I, footnote 14.

[3] Gregory XVI, *Mirari vos, Recueil des allocutions consistoriales, encycliques et autre lettres apostoliques citées dans l'Encyclique Quanta cura et le Syllabus* (Paris: Adrien le Clerc, 1865), p. 169.

and contrivances these men use to spread their hatred for truth and light. They are experienced and skillful in deceit, which they use to set in motion their plans to quench all zeal for piety, justice, and virtue, to corrupt customs, to cast all divine and human laws into confusion, and to weaken and even over-throw, if it were possible, the Catholic religion and civil soci-ety.

"For you know, Venerable Brethren, that these bitter enemies of the Christian name, inflamed with the blind passion of their unbridled impiety, in their madness and unheard-of au-dacity go so far as to open their mouths and blaspheme against God (Apoc 13:6), to publicly and shamelessly teach that the mysteries of our sacrosanct religion are fictions of human in-vention, and that the teaching of the Catholic Church is op-posed to the well-being and prerogatives of human society. They even dare to deny Christ Himself and God.

"And so that they may more easily mislead the people into error, deceiving in particular the imprudent and inexperi-enced, they pretend that they alone possess the secret of pros-perity. They claim for themselves without hesitation the title of philosophers, as if philosophy, which is wholly concerned with the search for truth in nature, should reject those truths which God Himself, the supreme and most clement Author of nature, has deigned to manifest to men by His singular goodness and mercy, so that mankind may attain true happiness and salva-tion.

"Hence, by means of distorted and fallacious argu-ments, these enemies never stop invoking the power and excel-lence of human reason, raising it above the holy faith in Christ, and they spread everywhere with great foolhardiness that this faith is opposed to human reason. Without doubt, they could not have devised anything more senseless, impious, and op-posed to reason itself. For although faith is above reason, there is no opposition or discord whatsoever between them, since both proceed from the same greatest source of eternal and un-changing truth, God

"With no less deceit and audacity, Venerable Brethren, other enemies of divine revelation, by exalting human progress, with reckless and sacrilegious effrontery want to import the doctrine of human progress into the Catholic religion, as if re-ligion were not the work of God but of men, or else some phi-

losophical discovery that could be perfected by human means."[4]

Therefore, in this document Pius IX vigorously condemned the errors of the philosophers, Rationalism, and the utopian notion of progress, the foundations of the modern world.

§ 7 He went further. In his Encyclical *Quanta cura*, he proscribed two other foundations of the modern world, Naturalism and Liberalism:

"You well know, Venerable Brethren, that in our days there are many men who, by applying to civil society the impious and absurd [doctrine of] Naturalism, dare to teach 'that both the constitution of public society and civil progress require that human society be conducted and governed without any concern for religion, as if it did not exist, or at least without making any distinction between the true Religion and the false one.' And, against the doctrine of Scripture, the Church, and the Holy Fathers do not hesitate to assert that 'the best situation of civil society is one in which civil authority is not given the power to restrain, by enacted penalties, the violators of the Catholic Religion so far as public order may require.'

"Departing from this totally false idea of social government, its propagators fearlessly foment the erroneous opinion, most fatal in its effects on the Catholic Church and the salvation of souls, which our predecessor called 'a delirium' (*Mirari vos*), that 'liberty of conscience and worship is an inalienable right of the individual, which should be legally proclaimed and established in all rightly constituted societies; that citizens have a right to an absolute liberty without restraint by any ecclesiastical or civil law; whereby they may openly and publicly manifest and state any of their ideas whatsoever, either by word of mouth, by press, or in any other way.' But, while they rashly affirm this, they do not realize and consider that they are preaching 'liberty of perdition' (St. Augustine, *Epistle 105*, al. 166), and that 'if human arguments are always allowed free room for discussion, there will never be wanting men who will dare to resist truth and to trust in the verbosity of human wisdom. Whereas we know, from the very teaching of Our Lord Jesus Christ, how carefully Christian faith and wisdom

[4] Pius IX, Encyclical *Qui pluribus* on the modern errors and how to combat them, November 9, 1846, *Recueil des allocutions*, pp. 175-7.

should avoid this most injurious drivel' (St. Leo, *Epistle 14*, a. 133)."[5]

§ 8 Having been condemned at its very foundations, the modern world also received an explicit censure in the 80th anathema of the *Syllabus*. It prohibited thinking that "the Roman Pontiff can and must reconcile himself to and come to terms with progress, Liberalism, and modern civilization" (DR 1780).

§ 9 Pius XII also energetically condemned the modern world when he compared its pride to that of Lucifer: "In the same way that it [the modern world] tried to throw off the suave yoke of God, it simultaneously repudiated the order He established; and, with the same pride of the rebellious Angel at the beginning of Creation, tried to institute another order according to its own will. After almost two centuries of sad experiments and missteps, all who are still of upright heart and mind confess that any such dispositions and impositions – those which have the name but not the substance of order – did not give the results they promised and do not correspond to the natural hopes of man."[6]

§ 10 Yet other documents by various Pontiffs confirm the opposition of the Holy Church to the modern world.[7]

§ 11 It is evident, therefore, that the errors that gave rise to and shaped the modern world are so directly contrary to Catholic doctrine that there can be no reconciliation with its principles. The Church and the modern world face each other in radical opposition, similar in many ways to the hostility that early Christianity faced under the pagan domination of the Roman Empire.

§ 12 How, then, could one imagine an "opening" to the modern world? Sound doctrine would never admit a "pastoral zeal" that failed to make robust warnings against the doctrinal errors of the modern world in order to try to convert it. Further, even though conciliar progressivists speak often about "love of the world" and "pastoral" action, they never refer to converting the world.

[5] Pius IX, Encyclical *Quanta cura*, December 8, 1864, *Recueil des allocutions*, pp. 5-7.

[6] Pius XII, Radio-message of Christmas 1949 (Petrópolis: Vozes, 1952), n. 28.

[7] See Vol. I, *In the Murky Waters of Vatican II*, Chap. I, footnote 14.

§ 13 A Catholic who analyzes the Church-world *rapproche-*
ment becomes confused, since the fixed pole in this relation-
ship – to which the other must adapt – is not the Church, but
the modern world. This contradicts the constant missionary ac-
tion of the Catholic Church throughout History. Such a surpris-
ing reversal of roles would seem more likely to conceal an in-
vitation to defect from the Faith in the name of adaptation.

*

Second Premise

POINTS OF *GAUDIUM ET SPES* THAT APPEAR TO CONTRADICT THE CHURCH'S PERENNIAL TEACHING ABOUT THE MODERN WORLD

§ 1 A careful study of *Gaudium et spes* will show various points of discrepancy with regard to prior condemnations of the Pontifical Magisterium. Some passages from the conciliar document imply an adherence to basic errors of the Enlightenment and the French Revolution, as well as to schools of thought that in a certain way derived from them, such as Socialism and Freudian psychology.

While at times these passages pay tribute to ambiguity,[1] they are more notable for how they clash with the principles of

[1] In some of the transcribed texts that aim at combating economic and social inequalities, the use of imprecise expressions such as *immense inequalities* or *excessive differences* seems characteristic of the ambiguity peculiar to the language of the conciliar documents. The inequality is immense in relation to what? The differences excessive compared to what? Reference points are lacking in these judgments. If the inequality were accentuated or excessive when comparing a lower class and the one immediately above it, there would indeed be a factor of disharmony in the socio-economic structure, which could reveal unfair distributive principles. However, if the terms of comparison were the poorest and the richest classes, the accentuated and excessive inequalities would be normal, because between the two extremes would lie the other classes, and this would not necessarily reveal an unfair distribution. To combat such *excesses* would mean opposing economic and social inequality itself. Therefore, the use of the term *inequality* is ambiguous and predisposes the reader against all inequalities, and encourages adherence to the egalitarianism of modern society.

This is the same footnote 54 from Volume IV, *Animus delendi I*, Chap. IV. For more on the subject of ambiguity in the conciliar documents, see Vol. I, *In the Murky Waters of Vatican II*, Chaps. III-VIII.

the Faith and social doctrine, or for their affinity with the utopian ideals of the Enlightenment and Socialism.

1. Adhesion to the ideals of Liberty, Equality, and Fraternity

A. Equality

§ 2

 * "God intended the earth and all that it contains for the use of every human being and people **Whatever the forms of ownership may be, as adapted to the legitimate institutions of people attention must always be paid to the universal purpose for which created goods are meant.** In using them, therefore, **a man should regard his lawful possessions not merely as his own but also as common property in the sense that they should accrue to the benefit of not only himself but of others Men are obliged to come to the relief of the poor, and to do so not merely out of their superfluous goods**" (69a, b).

 * "**In economic enterprises** it is persons who work together, that is, free and independent human beings created to the image of God. Therefore **the active participation of everyone in the running of an enterprise should be promoted.** This participation should take into account each person's function, whether it be one of ownership, hiring, management, or labor. It should provide for the necessary unity of operations.

 "However, decisions concerning economic and social conditions, on which the future of the workers and their children depends, are often made not within the enterprise itself but by institutions on a higher level. **Hence the workers themselves should have a share also in controlling these institutions,** either in person or through freely elected delegates" (68a, b).

 * "If the demands of justice and equity are to be satisfied, **vigorous efforts must be made,** without violence to the rights of persons or to the natural characteristics of each country, **to remove as quickly as possible the immense economic inequalities which now exist**" (66a).

* "While an enormous mass of people still lack the absolute necessities of life, some, even in less advanced countries, live sumptuously or squander wealth. Luxury and misery rub shoulders. While the few enjoy very great freedom of choice, the many are deprived of almost all possibility of acting on their own initiative and responsibility

"A similar lack of economic and social balance is to be noted between agriculture, industry, and the service sectors, and also between different parts of one and the same country. The contrast between the economically more advanced countries and other countries is becoming more serious day by day, and the very peace of the world can be jeopardized in consequence.

"Our contemporaries are coming to feel these inequalities with an ever sharper awareness. For they are thoroughly convinced that the wider technical and economic potential which the modern world enjoys can and should correct this unhappy state of affairs. **Hence numerous reforms are needed at the socio-economic level**, along with universal changes in ideas and attitudes" (63c, d, e).

* "For excessive **economic and social differences** between the members of the one human family or population groups **cause scandal, and militate against social justice, equity, the dignity of the human person, as well as social and international peace**" (29c).

* "**Many of these causes** [of wars] **stem from excessive economic inequalities** and from excessive slowness in applying the needed remedies" (83).

* "**Let adequate organizations be established for repairing the deficiencies caused by an excessive disproportion in the power possessed by various nations**" (86c).

B. Liberty: religious liberty

§ 3 *** The Church sincerely professes that all men, believers and unbelievers alike, ought to work for the rightful betterment of this world** in which all alike live Hence **the Church protests against the distinction which some state authorities unjustly make between believers and unbelievers, thereby ignoring fundamental rights of the human person.**" (21f).

*** "The Gospel has a sacred reverence for the dignity of conscience and its freedom of choice"** (41b).

*** "The desire for such dialogue excludes no one,** though an appropriate measure of prudence must undoubtedly be exercised. **We include those who** cultivate beautiful qualities of the human spirit, but **do not yet acknowledge the Source of these qualities. We include those who oppress the Church and harass her in manifold ways ... we are all called to be brothers.** Therefore, if we have been summoned to the same destiny, which is both human and divine, **we can and we should work together without violence and deceit in order to build up the world in genuine peace"** (92e)

*** "The Catholic Church gladly holds in high esteem the things which other Christian Churches or ecclesial communities have done or are doing cooperatively by way of achieving the same goal** ["to make the family of man and its history more human"] (40d).

C. Universal fraternity

§ 4 *** "This sacred Synod proclaims the highest destiny of man and champions the godlike seed which has been sown in him. It offers to mankind the honest assistance of the Church in fostering that brotherhood of all men** which corresponds to this destiny of theirs (3b).

* "He [the Word] Himself revealed to us that 'God is love' (1 Jn 4:8) To those, therefore, who believe in divine

love, **He gives assurance that the way of love lies open to all men and that the effort to establish a universal brotherhood is not a hopeless one**"(38a).

* **"The proposals of this sacred Synod look to the assistance of every man of our time, whether he believes in God or does not explicitly recognize Him.** Their purpose is to help men gain a sharper insight into their full destiny, so that they can fashion the world more to man's surpassing dignity, **and search for a brotherhood which is universal** and more deeply rooted" (91a).

* **"The international institutions,** both universal and regional, **which already exist assuredly deserve well of the human race. These stand forth as the first attempts to lay international foundations under the whole human community for the solving of the critical problems of our age** **The Church rejoices at the spirit of true fraternity flourishing between Christians and non-Christians in all these areas**" (84c).

* **"Human culture must evolve today in such a way that it can** develop the whole human person harmoniously and, at the same time **assist men in those duties which all men, especially Christians, are called to fulfill in the fraternal unity of the one human family**" (56).

* **"If an economic order is to be created which is genuine and universal, there must be an abolition of excessive desire for profit, nationalistic pretensions, the lust for political domination, militaristic thinking, and intrigues designed to spread and impose ideologies**" (85c).

2. Union with the Modern World

§ 5

* **"The Catholic Church** **is firmly convinced that she can be abundantly and variously helped by the world in the matter of preparing the ground for the Gospel.** This help she gains from the talents and industry of individuals and from human society as a whole" (40d).

* "Thus **we are witnesses of the birth of a new Humanism**, one in which man is defined first of all by his responsibility toward his brothers and toward History" (55).

* "**The living conditions of modern man have been so profoundly changed in their social and cultural dimensions that we can speak of a new age in human history. Fresh avenues are open, therefore, for the refinement and the wider diffusion of culture.** These avenues have been paved by the enormous growth of natural, human, and social sciences, by progress in technology, and by advances in the development and organization of the means by which men communicate with one another

"**Customs and usages are becoming increasingly uniform.** Industrialization, urbanization, and other causes of community living create new forms of culture (mass-culture) from which arise new ways of thinking, acting, and making use of leisure. **The growth of communication between the various nations and social groups opens more widely to all the treasures of different cultures. Thus, little by little, a more universal form of human culture is developing**" (54).

* "Therefore, by virtue of the Gospel committed to her **the Church proclaims the rights of man. She acknowledges and greatly esteems the dynamic movements of today by which these rights are everywhere fostered**" (41c).

3. Applause for modern Psychology and Sociology

§ 6

* "**Advances in** biology, **psychology, and the social sciences not only bring men hope of improved self-knowledge. In conjunction with technical methods, they are also helping men to exert direct influence on the life of social groups.** At the same time, the human race is giving ever-increasing thought to forecasting and regulating its own population growth" (5b).

* "**In pastoral care, appropriate use must be made** not only of theological principles, but also of **the findings of**

the secular sciences, especially of psychology and sociology" (62b).

* "**Recent psychological research explains human activity more profoundly**" (54a).

* "**Let them [the faithful] blend modern science and its theories and the understanding of the most recent discoveries with Christian morality and doctrine.** Thus their religious practice and morality can keep pace with their scientific knowledge and an ever-advancing technology. Thus too they will be able to test and interpret all things in a truly Christian spirit" (62f).

4. Incentive to socialization[2]

§ 7

* "**The Church further recognizes that worthy elements are found in today's social movements, especially** **a process of wholesome socialization**" (42c).

* "**Socialization,** while certainly not without its dangers, **brings with it many advantages with respect to consolidating and increasing the qualities of the human person and safeguarding his rights**" (25b).

* "**The proper relationship between socialization and personal** independence and **development can be variously interpreted according to the locales** in question **and the degree of progress achieved by a given people**" (75c).

* "Thus, a man's ties with his fellows are constantly being multiplied. At the same time '**socialization' brings further ties**, without, however, always promoting appropriate personal development and truly person relationships ('personalization')" (6e).

[2] See pontifical documents condemning Socialism in Vol. I, *In the Murky Waters of Vatican II*, Chap. I, footnote 14c.

* "**If an economic order is to be created which is genuine and universal, there must be an abolition of excessive desire for profit** **Proposals are made in favor of numerous economic and social systems. It is to be hoped that experts in such affairs will find common bases for a healthy world trade**" (85c).

* "Depending on circumstances, therefore, **reforms must be instituted** **insufficiently cultivated estates should be distributed** to those who can make these lands fruitful" (71f).

* "**Laborers and farmers seek** not only to provide for the necessities of life, but to develop the gifts of their personality by their labors, and indeed **to take part in regulating economic, social, political, and cultural life**. Now, for the first time in human history, all people are convinced that the benefits of culture ought to be and actually can be extended to everyone" (9b).

*

§ 8 For faithful Catholics who sincerely want to follow the teaching of the Holy Church, the situation is chaotic. On one hand, the clear teachings of the Church preach against and combat the errors of the modern world in which she lives. On the other hand, Vatican II affirms the opposite.

Has the perennial teaching of the Church changed? Is that which was once wrong now right? Or has Vatican II abandoned the doctrine of the Church? It is a grave question, but no Catholic is dispensed from answering it, given that his duty is to maintain the integrity of the Faith and to accompany Holy Church even in the most dolorous steps of her History.

In an effort to find a response, Part I will offer the Reader documents that seem to reveal a radical change of the Conciliar Church with regard to the former position of the Holy Catholic Church toward the modern world

Chapter I

THE CULT OF MAN
PROMOTED BY RECENT POPES AND
CONCILIAR PROGRESSIVISTS

§ 1 Progressivists make a strange inversion of poles when dealing with relations between God and men. The Commandment of Our Lord Jesus Christ, which summarizes all the others, orders: "And thou shalt love the Lord thy God with thy whole heart, and with thy whole soul, and with thy whole mind, and with thy whole strength and Thou shalt love thy neighbor as thyself" (Mk 12; 30-31). In a sophistic interpretation of the words of St. John "For he that loveth not his brother whom he seeth, how can he love God whom he seeth not?" (1 Jn 4:20), progressivists invert the Commandment, turning it into: "Thou shalt love man above all things, and God as thyself."

§ 2 Various expressions are used to describe this inversion. Some call it *Transcendental Anthropology* or *Anthropological Reduction*; others term it *Christian Humanism*, and yet others, *Integral Humanism*. Such names appear to convey the notion that they represent different schools of thought or, at least, more or less avant-garde tendencies within the same current. In fact, they are only stages of the same process that have rapidly advanced toward the final "commandment" – the cult of man.

§ 3 To this tactical ploy similar to that of the Modernists,[1] they add a doctrinal sophism: Man is made to the image and likeness of God. Therefore, he who loves man necessarily loves God.

§ 4 Such reasoning inverts the foundations of the Commandment of Christ, whose major premise is the love of God,

[1] In the Encyclical *Pascendi Dominici gregis*, St. Pius X warned against a similar artifice: "It is one of the most astute devices of the Modernists to present their doctrines without order and systematic arrangement, in a scattered and disjointed manner so as to make it appear as if their minds were in doubt or hesitation, whereas in reality they are quite firm and constant" (n. 4).

followed by the minor premise of an upright love of self, whose conclusion is the love of neighbor. To the contrary, in the progressivist "commandment," the major premise is the love of man or one's neighbor; the minor premise is love of oneself, and its conclusion is the love of God. This sophistic legerdemain produces a complete revolution regarding the concept of the love of God – termed by the progressivists as a 'Copernican revolution'[2] – and installs the cult of man.

§ 5　　　　Long ago St. Augustine predicted the consequences of inverting these poles of the love of God and love of self and neighbor. The words of the great Bishop of Hippo can be applied quite aptly to the present conciliar "Copernican revolution":

"Two loves built two cities: the earthly city was made by the love of self, even to the contempt of God; the heavenly city by the love of God, even to the contempt of self. The former glories in itself, the latter in the Lord. For the one seeks glory from men; but the greatest glory of the other is God, the witness of conscience. The one lifts up its head in its own glory; the other says to its God, 'Thou art my glory, and the lifter up of mine head.' [Ps 3:4]

"Therefore the wise men of the one city, living according to man, have sought for profit to their own bodies or souls, or both, and those who have known God 'glorified Him not as God, neither were thankful, but became vain in their imagina-

[2] a. Belgian theologian Emmanuel Lanne, O.S.B., used the expression "Copernican revolution" in his commentary on the thesis of Karl Rahner. Rahner postulated that the great novelty of Vatican II was to envision the local church as a realization of the One, Holy, Catholic, and Apostolic Church in his work *Das neue Bild der Kirche*, in *Schriften zur Theologie*, vol. 8, Einsiedeln, 1967, pp. 333-4. (*L'Église locale et l'Église universelle*, in *Irenikon* 43, 1970, p. 490, *apud* Y. Congar, *Le Concile de Vatican II - Son Église, peuple de Dieu et Corps du Christ*, Paris: Beauchesne, 1984, pp. 170-1).

b. The term "Copernican revolution" found common usage in post-conciliar progressivist language to refer to the change in the concept of the Church as *societas perfecta* to the Church as people of God see Vol. IV, *Animus delendi I*, Chap. IV, § 2.

c. By extension, it refers to the "anthropological reduction" mentioned above. About the "anthropological reduction" or "transcendental anthropology" of Rahner and his role in conciliar theology, see Vol. VI, *Inveniet fidem?*, Chap. III. 5.C, D.

tions, and their foolish heart was darkened.' Professing themselves to be wise 'they became fools' and changed the glory of the incorruptible God into an image made like to corruptible man because they led peoples or followed them to the altars of idolatry; 'and preferred to render to the creature the cult and homage due to the Creator, who is blessed by all centuries'(Rom 1:25)."[3]

St. Augustine was even more radical describing the opposition of the two cities. He wrote: "Cursed is the man who trusts in man, consequently, no one ought to trust in himself. He must renounce this if he wants to become a citizen of the city of God, which is not dedicated here in the name of the sons of Cain, that is, in the fleeting course of this mortal world, but in the immortality of perpetual blessedness."[4]

§ 6 What we are facing, therefore, is a revolution that is trying to transform the City of God into the City of Man. While this inversion is taking place, many progressivists find common ground to dialogue with enemies of the Church by overemphasizing the role of man and relegating the cult of God to a second plane.

§ 7 This inversion of poles might even be said to draw conciliar theology closer to Judaism. As Fr. Chenu explained: **"There is a phrase that Fr. Congar likes to quote,** a phrase **by rabbi Abraham Heschel** that says: **'The Bible is not a theology for man, it is an anthropology for God.' This is a beautiful, very insightful formula**. In other words, the Bible is not primarily a vision of God by man; it is a vision of man by God. It is God who reveals to man who man is. As a consequence, **all theology implies an anthropology**; clearly, it remains a discourse about God, but **a discourse about God that unfolds into a discourse about man with respect to himself.** This is the new perspective."[5]

§ 8 After this sleight-of-hand transformation of the love of God into the love of man, innumerable progressivists felt at ease to start preaching the cult of man. The following texts provide examples.

[3] *De Civitate Dei* (Paris: Jacques Lecoffre, 1854), lib. 14, c. 28, vol. 2, pp. 359-60.

[4] *Ibid.*, lib. 15, c. 18, p. 410.

[5] *Jacques Duquesne interroge le Père Chenu* (Paris: Centurion, 1975), pp. 83-4.

§ 9 This revolution can be found in the praise Paul VI made of the United Nations (UN), an organization symbolic of the city of man. In the message he delivered there on his visit, he affirmed:

"Our message is meant to be, above all, a solemn, moral ratification of this high Institution. This message is born from our historic experience. **It is as a 'specialist in humanity' that we bring to this Organization the approval of our more recent predecessors, that of the whole Catholic Episcopate and our own, convinced as we are that this Organization represents the obligatory pathway for modern civilization and world peace."**[6]

§ 10 In his homily of December 7, 1965 delivered at the closing Mass of the Council, Paul VI showed himself a partisan of a radical Humanism and declared his adhesion to the cult of man:

"Secular and profane Humanism ended by revealing its terrible stature, defying, so to speak, the Council. **The religion of the God who willed to become man encountered the religion (for that is what it is) of the man who wants to become God. What happened? A combat, a fight, an anathema? This could have happened but did not.**

"The old story of the good Samaritan was the paradigm for the Council's spirituality. Indeed, an immense love of men profoundly permeated it. Human needs, examined and considered in detail have absorbed the attention of our Synod. You modern humanists, who renounce transcendental truths, **ought to pay tribute to the Council for at least this and acknowledge our new Humanism. For we also, and we more than anyone, are worshipers of man."**[7]

[6] Paul VI, *Messaggio di Paolo VI all'Assemblea Generale delle Nazioni Unite*, in *La visita di Paolo VI alle Nazioni Unite*, p. 59; see complete analysis in this Volume, Part I, Chap V, §§ 4-18.

[7] a. *Homily at the Closing Session of the Council*, December 7, 1965, in *Insegnamenti di Paolo VI*, vol. 3, p. 721.

b. Paul VI's statement, "we are worshipers of man," has been the object of heated arguments. Rev. Abbé Georges de Nantes wrote a book accusing the Pontiff of heresy: *Liber accusationis* (St. Parrès lés Vaudes: CRC, 1973, 111 pp.). Fr. Yves Congar came to the defense of Paul VI by asserting that the expression "worshiper of man" had been taken out of its proper context, which he claimed would

reflect the thinking of Jacques Maritain's work *Humanisme intégral* (cf. *La crisi nella Chiesa e Mons. Lefèbvre*, Queriniana: Brescia, 1975, pp. 69-70).

c. **This Work**, in keeping with its serene and serious tone, **does not attempt to qualify** the statements and actions of the conciliar Pontiffs as heretical or under suspicion of heresy. **It aims** only **to analyze and compare them to the traditional teaching of preceding Pontiffs and the Ordinary and Universal Magisterium**. With this, the doctrines and actions of the present-day Popes that differ from the infallible Magisterium of the Church will be *ipso facto* judged, and the Author of this Work will not pretend for himself an authority he does not possess.

d. On the theological hypothesis of a heretical Pope, see Arnaldo Vidigal Xavier da Silveira, *L'Ordo Missae de Paul VI: Qu'en penser?* (Chiré-en-Montreuil: Diffusion de la Pensée Française, 1975), especially part II, chapters VI and VII, which analyze the opinions of renowned theologians such as St. Robert Bellarmine, Ballerini, Wernz-Vidal, Cardinal Billot, and others. They hold that a Pope who would fall into heresy would lose *ipso facto* the pontificate (pp. 266-271).

f. Following the criteria established above, I do not take sides in the attempt of the Abbé de Nantes to initiate a process against Paul VI for heresy, schism, and scandal. From a canonical standpoint, I do not know what would be the effects of an appeal directed to a Pope asking him to judge himself as a heretic.

If it were a moral admonition it would be understandable. If its intent were to alert the Pope and the faithful to doctrinal errors into which he appears to be falling, it would be laudable. If it were a judgment made by anyone other than another Pope, it would be condemnable. The possibility of initiating a canonical legal process – which would seem to be the intention of the French Abbé – in which the judge is the defendant, goes beyond my meager knowledge in this matter. Further, I am unaware if some legal action was ever taken, as the Abbé de Nantes apparently wanted.

g. Since, however, in the analysis of the thinking of Paul VI, this Volume quotes the same phrase that raised the polemic, I have a word to say about the seriousness of the use of the phrase "we also are worshipers of man."

1. With regard to Fr. Congar's defense, it is noteworthy that he – who accused the Abbé de Nantes of a dishonest use of Paul VI's text – exempted himself from providing the evidence that would contradict Paul VI's statement on the worship of man. This omission certainly weakens his defense.

Furthermore, in order to justify Paul VI, Congar tries to cover him in a context far broader than the mere homily. He refers to the work of

§ 11 On the same occasion, Paul VI affirmed that at Vatican
II the Church "almost declared herself a slave of humanity."
This is a shocking revolution regarding the ends of the Church,
which existsfor the service of God and to be Queen and Mis-
tress of men. These are his words: "There is still something
else we must note: **all** of these **doctrinal riches [from the**

Jacques Maritain, *L'humanisme intégral.* Now, if, in order to under-
stand each pontifical statement, however clear and categorical it
might be, one would have to resort to works not even mentioned in it,
this would amount to establishing the kingdom of chaos and confu-
sion in the expression of thought.

It would also imply that Paul VI was intellectually irresponsible. For if
Congar's defense is accepted as valid, then the Pope did not mean
to say what he in fact affirmed, but his statement could only be un-
derstood in light of works that he did not cite. Hence Congar's inter-
vention does more to weaken Paul VI's position than to defend it.

By resorting to a vastly broader context than the homily in question,
Congar gave the impression of one who suffered from a symmetrical
and analogous intellectual dishonesty that he unjustly imputed to
those who attack the expression of Paul VI. Indeed, instead of using
a text without a context, he used a context that does not necessarily
explain the text at issue. Here also the weakness of Congar's de-
fense showed through. Was it a weakness of Congar, or the weak-
ness of Paul VI's position?

2. I carefully analyzed the whole homily and concluded that the text
quoted is entirely consistent with the overall thinking expressed by
Paul VI. This is confirmed in two other passages quoted below,
which provide the Reader with three excerpts of paramount doctrinal
importance extracted from a not-so-long speech. Therefore, the
phrase has not been taken out of context. If, however, someone
could demonstrate to me that the context was poorly understood, his
correction will be accepted with humility and gratitude.

3. Finally, I would like to note that this Work does not attribute to
Paul VI and the progressivists in general a direct denial of God. As I
said above (§§ 1-6), we are dealing with an inversion of the place that
belongs to the love of God, which has been replaced by the love of
man. The fact that the progressivist neo-Humanism frequently uses
the names God and Christian or calls itself theocentric does not
change the essential inversion it made in the greatest Command-
ment. Should someone want to prove the error of my analysis, he
would have to delve deeply into the essence of this question, rather
than merely skirmish with words by alleging, for example, that Paul
VI pronounced the name of God 21 times in his homily.

documents of Vatican II] are turned in a single direction: to serve man**. Man, let us say, in all his breadth, and in all his weakness and indigence. **The Church almost declared herself a slave of humanity** The idea of ministry has taken a central place."[8]

§ 12 He returned to this theme further on in his homily: "The modern mentality, accustomed to judging everything for its value, that is, its utility, has to admit that **the Council's value is great at least in this: everything was addressed to the utility of man. Never let it be said,** therefore, **that a religion like the Catholic one is useless. For in its most conscious and efficient form, which is the conciliar, it declares itself totally** favorable to and **at the service of man.**"[9]

§ 13 Six years later, commenting on the space voyage of American astronauts to the moon, Paul VI could not contain his enthusiasm. In a veritable hymn of praise to the glory of man, the "prince of the heavens," he exclaimed: "**Honor to man!** Honor to human thought! Honor to science! Honor to technology! Honor to work! **Honor to human audacity! Honor to the synthesis of scientific activity and man's sense of organization!** Different from other animals, man knows how to furnish his mind and hands with instruments of conquest. **Honor to man, king of the earth, and now also prince of the heavens.**"[10]

§ 14 Following the orientation of Paul VI and *Gaudium et spes*, John Paul II repeated his proclamation on the cult of man – which he had already made at UNESCO – in a speech delivered in Seoul to the cultural world: "I made it a point to proclaim before all the nations gathered at UNESCO what I now wish to repeat because of its relevance: '**Man must be affirmed for himself, and not for any other reason or motive: only for himself alone! Even more, man must be loved because he is man.**'"[11]

[8] Paul VI, Homily at the Closing Session of the Council, *Insegnamenti di Paolo VI*, vol. 3, p. 730.

[9] *Ibid.*, p. 731.

[10] Paul VI, *Angelus*, February 7, 1971, *Insegnamenti di Paolo VI*, vol. 9, p. 91.

[11] John Paul II, Speech to the Cultural World, in Seoul, May 5, 1984, *L'Osservatore Romano*, May 6, 1985, Supplement, p. XII.

§ 15 Upon receiving the credentials of the Swedish ambassador to the Vatican, John Paul II pronounced these words that confirm the man-centered orientation that directs the Conciliar Church: "You know, esteemed Ambassador, that **the Church's sole object in the international life is to defend man – his personal life, his spiritual liberty, and a good understanding among peoples,** so that each man and each human community can find its place, develop itself, and enjoy the riches and beauties of Creation."[12]

§ 16 John Paul II defended similar principles in 1979 during his visit to the UN. There, he stated: "In this relation [of man's place in History] **every national and international political activity** finds its reason for being in activity that **comes from man, is exercised by means of man, and is turned toward man.** If such activity moves away from this fundamental relation and end ... it loses its reason for being and can become a source of alienation. It can become a stranger to man and fall into contradiction with humanity itself. In reality, **the reason for being of every politics is the service of man. It is an adhesion,** filled with solicitude and responsibility, **to the problems and essential duties of his earthly existence,** in his social dimensions and fullness. The well-being of each person today also depends on this."[13]

§ 17 Presenting his Christmas greetings to the Roman Curia in 1993, John Paul II again affirmed this vision of the Church serving man: "**The Church wants to serve the cause of man,** by acting in a concrete way to affirm his dignity in a stable context of justice and peace."[14]

§ 18 The constant defense that John Paul II has made of man and his rights generated this critique of Jean Guitton, French philosopher and writer: "I think that the Pope speaks too much

[12] John Paul II, Audience of March 18, 1993 with the new Ambassador of Sweden, published under the title, ""Nella vita internazionale la Chiesa non persegue altro che la difesa dell'uomo e la buona intesa tra i popoli," *L'Osservatore Romano*, March 19, 1993, p. 6.

[13] John Paul II, Speech to the General Assembly of the United Nations, October 2, 1979, *Insegnamenti di Giovanni Paolo II,* 1979, vol. 2, p. 525.

[14] John Paul II, Speech to the Cardinals, the *Pontifical Family*, the *Curia* and the *Roman Prelature*, December 21, 1993, published under the title, "Il 1993: ricchezze, progetti, speranze," *L'Osservatore Romano*, December 22, 1993, p. 5.

about men. If I were Pope, I would speak more about God. John Paul II dedicates too many words to the rights of men, to democracy... He should be thinking about the day when he will leave this world and be judged by God. His successor? Be he white, black, or yellow, I would like to see a man who is not afraid of public opinion and who speaks about God to men."[15]

§ 19 This was not the first critique John Paul II received on this topic. On the tenth anniversary of his pontificate, this comment was heard everywhere: "At the end of the first decade of his pontificate, John Paul II in reality appears more like a great and sensitive expert on 'humanity' rather than divinity."[16]

§ 20 Turning from the contemporary Popes to prominent theologians, one finds Cardinal de Lubac, who wrote: "**The Catholic Church is encouraging all the faithful along this road [of 'building the world'] by virtue of her love for men and the 'cult of man' inspired by our faith.**"[17]

§ 21 Commenting on the controversial words of Paul VI who called himself a "worshiper of man," de Lubac made this remark: "**Through a kind of peaceful emulation, we want to show, in acts as well as in doctrine, that we Christians as well, 'we more than anyone else, we have the cult of man.'**"[18]

§ 22 The French Cardinal also endorsed the thinking of Teilhard de Chardin, whom he called a "lettered Christian Humanist": "**I see the complete solution to the problem of happiness in the direction of a Christian Humanism, or if you prefer, a super-human Christianity.**[19],[20]

[15] Jean Guitton, "Guitton, lettere per l'aldilà," interview by Ulderico Munzi, *Corriere della Sera*, February 9, 1995.

[16] Francesco Margiotta Broglio, "Il rebelli di Colonia," *Corriere della Sera*, January 28, 1989, *apud Adista*, February 9-11, 1989

[17] Henri de Lubac, "Teilhard de Chardin in the Context of Renewal," V.A., *Theology of Renewal - Renewal of Religious Thought* (Montreal: Palm Publishers, 1968), vol. 1, p. 208.

[18] H. de Lubac, *Athéisme et sens de l'homme - Un double requête de Gaudium et spes* (Paris: Cerf, 1968), p. 14.

[19] P. Teilhard de Chardin, *Cahiers*, *apud* H. de Lubac, *Athéisme et sens de l'homme*, p. 70.

§ 23 With his parody of the greatest Commandment, Teilhard de Chardin appeared as a harbinger to Paul VI with his homage to the UN's "service to humanity." These were Chardin's words referring to the UN: "**We are beginning to understand, and this is forever: from now on the only possible religion for man is one that will teach him,** *above all*, **to recognize, love, and passionately serve the Universe of which he is a part.**"[21]

§ 24 Cardinal Leo Jozef Suenens, one of the most prominent Prelates at the Council, was also an adept of "belief in man": "**We believe in God because we believe in man.** Man is the image of God. **It is through the understanding of man, a profound and complete love for man, and faith in man 'despite everything' that we are able to discern the mystery of God.**"[22]

§ 25 Cardinal Hans Urs von Balthasar, so dear to John Paul II, wrote along the same lines: "God speaks through man. Not only what man says, but *everything he is* becomes a voice of God **Even in revelation, man will not find God anywhere except in man.**"[23]

§ 26 In the name of man, Fr. Hans Küng "revoked" the Commandments of the Law of God. In a dialogue with Pinchas Lapide, a Jewish scholar, Küng affirmed that the Commandments should exist only for men: "In all of these legal questions – be it divorce, the Sabbath, or rules for purification – **Jesus is interested in only one thing: the good of man The commandments exist for men, and not men for the commandments!**"[24]

§ 27 Writing on prayer, Cardinal Joseph Ratzinger presented a new, man-centered meaning of the plea for divine help: "**It [prayer] could still with difficulty be considered an invoca-**

[20] H. de Lubac, *L'Éternel féminin - Étude sur un texte du Père Teilhard de Chardin* (Paris: Aubier-Montaigne, 1968), p. 41.

[21] *Apud* Philippe de La Trinité, *Dialogue avec le marxisme - 'Ecclesiam suam' et Vatican II* (Paris: Cèdre, 1966), p. 91.

[22] L. J. Suenens, *Cristianismo sem Deus?*, V.A., *Cristianismo sem Cristo?* (Caixas do Sul: Paulinas, 1970), p. 70.

[23] Hans Urs von Balthasar, "Dieu a parlé un langage d'homme," V.A., *Parole de Dieu et liturgie* (Paris: Cerf, 1958, pp. 92-3).

[24] H. Küng and P. Lapide, *Gesù, segno di contraddizione* (Brescia: Queriniana, 1980), p. 28.

tion for divine help, but it should be seen as acknowledge-ment of the *praxis* of the assistance that man renders to himself. Faith in progress, often called dead, lives anew, and the optimistic hope that man still can create the city of man finds new adherents."[25]

Speaking even more clearly, Ratzinger advocated con-structing the "city of man," which he identified with the King-dom of God. To achieve that objective, man should be the hope of man. He wrote: "**We must understand the surprising op-timism that the Council adopted to come to terms with the age of technology and appreciate its advances as the reali-zation of the creative mission of subjecting the earth to man.** Doing this, it does not succumb uncritically to the eupho-ria of technology, which still has not become aware of its own abysses **To create the city of man becomes an attempt filled with meaning** when one knows who man is, when one is aware of the measure of man. Technology becomes the hope when it takes its correct form, departing from the likeness of man to God, which constitutes the core of its essence

"**Man is the hope of man**, although he also is the hell of man and his constant menace. That the faith, in final analy-sis, should dare to consider man as a hope stems from the fact that for hope, man is no longer an obscure being that continu-ously is finding himself, but is ultimately called Jesus Christ. In Him, and definitely only in Him, man is the hope of man.

"This is to say that God did not want to be the hope of man in any other way than by becoming a man himself. **The Kingdom of God will be the city of man.**"[26]

§ 28 Cardinal Silva Henríquez, a figurehead of various pro-gressivist projects at the Council, summarized the enormous doctrinal revolution that took place at Vatican II. In his mem-oires, Silva Henríquez wrote: "It is impossible to summarize the immense richness of the Council. Notwithstanding, **I will synthesize its message, saying that at it the religion of the God who became man encountered the religion of the man who became god. The immense good-will that developed there,** which led us to explore human problems from their es-chatological dimensions to their more concrete aspects, **estab-**

[25] Joseph Ratzinger, *Fé e futuro* (Petrópolis: Vozes, 1971), p. 61.

[26] *Ibid.*, pp. 63-4.

lished a new Humanism. By means of it, the Church re-claimed for herself a principal role as defender of man.

"All the doctrinal richness was turned in only one direction: to serve man in all his conditions, weaknesses, and needs. From that day of December 1965, the Church proclaimed herself a servant of humanity."[27]

§ 29 These significant statements by two Popes and some of the great names of present-day theology – de Lubac, von Balthasar, Congar, Chenu, Suenens, Ratzinger, Teilhard, and Küng – permit the Reader to understand the gravity of the inversion that was perpetrated in Catholic doctrine as the Church approximated the ideals of the modern world. In the Conciliar Church the cult of God became the cult of man.

Unfortunately, however, there is even more.

* * *

[27] Raúl Silva Henríquez, *Memórias* (Santiago, Chile: Ed. Copygraph, 1991), vol. 2, p. 72

Chapter II

THE ESSENTIAL GOAL OF SECULARIZATION IS TO ABOLISH THE SACRED CHARACTER OF THE CHURCH.

§ 1 The cult of man is but the central point of a broad-ranging initiative to adapt the Church to the modern world. The roots of this adaptation are found in Humanism, the Renaissance, and Protestantism. It expresses the ideals of the French Revolution, tends toward Communism, and finally, toward a self-managing and tribal Neo-Socialism. Egalitarianism and moral liberalism are the principles that drive this revolutionary process, and in each stage they become more explicit.

Item 1 will present a definition of secularization and show its affiliation with the Enlightenment of the 18th century. Item 2 will analyze more specifically the origin of secularization and its relation to the Enlightenment and Modernism.

1. Doing away with hierarchy and sacrality. General lines to define secularization.

§ 2 Fr. Edward Schillebeeckx, indisputably one of the most famous conciliar theologians, [1] attributed the origins of secularization to Protestantism and the Enlightenment. Along with its historical genesis that he so aptly traced, he described secularization as a process that destroys hierarchical structure. This is the formal meaning of secularization.

An excerpt from Schillebeeckx's text cleverly describes two worldviews: "**In the past**, before this rationalist perspec-

[1] Cardinal Bernard Alfrink invited Fr. Schillebeeckx, OP, to assume the important post of theological adviser to the Dutch Episcopate, a role he carried out with capacity. Later, Schillebeeckx and Fr. Hans Küng were founders and propelling forces of the magazine *Concilium*, known for its vanguard progressivist positions in theological matters (*Jean Puyo interroge le Père Congar*, Paris: Cerf, 1975, pp. 155-6).

tive had been discovered, the personal and social life of man was permeated by Religion and the Church. This does not mean that Religion was a sideline external phenomenon that had secondarily penetrated secular life. On the contrary, **secular life in itself was seen and experienced as being religious. Religion and Church were inherent to all aspects of secular life. Now, however, with the increase of secularization, everything is viewed from the rationalist spectrum, and has consequently been removed from the sphere of the Church and Religion. Thus, secularization can be called at the same time desacralization.**

"The question arises about the place that remains for Faith. Since Protestantism and the Enlightenment, God was left outside the scope of rational understanding. As a result, **the Faith took on a 'vertical' relation different from the 'horizontal' historical course of secular life. Slowly men came to realize that this reduces the Faith to a useless superstructure. The Faith has no meaning for men if there are not elements in the secular life that point to something higher, to God."**[2]

§ 3 Antoine Vergote, professor of Philosophy and Religion at the Catholic University of Louvain, described the clearly desacralizing character of the modern world: "**Anthropocentrism replaced theocentrism and sacrocentrism. The world is, above all, the world of man and, therefore, desacralized. Civilization has become to a large extent profane or secular."**[3]

§ 4 A German theologian, Cardinal Leo Scheffczyk, described the anthropological concept of secularization in this way: "**The situation of the modern world is characterized by secularization, an autonomy in ethics, an immanence in religion, and the secular character of worship Humanity has taken the place of God, work has replaced divine ser-**

[2] Edward Schillebeeckx, "Introdução," V. A., *Cinco problemas que desafiam a Igreja hoje* (São Paulo: Herder, 1970), pp. 3-5.

[3] Antoine Vergote, "La presenza della Chiesa nella società," V.A., *L'avvenire della Chiesa - Il libro del Congresso* (Brescia: Queriniana, 1970), p. 162.

vice, and the longing for the sacred was replaced with a longing for progress."[4]

§ 5 Sabino Palumbieri, professor at the Salesian Pontifical Atheneum, pointed to the denial of the transcendent as a consequence of secularization: "In the preparatory documents to the Ecumenical Meeting of Upsala (1968),[5] **secularization is defined as the 'process of man's emancipation from the idolatry of any element of the created order or his own ideas. Secularization makes man free to responsibly shape his own and the world's future.'**

"Man refuses to acknowledge any authority or structure as absolute, but rather holds himself open to the future. This process does not necessarily involve the denial of God, although it frequently implies rebellion against religious structures insofar as they are considered structures of absolutism and servitude."[6]

§ 6 The same author also included "liberation" and Socialism in the process of secularization: "**Secularization leads to a new picture of values centered around man, man as a value. This effort to construct values is defined as a process of:**

"1. *Personalization*: **an effort to defend and promote the dignity of the human person;**

"2. *Liberation:* **a struggle against threats and prejudices that damage the dignity of the person, with special emphasis placed on the world of women, the Third World, and the world of the proletariat and sub-proletariat;**

"3. *Socialization:* **participation in research and in the communitarian management of the various spheres of action** (neighborhood, school, union, party, company, community, Church)."[7]

[4] Leo Scheffczyk, *L'uomo moderno e il messagio evangelico, apud* Gino Concetti, "Soteriologia cristiana e culture odierne al Congresso internazionale di teologia," *L'Osservatore Romano,* February 9, 1984, p. 5.

[5] Section 5, n. 2

[6] Sabino Palumbieri, "Vita nello Spirito nell'orizzonte di um mondo secolarizzato," V.A., *Lo Spirito Santo pegno e primizia del Regno - Atti della 19 Sessione di formazione ecumenica organizzata dal Segretariato Attività Ecumeniche (SAE)* (Turin: Elle Di Ci, 1976), p. 303.

[7] *Ibid.,* p. 304.

§ 7 The relations between secularization and Socialism resulted in a new definition of the latter as a messianic stage that will install the reign of God. Schillebeeckx was a defender of this thesis:

"**The discovery of the human being in his full secularism** **fundamentally characterizes the present day behavior of the Church. Today's Church**, without renouncing its faith in grace and the kingdom of God, but rather because of this faith, **must believe more than ever in man.** At the moment man has consciousness of himself, we find ourselves facing a reality whose most intimate secret is understood only through the revelation of the kingdom of God. **The spiritual and temporal goods** promised as signs of the kingdom of God by the Prophets and the Christ-*Kyrios* [Christ-Lord] **must be fraternally shared among men as a sign of the return of Christ. This earthly Socialism** **this Christian messianism** **is a sign that points to Christ not only as Head of the Church, but also as Sovereign of the world**

"**The humanization of the world and of man are essential parts of the messianic riches that Christ acquired with the sacrifice of His life, and which Christians,** co-heirs of Christ, **must share fraternally among themselves.**

"**Giving value to the human in the cultural, social, and economic spheres, making the same quality of life possible to all, helping the underdeveloped countries, etc., are not secular, worldly tasks** **Rather, they constitute a profound realization of Christian messianism. We Christians frequently abandon this messianism to non-Christians** [i. e., Marxists], **to those who reduce its most profound inspiration to a purely earthly messianic dynamism. This is what touches the heart of men, because all men of good will sense that a nucleus of truth is found in this earthly messianism** [of Marxism]. **It is a** *hairesis* **[choice], an essential element of the Christian mission on this earth. Only if Christian laymen bring this earthly aspect of messianism to the world will the Church speak to hearts."** [8]

§ 8 These excerpts provide important elements of progressivist thinking in their definition of secularization. The authors above consider secularization as synonymous with desacraliza-

[8] Edward Schillebeeckx, "I laici nel popolo di Dio," V.A., *I grandi temi del Concilio* (Rome: Paoline, 1965), pp. 367-9.

tion. Applied to the Church, secularization signifies, therefore, adaptation to the modern world. Applied to the world, it means abandoning the Faith and Religion, and accepting man as the center of everything, anthropocentrism.

2. Secularization is the acknowledged daughter of the Enlightenment and Modernism

Item 1 showed that secularization is the daughter of Protestantism and the Enlightenment. Item 2 will reaffirm its affiliation with the Enlightenment and point out how Modernism was a precursor of the secularization defended by Progressivism.

§ 9 Cardinal Urs von Balthasar presented the theses of Voltaire as a decisive factor for the implantation of the present notion of secularization. He considered the famous revolutionary leader praiseworthy for having desacralized the conception of History, which until then had been considered the history of fidelity to divine plans: the history of salvation. Thus the impious Voltaire is at the root of a process that today is one of the ensigns of the Conciliar Church...

Von Balthasar wrote: **"It was Voltaire and, a little before him, Vico, who went beyond this meaning of history characterized by primitive theology, and favored instead a secular history of civilization, human in its general mark. Only then did the history of the world separate itself from the history of salvation**

"From the theological point of view, this secularization should not be too greatly deplored, since the old naïve identification of salvation history with the history of the world was a usurpation What took place in the history of humanity between 'Adam' and Abraham, in a different sense than the theological, can be called 'evolution,' which announced its presence in an increasingly notable way. It was then, when the distinction between the two 'evolutions' became clear, that the question of the theological sense of extra-Biblical history could be posed in a meaningful way."[9]

[9] H. U. von Balthasar, *De l'intégration* (Bruges: Desclée de Brouwer, 1970), p. 124.

§ 10 In another passage, von Balthasar reaffirmed this gene-sis: "A dialogue can only be born between the Theology of History and the Philosophy of History when the demands of empiricism are taken seriously and when the *logos* [10] proper to peoples becomes the object of scientific research. This dia-logue is what the present work attempts to do. **Voltaire, and before him Vico, were the first to manifest this intention. History was no longer understood as the history of salva-tion, but as the dimension of man as man. A history directly understood as made by man now finds itself confront-ing a history whose [antiquated] meaning was that in the beginning God founded it in the chaos of time."[11]**

§ 11 Progressivists claim that the first roots of secularization were found in Protestantism. The tree grew and gave its bad fruits in the Enlightenment. Cardinal Yves Congar set this the-sis forth with clarity and precision:

"We can follow the progress of what we call 'seculari-zation' or 'laicization' ... in different fields. It began in politics and economic interests (trade with non-Christians). After the Reformation broke the religious unity, politicians (Richelieu) and even Popes were looking after their own interests, putting aside religious beliefs. After Machiavelli, Hobbes and Grotius elaborated the theory of the secular State. For a long time, the nationalities affirmed themselves at the expense of the senti-ment of unity in Christendom.

"Departing from the 13th century, laymen have sought to become the heads of activities that duly belonged to them. The management of hospitals remained Christian, but passed to the city communes (the Abbé de Saint-Pierre coined the word 'beneficence' – a purely secular term! – to replace 'charity'). In 1371, the English Parliament asked that the offices of chancel-lor, treasurer, seal bearer, etc. be given to laymen rather than to clergy. It was the de-clericalization of offices of power. It would take yet some time longer for knowledge, and within it, Metaphysics and Morals, to separate itself from Religion. H. Busson gave the date of 1533 for this. One could also mention Montaigne [as a landmark], and, at the beginning of the 17th century, Charron.

[10] Von Balthasar used the term *logos* to signify how each people is called to reflect the initial *Logos*, that is, the Word of God.

[11] H.U. von Balthasar, *De l'intégration*, p. 176.

"In the intellectual sphere, then, **we reach the great crisis of ideas and culture that, beginning with the Renaissance, affirmed itself after 1680 and developed during the Grand Century, that is to say, the 18th century, which Michelet calls the century of 'the Lights.'** This grand century is the one that goes from Pierre Bayle to Isaac Newton to Immanuel Kant, from John Locke to Lessing to Condorcet. **In this century, all of cultural society replaced the laws and their applications that come from on high, replaced that which is superior to man, with the explanations that come from man himself, from his nature, his reason, from experimental knowledge.** What Newton did for Cosmology, Locke did for the mind and Psychology, Buffon for animal life, and Montesquieu for laws and societies. **Voltaire and the Encyclopedists wanted to redirect reason to the possession of its rights by an implacable criticism of received opinions, sacred authorities, superstitions, the Bible, and all supernatural beliefs. 'This century is the beginning of the triumph of reason.' It is the rising of the Lights.**

"'What are the Lights?' Kant asked. 'Man coming of age, becoming responsible for himself. Minority is the incapacity to be served by his own knowledge without the direction of another. He is responsible for this intellectual minority, not because of a lack of intelligence, but a lack of decision and the courage to use it except under the guidance of another. *Sapere aude!* [Know how to dare!] Have the courage to use your own intelligence! This is the motto of the Lights.' (Kant, 1784).

" **In this passing from hieronomy** [the primacy of the sacred] **to autonomy** [the primacy of the individual], **from theocentrism to anthropocentrism, a new conception of man and the use of his mind was at stake. There were no more objectively given higher norms. Dogmatism – responsible for so many abuses and even crimes! – was abhorred. The mind sought for a truth progressively discovered in the course of a completely human history. Lessing preferred research to possession** [of truth]. **He saw history as progressive pedagogy.** Obviously, searching includes the right to err… **Seen in this light, it is not surprising that the *subject* [man] …. became interesting in proportion to his sincerity, and the value of human authenticity became more important than objective truth 'in itself.'**

"Among us [in France] the ideas of the 18th century took hold in the last third of the 19th century. Ideas like the

notion of a divinity unlinked to forms of a positive revelation and a progressive religion in which Christianity was one stage that was still evolving in a rational direction... The ideas were dynamite. **They exploded and created a favorable ambience in the socio-political plane: 1789, for the ideas of the 18th century; 1917, for Marxism-Leninism...**

"**The 19th century was a century of social evolution and revolutions. It prepared the change that we know today. In the violent moments of 1830, 1848, and 1871, a fundamental revolution was worked through industrialization, urbanization, the shaping of a proletariat without the protection of organizations or laws A new people was born, a people the Church absolutely did not recognize** or bring to the Baptismal font. **The Church remained welded to the structures and forms of thinking of a stable and hierarchical rural world, far removed from the new currents of ideas.**" [12]

§ 12 In a work launched during the Council, Congar traced the progressivist line of conduct with regard to the modern world. According to him, the Church "is called to openly break with the old ways of witnessing," an action that he wanted Vatican II to make official: "**In face of this world, or rather in the midst of it, the Church is called to openly break with the old ways of witnessing inherited from the time she held the scepter in her hands. She must find a new way of witnessing before men. This new style,** already clearly delineated in personal initiatives and vanguard groups known in every country, **should receive a type of official approval from the Universal Church and from solemn actions in the upcoming sessions of the Council.**"[13]

§ 13 Congar's efforts to encourage the Council to speak on this were not in vain. The hoped-for official approval in fact was given with the promulgation of the Constitution *Gaudium et spes* on the last day of the Council.

§ 14 After Vatican II, Cardinal Yves Congar expanded on his theory on the origins of secularized theology. Feeling secure with the progressivist victories at the Council, he did not fear to affirm that contemporary progressivist thought is a suc-

[12] Y. Congar, *Pour une Église servante et pauvre* (Paris: Cerf, 1963), pp. 132-3.
[13] *Ibid.*

cessor of Modernism. He went so far as to make a *mise au point* on the "transcendental anthropology" of Fr. Karl Rahner, one of the principal theorists who set the foundations for the cult of man and secularization in the post-Conciliar Church. On this topic Congar wrote:

"This anthropological reference is obviously at the heart of basic theology understood as a reflection of the Faith, and as such, interested in clarifying its credibility (that is, the conditions that make the Faith acceptable to man) and its congruency (that is, the intimate relationship between being man and having Faith) **This basic theology** [understood as a reflection on Faith] **was the aim of all the great apologists [of Modernism], most especially of Maurice Blondel**, whose stature seems to be growing with the passing years.

"**Others have surged** since then: for example, **Karl Rahner follows Joseph Maréchal** rather than Blondel. **Rahner's idea is to elaborate a 'transcendental anthropology.' He understands this as a scientific effort to bring to light the conditions by which the propositions of Faith make sense to us. There is one method of apologetics that insists more on divine authority. There is another that insists more on human truth.** The first above all else supposes the divine authority revealing extrinsic to us in a purely formal and external way, making us accept the propositions of Faith in this way. The second method emphasizes the fact that it is God Himself who directs us. Here the emphasis is placed on the truth of the relationships between the great themes contained in revelation and the one to whom they are addressed, man. This latter is Rahner's method, a way of de-mythifization

"Rahner preserves intact the objectivity of the revealed propositions. But he strives to show their relation with the human subject by presenting the necessary conditions appropriate to man that can attract his interest. This will eventually result in making anthropology an extension of every treatise of theology: the Trinity, the Incarnation, salvation, Angelology, Sacramentology, eschatology. **In this way, a de-mythologizing process will be achieved,** not by means of a de-objectifization, but **by a detailed explanation of the relations between objects, or** better, **between the realities and**

**the human subject who is always involved in their under-
standing.**"[14]

These documents show the Reader how conciliar secu-
larization comes directly from the Enlightenment and Modern-
ism.

* * *

[14] Y. Congar, "Theology's tasks after Vatican II," V.A., *Theology of
Renewal*, vol.1, pp. 62-3.

Chapter III

SECULARIZATION AND
THE SELF-DESTRUCTION OF THE CHURCH

§ 1 The last Chapter presented the definition and origins of conciliar secularization. With this, conditions are in place to reach the central point of Part I. Its objective is to present evidence for the Reader to judge this secularization. Would it be a sincere desire to convert the world and men and bring them into the bosom of the Church? Or would it be another pretext to destroy the Holy Church in some of her essential characteristics?

§ 2 Generically referring to the Catholic Church, Our Lord said: "You are the salt of the earth the light of the world" (Mt 5:13-14). This is one of the divine tenets of the mission of the Church with regard to the temporal order. Until Vatican Council II, she always fulfilled this mission. Even though the spiritual and temporal spheres are distinct, autonomous, and sovereign, the Church exercised an admirable beneficial influence over the temporal order. That relationship, in which the Church had primacy over the State, had long been sealed by the Pontifical Magisterium[1] in a constant teaching.[2] The progres-

[1] In the Bull *Unam Sanctam*, the great Pope Boniface VIII stated: "And we are taught by the Gospel that in the Churchs's power are two swords, namely the spiritual and the temporal Therefore, each is the power of the Church, that is, a spiritual and a material sword. But the latter, indeed, must be exercised for the Church, the former by the Church. The former by the hand of the priest, the latter by the hand of kings and soldiers, but at the will and sufferance of the priest. For it is necessary that a sword be under a sword and the temporal authority be subject to spiritual power It is necessary that we confess the more clearly that spiritual power precedes any earthly power both in dignity and nobility, as spiritual matters themselves excel the temporal For, as the Truth testifies, spiritual power has to establish earthly power, and to judge if it was not good." (DR 469)

[2] Two pontifical documents, among others, reaffirmed the thinking of Boniface VIII:

sivists, however, tried to abolish the traditional doctrine on the Church-State relationship, and replace it with an opposite one. To the measure that the Church admits that she should adapt herself to the world, she indirectly admits the primacy of the temporal order over the spiritual one and thus renounces her former position.

§ 3 Then, after adapting to the world, according to progressivists, the Church should make herself the servant of the world. This new doctrine is based on the Decree *Ad gentes*[3] of

a. In the Constitution *Inter multiplices*, of August 4, 1690, Alexander VIII censured the errors of the Gallican clergy. He condemned the error which claimed that "God gave to blessed Peter and his successors the Vicars of Christ, and to the Church herself, the power over spiritual things and over those pertaining to eternal salvation, but not power over civil and temporal affairs, since Our Lord said: 'My Kingdom is not of this world' (Jn 18:36), and again 'Render therefore to Caesar the things that are Caesar's, and to God the things that are God's' (Lk 20:25). Therefore let it remain as the Apostle said: 'Let every soul be subject to higher powers: for there is no power but from God; and those that are, are ordained of God. Therefore he that resisteth the power, resisteth the ordinance of God' (Rom 13: 1, 2). By the command of God, therefore, kings and princes cannot be subject to ecclesiastical power in temporal affairs; nor can they be directly or indirectly deposed by the authority of the keys of the Church, nor can their subjects be released from loyalty and obedience or dispensed from fulfilling their oath of allegiance. This judgment, necessary for public tranquility and no less useful to the Church than to the Empire, must be maintained absolutely as being in harmony with the Word of God, the tradition of the Fathers, and examples of the Saints" (DR 1322).

b. In the Encyclical *Quas primas* of December 11, 1925, on the kingship of Our Lord Jesus Christ, Pius XI condemned laicism, which today could be called secularization: "We name the plague of our age the so-called laicism, with its errors and nefarious efforts It started by denying the power of Christ over all nations; the right of the Church, which exists from the very right of Christ, to teach the human race, to make laws, and to lead the peoples to eternal salvation. Then, indeed, little by little the Religion of Christ was placed on the same level with false religions, and was treated without any of the decorum she deserves; she was subjected to civil power, and was almost given over to the authority of rulers and magistrates" (DR 2197).

[3] The Decree *Ad gentes* states: "The Church in no way desires to inject herself into the government of the earthly city. **She claims no**

Vatican II and is defended by innumerable authors, as the following Items shall demonstrate.

1. Union with the world "razes the walls" that defended the Church

§ 4 Denial of the Church's mission with regard to the temporal order is one of the consequences of secularization. The progressivists see the modern world as something that should inspire the Church. They want to destroy the walls that the Church erected to affirm her separation from the world and defend herself from its influences.

§ 5 The defense of these theses has been penned by various theologians. Among them, Cardinal Urs von Balthasar stands out with his book *Razing the Bastions*. The ramparts that he proposes to raze are those of the Catholic Church. With this work, von Balthasar became the progressivist spokesman who explained the plan to destroy the boundaries between the Church and the world:

"The last and highest wall between God and the world has been kept standing for much too long. With it, one who wished to turn to God had to turn away from the world either for a period of time or forever. Now this final wall is collapsing. And although God's sacred Being can never be confused with a created being or the totality of his creatures, nevertheless **God desires to be visible to us only in the context of his creatures. Even in the eternal beatitude, where we will see Him face to face, our vision will not be independent from the world**

"The Chinese Wall is being demolished today. While we lament, we can only approve it. What it stands for no longer has value The walls that are toppling can bury much that seemed alive under their protection. But the contact with the space that comes into being is something greater."[4]

§ 6 Von Balthasar continued: **"The barriers between the *Civitas Dei* and the *civitas terrena* have fallen to the benefit**

other authority than that of service to men with the help of God, in a spirit of charity and **faithful service"** (AG 12c).

[4] H. U. von Balthasar, *Abbatere i bastioni* (Turin: Borla, 1966), p. 16.

of a solidarity, the fruit of a new choice in the temporal as well as spiritual orders."[5]

§ 7 The same author commented on the "advantages" of destroying the ramparts of the Church: **"The collapse of the internal unity and the razing of the external bastions has had repercussions in the consciousness of the Church [Today] the Church as a whole has a greater sensibility; her awareness of the world, which had been harshly repressed, has re-established itself and has begun to move with a freshness and originality among a responsible laity. Through the mediation of 'outsiders' [Protestants and Schismatics] a new type of osmosis between the Church and the world is beginning, one that draws both in and out, like respiration."[6]**

§ 8 The mentality of modern man, to which so many progressivists say the Church must adapt, is described by Rahner as something that destroys everything in the past. It is not difficult to conclude that this adaptation implies the destruction of the past of the Catholic Church. Rahner affirmed:

"Today's man has, we might say, an almost radical need to demythologize everything, to tear down all the façades, to do away with every prohibition, and to question what will remain after we will have suppressed all the laws and destroyed all the ideologies. In fact, nothing remains except this: we can only live if we love one another with true love If we Christians did not know that in the end **all Christianity is contained in this love – which remains intact after all the myths and external superficialities have been torn down** certainly we would not be prepared today to truly understand our Christianity and witness to it as the force that is always active and full of an ever new life."[7]

In summary, Rahner clearly presented the destruction that should be accepted with the Church's adaptation to the mentality of modern man. His description of the "advantage" that would come from this adaptation was confused and insufficient.

[5] *Ibid.*, p. 97.

[6] *Ibid.*, p. 71.

[7] K. Rahner, *Graça divina em abismos humanos* (São Paulo: Herder, 1968), pp. 116-7

§ 9 There is no confusion, however, in the language of Fr. Luis Maldonado, a theologian at the University of Salamanca. He clearly affirmed the need for the Church to destroy herself in order to be able to dialogue with the world:

"The progressive consciousness that the Church is gradually acquiring from placing herself within the whole universe, beyond the narrow limits of her visibility and institutionality, tears down the harsh walls of separation and restraint that a certain historical mentality had erected between her and the world. This entering into the world now leaves her more open, unprotected, and exposed to the weather, set in the sand and dirt, leveled to the ground of day-to-day history. She has become less differentiated and more identified with what surrounds her. She runs the risk of being confused or of confusing herself with the purely worldly. But she achieves new levels of authenticity in her destiny of *kenosis*[8] and incarnation, following the example of the Master."[9]

§ 10 Without speaking so categorically, Fr. Chenu, one of the principal names of *Nouvelle Theologie* [the New Theology], clearly intended to invert the former transcendent position of the Catholic Faith and replace it with the immanence and anthropology characteristic of the modern world. The following passage from Chenu, whose immediate aim is the analysis of liturgy, made this clear:

"Dualism cannot be eliminated from all liturgical prayer. The Christian is tempted to resolve the corporal-spiritual, time-eternity duality by an evasion, that is, by escaping to the world beyond, the sacral, and the transcendent. **Today we are attempting unification in an opposite sense: by placing the eternal in the temporal, the spiritual in the corporal, by bringing God back into the secular world.** We are giving to Creation its extension and density.

"Analogously, **we are insisting on immanence, anthropology. It is a way of rediscovering the theology of the Incarnation, or, that is to say, a regime where God is on the**

[8] See a summary of the doctrine of *kenosis* in Vol. IV, *Animus delendi I*, Chap. II. The complete explanation of progressivist thinking on the topic can be found in Vol. VIII, *Fumus Satanae*, Chaps. V, VI.

[9] Luis Maldonado, *La nueva secularidad* (Barcelona: Nueva Terra, 1968), p. 77.

earth. I can only perceive the presence of God, his economy and his providence, in earthly events. Otherwise I make of Him a false god, an idol, an abode for evasion and, as the Marxists say, alienation."[10]

§ 11 This abandonment of the transcendent position of the Church and her consequent de-sacralization were applauded again by Chenu when he analyzed *Gaudium et spes*. An important fact: Fr. Chenu can be considered the one who inspired the *Message to Humanity,* the official document issued at the beginning of the Council. The first part of *Gaudium et spes*, to which Chenu refers in the text below, is in a certain way a summary of that message:

"It was an inductive method that was expressed a little bit everywhere, but most especially in the famous *Schema 13* [the name under which *Gaudium et spes* was known until it was officially approved]. **It was also the first time in the history of the councils that a text of this type was preceded by an introduction that is a secular analysis rather than an exposition of the prior position of the Church. The authors of the text began by making an abstraction, so to speak, of the problem of the Church in order to study the world in itself**

"The Church, by officially becoming conscious of herself, obliges herself to become conscious of what has changed in the world. If you like, a Church that had lived in her own establishment made the decision that from now on she would be known in the movement of the world.

"In the five or six pages of introduction in the first part of *Gaudium et spes*, there are some very strong statements. For example: 'We are witnessing a social and cultural transformation,' 'We are entering a new era,' 'We are in a crisis of growth that shakes the world.' **I reread all these texts with pleasure as a historian, not only as a theologian, and not because they make an unsettling observation of novelties, but because they go all the way to the technical and economic roots, something the Church had never done until then."**[11]

Thus, the radical change of the mission of the Church with regard to the temporal order and, in a certain way, her de-

[10] *Jacques Duquesne interroge le Père Chenu*, pp. 79-80.

[11] *Ibid.*, p. 183.

struction, seem to be consequences of the conciliar initiative of adaptation of the Church to the world, of secularization.

2. The mission of the Church would be "to putrefy with the world" and to "burn the dead wood" of her past

§ 12

So radical is their intent to modify the mission of the Holy Church that some of the most representative theologians of the progressivist current go so far as to say that she should "putrefy with the world." This statement by Fr. Depierre was encored and commented on by Cardinal Yves Congar: **"Every Christian within the world is a frontier of grace. No longer in sacred buildings or specific religious activities, but in the exercise of his profession, in the street, at work, in the labor unions, and in municipal or political action. For these Christians the Church is integrated into the structures of global society. She can become Church in those places where men live their lives as men.**

"If her future is to be present in the future of the world, then she must engage that future every day in the lives of her faithful. **Examples? Only look around you: studies and polls, accounts of activities and newspaper reports show the Church being constructed within the very fabric of global society. This is also Church, but in her form of leaven in the dough, rather than an illuminated city on a mountain.**

"Doesn't Fr. Depierre characterize her mission as "to putrefy with" [the world]? In times past the world could exist within the framework of the Church, acting within and submitting to Church norms **Today the Church is called to exist in a plurality of cultures, in the history of men and on the road of men, within the framework and life of secular life."**[12]

§ 13

It was also Congar who sustained that the Church should "burn the dead wood" of her past, that is, destroy her tradition: **"A world emancipated from this tutelage [of the 'clerical Church'], a 'lay' world, constituted and affirmed itself first politically, and then culturally. This world has been attacking clerical discourse for more than a century**

[12] Y. Congar, *Église Catholique et France moderne* (Paris: Hachette, 1978), pp. 78-9.

with an acid criticism coming from socio-politics, philosophy and the human sciences. After having rejected (or ignored) this criticism, today the Church is listening to it. She is opening herself to the world as it is. It is a terrible self-examination, but she can face it with the conviction that the dead wood can be burned and that she lives from a perpetually new sap that can never die …. Beyond the institutions and power, beyond the order of intelligence is the order of charity, that of love, that of liberty, and the order of communion of which love is the beginning."[13]

Without a doubt these are radical statements, which, in the name of secularization, doom the traditional conception of the mission of the Church to destruction and death.

3. The Church should be the servant of the world

§ 14 Until now this Work has considered many ominous developments of the new conception of the Church-world relationship. What was analyzed in the prior Items of this Chapter refer to adaptation of the Church to the world. This adaptation, however, is only the first phase of the process of secularization. In a second stage, the progressivists plan to transform the Church into "servant" of the world, a radical, explicit, and indisputable inversion of her age-old primacy over the temporal order. The foundation for this idea that the Church should serve the world and man is also found in the Council.[14]

[13] *Ibid.*, pp. 277-8.

[14] One can read in the Constitution *Gaudium et spes*: "In our times **a special obligation binds us to make ourselves the neighbor of absolutely every person, and of actively serving him** when he comes across our path" (*GS* 27).

Also the Decree *Ad gentes* states: "This mission [to make itself fully present to all men and peoples] is a continuing one. In the course of History it unfolds the mission of Christ Himself, who was sent to preach the Gospel to the poor. Hence, prompted by the Holy Spirit, **the Church must walk** the same road which Christ walked: **a road of poverty and obedience, of service and self-sacrifice** to the death, from which death He came forth a victor by His resurrection" (*AG* 5b).

The following documents present an overview to the Reader of the progressivist plan for the Church-world relationship and its self-destructive consequences.

§ 15 The first statements are from Fr. Hans Küng,[15] in a book that counted on the collaboration of Fr. Joseph Ratzinger.[16] Küng wrote: **"From the standpoint of the Gospel, in final analysis only one essential element exists in the whole complex of relationships between the Church and the world: service to the world To serve means to make the courageous renunciation of sociological positions of power** that came to her [the Church] through the boons or vicissitudes of History, but **whose justification today is irreparably obsolete To serve the world, therefore, is to renounce dominion over the world and the pretension of directing it, to renounce the politics of power, prestige, privileges, and special rights."**[17]

§ 16 In another passage, Küng defended the same thesis: **"A Church that forgets that she exists only for the generous service of men, her enemies, and the world loses her dignity, her power to convince, and her reason for being because she no longer truly follows Christ. A Church, however, that remains conscious not of what she will be, but of the kingdom of God that will come 'in power and glory,' finds in her littleness her true grandeur. She knows that she is great precisely when she renounces power and pomp."**[18]

Even more clearly: **"The Church in no way desires to inject herself into the government of the earthly city. She claims no other authority than that of service to men with the help of God, in a spirit of** charity and **faithful service"** (AG 12c).

[15] Anyone who thinks that the works of Fr. Hans Küng have been condemned and, therefore, his statements would not express conciliar thinking, can read Vol. IV, *Animus delendi I*, Chap. III, §§ 7-71. It analyzes the concrete points for which the theologian was censured as well as others upon which he continues to write freely, with the implicit support of the Congregation for the Doctrine of the Faith.

[16] In the preface of his work *The Church*, Küng stated: "I cordially thank my colleague in theology, Prof. Joseph Ratzinger, who directs the Ecumenical Studies with me, for his invaluable help" (Hans Küng, *A Igreja*, Lisbon: Moraes, 1969, vol. 1, p. 8).

[17] *Ibid.*, vol. 2, pp. 328-9.

[18] *Ibid.*, vol. 1, p. 144.

§ 17 In the next passage, the theologian of Tübingen for-
mally addressed the supposed obedience that the Church
should render to the world, the obedience of a servant to his
master: **"To be precise, it is the Church that must perma-
nently renew her conversion to the message of the world –**
in constant *metanóia* – **in order to submit to the kingdom of
God that is to come, and, by virtue of this, turn lovingly to-
ward the world and people. This is not an ascetic isolation
from the world, but a basic obedience, in love, to the will of
God in the day-to-day world,** not fleeing from the world, but
working for it

 **"It is absurd to suppose that the Church should
present her own liturgical, dogmatic, and juridical laws
and her precepts, traditions, and customs as command-
ments of God It is absurd to suppose that she should
declare as eternal her [doctrinal] judgments conditioned by
the times, which only through artificial and forced inter-
pretations would be adapted to each new epoch. It is ab-
surd to suppose that in place of the 'signs of the times,'
she should seek the 'traditions of times past'**

 **"It is herself that the Church enslaves and binds to
the degree that, at this end of times, she forgets to whom
she owes obedience, usurps sovereignty for herself, and
makes herself Queen and presents herself as Mistress."**[19]

§ 18 The revolutionary character of the methods proposed to
effect this change becomes even clearer in another work of
Küng: **"The Church and her institutions should be reformu-
lated with the aim of serving men. All the institutions and
constitutions should serve people. Instead of mythologizing
institutions that became historic in the sphere of a theologi-
cal conservativism, [there should be] a permanent renewal
of institutions, with an adaptation that is flexible to changes
in the social structure.**[20]

§ 19 These different proposals are supported by the Council,
as confirmed by Küng: **"Vatican II receives the world as it
presents itself in an entirely different way than that of Vati-
can I: it was emancipated. Vatican II definitively broke
with the medieval mentality present in the Church up to the
19th and 20th centuries.**

[19] *Ibid.*, vol. 1, pp. 147-8.
[20] H. Küng, *Veracidade*, p. 106.

"Basically, it deals with the relation of the Church with the world in the pastoral Constitution *Gaudium et spes,* which presents a positive attitude of the Church toward the progress of humanity, even though it is not an uncritical one."[21]

§ 20 Writing about Vatican II, Fr. Gustave Martelet, a conciliar *perito* and professor at the Jesuit Theological University at Lyons, further explained what Küng called the "medieval mentality." Martelet dealt with the notion of the Church as *societas perfecta*, which was set aside by the Council: "**Opening herself as a people to the multitude of men and the totality of human existence, the Church of the Council thus placed the excessively narrow idea of the 'perfect society' on a secondary plane."**[22]

§ 21 For Cardinal Congar, the non-opening of the Church to the world and her turning inward on herself would be an unpardonable sin: "ecclesiocentrism." He wrote: "**The Church is no longer the place for living the Gospel as a sacral and separated society, but rather a human and secular reality. From this primacy given to the** *ad extra* **[turned to the outside] over the** *ad intra* **[turned to the inside] comes a new focus, that of 'mission,' that of unity of Christians. If Jesus Christ is a 'man for others,'** according to the magnificent expression of Bonhoeffer, **there should also be a Church for others. The most unpardonable sin, then, is 'ecclesiocentrism,' the Church preoccupied above all with herself, with her growth, and with her own unity instead of being concerned about serving the growth and unity of men."**[23]

§ 22 Addressing the subject of *rapprochement* with Atheism – which could be read as Communism – Cardinal Suenens also stated the need to subvert the former position of the Church, which he insultingly branded as "quietist": "**The best way to face the challenge of Atheism is to present a Christianity at the service of the full development of man and in the vanguard of human progress We are invited to make Chris-**

[21] *Ibid.*, p. 123.

[22] Gustave Martelet, *Deux mille ans d'Église en question* (Paris: Cerf, 1984), p. 55.

[23] Yves Congar, *Église Catholique et France moderne* (Paris: Hachette, 1978), p. 63.

**tianity leave its *status quo*, the state of a quietist Christian-
ity, and to make the earth more habitable for mankind."[24]**

§ 23 These, then, are the goals for the Church set out by
conciliar progressivists:

- The service of man and not the service of God;
- A preoccupation with serving the world and no longer
 the search for her own perfection and the sanctity of her
 children;
- The abandonment of her Magisterium, Tradition, and
 institutions in the name of modernity.

What is really behind this secularization? The glory of
God? The conversion of men and the salvation of souls? Or the
destruction of the Catholic Church?

 *

§ 24 The three Items of this Chapter show how, based on the
documents of Vatican II, the progressivists are fighting for a
secularization, an adaptation of the Church to the world that
leads to the destruction of the Holy Church.

 * * *

[24] L. J. Suenens, "Cristianismo sem Deus?," V.A.., *Cristianismo sem
Cristo?*, pp. 80-1.

Chapter IV

SECULARIZATION ENTAILS
A CHANGE IN THE FAITH AND
THE VIRTUAL ABOLISHMENT OF MORALS

Not content with their aims to destroy the mission of the Church and raze the "walls" of her institution, the progressivists also launched a program of secularization that assailed other points of Catholic Doctrine.

1. Secularization demands a change in the Faith

§ 1 Many progressivist theologians claim that for the Church to speak to contemporary men, she would need to make a new interpretation of the Faith.[1] This Item will provide the Reader with some representative examples.

§ 2 Schillebeeckx gave the progressivist rationale for why adaptation of the Church to the world should demand questioning Revelation and reinterpreting the Faith: "There has always been the problem of the interpretation of the Bible, but today it has become more acute than ever before for two principal reasons. *First*, because **we no longer belong to the same culture. We no longer have the same mentality about man and the world nor the same perspectives that would have prevailed at the time of the first interpretations of the 'Christ event' and those that followed** *Second*, because **we belong to an epoch that admires the requirements of textual and historical criticism, an epoch that considers it immoral to submit unconditionally to anything** without rational justification. **Everyone, including the man of good will, rejects *a priori* a type of blind faith that lacks an authentic and intelligently human foundation.** Even with our unconditional obedience to Faith, we cannot run away from the need to make eschatologi-

[1] On the progressivist demands to change the Catholic Faith, see Vol. VI, *Inveniet fidem?* Chaps II, IV, VI; Vol. VII, *Destructio Dei*, Chap. IV; Vol. IX, *Creatio*, Chap. III; Vol. X, *Peccato, Redemptio*, Chaps IV-X.

cal dogmas intelligent and somehow comprehensible. **Today, the faith** quite simply **demands that the believer pass through the hard test of a new interpretation of his faith** if he wants to be faithful to the message of the Gospel."[2]

§ 3 Cardinal Pierre Eyt, then Dean of the Catholic Institute of Paris and a member of the International Theological Commission, also defended a change in the Faith as the basis for a "subversion" of society to achieve ends he did not describe clearly. Cardinal Eyt wrote: "**If our Faith does not appear to today's man as the motive and motor for a decision for social change, it would have no meaning at all for him.** If Jesus did not want us to 'change our lives and transform the world,' He would be present in this world only as a historical object or a vague moral reference point.

"**What was conventionally called the 'social doctrine of the Church' must admit a new decree in our effort to communicate the Faith. It is no longer a matter of the Church looking exclusively for the *ratio peccati moralitatis* [the moral cause for sins], which until now has motivated the interventions of the Magisterium and the actions of the laity. On the contrary, it is a matter of installing the man-who-is-to-come at the very core of the plan for society that is being built,** and, for this to happen, he must fulfill all the requirements of the vision of the man announced in the Gospel …. **Faith in the One who gives man an absolute future demands this subversion in order to 'move forward.'"**[3]

§ 4 Fr. Teilhard de Chardin provided an explanation of this vague "moving forward" mentioned by Eyt. He presented a strange conception – immanent to the core – of a "God before us" that should replace the God of Revelation and dogma, and thus prepare us for the "Religion of tomorrow."

Teilhard affirmed: "**Humanity is changing. Why shouldn't Christianity change as well? More precisely, I think that the Reform at hand (much more profound than that of the 16th century) is no longer a simple question of institutions and customs, but of Faith.** In some way **our image of God has expanded:** transversely …. **from the tradi-**

[2] E. Schillebeeckx, "Algumas reflexões acerca da interpretação da escatologia," *Concilium* 1969/1, Lisbon: Liv. Morais, pp. 38-9.

[3] Pierre Eyt, "Igreja e mutações sócio-culturais," V.A., *A Igreja do futuro* (Petrópolis, Brazil: Vozes, 1973), pp. 28-9.

tional and transcendent God above us, a type of God before us surged a century ago in the direction of some 'ultra-human.' In my opinion, the whole thing lies in this. **Man must rethink God no longer in terms of the cosmos, but the Cosmogenesis[4]: a god who is not adored or attained except through the realization of a universe that he illuminates and (irreversibly) fills with love departing from within. Yes, the 'above us' and the 'before us' are synthesized in the 'within us.'**

"**This fundamental act of generating a new Faith for the earth can only be made by a Christianity that departs from the startling reality of its 'Resurrected Christ' –** not some abstract entity, but the object of a great mystical current, extraordinarily adaptable and vivacious. I am convinced that a new Christology, expanded to the organic dimensions of our new universe, is being prepared to emerge as the religion of tomorrow."[5]

The need for a new understanding of God, in essence, a change in the Faith, has also been penned by Küng: "**Today, for this new world, theology must urgently rethink, on new foundations, its way of understanding man, nature, and God.**"[6]

2. Secularization implies the abandonment of Morals

§ 5 The destruction of Catholic Morals is another consequence of the cult of man and secularization.

§ 6 For the progressivists, the very notion of good and evil, a presupposition of Morals, should no longer be founded on revealed truth and the dogmas of Faith. Instead it should base

[4] Cosmogenesis is the term coined by Teilhard de Chardin to refer to the supposed universal evolutionary process that would have started from brute matter and become life, through Biogenesis. From this, it became man, through Anthropogenesis. The final stage would entail evolution to the new-man, through Christogenesis. We would now be in this final phase of the process of Cosmogenesis.

[5] Pierre Teilhard de Chardin, *Lettre à Maxime Gorce, apud* Philippe de la Trinité, *Dialogue avec le marxisme?*, pp. 94-5.

[6] H. Küng, *A Igreja*, vol. 2, p. 327.

itself today on the "good of man." This "good of man" can be understood as synonymous with the enjoyment of life, as also with an egalitarian distribution of earthly goods, depending upon whether one is trying to realize the modern world in its Capitalist or Socialist version. This concept of morals is an inversion of Catholic Morals and harmonizes with the neo-pagan longings of the modern world. It is secularized morals. The defense of such secularized morals by notable progressivists can be verified in the passages below.

§ 7 In a work directed by Cardinal József Tomko, then Prefect of the *Congregation for the Evangelization of Peoples*, Professor Francesco Botturi of Milan's Sacred Heart University affirmed: **"The meaning of the words 'good' and 'evil' cannot be transferred to any impersonal, arbitrary criteria: good and evil are concepts that can acquire a meaning only in personal experience, in the first person."**[7]

§ 8 For Prof. Antoine Vergote of Louvain University, Catholic Morals should "be incarnated" in modern humanism. That is to say, it should address the enjoyment of life and the fight for the social liberation characteristic of modern man. In the future, the Church should assume the egalitarianism and sensuality of present day society. These were his words:

"In the future it will be necessary for Christians – who are the effective Church **– to be more conscious of the fact that the faith only becomes true,** only verifies itself **through the prophetic dynamism that it produces in civilization. To seriously consider creation and the incarnation as the 'axis of history' means to stop opposing God eternal to humanism, the vertical dimension to the horizontal. To believe in a living God,** creator, Father and Spirit, **also means to be in solidarity with everything that attempts to liberate man, to overcome psychological and social subjection.** A very rigid Christocentrism isolates itself from humanity and destroys the purport of creation as a fundamental alliance.

"A more unified vision of the work of Christ and creation will further liberate us from the opposition between ethical duty and the enjoyment of life. We should not forget that we have come from centuries of mistrust in relation

[7] F. Botturi, "Oggettivismo e crisi della responsabilità," V.A., *Peccato e riconciliazione; alla ricerca della grandezza* (Rome: Paoline, 1983), p. 28.

to pleasure. With an excessive emphasis on ethics opposed to the natural creativity of man, **we have enclosed believers in a moralism of duty against which the whole present day culture is rising. Contemporary eroticism represents a reaction against an oppressive moralism. The protest against inequality and any form of slavery and racism and the reclaiming of the right to enjoy are the driving motors of our society. The future of the Church will depend on its power to take on these two motors,** to value them as belonging to the work of creation that is indissolubly offered for enjoyment and progressive humanization."[8]

The moral "legitimization" of the unruly passions – notably the sexual passion – was defended by Fr. Teilhard de Chardin: "I will avoid denying the destructive and disintegrative potentialities of passion. I even agree that, until today, outside of the reproductive function, **men on the whole have used love above all to corrupt and inebriate themselves. But what do such excesses prove? Because fire devours and electricity shocks, should we stop being served by them? The Feminine[9] is the most terrible force of matter. This is true. 'For this reason it must be avoided,' say the moralists. 'For this reason it must be tamed,' I would respond.**

"In every domain of the real (physical, affective, and intellectual), 'danger' is a symptom of power. Isn't it true that the mountains create the abysses? **The routine education of Christian consciences tends to make us confuse 'guardian-**

[8] A. Vergote, "La presenza della Chiesa di domani," V.A., *L'avvenire della Chiesa – Il libro del Congresso* (Brescia: Queriniana, 1970), pp. 168-9.

[9] For Teilhard as well as many other progressivists, Gnostics and Kabalists (see Vol. VIII, *Fumus Satanae*, Chaps. 1 and VII), the "Eternal Feminine" would be a feminine charm immanent in the whole universe that would stimulate elements of the less elevated stages to ascend in the evolutionary process in the search for a loving union with this Feminine. In the concrete case of the human passions, the Feminine immanent in them, especially in the sexual passion, would be of the type that arouses the appearance of a new kind of love, a spiritualized eroticism that would guide the "Christified" man in the final phase of evolution (see Teilhard de Chardin, "L'Éternel Féminin," in *Écrits du temps de la guerre*, Paris: Seuil, 1965, pp. 283-4). A critical analysis of the theory of the Eternal Feminine may be found at www.TraditionInAction.org / Hot Topics.

ship'[10] **with prudence, security with truth.** To avoid the risk of committing a fault has become more important in our eyes than to conquer a difficult position for God. That is what kills us.

'"The more dangerous something is, the more life-affirming its conquest.' The modern world was born from this conviction. From it also our Religion must be reborn. It serves no purpose for us to evoke the dangers of an adventure in order to legitimize that prohibition made in the realm of principles by a certain Christian asceticism against the use of the Feminine. This would only serve to attract us if we have 'adventuresome' souls. Before turning away from scaling this peak, we expect them to explain to us why climbing it would not make us draw closer to God."[11]

§ 9 The opening of Progressivism to the principles and practice of Freudian psychoanalysis appears as yet another attempt to abandon Catholic Morals and replace it with the neo-pagan amoralism of the modern world.

§ 10 In this sense, Cardinal Congar modified the traditional notion of sin for a new one adapted to Freudian psychology and the new progressivist morals: **"Psychoanalysis demythologized a certain representation of sin and discredited a certain preaching about it: the one that confused it with a sentiment of guilt, which prolonged the sentiment of prohibitions and the pressure of the superego imposed by the group and parents under the distressing threat of a retraction of love and abandonment. Going beyond this 'impious cleansing of guilt,' the authentic biblical and Christian idea of sin reaffirms its truth. There is no sin except before God** and in relation to His offering of alliance and communion. **Sin has no meaning except in relation to a plan of God for men and by men."**[12]

§ 11 Gianfrancesco Zuanazzi, instructor at the Marriage and Family Studies Institute at the Lateran Pontifical University, in an article for a book directed by Cardinal Joseph Tomko, defended the assimilation of the principles of psychoanalysis

[10] This "guardianship" would mean adopting the least risky solution in case of doubt.

[11] Pierre Teilhard de Chardin, "L'evolution de la chasteté," *Les directions de l'avenir* (Paris: Seuil, 1973), pp. 80-81.

[12] Y. Congar, *Un peuple messianique* (Paris: Cerf, 1975), pp. 157-8.

made by progressivist morals. Commenting on various disciples of Sigmund Freud, Zuanazzi stated:

"There is only one sin [according to Erikson, Lebovici, Hesnard, and Berge]: **evil concretely carried out against man. All the rest, that is to say, 'interior culpability,' is a fruit of the 'moral myth of sin' and is part of the 'morose universe of guilt.'** These theses, however, also can suggest something to the moralist: they can set him on guard against the ambiguities of an archaic pre-Morals of taboos and prohibitions We affirm that the lesson of psychoanalysis has been invaluable to keep us from dissembling as virtue what is only the fruit of our sensibilities** [the sinner's feeling of guilt]. Are we sure that this is an entirely new lesson? **Wouldn't it be good for us to reread along with Freud our great masters of the spiritual life?"**[13]

§ 12 Another example comes from the conciliar *perito* Fr. Piet Schoonenberg, one of the authors of the *Dutch Catechism*. Dealing with the principles that should orient sexuality, he clearly exposed the prodigious revolution worked by Progressivism in the field of Morals. The norm now would be to let man do what he likes, because "only man is the measure of man." Schoonenberg wrote:

"We have always had the tendency to apply an external measure [in the field of Morals] to man. I think that we are now beginning to see more clearly that only man can be the measure of man. Sexuality, for example, is good to the measure that it makes man a truly human being. This is really the only norm and, in all probability, will lead to a new form and appreciation of matrimony, dating, encounters, etc. This also touches acutely on the question of remaining celibate for the sake of the kingdom of God."[14]

These concepts represent the adoption of libertarian morals with Freudian tones and signify the abandonment of Catholic Morals.

[13] G. Zuanazzi, "Freud, la morale e la colpa," V.A., *Peccato e riconciliazione: alla ricerca della grandezza*, pp. 23-4.

[14] P. Schoonenberg, untitled, V.A., *Cinco problemas que desafiam a Igreja de hoje* (São Paulo: Herder, 1970), p. 73.

One can see that the secularization preached by Progressivism brings about a change in the Faith and the virtual abolishment of Morals.

* * *

Chapter V

SECULARIZATION IMPOSES
THE END OF THE CATHOLIC STATE AND
CONTESTS THE MODERN STATE[1]

§ 1 One of the fruits of the ideas of the French Revolution spread by the Christian West was the attack on the Catholic State. It was characterized by the separation of Church and State, confiscation of a good part of the Church properties, equality for the true Religion along with the false confessions in civil law, assaults against an exclusive Catholic education and the establishment of a secular one, and non-recognition of Catholic marriage by the State. At the end of the 19th century, one hundred years after the French Revolution, the fires of this struggle between the secular offensive and the Church were burning fiercely.

§ 2 Had it not been for the infiltration of such ideas into the Catholic camp through the Modernist movement and, beginning in the 1930s, with the irruption of Progressivism, the Church with her normal superiority would have won this war – just as she triumphed over the *Kulturkampf* in Germany under

[1] a. The term Modern State will be used to mean the egalitarian and bourgeois conception of a liberal State that was born from the French Revolution. This excludes, therefore, not only States that maintained their pre-Modern State structures and retained a hierarchical, organic, or feudal political constitution, but also States with an even more revolutionary configuration than the Modern State, such as those established in Communist countries.

b. Although revolutionary in its egalitarian structure, its amoral customs, and its indifferent attitude toward the Faith, the Modern State retained from its Catholic precursor some principles of the natural order, such as the right of private property, free enterprise, and certain institutions and traditions. Defending such points should in no way be construed as adherence to the ideals of the French Revolution, but rather as preserving the good remnants of the natural order that still remained from a healthy Catholic past. Today such remnants habitually are the targets of progressivist critiques, as this Chapter will show.

Bismarck. Her forces, however, were divided by the dual battle she was obliged to take up: an internal fight against the Modernist-Progressivist fifth column, and the external combat against the liberal secular offensive. Thus, the Church gradually lost ground as the Modern State continued to usurp the prerogatives of the Catholic State.

§ 3 Nevertheless, even though much of the Modern State had been established *de facto*, the Church did not grant it legitimacy *de jure*. She always continued to defend the Catholic State against the Modern institution, as can be seen in papal documents of the past.[2]

§ 4 Unfortunately, however, during his October 1965 visit to the seat of the United Nations, Paul VI officially broke with this line of conduct. As already demonstrated,[3] by its very nature and its declared aims, the UN seeks to embody the Modern State and act as the supreme organ of the Universal Republic, the long-desired dream of revolutionaries past and present.[4]

[2] A summary of papal teachings praising the fundaments of the Catholic State and opposed to the Modern State, essentially a-confessional and egalitarian, can be found in excerpts from the Encyclical *Immortale Dei* of Pope Leo XIII. On the fundaments of the Catholic State, see nn. 5, 11, 12, 16, 20; for a critique of the Modern State on its myth of the sovereignty of the people, see n. 36; on its religious indifferentism, n. 37; on its freedom of thought and expression, n. 38. Also see Item 1 of this Chapter.

[3] Atila S. Guimarães, *The Universal Republic Bleesed by the Conciliar Popes* (Los Angeles: TIA, 2002), pp. 9-11.

[4] a. The formation of the United States of Europe as a stage in the process of establishing the Universal Republic is a five-hundred-year-old revolutionary dream.

Toward the end of the 15th century, in his book *Querela pacis,* the well-known humanist and precursor of Protestantism, Erasmus of Rotterdam, defended the thesis that the whole world is the motherland of us all (Stefan Zweig, *Triunfo e infortúnio de Erasmo de Roterdão*, Porto: Livraria Civilização, 1970, p. 94). The assertion has a surprisingly familiar ring today.

Author Stefan Zweig summarized the thinking of Erasmus, who held that doing away with the European nations would constitute one step toward the Universal Republic: "Because it is too narrow, [Erasmus thought that] the patriotic ideal must also cede way to the European international ideal The animosities felt by Englishmen, Germans, and Frenchmen seemed absurd to Erasmus. 'Why do these stupid names separate us?' he used to ask In fact, many men before

him had attempted the unification of Europe by sword and fire. For Erasmus, on the contrary, Europe should be a moral idea With Humanism arose the hypothesis, still not achieved today, of the United States of Europe, brought together under the sign of a common culture and civilization (*ibid.*, pp. 94-5).

b. During the French Revolution, Anacharsis Klootz, a revolutionary Prussian baron living in Paris and affiliated with the radical Jacobin party, sustained the same idea of a Universal Republic. On July 19, 1790, he appeared at a session of the French Assembly as the head of an embassy that supposedly represented all of mankind. Two years later he published the book, *La república universelle*, which earned him the title of *citoyen* [citizen] bestowed on him by the Legislative Assembly (Henri Delassus, *La conjuration anti-chrétienne – Le Temple maçonnique voulant s'élever sur les ruines de l'Église Catholique*, Lille: Desclée de Brouwer, 1910, vol. 2, pp. 578-9).

c. In the late 18th century, German philosopher Immanuel Kant likewise championed a Universal Republic. He proposed the creation of a federation or league of the nations of the world. Kant believed that such a federation would allow countries to unite and punish any nation that committed an act of aggression. This idea of the German thinker helped to inspire the foundation of the League of Nations, which was the seed of the present day United Nations (*Encarta Encyclopedia Online 2001*, entries *League of Nations*, and *United Nations*).

d. During a considerable part of his life, French thinker and writer Victor Hugo represented one of the most clearly defined poles of revolutionary thinking. He was ordered into exile by Napoleon III for his political opposition to the so-called Prince-President who became Emperor. In fact, Hugo wrote a strong, sarcastic piece entitled *Napoléon, le petit* [Napoleon, the little] to show the contrast between Napoleon Bonaparte, whom Hugo called *Napoléon, le grand* [Napoleon, the great] and his successor. According to Hugo, *Napoléon le petit* was an insignificant man who did not deserve to be head of the French nation. The work raised the laughter of the French people and incited the fury of the government, which ordered the author into exile.

In 1852, en route to the islands of Jersey and Guernsey, Hugo passed through Belgium, where he delivered a speech to fellow revolutionaries. In it, he encouraged their yearnings for a Universal Republic with these words: "Friends, today we have persecution and pain; tomorrow, the United States of Europe, a brotherhood of peoples. A day inevitable for our enemies, a day certain to come for us. Friends, however great the anguish and hardships of this passing moment might be, let us fix our thoughts on this splendid tomorrow, already visible to Europe in its grand perspective of liberty and fra-

ternity. Contemplate this, all you who are outlawed by France, and you will find your peace! At times it is awe-striking to see such a great light before your eyes during this lugubrious night in which you find yourselves. This light that fills you is the radiance of the future.

"French and Belgian citizens the Universal Republic is the universal motherland. When the day comes, nationalities and homelands will release a war cry against despots. When the work is completed, unity, holy human unity will place a kiss of peace on the foreheads of all nations. Let us go forward, step by step, from initiation to initiation, passing through each setback or sorrow until we achieve the grand formula. Let every step won enlarge the horizon. There is something more than a German, a Belgian, an Italian, an Englishman, or a Frenchman: it is a citizen. There is something more than a citizen, it is man. The end of nations is unity, just as the end of the roots is the tree, the end of the winds, the sky, the end of the rivers the sea. Peoples! There is but one people. Long live the Universal Republic!" (*Pendant l'exil; actes et paroles*, Paris: Jules Roulff, n.d., vol. 1, pp. 67-8).

e. Following these same general lines is Hugo's *apologia* of November 29, 1853 commemorating the 23rd anniversary of the Polish Revolution (*ibid.*, vol. 1, pp. 118-9.); his initial message of greetings sent from Brussels to the *Peace Congress* in Lausanne, Switzerland, September 4, 1869 (*ibid.*, vol. 2, pp. 22-26); his opening speech at the same Congress (*ibid.*, vol. 2, pp. 26-7.), and his letter of February 27, 1870 to American admirers (*ibid.*, vol. 2, pp. 73-4).

f. Fontaine, a famed orator present at the *Conference of Socialist Students* in Liège 1865, from which emerged the directors of *Socialist International*, made this declaration there: "We, revolutionaries and Socialists through the realization of the republican idea in the political sphere, want to achieve a federation of peoples" (*apud* H. Delassus, *La conjuration anti-chrétiènne.*, vol. 1, p. 88).

g. In the 19th century, Clavel, an initiate in Freemasonry, explained that Masons were constructing "the largest [political] structure that has ever existed, since it knows no other limits but that of the earth" (Bazot, *Tableau philosophique, historique et moral de la franc-maçonnerie*, pp. 20-28, *apud* H. Delassus, *ibid.*, vol. 2, p. 566). He went on to expound the aims of Freemasonry: "To erase distinctions of social class, beliefs, opinions, and motherlands among men in a word, to make all of humankind only one single family" (*ibid.*, pp. 566-7; see other statements by Socialists and Freemasons advocating the Universal Republic in H. Delassus, *ibid.*, pp. 569-70, 572, 593-4).

h. During the Franco-Prussian War of 1870, the theosophists (Nesta Webster, *Secret Societies and Subversive Movements* (San Diego: The Book Tree, 2000, pp. 336-7) and pacifists voiced similar aims,

§ 5 Thus, the Pontiff's visit was more than a symbolic ges-
ture. It was a concrete, solemn capitulation to the indifferentist
principles of the Modern State. During this unfortunate trip, he
also ratified the Vatican renunciation of the Papal States.[5]
These were his words:

making the Universal Republic one of their slogans (Georges Goyau,
L'idée de patrie et l'humanitarisme, pp. 113, 115, *apud* N. Webster,
ibid., p. 337).

i. In an article on European unification, 20th century Italian politician
Giovanni Spadolini showed the role of ecumenism in achieving these
aims: "A union is born between Ecumenism [understood as a
movement for world unification] and Europeanism, the dream of
building a 'Sun City,' that is, a fraternal community of men in Europe,
a favored continent almost predestined to achieve new forms of in-
ternational cooperation without wars or national hatreds. This is the
ideal that shines forth in Kant's *Treatise on Perpetual Peace*, as well
as in Abbé de Saint Pierre, Rousseau, and Voltaire" ("A minha Eu-
ropa," *30 Dias*, August/September 1991, p. 58).

Further on he observed, "At the beginning of the 19th century, Saint-
Simon wrote: 'The transformation of Europe in a unitary sense will
be more easily achieved on the day when all peoples have one [sin-
gle] parliamentary system'" (*ibid.*, p. 59).

The revolutionary tone of this ideal was also revealed by Spadolini:
"Throughout the 19th century, Europeanism and democracy consti-
tuted one and the same thing, thanks to the efforts and struggles of
conspirators who believed in a Europe of peoples as opposed to a
Europe of dynasties and aristocracies. Foremost [among these] was
Giuseppe Mazzini, the first to speak about a 'Young Germany' to the
founding members of the 'Young Europe' organization" (*ibid.*, p. 60).

The Italian politician concluded with imagining a United Europe
linked to the United States in the West and the Soviet Union in the
East, a reality not that far removed from the dream of the Universal
Republic. Here are his words: "If in this [20th] century, and thus in this
millennium, we can achieve the building of a United Europe, with a
strong relationship with the other shore of the Atlantic and in con-
stant communication with the Soviet Union, then Mazzini's dream of
a 'Young Europe' will have been realized We know that this last
part of the [20th] century will be decisive for the new Europe This
Europe is the common meeting ground of peoples who believe in the
eternal values of liberty and democracy. The common meeting
ground destined to open itself to the 'global village' of humanity"
(*ibid.*, p. 62).

[5] The Papal States comprised the territories ruled by the Pope as
temporal King from 754 to 1870. In 1870 the papal territories were

"**He [the Pope] has no temporal power whatsoever,** nor any ambition to compete with you. In fact, **we have no demand to make, no question to raise.** At most, **we ask only to express this desire, to make this request: that is, to be permitted to serve you** in those matters within our competence, **disinterestedly, with humility and love.**"[6]

§ 6 What can be said about this spectacular submission of the Vicar of Christ to the UN? How is it possible for a Catholic to be uncritical of a Pontiff who directs himself to the organ that aims to be the representative of the Universal Republic and solemnly declares himself its servant: "We have no demands to make, at most, we ask to be permitted to serve you in those matters within our competence, disinterestedly, with humility and love."

§ 7 What an abysmal difference between this shameless submission and the majestic attitude of Pope St. Gregory VII before the supreme temporal authority of his epoch, Emperor Henry IV of the Holy Roman Empire. Consider the great contrast between these scenes.

§ 8 In the 11th century, the Emperor, dressed in a penitential sack shirt, prostrated himself on the ground in order to ask pardon of the Pope and offer him homage. In the 20th century, Paul VI presented himself as a beggar and humbled himself to pay homage to the revolutionary temporal power.

§ 9 In the Middle Ages the Papacy attained the plentitude of glory with the famous *Dictatus Papae* of St. Gregory VII, a document in which he showed the superiority of the Pope in relation to the supreme temporal authority. In 1965, the Papacy suffered its lowest point of humiliation with this speech of Paul VI analyzed here. It is a humiliation all the more grave in that it was made voluntarily, without any type of coercion. Paul VI asked the UN permission "to serve it disinterestedly, with humility and love."

seized in a revolutionary movement to unite Italy, and the States of the Church *de facto* ceased to exist. In 1929 the temporal sovereignty of the Pope over only Vatican City was recognized by the Lateran Treaty.

[6] Paul VI, "Messaggio di Paolo VI all'Assemblea Generale delle Nazioni Unite," *La visita di Paolo VI alle Nazioni Unite*, p. 58.

He also stated: "**Our message desires, above all, to be a solemn, moral ratification of this lofty Institution [the UN].**"[7]

§ 10 Paul VI thus fell on his knees before the Modern State, presenting himself as its servant. He ratified the renunciation of the Pontifical States and sought to end the glorious struggle the Church had been waging for two centuries against the usurpation of the Catholic State. *"Ignominia domus Domini tui"* [thou art the shame of the house of thy Lord] (Is 22: 18). These were the words of the Holy Ghost, through the pen of Isaias, to describe Sobna, the Prefect who dishonored the Sacred Temple he governed at that time. They might with purpose be paraphrased here...

*

§ 11 Unfortunately, Paul VI's praise of the revolutionary ideals of the Modern State went beyond his official support of the UN. On the same occasion the Pontiff praised revolutionary principles of fraternity, equality, and liberty.

§ 12 *Fraternity:* "**Your vocation is to bring about fraternity not just among some peoples, but all peoples.** Is this a difficult undertaking? Undoubtedly. But that is the mission, **such is your very noble mission. Who cannot see the need to** gradually **establish a world authority able to act efficaciously in the juridical and political spheres?**

"**Again, we repeat our desire: go forward!** We will say more: **Do so in such a way as to reunite those who have fallen away from you. Find a way to bring to your pact of fraternity those who still are not participating in it.**"[8]

§ 13 *Equality:* "**The logic of our desire**, which addresses, one could say, the structure of your Organization, **leads us to add yet other directives.** They are the following: **let no one, as a member of your union, be superior to the others:** *no one above anyone else.* **It is the rule of equality.**"[9]

[7] *Ibid.,* p. 59.

[8] *Ibid.,* p. 62.

[9] *Ibid.,* p. 63.

§ 14 *Liberty:* "**What you proclaim here are the** basic **rights and duties of man**, his dignity, **his liberty and, before all else, his religious liberty. We consider you the interpreters of the highest part of what there is in human wisdom**, we would almost say, **its sacred character**.[10]

§ 15 With this visit and these words Paul VI went far beyond the longings of the most radical revolutionary dreamers. In fact, who could imagine that a Pope would ratify the most pernicious ideals of the enemies of the Church such as the Ghibellines and Freemasons? It was done, notwithstanding, by the main architect of the conciliar Revolution, Giovanni Baptista Montini.

§ 16 On the eve of the Council's closing, in his Apostolic Letter commemorating the 7th centennial of Dante's birth, Paul VI again referred to the UN praising the "divine poet's anticipation" of the organization. Actually, Dante's work on the monarchy quoted by Paul VI expressed the strong political sentiments of the Ghibelline current to which Dante belonged. This medieval movement, which is still active today, struggled for the supremacy of the emperor over the Pope in opposition to the constant teaching of the Church. In *De monarchia* Dante argued for the Ghibelline ideal of a lay supra-national government. The portrait Dante presented is considered by many as a pre-figure of the Universal Republic.

§ 17 After expounding on the relationship between the spiritual and temporal powers in the Middle Ages, Paul VI commented:

"The emperor is invested with a mission that is, above all, a moral one, as it leads to the triumph of justice and the curtailment of greed, the cause of disturbances and wars. **Hence it follows that a universal monarchy seems necessary. This institution**, expressed by statements and terms proper to the Middle Ages, **clearly demands that primacy be given to a supranational power by which one single law will prevail to safeguard peace and concord among peoples. The divine poet's anticipation [of such an organization] is in no way implausible or misleading**, as it could appear to some, **since in our times a way by which the peoples of human so-**

[10] *Ibid.*, p. 67.

ciety can be brought together with great profit and benefit has been found with the United Nations Organization."[11]

§ 18 Soon after these lamentable positions were taken publicly by Paul VI, Vatican II approved two documents on the last day of the Council (December 7, 1965):

- The Constitution *Gaudium et spes,* which seems to endorse many principles of the Enlightenment and the French Revolution that serve as foundation for the Modern State, and,

- The Declaration *Dignitatis humanae,* which takes up the basic principles of the rights of man adopted by the UN in 1948, and defends freedom of worship for the false religions.

§ 19 John Paul II ratified the Conciliar Church's support for the aims and desires of the United Nations. During his visit to its headquarters on October 2, 1979, in response to the opening greeting of Secretary General Dr. Kurt Waldheim, the Pope stated: **"Your organization has a special significance for the world, because the thoughts and hopes of all the peoples of our planet converge in it."[12]**

§ 20 He also praised the UN objective **"to promote respect for human rights and the fundamental liberties for all, without distinction of** race, sex, language, or **religion."[13]**

§ 21 He closed his salutation with this wish: "That the hopes that they [men, women, and children] place in the efforts and solidarity that unite us will never be disappointed. **In the United Nations they can experience the fact that there is only one world, and that the UN is the home of everyone."[14]**

§ 22 In his official speech to the UN General Assembly later in the day, John Paul II emphasized his praise and pledge of support for the ideals of the organization. He also noted that he

[11] Paul VI, Apostolic Letter *Altissimi cantus,* December 7, 1965, A.A.S., 1966, vol. 58, p. 31.

[12] John Paul II, Greeting to the General Assembly of the UN, October 2, 1979, *Insegnamenti di Giovanni Paolo II,* 1979, vol. 2, p. 520.

[13] *Ibid.*

[14] *Ibid.,* p. 521.

was following in the steps of John XXIII and Paul VI in their approval and admiration for the UN. His words follow:

"The Apostolic See not only bears strongly in mind its own collaboration with the UN, but, since the birth of the Organization, it has always expressed its real esteem for and concurrence with the historical significance of this supreme forum for the international life of contemporary humanity Popes John XXIII and Paul VI had confidence in this important institution as an eloquent and promising sign of our times. And the one who speaks to you now, since the first months of his own pontificate, has often expressed the same confidence and conviction fostered by my predecessors."[15]

§ 23 John Paul II then went on to praise specific rights present in the UN *Declaration of the Rights of Man*: **"the right to freedom of expression the right to freedom of thought, conscience, and religion, and the right to express one's own religion individually or in a group, as well as in private or in public."[16]**

§ 24 One cannot avoid asking: With this support, can the Pontiff escape the charge of religious Indifferentism?

§ 25 In this context, the Pope then presented a definition of equality that, taken in its generic sense and stripped of nuances, would seem to have revolutionary characteristics. **"Equality of rights,"** said John Paul II, **"would mean the exclusion of the diverse forms of privilege for some and the discrimination of others."[17]**

§ 26 On the occasion of the 50th anniversary of the United Nations Organization on October 6, 1995, Pope John Paul II again visited the entity. There he made yet another public eulogy: **"My words, which I desire to be a sign of the esteem and regard of the Apostolic See for this Institution, join willingly with the voice of all who see in the UN the hope for a better future for the society of men."[18]**

[15] John Paul II, Speech delivered to the UN General Assembly on October 2, 1979, *ibid.* p. 523.

[16] *Ibid.*, pp. 531-37.

[17] *Ibid.*, p. 537.

[18] Speech to the General Assembly of the United Nations of October 5, 1995, published under the title "Nella sede dell'Organizzazione

§ 27 The Pontiff then provided some vague reasons to justify his unrestricted support for the UN: "Because of its specifically spiritual mission that makes it solicitous for the integral good of every human being, **the Holy See from the beginning has firmly upheld the ideas and objectives of the United Nations Organization.**"[19]

§ 28 Perhaps sensing dissatisfaction with the UN (in French, ONU), which many French have wittily dubbed *Organization Nullement Utile* [absolutely useless organization], John Paul II predicted a more auspicious future for it. In fact, he stated: "**It is necessary for the United Nations Organization to move beyond the cold training stages of an administrative institution and become a moral center, where all the nations of the world feel themselves at home,** by developing the common conscience of beings, that is to say, a 'family of nations.'"[20]

§ 29 As if these praises were not sufficient, some days after on October 21, 1995, Cardinal Angelo Sodano, Vatican Secretary of State, delivered a solemn homily at St. Patrick's Cathedral in New York, in which he compared the leadership of the UN to the mission of Moses. This would seem to indicate a prophetic role to be carried out by the organization. In his homily, Sodano thus exalted the entity:

"The theme of evangelical perseverance is an appropriate one for us to give thanks to the All-Powerful God for the first fifty years of the United Nations Organization. The theme illustrates the importance of working together to attain an objective. **Like Moses, a world leader is called to serve its people by promoting the well being of the whole human family.** **Giving thanks for the past fifty years offers us the opportunity to recommend to you [here present] the noble values that inspired the foundation of the United Nations Organization.** Recognizing the interdependence of the human family, we are quite aware of the fact that much more still remains to be done."[21]

delle Nazioni Unite, che celebra il 50 anni di fondazione, il Papa consegna all'umanità un messaggio di portata storica," *L'Osservatore Romano*, October 6, 1995, p. 6, n. 1.

[19] *Ibid.*

[20] *Ibid.*, p. 7, n. 14.

[21] Angelo Sodano, Homily at St. Patrick's Cathedral, October 21, 1995, published under the title "Santa Messa presieduta dall'Emmo.

§ 30 Three days later, on October 24, Sodano spoke as if he would like to establish the Holy See as chaplain of the UN. This could be deduced from his words to the General Assembly of the entity: **"By its presence among you, the Holy See**, sovereign subject of international law with moral and religious ends, **wants to help give this Organization the spiritual force so that it might defend more efficiently the principles of its *Charter of Foundation*, principles that constitute an incontestable reference point for international relations."**[22]

Thus what we are seeing here seems to be the Conciliar Church fully uniting with the Modern State and renouncing the former behavior of the Catholic Church. Is this the bottom of the abyss?

Unfortunately, it is not.

*

§ 31 As soon as the Conciliar Church had solemnly and officially rejected the Catholic State, it began to quarrel with the Modern State, which the Church came to view as not far enough advanced along the paths of egalitarianism and moral liberalism.

§ 32 In the past decades, the progressivist Church has multiplied its criticisms of private property and the free enterprise system with its consequences of profit distribution and open market, in short, Capitalism. The latter has been presented as egotistic and based on "structures of sin." The Conciliar Church began to demand an urgent "liberation" and increasing socialization in the Modern State.

§ 33 At the same time, it has introduced, or allowed the introduction of, elements that tear down the last moral restraints in the West. This would include, in many cases, the exaltation of love as the primary end of matrimony, a tacit acceptance of birth control, and an implicit permission for divorce, without

Card. Angelo Sodano nella Cattedrale di San Patrizio a New York," *Bolletino – Sala Stampa della Santa Sede,* October 22, 1995, p. 8.
[22] A. Sodano, Speech to the UN General Assembly on October 24, 1995, published under the title "Intervento dell'Emmo. Card. Angelo Sodano alle Nazioni Unite nel 50° anniversario di fondazione," *Bolletino – Sala Stampa della Santa Sede,* October 26, 1995, p. 19.

using this name. All of these factors that corrode family morality are presented as necessary for the "full realization of the human person."

In other cases, there is toleration for pre-marital experiments and masturbation, practices that corrupt the youth but are touted as imperatives of the new psychiatry to which everyone must adapt. Finally, there is the increasing tolerance of and support for homosexuals and prostitutes under the label of pastoral work.[23]

§ 34 It was not enough, therefore, to have strongly supported the egalitarianism and liberalism proper to the Modern State. In the next stage of the process, the progressivist Church presented new demands and took large strides toward a kind of Socialist State.

§ 35 This Socialist State is not necessarily presented as the same thing as the Soviet system, which various progressivists have criticized. Such critiques, however, do not contest the essence of the Socialist regime. They only censure it for not having been faithful to its own principles by committing excesses against freedom. One could say that what the progressivists want goes even further than the Communist regimes themselves had realized,[24] and lies closer to the *synthesis* that Marx dreamed of to replace the dictatorship of the proletariat.[25]

[23] The author of this Collection has selected numerous files on the destruction of Catholic Morals being realized by progressivists as another fruit of Vatican II. This material, which could comprise several volumes, would include the topics of these last two paragraphs. Except for in Vol. III, *Animus injuriandi* II, Chap VII, the subject of Morals was not more specifically addressed in this Collection on the Council because it had already extended to eleven volumes. But should the need arise, I will publish part of or the whole selection I made on these topics.

[24] a. Expressive words on this topic were voiced by missionary Bishop Pedro Casaldáliga – Spanish by birth but living in Brazil for more than 30 years – in his book *I Believe in Justice and Hope:* "The Socialism that I am fighting for, along with so many other brothers in the Faith who share the passion for Justice, as the best sociopolitical tool for the transformation of human society is not some specific regime, much less a particular party. It is not Russia nor Cuba, nor China, nor Algeria, nor the Chile of Allende. It has, however, something of them **Trying to be Christian, I know that I can and should go further than Communism**" (*Yo creo en la justificia y la esperanza,* Bilbao: Desclée de Brouwer, 1976, p. 180).

b. These and other statements by Bishop Casaldáliga were analyzed in detail by Prof. Plinio Corrêa de Oliveira, in his work, *The Church in the Face of Communist Threat: An Appeal to the Silent Bishops* (*A Igreja ante a escalada da ameaça comunista - Apelo aos Bispos silenciosos,*São Paulo: Vera Cruz, 1976, p. 22). This work had widespread repercussions. According to Vaticanist Rocco Morabito, "At various times it was possible to find on Vatican work tables copies of the book published in São Paulo and written by Plinio Corrêa de Oliveira – *A Igreja ante a escalada da ameaça comunista* – which contains long citations from the writings and poems of Bishop Pedro" (*O Estado de São Paulo,* April 8, 1977).

c. Notwithstanding, the Holy See showed no concern to condemn the actions of the explosive revolutionary Prelate. On the contrary, as rumors spread that the Brazilian government intended to expel him from the country, many highly placed ecclesiastics came to his support, among them Paul VI himself. A news item in the archdiocesan paper of São Paulo made this report: "The Pope [upon receiving Archbishop Paulo Evaristo Arns] showed himself to be very moved by and in solidarity with the people of God from the remote interior [of Brazil] and their Bishop ... At the end of the private audience, the Pope told Archbishop Paulo Evaristo that to meddle with the Bishop of São Félix [Pedro Casaldáliga] would be to meddle with the Pope himself" (*O São Paulo,* January 10-16, 1976, *apud* P. Corrêa de Oliveira, *Tribalismo Indígena, Ideal comuno-missionário para o Brasil no século XXI,* pp. 119-120).

In the dozen years that have passed since Prof. Oliveira's denouncement in his book *The Church in face of the Escalating Communist Threat,* Casaldáliga has boldly continued his subversive preaching without fear of Vatican censures.

d. In mid-September 1988, he received a letter from the *Congregation for the Doctrine of the Faith* and the *Congregation of Bishops,* sent by their respective Prefects, Cardinals Ratzinger and Gantin. It warned him about his conception of the Eucharist, his criticisms of the Holy See, his favorable position toward Liberation Theology, as well as his travels to Sandinista Nicaragua.

This letter, however, did not contain any sanctions whatsoever. It was a mere invitation to observe with more fidelity the positions of the Holy See in matters of social doctrine, and to refrain from traveling to other countries without the knowledge of the local Episcopate (*30 Giorni,* Port. Ed., November 1988, p. 8). The Vatican immediately denied news reports in Brazilian newspapers that Msgr. Casaldáliga had been forbidden for an undetermined length of time to speak publicly, travel, and publish books and articles. Fr. Giovanni D'Ercole, vice-director of *Sala Stampa,* the Vatican press office, explained that

the news that reported Msgr. Pedro Casaldáliga had been punished and silenced was not true (*Vida Nueva*, Madrid, October 1, 1988).

For his part, the Apostolic Nuncio in Brazil, Archbishop Carlo Furno, offered this clarification: that the letter only had alerted Bishop Casaldáliga to "some of the duties of the Bishop" and invited him "to always be completely faithful to the teaching of the Magisterium of the Church" (*O Estado de São Paulo*, September 25, 1988).

Even in face of this mild Vatican warning, Bishop Casaldáliga refused to sign the formal papers of the conversations he had in Rome with Cardinals Ratzinger and Gantin. According to *30 Giorni*, "The Bishop asked for time and complained to the Pope about the request made to him. He was granted some time for reflection. The text he was supposed to sign arrived later in Brasilia, but Msgr. Pedro told the Nunciature that he did not have time to go there The Nuncio, Msgr. Carlo Furno, ordered the text to be translated and mailed it to the Bishop's residence. Again Bishop Pedro refused to sign it under the pretext that it was not an official communication" (*30 Dias*, November 1988).

e. A wave of support among the radical progessivist branch of the National Conference of Brazilian Bishops – NCBB – broke out for the missionary-Bishop's insubordination. Its president, Bishop Luciano Mendes de Almeida, even traveled to Rome "to discuss the Casaldáliga case with Pope John Paul II," and to hand deliver to him a letter of protest from the Basic Christian Communities of the Diocese of Goiás Velho (*Folha de São Paulo*, September 28, 1988). On September 27, 1988, twenty Brazilian Bishops sent Cardinal Ratzinger a letter of protest manifesting their "alarm" over the "summons" received by Bishop Casaldáliga, and expressing their "profound communion" with the subversive Prelate (*Il Regno*, Bologna, September 15, 1988, pp. 558-9).

f. As it turned out, the Holy See clearly affirmed that it had not condemned Msgr. Casaldáliga. Further it humbly accepted the arrogant official protest of the NCBB president and numerous Prelates for the timid warning that it had dared to make.

[25] Marx transposed the Hegelian method of seeking truth onto the historical, social-political, and economic fields. This method supposes a philosophical evolution by means of a *thesis*, *antithesis*, and *synthesis*. For Marx the *thesis* – the hegemony of the bourgeoisie – would be opposed by an *antithesis* – the dominance of the proletariat – which would generate a *synthesis*, the disappearance of the State. From Lenin up to our times, the Communists have claimed to situate themselves in the second phase of the process, that is, in the dictatorship of the proletariat. Judging from more recent preachings of the progressivists, one could say that they are aiming for the establishment of the *synthesis*, the final stage of the Marxist ideal.

§ 36 In fact, the Conciliar Church would make one think that it had become the driving force of social revolution today. One need only consider various items on its social-economic agenda:

 • Its frequent exaltation of work[26] and sharp critiques of the Capitalist regime[27];

[26] a. The topic of work, dealt with by Paul VI in *Populorum progressio,* was also developed in the Encyclicals *Laborem exercens* and *Sollicitudo rei socialis* of John Paul II. On his visit to Modena, Italy, the Pontiff referred enigmatically to the "new fact" that is the "revolution of work": "I would like to make an exegesis of the words of St. Benedict, *'labora et ora'* [work and pray]. I believe that these words, spoken and organized in that way, explain to us the meaning of the social teaching of the Church. While the reality of human work has always been present in the world and history of humanity, nations, and peoples, it became an entirely new measure in the last centuries. Human work became the new fact: the 'revolution of work.' Humanity has lived and still lives this 'revolution of work'" (*L'Osservatore Romano,* June 5, 1988, p. 8).

b. In *Laborem exercens* John Paul II placed the noble labor of the mind on equal footing with rude manual labor: "**The word work means any activity by man, whether manual or intellectual**" (*Laborem exercens,* Initial Greetings, São Paulo: LTR, 1983, p. 7)

c. Further on, he emphasized the role of work to realize man fully: "It is as a person that man is the subject of work. As a person he works, he performs various actions belonging to the work process. Independent of their objective content, these actions must all serve to realize his humanity, to fulfill the calling to be a person that is his by reason of his very humanity" (*ibid.,* n. 6.2).

d. This "self-realization" of man through work preached by John Paul II is similar to the "self-creation" of man through work defended by Marx. In fact Marx affirmed: "All the so-called history of the world is nothing more than the self-creation of man through human work, nothing more than the coming-into-being (*Werden*) of nature for man" (Istvan Mészáros, *Marx: a teoria da alienação,* Rio de Janeiro: Zahar, 1981, p. 76).

e. This similarity between the thinking of John Paul II and Marxism has been pointed out by moderate progressivist intellectuals as well as by exponents of Liberation Theology.

In an interview in Rio de Janeiro, Italian writer Rocco Buttiglione, a conservative expert on the thinking of Karol Wojtyla, affirmed: "Even

- Its various sanctions made in passing of secondary characteristics of Communism;[28]

a superficial reading of the Encyclical *Laborem exercens* causes surprise by the fact that in various places in this Encyclical one can find Marxist terminology used with precision and sharpness to explain the contemporary world John Paul II took up the concept of "alienation" as well as the Marxist concept of *praxis*. Marx affirmed that man creates himself, constructs himself through his own work Karol Wojtyla agrees with the fact that man, in a certain sense, creates himself through his own work" (R. Buttiglione, "Cultura e Filosofia," *Antropologia e praxis no pensamento de João Paulo II*, Rio de Janeiro: Lumen Christi, 1985, pp. 42-3).

f. In the same sense, Uruguayan liberation theologian Fr. José Luis Segundo wrote: "What Marx said about human relationships being represented by work, as well as about liberty and the vocational character that work must have so that man can be fulfilled without the need to put in over-time for his spiritual and human development, is very similar to the personalist and Christian vision of work that Pope John Paul II has re-examined in his Encyclical *Laborem exercens*" (J. L. Segundo, *Teologia da Libertação - Uma advertência à Igreja*, São Paulo: Paulinas, 1987, p. 127).

[27] See §§ 69-86.

[28] a. The critiques of Prelates of the post-Conciliar Church about Communism are generally turned against its atheist and violent aspects. On the other hand, any criticism of the philosophical roots of the Communist system, formerly severely condemned by the Roman Pontiffs, is no longer heard from the lips of Bishops. By the way, in the official documents of the Council not even one word was written on Communism, not even a soft critique on its secondary aspects (see Vol. I, *In the Murky Waters of Vatican II*, Chap VI, §§ 85-99).

b. In Medellin, the Bishops' warning about the Communist danger referred only to excesses of violence. Even in these circumstances they praised other aspects of Communism:

"Finally **we direct ourselves to those who**, in face of the gravity of the injustice and illegitimate resistance to changes, **put their hope in violence. Along with Paul VI, we recognize that their attitude 'often is ultimately motivated by noble impulses of justice and solidarity'** [Speech in Bogotá, at the Progress Day Mass] **Certainly violence or 'armed revolution' usually 'generates new injustices, introduces new imbalances, and provokes new disasters. One can never combat an existing evil at the cost of a greater adversity'** [Paulo VI, *Populorum progressio*, n. 31]" (CELAM, *A Igreja na atual transformação da América Latina à luz do*

- Its encouragement of worker participation in company management and profit sharing,[29] of student input in

Concílio - Conclusões de Medellín, Petrópolis, Brazil: Vozes, 1980, p. 72).

Further on, the Bishops again criticized the violence of Communism: **"The youth,** particularly sensitive to social problems, call for profound and rapid changes that guarantee a more just society. Often it **is tempted to express these demands by means of violence. It is a tangible fact that the excessive idealism of youth easily exposes it to the action of groups with various extremist tendencies"** (*ibid.*, p. 81).

[29] a. *Gaudium et spes* encourages worker participation in company management: "In economic enterprises it is persons who work together, that is, free and independent human beings created to the image of God. Therefore, **the active participation of everyone in the running of an enterprise should be promoted**" (*GS* 68).

b. John Paul II echoed this conciliar doctrine when he defended the right of participation of farm workers during a visit to Brazil: "**The workers of the earth, like all other workers, may not be denied under any pretext the right of participation** and communion in the life of the enterprises** and organizations designed to define and safeguard their interests in the difficult and dangerous journey toward the indispensable transformation of the structures of economic life" (Homily during the Mass in Recife, July 7, 1980, *A palavra de João Paulo II no Brasil*, p. 248).

Later, he repeated this message: "**It is very important for all the protagonists of economic life to have the real possibility of freely and actively participating in the elaboration and control of decision-making at all levels that involve them**" (Meeting with workers in São Paulo, *ibid.*, p. 130).

c. By promoting this self-management, *Gaudium et spes* and John Paul II appear to set themselves against the teaching of Pius XII on the right of private property and its social function. In fact, Pius XII affirmed: "For this reason, **Catholic social doctrine speaks out determinedly on the right of private property**, among other questions. Here also are the profound reasons why **the Popes of the social encyclicals, and we also, refuse to deduce from the nature of the work contract, either directly or indirectly, the worker's right of co-ownership in the capital of the company and, consequently, his right of co-management**" (Pius XII, Radiomessage to the Katholikentag of Vienna, *Discorsi e Radiomenssaggi di Sua Santità Pio XII*, Editrice Poligòtta Vaticana, vol. 14, p. 314).

teaching and education,[30] and of lay participation in the direction of parishes and Dioceses[31];

[30] a. Student participation in school management, called the democratization of education, was defended in the *Conclusions of Medellín*:

"The democratization of education is an ideal that is far from being achieved on all levels, above all, in universities" (CELAM, *A Igreja na atual transformação da América Latina*, p. 73).

b. **"The youth should be heard on matters relating to their formation**. It should not be forgotten that the student tends to self-improvement and, for this reason, values should be presented to him so that he can assume an attitude of personal acceptance toward them. **Self-education** **is an indispensable requirement to achieve a true community of students** (*ibid.*, p. 76).

[31] a. The Puebla Document defended the participation of the laity in the direction of Dioceses and parishes: **"Participation of the laity is required not only in the execution phase of overall pastoral action, but also in its planning and in the decision-making bodies themselves** "(*Puebla Message, 1979 – La evangelización en el presente y el futuro de America Latina*, Madrid: BAC, 1982, n. 808).

In the Apostolic Exhortation *Christifideles laici*, of December 30, 1988, John Paul II addressed the need for a greater lay collaboration in the direction of Dioceses and parishes:

b. *On the diocesan level:*

"The recent Synod [of the laity] has favored the creation of *Diocesan Pastoral Councils*, as a recourse at opportune times. In fact, on a diocesan level this structure could be the principal form of collaboration, dialogue, and discernment as well. **The participation of the lay faithful in these Councils can broaden resources in consultation and the principle of collaboration – and in certain instances also in decision-making – if applied in a broad and incisive manner.**

"The participation of the lay faithful in diocesan Synods and in local Councils, whether provincial or plenary, is envisioned by the *Code of Canon Law* (Canons 443 § 4; 463 §§ 1, 2). This participation should contribute to Church communion and the ecclesial mission of the particular Church, both in its own surroundings and in relation to the other particular Churches of the ecclesiastical province or Episcopal Conference" (*L'Osservatore Romano*, January 30-31, 1989, Supplement, p. IX, n. 25).

c. *On the parish level:*

"The Synod Fathers have given much attention to the present state of many parishes and have called for a greater effort in their renewal So that all parishes of this kind may be truly communities of Christians, **local ecclesial authorities ought to foster the fol-**

- Above all, its much trumpeted Liberation Theology[32] and its preferential option for the poor.[33]

lowing: a) **adaptation of parish structures** according to the full flexibility granted by Canon Law, **especially in promoting participation by the lay faithful in pastoral responsibilities**" (*ibid.*, n. 26).

In addition to the specifically diocesan and parish levels, lay participation is advocated:

d. *On a general level*:

Directing himself to Cardinal William Baum at a meeting of 37 American Bishops with members of the Roman Curia, Archbishop Daniel Pilarczyk said: "**In the past, the priest was the only one responsible for the parish, but now he should make decisions consulting the lay persons responsible for the various sectors**" (*apud Adista*, Rome, April 28-31, 1989).

The Puebla Document also addressed lay participation in a more general way: "Their sense of belonging to the Church has increased everywhere, not only because of a more stable Church behavior, but also because of their greater participation in liturgical assemblies and apostolic works. In many countries, the *Basic Christian Communities* provide proof of this incorporation and desire to participate. **There has not been enough lay engagement in the temporal world, so necessary for structural change. One could say that there is generally a greater need now for the participation of the laity in the life of the Church**" (*Puebla Message, 1979*, n. 125).

[32] a. From the progressivist view, every manual worker is oppressed by Capitalism and its structures of sin. Thus he should be liberated from this oppression. This is what is proposed by the famed Liberation Theology of Fr. Gustavo Gutierrez and Leonardo Boff, which took root in 1968 at the gathering of the Latin American Episcopate in Medellin, where Pope Paul VI was present (See Introduction, footnote 9).

b. The theme of liberation from the apitalist "structures of sin" has been developed in the following documents, among with many others:

- Encyclicals *Populorum progressio* (1967), *Octagesima adveniens* (1971), and *Evangelii nuntiandi* (1975) of Paul VI;
- *Laborem exercens* (1981) and *Sollicitudo rei socialis* (1988) of John Paul II;
- in Medellin, *The Church in the present day transformation of Latin American following the light of the Council* (1968);
- at the World Synod of Bishops on justice (1971);

§ 37 Thus the Conciliar Church would appear to be aiming to establish a new regime in the West that would be neither Capitalism nor Communism, but rather the long desired trans-Communist synthesis.[34]

- in Puebla, *Evangelization in the Present and Future of Latin America* (1979).

[33] The expression "preferential option for the poor" was coined in the *Puebla Document*: "We affirm the need for conversion of the whole Church to a **preferential option for the poor**, with the purpose of its full liberation" (n. 1134). Later, the same document emphasized: "**Thus the poor are the first recipients** of the mission, and their evangelization is the sign and proof par excellence **of the mission of Jesus**" (n. 1142).

[34] a. Allusions to the new society yearned for by the progressivists, in which Capitalism and Communism would be superceded, are found in the *Conclusions of Medellín*: "Peace in Latin American is not just the simple absence of violence and bloodshed. The oppression exercised by power groups can give the impression of maintaining peace and order, but in reality they foster the 'continuous and inevitable germ of rebellions and wars' (Paul VI, Message of January 1, 1968). **Peace is only obtained by creating a new order that 'brings a more perfect justice among men'** (*Populorum progressio*, n. 76)" (CELAM, *A Igreja na atual transformação da América Latina*, p. 60).

The document further emphasized: "**Education** at all levels must become creative, since it **must anticipate the new type of society that we are seeking in Latin America**" (*ibid.*, p. 74).

b. In the Encyclical *Sollicitudo rei socialis* John Paul II affirmed: "**The social doctrine of the Church adopts a critical attitude toward both liberal Capitalism and Marxist collectivism. For, from the point of view of development, the question naturally arises: in what way and to what extent are these two systems capable of changes and updatings** such as to favor or promote a true development of individuals and peoples in modern society?" (n. 21). John Paul II again refers to the foundation of a new society: "Surmounting every type of imperialism and determination to preserve their own hegemony, **the stronger and more gifted nations must have a sense of moral responsibility for the other nations, so that a real international system may be established which will rest on the foundation of the equality of all peoples**" (n. 39).

Again, he returned to the same point: "The existing [international] institutions and organizations have worked well for the benefit of peoples. Nevertheless, **humanity** is in a new and more difficult phase of its genuine development. It **needs a greater degree of in-**

§ 38 Would this trans-Socialist synthesis suppose the existence of a State? Or, on the contrary, would it already be a stateless society made up of small self-managing cells bound together by a more or less tribal constitution and animated by a pentecostal-totemic mysticism?[35] This Volume hopes to respond to that very question.[36]

1. Church Doctrine that supports the Catholic State and opposes the Modern State

§ 39 Papal teaching on the fundaments of the Catholic State and opposed to the essentially a-confessional and egalitarian Modern State are summarized in passages from the Encyclical *Immortale Dei*.

§ 40 Leo XIII taught that by the fact that authority proceeds from the very nature of society and man, it has God as author. After demonstrating this, he continued: "Hence it follows that all public power must proceed from God. For God alone is the true and supreme Lord of the world. Everything, without exception, must be subject to Him and must serve Him. Therefore, whosoever holds the right to govern holds it from the one single source, namely, God, the Sovereign Ruler of all. 'There is no power but from God' (Rom 13:1)" (n. 5).

§ 41 The Sovereign Pontiff was rigorous against religious indifferentism: "It is a public crime for societies to act as though God absolutely did not exist. So also is it a sin for the State not to have care for religion, regarding it as something beyond its scope or of no practical benefit, or to adopt from the many forms of religion the one that fits its fancy. For we are all bound absolutely to worship God in that way which He has shown He desires to be honored" (n. 11).

ternational administration in the service of the societies, economies, and cultures of the whole world" (n. 43).

[35] See Plinio Corrêa de Oliveira, *Revolution and Counter-Revolution*, Part III, Chap. III, Items 1 and 2; *Tribalismo indígena, Ideal comuno-missionário para o Brasil no século XXI*; "What does Self-Managing Socialism Means for Communism: A Barrier? Or a Bridgehead?" *The New York Times*, December 13, 1981.

[36] See Items 2, 3 of this Chapter and Part I, Chap. VI.

§ 42 He also addressed the heads of States: "All who rule, therefore, should hold in honor the holy name of God, and one of their chief duties must be to favor Religion, to protect it, and to shield it under the credit and sanction of the laws, and neither to decree or sanction any measure that may compromise its integrity" (n. 12).

§ 43 Leo XIII's argument on the supremacy of the Catholic Church was irrefutable: "And just as the end at which the Church aims is by far the most noble of ends, so also is her authority the most exalted of all authority, and can in no way be looked upon as inferior to the civil power or in any way subject to it" (n. 16).

§ 44 He also dealt with the question of the Church having the right to intervene in the State *ratione peccati*, that is, in those questions that imply sin. He stated: "Whatever, therefore, in things human is of a sacred character, whatever belongs either to the salvation of souls or to the worship of God – either by its own nature or by reason of its end – all this is subject to the authority of the Church. As for other things that fall under the civil and political order, they are rightly subject to the civil authority, since Jesus Christ commanded to render to Caesar what is Caesar's, and to God what belongs to God" (n. 20).

Leo XIII also refuted the fundaments of the Modern State:

§ 45 *The sovereignty of the people*: "Now, simple natural reason demonstrates that this way of understanding civil government is wholly at variance with the truth. Nature itself bears witness that all authority, of every kind, proceeds from God, who is its august and supreme source.

"The sovereignty of the people, which takes no account of God and is said to reside in the natural populace, in itself is a doctrine well calculated to flatter and inflame many passions. Nonetheless it lacks all reasonable proof and all power of insuring public safety and preserving order. Indeed, from the prevalence of this teaching, things have come to pass that many leaders hold as an axiom of civil jurisprudence that sedition may be rightfully fostered. For the opinion prevails that rulers and heads of government are nothing more than delegates chosen to carry out the will of the people. Whence it follows that all things are as changeable as the will of the people, so that risk of public disturbance is ever hanging over our heads" (n. 36).

§ 46 *Religious indifference*: "To hold, therefore, that there is
no difference in matters of religion among forms that are unlike
and even contrary to each other, most clearly leads in the end
to the rejection of all religion in both theory and practice. It is
Atheism without the name. In effect, whoever believes in God,
to be consistent with themselves and not fall into absurd con-
clusions, must necessarily admit that the diverse cults of wor-
ship, among which there is so much difference, disparity, and
opposition even on the most important points, cannot all be
equally probable, equally good, and equally acceptable to God"
(n. 37).

§ 47 *Freedom of thinking and expression*: "So, also, liberty
of thinking and of publishing whatsoever each one likes with-
out any hindrance is not in itself a good over which society can
rejoice. On the contrary, it is the source and origin of many
evils. Liberty, that element of perfection for man, should be
applied in relation to that which is true and good. However,
the essence of goodness and truth cannot be changed at the will
of man, but remains ever one and the same, and by the nature
of things is immutable. If the mind assents to false opinions, if
the will chooses and follows after the evil, then neither the
mind nor the will can achieve its perfection. Both fall from
their native dignity and are corrupted. Whatever, therefore, is
opposed to virtue and truth, may not be permitted to come be-
fore the eyes of men to tempt them. And much less can such be
sanctioned by the favor and protection of laws" (n. 38).

§ 48 *Excluding the Church from public life.* "To exclude the
Church, founded by God Himself, from public life, from mak-
ing laws, from the education of youth, from domestic society,
is a grave and pernicious error" (n. 39).

§ 49 Listening to these wise words of Leo XIII one can hear
not only the voice of a great Pontiff but the majestic and grave
chorus of multiple past Popes who established the Pontifical
Magisterium on this topic. Should someone want to go a step
deeper, he might say that the very voice of the Holy Ghost is
superbly echoed in these teachings. How can this be proved? If
an error could be found in a doctrine the Catholic Church
would have taught for many centuries, it would be because the
assistance of the Holy Ghost was not constant in the Church.
Now then, this assistance was and is constant according to the
promise of Our Lord (Mt 28:20; Jn 14:16). Therefore, that doc-
trine is infallible, by the very fact of being the same throughout

the centuries. It is the infallibility granted to the perennial ordinary Pontifical Magisterium.

Therefore, whosoever denies this doctrine rejects the infallible teaching on this matter. In other words, he stops being Catholic.

2. The new progressivist concept of the temporal sphere in general, and the State in particular

§ 50 Adding a new dimension to the principles that inspired the French Revolution, the progressivists present a picture of the Church and State, the spiritual and the temporal spheres, that constitutes a true *Weltanschauung* [world vision]. This Item will try to point out elements that configure such a world vision. By understanding this picture, one can understand why Progressivism at times attacks the Catholic State and exalts the Modern State, and at other times combats the Modern State and preaches a neo-Socialist State. With this knowledge in his hand, the Reader will be able to judge to what degree the progressive world vision is contrary to the doctrine of the Church and to what measure it seeks her destruction.

§ 51 Cardinal Yves Congar affirmed that the ideal society sought by Vatican II was a neo-Socialist global community: "The Council which opened by sending a message to the world followed the plan *Ecclesia ad intra - Ecclesia ad extra* [Church turned to inside, Church turned to outside], and ended with the Constitution *Gaudium et spes* and seven messages directed to all men.[37] The texts and speeches of Pope John XXIII and Paul VI are imbued with the same spirit. Underlying these **one can discern a new view of the world, and consequently, of the Church's relations with the world.**

"In place of a static and hierarchical conception
which saw in the 'temporal' only the aspect of political and legal organization that subordinated this 'temporal' to the priestly authority of the Church, there arose a vision of the

[37] More specifically, the message was directed to politicians, thinkers and scientists, artists, women, workers, to all who suffer, and to youth.

world as a dynamic whole, more as 'history' than as 'nature.'[38]

"Since then, the Church has no longer placed herself above the temporal as an ontologically superior authority. She sees herself in the same movement of History, understanding its meaning: the coming of the kingdom of God, eschatology.[39] **Her relationship with the world is seen as functional,** and she understands herself fully in her function. **She sees the world as a dynamic whole** – at the same time political, economic-social, and cultural, marked by day-to-day relationships between men and women, agents of production, etc. And as a dynamic whole, she sees it **engaged in a difficult process of man dominating his natural energies, including those that constitute him. In this new world, every man becomes present to every other man by means of rapid and mass communication.**"[40]

[38] Progresssivists seem to think that men should no longer have fixed political-social institutions like the State, much less the grouping of States that formed Christendom in the past. Such institutions, which are in accordance with the nature of the political-social body, would supposedly be obsolete.

Instead, they imagine that men, gathering together in self-managing communities with embryonic structures, should insert themselves directly into the evolutionary historical process as each group in its own way seeks the final end of evolution, that is to say, the phase in which humanity would have ascended to a more perfect stage, that of the new man. For them, then, men should no longer be linked to the State, which would be a static structure, but rather be turned directly to History itself, a dynamic conception.

In this conception, the mission of the Church would be directed toward the goal of evolution and the dynamic process that unifies the human race – socialization. It would fall to the Church to show that this aim – the new man – makes up part of the Faith, and that socialization would be a "sign" announcing the kingdom of God.

I offer this somewhat hypothetical explanation so that the Reader might better understand the at times obscure texts in this Item. As the Chapter advances, the Reader will see that the hypothesis certainly gains in probability.

[39] About the progressivist concept of eschatology, see Vol. III, *Animus injuriandi II*, Chap. V.2. A.

[40] Y. Congar, *Un peuple messianique*, pp. 20-21.

In this passage, Congar adopts an idea of Church that should no longer be above the temporal, but intervene in the "functional" aspects of the world. This is not so different from saying that the Church should have a cumulative mission with the State. It seems to be a preliminary notion of a new progressivist theocracy that is being prepared to govern both the Church and the State.

§ 52 In another work, the theologian tried to establish the new concepts of the temporal, the State and the Church:

"The temporal – **It is no longer only the political power**, empire, or kingdom. **It is the ensemble of efforts that man makes on the different levels – personal, social, and universal – in order to direct and develop human life on earth. This sentiment of the temporal also is historical and cosmic, because man is humanity** at the same time that he is a person. **This sentiment departs from the experience of centuries, in a kind of duel with nature. For this reason this vision of the temporal also is centered on man, the subject of that process by which it constructs itself.**

"Whereas the [concept of] temporal in the theology of the two powers came from a fixed and hierarchical view of the world, in which each thing had its place in the great tide of beings today the temporal is history. It is the fruit of the restless and conflicting effort of men. In these conditions, the temporal no longer refers to the Church as the secular power would refer to the spiritual power. It looks to the period in which, according to faith, **creation rises,** as well as to the lordship of Christ, the key of creation. A Teilhardian vision, if you like, but also very Irenaean [from St. Irenaeus] and Pauline."[41]

In other words, the concept of temporal for the progressivist thinker would have to be understood not as a static social concept – a notion that could be applied to any civil sphere that existed, exists, or will exist – but as a dynamic reality. That is, each small group of men would have a distinct notion of temporal, according to their stage in a supposed evolutionary process that would encompass the entire universe. Therefore, the "old" conception of temporal should be abandoned. To determine what would replace this notion, the gurus of the Conciliar Church would have to discern in each small group the stage of

[41] Y. Congar, *Église Catholique et France moderne*, pp. 230-31

the evolution through which it is passing. After that, this "prophetic" Church would indicate the road to follow, in order to proceed in the march of evolution.

§ 53 Congar continued: *"**The State** – **The vocabulary of the Council is probably not absolutely consistent.** The chapter of *Gaudium and spes* that interests us most refers to 'the political community.' In the Middle Ages, one spoke of 'kingship,' 'royal power,' 'temporal power.' Today we would say 'the State.' The council says 'the public (or civil) power.' **This broader notion of the temporal corresponds logically to a broader vision of the subject that makes it up: the human community.**

"**But the concept of public power also underwent a certain change …. The temporal is no longer the communitarian and fraternal prudence of the princes of old. It is above all what is called the juridical State, limited in its functions. And its first function consists of protecting and promoting the rights of its people and facilitating the exercise of the natural duties of man. It is a personalist vision: 'The human person is the basis, the end, and the subject of the whole social process.'**[42]

§ 54 *"**The Church** – Vatican II certainly did not eliminate or even diminish the authority derived from that of the Apostles in the Church. With the significant ordering of the chapters of the Constitution *Lumen gentium*,[43] **the Council emphasized the primacy of the *Christian* on the juridical configuration of the people of God. The Church is viewed principally as the community of the faithful endowed with supernatural gifts on a sacramental foundation. The category of '*societas perfecta*,** a complete society sufficient in itself' is not denied by the ecclesiology of the Council,[44] but it **no longer plays an active role. The Church,** if she exists in herself, **does**

[42] About the conciliar progressivist concept of the human person, see Vol. VII, *Destructio Dei*, Chap. IV.3.C.

[43] The initial project of *Lumen gentium* dealt with the Hierarchy of the Bishops and then with the faithful, following the order of importance of roles, as the Church always did. The final document inverted this order, giving more importance to the "people of God" than to the Hierarchy. It is to this inversion that Congar is referring in his text.

[44] This moderate statement of Congar does not correspond to current progressivist thinking. See Vol. IV, *Animus delendi I*, Chap. IV.

not exist except with a mission for the world, as a 'sacrament of salvation,'[45] 'the sign and the means of intimate union with God and the unity of the whole human race.'

"**In relation to the 'classic' positions, especially those of the Middle Ages and Christian Europe, all of these changes are profoundly coherent. They underlie a new view of relations between the Church and the world, the spiritual and temporal. A Church that relates the temporal to eschatology and the spiritual to the whole mystery of Christ, rather than first and foremost to hierarchy, is a Church where Christians can relate to the world by virtue of the spiritual catholicity of their faith.**"[46]

§ 55 Relating the temporal to eschatology means relating it to the last step of the evolution in the universe, which would be the transformation of man into a kind of divinity. Relating the Church to the mystery of Christ would be relating her to a mysterious divine presence that would be immanent in each phase of the evolution, waiting to be released at the end of the process. A doctrine very similar to the one defended by Jesuit Teilhard de Chardin.

§ 56 Later, Congar commented on the omission of the concept of the State in *Gaudium et spes*. This represents, according to him, a deliberate change in the notion of the State:

"Here [in *Gaudium et spes*] as in all the conciliar documents, the word State is used often. **Much is said about rulers, but above all about the 'political (or civil) community.' The question has been relocated from the plane of relations between one authority and another, one structure and another, to the plane of relationships in the Christian Faith professed by the *Ecclesia* or the 'ecclesial community' (n. 44 § 3) and the community of men, the human family, or the human race. The spiritual-temporal problem here concerns the relations between the Faith and History, between the Gospel and civilization**

"**The Church recognizes the positive value and the autonomy of this world. She does not reduce it to the role of a simple means to get to heaven We have gone beyond the Middle Ages. It is no longer a matter of subordinating**

[45] About the concept of the Church as sacrament of salvation, see Vol. IX, *Creatio*, Chap. I.

[46] Y. Congar, *Église Catholique et France moderne*, pp. 230-32.

the temporal domain to the Church. It is a matter of refer-ring it to eschatology."[47]

According to this new conception of Church-State rela-tions, one could say that the State as well as the Church have become undefined realities. The two entities, however, should join hands to reach the goal of the evolution of the human spe-cies.

§ 57 What Progressivism desires, then, referring to the spiri-tual sphere, is the disappearance of the institutional unity of the Church and her characteristic boundaries. In place of a two-thousand-year institution it would establish an undefined real-ity formed by small autonomous groups without a central authority.[48]

§ 58 As for its plans for the temporal sphere, one can see that something similar seems prepared in relation to the State. Its normal structure should be replaced by self-managed groups and its borders would become porous.

§ 59 A State concerned about a "divine evolution," a Church concerned about resolving secular problems represents a mu-tual invasion of the respective spheres, apparently tending to-ward a complete erosion of one into another.

§ 60 Since Vatican II, Catholics have been presented with the ambiguous notion of the Church as "sacrament of salvation of the world." The principle by which the Church only has the right to intervene in the State *ratione peccati* [for reason of sin] is being abandoned, as the Church embraces social issues and involves herself in programs promoting the temporal goals. Who can predict how far the new Church will go in intervening in temporal matters that were exclusive concerns of the State before Vatican II?

What one is witnessing in fact is a mixture of Church and State. The Church mixed with the State; the State mingling with the Church. Yet another ominous result of the conceptions implied in the ambiguity of Vatican II. This miry mix of Church and State emerges as a final goal... And a new theoc-

[47] Y. Congar, "Le rôle de l'Église dans le monde de ce temps," V.A., *L'Église dans le monde de ce temps* (Paris: Cerf, 1967), vol. 1, pp. 313-4.
[48] Vol. IV, *Animus delendi I*, Chap. IV, §§ 235-253; Chap. VII, §§ 17-25.

racy seems to be born, attributing to itself the combined mission of Church and State.

These hypotheses, wakened by the consideration of the texts of Congar, an important representative of Progressivism, will be confirmed below.[49]

3. Progressivism Contests both the Catholic State and the Modern State

Item A will examine first and primarily progressivist critiques of the Catholic State and its eulogies of the Modern State – both opposed to the perennial teaching of the Church. Afterward, Item B will show that the progressivist current is also making critiques of the Modern State.

A. Discrepancies with the Catholic State and Affinities with the Modern State

§ 61 Cardinal Congar described how the modern mind conceives of the Church and the State. He also explained how this spirit has changed the Church-State relationship: "**Instead of a departure point from on high,** from sacred objects and **from principles of hierarchy, the modern spirit starts from the individual person, from the autonomy of conscience. Religion is for the modern man** not only a personal matter, but, as a mystical conviction, it is **a private matter.**

"It is inevitable and normal, however, that believers of the same religion should gather together to profess and practice the worship of this religion. That assembly of worship is the Church. **Church and worship** thus take place in the public domain. With this, they **make themselves realities of the social or national life, regulated by the power of the State. This same State,** moreover, **is no longer conceived of as an organization whose purpose is to lead men to their true end, but as the practical service of free individuals** with the duty of harmonizing the common or public activities of all, respecting the ideas of each one.

[49] See Item 5 of this Chapter.

"It is essentially this that the Popes have anathematized under the names of 'liberalism' and later 'laicism.' In effect, these doctrines negated all the efforts of the Papacy since at least the Gregorian reform."[50]

§ 62 Clemente Riva, Auxiliary Bishop of Rome, published a commentary on the Declaration *Dignitatis humanae* of Vatican II in collaboration with Cardinal Jerome Hammer. Msgr. Riva compared the text of the conciliar document to the article in the UN *Universal Declaration of Human Rights* that establishes religious liberty.[51] Doing this, he clearly endorsed errors in the UN article that had been combated by the pre-Conciliar Popes.[52]

§ 63 According to Riva, *Dignitatis humanae* not only accepted these errors, but even took them further. The Auxiliary Bishop of Rome praised the UN article, his only complaint being that it was not radical enough.

He affirmed: "**The text voted on by the UN regarding religious liberty is certainly less open than the Declaration of Vatican Council II.** Here is the compromise settled on between the two points of view [of the U.S. and Russia] reported above: Member States strive that 'Everyone has the right to freedom of thought, conscience, and religion. This right includes freedom to change his religion or belief in conformity with the dictates of his own conscience without being subject to any coercion that could prejudice his liberty of choice or adhesion in this matter.'

"**What is evident is the exclusion of any reference to religious communities, the promotion of conditions favorable to religious liberty, the abandonment to the discretionary power of the State to establish limits to such liberty, proper to a liberal conception of religious liberty. The conciliar Declaration is without a doubt clearer and more advanced.**"[53]

[50] Y. Congar, "L'ecclésiologie de la Révolution Française au Concile du Vatican, sous le signe de l'affirmation de l'autorité," V.A., *L'ecclésiologie au XIXe siècle* (Paris: Cerf, 1960), pp. 89-90.

[51] Articles 18-19.

[52] See Part I, Premise 1; in this Chap. V, §§ 39-49.

[53] Clemente Riva, "Esposizione e commento," V.A., *La libertà religiosa nel Vaticano II* (Turin: Elle Di Ci, 1967), pp. 206-7.

§ 64 The foundation for the conciliar document advocating religious liberty in the State, Riva claimed, is egalitarian, similar to that which served the Enlightenment as the base for establishing the Modern State. Riva commented: **"One of the first concerns of the conciliar document [*Dignitatis humanae*] was to add the duty of the State to provide a juridical equality effective for all**.

"Juridical equality of citizens belongs to the common good of society and is founded in the profound natural equality of the human person in all individuals. All men are sons of God and the image and likeness of God shines in them all. The essential basic rights are common to all men, equal for every individual. Hence they should be guaranteed by an equality before the law.

"Now then, **the civil power has the duty of 'ensuring that the juridical equality of citizens never be openly or obscurely prejudiced for religious reasons, and that no discriminations should be allowed.' That right is injured by any obstacle or any coercion that either does not permit the citizen to adhere to and profess a certain religion, or forces him to embrace a particular religion.**"[54]

§ 65 In the passage below, Clemente Riva clearly stated how the conciliar document demands that the State must give citizens a radical religious liberty because it adopts the principle that all creeds, even those that preach principles destructive to others, have the right to influence the temporal order:

"The right of religious liberty demands the liberty to express 'the specific capacity of each doctrine to order society and animate every human activity.' Each religion undoubtedly has a vision of the world, reality, and all the human values. For this reason, **no religious community must be prevented from demonstrating** (*ostendere sigularem virtutem*) **the capacity of its own doctrine to influence, advise, and organize social realities and the various human activities in an ever better fashion**

"An individual and communitarian religious testimony always influences the ambience in which it is developed. And the doctrines of a religious conception of man and the world can help men to resolve or shed light on a solution for human problems, especially the most serious ones that involve the

[54] *Ibid.*, p. 204.

whole human person, life, or the meaning and the supreme and ultimate value of any reality."[55]

§ 66 This demand presented by Riva is simply incoherent. Since each confession differs from the others for dogmatic and moral reasons, the various religious influences on the temporal order will necessarily be divergent, if not opposed. To admit conflicting influences over the State is to doom the secular order to chaos and ruin.

§ 67 Another similar summary of this same *Dignitatis humanae* was made by Hans Küng. What clearly appears is that the conciliar declaration is different from the former position of the Church and opposed to the Catholic State. He stated: "**The declaration on religious liberty consists of: a) Each one has the right to religious liberty b) Every religious community throughout the world has the right to free public exercise of its religion to erect its buildings of worship and to own material goods c) The society, State, and Church should defend and foster religious liberty.**"[56]

The documents transcribed in this Item seem sufficient to demonstrate the discrepancies of conciliar progressivist thinking about the Catholic State and its affinities with the Modern State.

B. Criticisms of the Modern State

§ 68 Soon after Vatican II, the Conciliar Church initiated a series of attacks against the Modern State by preaching against the structures of the Western Capitalist world and encouraging social reforms. The direct attacks were aimed at the Capitalist regime as a whole. The indirect attacks – opposition to the institution of private property and promotion of Socialist reforms – were trained against eroding the Western liberal system and introducing legal measures into its structures that would permit the advance of socialization.

[55] *Ibid.*, p. 193.

[56] H. Küng, *Veracidade*, p. 124.

a. Attacks against the structures of Western society

§ 69
 After Paul VI's visit to Medellin in 1968, the Council of Latin American Bishops (CELAM), representative of the different Bishops' Conferences of South and Central America, gathered in Colombia for what would become a very significant meeting for the progressivist Church. At Medellin, CELAM launched a final document with a clear directive to the Hierarchy and Clergy to distance themselves from the temporal establishment and join forces with the new efforts for liberation. The final document stated:

"This Conference recommends that the face of an authentically poor Church, missionary and paschal, **independent from every temporal power and courageously committed to the liberation of the whole man and of all men, should show herself with ever growing clarity in Latin America."**[57]

§ 70
 The same document stimulated structural reforms of a Socialist bent: "Without underestimating auxiliary forms of social action, **the pastoral of the Church should preferably orient these groups [of the socio-economic elites] to take part in programs for socio-economic structures that will lead to their necessary reforms.**

"Supporting and following up on her concern about social change, the Church should pay special attention to the active minorities (union and co-op leaders) **who are carrying out important works of conscientization and human development in rural and worker environments."**[58]

§ 71
 The CELAM Bishops explained why they wanted to cut their ties with the established powers: **"The Church should always maintain her independence from the established powers and the regimes that represent them.** If necessary, **she should renounce the legitimate forms of presence that,** due to the social context, **arouse suspicions of an alliance with the established power,** which, for this same reason, would be a pastoral counter-sign."[59]

[57] CELAM, *Conclusions of Medellín*, n. 5.15a.

[58] *Ibid.*, n. 7.19b.

[59] *Ibid.*, n. 7.21c.

§ 72 The defense of a change of structures in Latin America continued: "**The originality of the Christian message does not rely** directly on the affirmation of structural changes, but on the insistence that we must place **on the conversion of man, which demands this change immediately. We will not have a new Continent without new and renovated structures.**"[60]

§ 73 John Paul II approved these general critiques when he clearly stated during a visit to Brazil that he was opposed to the "structures of sin" of Capitalism. During his homily at a Mass in Belo Horizonte, he stated: "Open to the social dimensions of man, **you do not hide your will to radically transform the structures that present themselves as unjust in society.** You say, with reason, that it is impossible to be happy seeing so many of your brothers lacking the minimum opportunities for a human existence. **You also say that it is indecent that a few should squander what is lacking on the table of the rest.** You are resolved to construct a just, free, and prosperous society, where each and every one can enjoy the benefits of progress."[61]

§ 74 CELAM also clearly inveighed against the right of private property in a context critical of the Capitalist business system: "**The Latin American business system and, due to it, the present day economy, are products of an erroneous conception of the right of property as a means of production and the purpose of economy.** Business, in a truly human economy, is not identified with the owners of capital, because it is fundamentally a community of persons and unity of work that has need of capital for the production of goods."[62]

§ 75 At a meeting in Puebla, (1979), CELAM affirmed: "**The fear of Marxism prevents many from facing the oppressive reality of liberal Capitalism.** One can say that **in face of the danger of a system clearly marked by sin, people forget to denounce and combat the reality that is already implanted by another system equally marked by sin.** It is

[60] *Ibid.*, n. 1.3. For more on this topic, see Introduction, footnote 9d-k.

[61] John Paul II, Homily during the Mass in Belo Horizonte, July 1, 1980, *A palavra de João Paulo II no Brasil* (São Paulo: Paulinas, 1980), pp. 38-9; *Insegnamenti di Giovanni Paolo II*, vol. 3, 2, 1980, p. 7, n. 3.

[62] CELAM, *Conclusions of Medellín.*, n. 1.10.

necessary to pay attention to this, without losing sight of the historical atheist and violent forms of Marxism."[63]

§ 76 The Bishops returned to the attack against the "structures of sin": "We confirm ... the situation of inhuman poverty in which millions of Latin Americans live as being a most devastating and humiliating scourge Upon analyzing this situation more deeply, we discover that **this poverty is** not just one random stage, but rather **the product of determined situations and economic, social, and political structures**, even though there are also other causes of misery. **The internal situation of our countries** in many cases **finds its origin and support in mechanisms that,** because they are not imbued with authentic humanism but with materialism, **on the international level make the rich richer at the cost of the poor becoming increasingly poorer'** (John Paul II, 3, 3, AAS, 71, p. 201)."[64]

§ 77 At the Bishops' Synod in 1983 that dealt with the theme *Reconciliation and Penance*, strong critiques were issued against the sin of the structures, which would be the sin for which the West would need to do penance.

§ 78 In an interview published in *L'Osservatore Romano*, Cardinal Joseph Tomko, then-Secretary of the Synod of Bishops, used a well-known Marxist criterion to criticize "**the unjust distribution of world resources, and that type of structure by which the rich have become richer, and the poor, poorer.**"[65]

[63] *Ibid.*, n. 92.

[64] CELAM, *Puebla, 1979 – La evangelización en el presente y en el futuro de America Latina,* nn. 29, 30.

[65] a. Jozef Tomko, "Riconciliazione e penitenza," *L'Osservatore Romano*, December 1, 1983, Supplement, p. II.

b. The idea that a system based on the right of property and free initiative produces a rich who are getting richer, and a poor, poorer was expressed by John Paul II in the Opening Speech of his Pontificate (A. A. S. 1979, vol. 71, p. 201). He reaffirmed it for the *Puebla Document* (n. 30, p. 70), and here it was repeated by Cardinal Tomko. This phrase became the slogan for the followers of Liberation Theology, where it was employed with an indisputably Marxist connotation.

c. Therefore, according to the Marxist *plus-valia* theory (from the Latin: surplus value, which defends that the worker must be paid for

§ 79 At the same Synod, the Archbishop of Cuttack-Bhubaneswar, India, Henry D'Souza, took a clear-cut stand against Capitalism: "**'Structural' sin is a reality ... Asia is the victim of 'structural' sin**. Asia is a rich continent but has a poor population **Forces are in operation today that leave the Continent in a situation of exploitation**. The world commercial system, militarism, **multi-nationalism, and the international banking politics are forces that have led to Asia's poverty.**"[66]

§ 80 The Archbishop of Delhi, Angelo Fernandes, also advocated the establishment of a new international economic order different from Capitalism to remedy this "structural sin": "**The contemporary world economic crisis demands** a more equitable way to resolve human problems and specifically, **a new international economic order** **From this perspective, sin is viewed in its historical character, which is a good**

all the benefits his work gives to his employer), the owner of the means of production unjustly retains a part of the wealth generated by the worker, whom he pays only a subsistent level salary. From this came Karl Marx's saying that the worker produces someone else's wealth and his own misery (*Die heilige Familie*, Werke, vol.. 2, p. 37, *apud* Gustavo Solimeo – Luis Solimeo, *As CEBs... das quais muito se fala, pouco se conhece - A TFP as descreve como são - Comentários e documentação totais*, São Paulo: Vera Cruz, 1982, p. 39).

d. This would supposedly be an inescapable result of the Capitalist system based on private property. According to Marx, "every day it becomes clearer that the same relations that produce wealth also produce misery and they do not produce the rich bourgeoisie without also producing a proletariat whose numbers are always increasing" (K. Marx, *Das Elende der Philosophie*, Werke, vol. 4, p. 141, *apud ibid.*).

In *Capital* Marx insisted on the same idea: "All methods for the production of surplus-value are at the same time methods of accumulation It follows, therefore, that in proportion as capital accumulates, the lot of the worker, be his payment high or low, must grow worse It is this law that establishes a fatal correlation between the accumulation of capital and the accumulation of misery. At one pole, accumulation of wealth is, therefore, at the same time accumulation of misery, agony of toil, slavery, ignorance, brutality, and mental degration at the opposite pole" (*Le Capital*, I, 680, *apud* Kostas Papaionnou, *Marx et les marxistes*, Paris: Flammarion, 1972, p. 154).

[66] *L'Osservatore Romano*, October 7, 1983, Supplement, p. III.

**departure point for a *theology of the social structures of sin*.
The Synod must make these structures known** and issue a
prophetic invitation to return to the loving designs of God for
humanity."[67]

§ 81 Cardinal Aloisio Lorscheider, Archbishop of Fortaleza,
Brazil, considered the Western social structure anti-
evangelical: "The thing that prevents reconciliation and
penitence is the spirit and phenomenon of domination **The
Church should change her social position. She should place
herself firmly on the side of the poor, victims of a structur-
ally anti-evangelical system.**"[68]

§ 82 In the Encyclical *Sollicitudo rei socialis*, John Paul II
pointed to private initiative and free enterprise – qualified par-
tially as the all consuming desire for profit and the thirst for
power – as responsible for the "structures of sin." As a solution
he proposed the exercise of an egalitarian solidarity, very simi-
lar to Socialism:

**"'Sin' and 'structures of sin' are categories which
are seldom applied to the situation of the contemporary
world Among the actions and attitudes opposed to the
will of God, the good of neighbor, and the 'structures' cre-
ated by them, two are very typical: On the one hand, the
all-consuming desire for profit, and on the other, the thirst
for power, with the intention of imposing one's will upon
others**

"Obviously, not only individuals fall victim to this dou-
ble attitude of sin; nations and blocs [Capitalist and Commu-
nist] can do so also. And this favors even more the introduction
of the 'structures of sin' of which I have spoken. If certain
forms of modern 'imperialism' were considered in the light of
these moral criteria, we would see that **hidden behind certain
decisions, apparently inspired only by economics or poli-
tics, are real forms of idolatry: of money, ideology, class**

"The exercise of solidarity within each society is valid
when its members recognize one another as persons. **Those
who are more influential, because they have a greater share
of goods and common services,** should feel responsible for the
weaker and **should be ready to share all that they possess
with them. Those who are weaker,** for their part, in the same

[67] *L'Osservatore Romano*, October 3-4, 1983, Supplement, p. II.

[68] *L'Osservatore Romano*, October 5, 1983, Supplement, pp. I-II.

spirit of solidarity, **should not adopt a purely passive attitude or one that is destructive of the social fabric,** but claiming their legitimate rights, should do what they can for the good of all

"The same criterion is applied by analogy in international relationships. **Interdependence must be transformed into solidarity, based upon the principle that the goods of creation are meant for all. That which human industry produces through the processing of raw materials, with the contribution of work, must serve equally for the good of all.**

"Surmounting every type of imperialism and determination to preserve their own hegemony, the stronger and more gifted nations must have a sense of moral responsibility for the other nations, so that **a real international system may be established which will rest on the foundation of the equality of all peoples** (nn. 36-39)."[69]

§ 83 In a study showing the support of the Conciliar Church for the principles of liberation, Jesuit Tony Mifsud, Professor of Morals at the Catholic University of Chile, presented together and summarized principles of many official documents that preach the need to change the basic institutions of the Western world, qualified as "structures of sin." He stated:

"The world of ethics is opening to a profound social restlessness in the name of the marginalized. **It is not just a question of eliminating hunger and reducing poverty.** It is not just a question of fighting wretched conditions, although this is urgent and necessary. **It involves building a human community** where men can live truly human lives, free from discrimination because of race, religion, or nationality, **free from servitude to other men** or to natural forces, which they cannot dominate satisfactorily. It involves building **a human world** where liberty is not an idle word, **where the poor Lazarus can sit down with the rich man at the same banquet table.**[70] **This is the reality of the social dimension of sin.**[71],[72]

[69] John Paul II, *Sollicitudo rei socialis*, nn. 36-39, *L'Osservatore Romano*, February 20, 1988, Supplement, pp. VIII-IX.

[70] Paul VI, *Populorum progressio*, n. 47.

[71] Synod of 1971, n. 16; Paul VI, *Octogesima adveniens*, n. 45; John Paul II, *Evangelii nuntiandi*, nn. 18, 36; CELAM, *Puebla Message*, 358, 1134, 1155-1158.

§ 84
The Chilean scholar continued his exposition of official documents against the present day socio-economic structures: "Social restlessness translates into an effort of solidarity with the oppressed. **The tragic and sinful reality**, since everything that injures the dignity of man in some way wounds God himself,[73] **indicates to us both a solidarity *with* and a program *against*.**[74] That is to say, **solidarity with the oppressed implies fighting against injustice in the name of God** the Father. **This would be** not only a solidarity for, but **a solidarity with, which emphasizes the protagonist role of the oppressed in organizing, defending, and promoting himself so that he might sit and partake with equal right and dignity at the table of humanity.**

"Promoting the human should be our line of action in favor of the poor so as to respect his personal dignity and teach him to help himself.[75] With this, **the people, not the State, will become the interlocutor who contests the Church.**[76] **Choosing man and his dignity, the Church will denounce the systems of both Capitalist liberalism and Marxist collectivism,**[77] **warning that the fear of Marxism prevents many from facing the oppressive reality of liberal Capitalism** [78] **and the consumer mentality.**[79] **Thus it is necessary to foster the inalienable values of liberty and equality, which permit**

[72] Tony Mifsud, "Lo sviluppo di un'etica della liberazione nei documenti della Chiesa a partire dal Concilio Vaticano II," *Concilum,* February 1984, p. 99.

[73] *Puebla Message*, 3.

[74] *Ibid.*, 1154.

[75] *Medellín Document,* Poverty of the Church, 11; Peace, 27, Education, 8; *Puebla Message*, 135, 474, 1153, 1162, 1163, 1220; *Octogesima adveniens*, n. 43; Synod of 1971, 17, 54, 73.

[76] *Medellín Document,* Youth, 15, Pastoral of the elite; 21; *Puebla Message*, 144.

[77] *Puebla Message*, 1155, 1156, see also 311-313, 542-546; *Medellin Document*, Justice, 10; *Laborens exercens*, 13, 14

[78] These criticisms of Marxism (see footnote 28) do not serve to defend the Catholic State, or even the Modern State. They are meant to open the way for the establishment of a self-managing Neo-Socialism, more revolutionary than Communism itself. Further proof of this will unfold in this Chapter.

[79] *Puebla Message*, 314, 547-550.

a dignified participation in the political and economic spheres, without marginalizing social sectors that lack the opportunity to exercise the rights and duties proper to citizens.[80],[81]

§ 85 Even after the fall of the *Iron Curtain*, when Hungary began an economic recovery based on the Western model of private property and free initiative, John Paul II condemned the entrance of Capitalism into that country. In his speech to members of the Hungarian Bishops' Conference, the Pontiff affirmed:

"At present your country finds itself under the influence of a consumerist orientation that is imposing itself and threatening to break down traditional values. The danger exists of passing from one dependence to another, one no less opposed to authentic human advancement, with the tendency to prevent Christianity from duly fulfilling its irrevocable role of integrating Hungarian history and culture. **For this reason, I say with the Apostle: 'Be not held again under the yoke of bondage'** (Gal 5:1)."[82]

§ 86 At the 34th General Assembly of the Society of Jesus that took place in Rome in March 1995, one of the approved documents dealt specifically with the sin of the world and the "structures of sin" of the Western world. The supreme organ of the Jesuits thus pronounced:

"What we are beginning to understand is that **the sin of the world,** which Christ came to abolish, **is reaching its greatest intensity in our times because of the structures that exclude the poor** – the immense majority of the world population – **from participation in the blessings of God's creation. We are beginning to see that poverty, the consequence of oppressive structures, nurtures a systematic violence** against the dignity of men, women, children, and the unborn, **which cannot be tolerated** in the kingdom desired by God

[80] *Ibid.*, 62, 311, 435, 496, 834.

[81] *Synod of* 1971, 3, 9, 18; *Octagesima adveniens*, n. 22; *Medellín Document*, Justice, 7.16; *Puebla Message,* 327, 502.

[82] John Paul II, Speech to the Hungarian Bishops on his *ad limina* visit of January 28, 1993, *L'Osservatore Romano,* January 29, 1993.

"Pope John Paul II speaks of the invasive 'structures of sin,' characterized precisely by the 'all-consuming desire for profit and hunger for power.'"[83]

With this abundant documentation, one can see that it would be difficult to find another point more emphasized by post-conciliar social teaching – be it Episcopal or Pontifical – than the combat against the structures of the Western world. One might call it a kind of holy war.

b. Stimulating land reform in Latin America

§ 87 To achieve structural changes in the present-day Latin American regimes, CELAM preached the need for agrarian reform. This far-reaching institutional change aims at de-stabilizing the Modern State and installing a Socialist regime.

These were the words of the Bishops gathered in Medellin: **"Human advancement for the worker and indigenous populations will not be viable without taking into account an authentic and urgent reform of the structures and the agrarian policy."[84]**

§ 88 The application of agrarian reform in the Latin American countries would not have been possible without the support of John Paul II himself. Commenting on land reform in Ecuador, he said: **"I know that** for some years **now a land reform has been underway** in which the Church of Ecuador played a noteworthy part. **I want to encourage this praiseworthy initiative."[85]**

§ 89 During a trip to Colombia, the Pontiff again stimulated agrarian reform under the pretext of freeing the peasants from "exploitation by the large landowners." Directing himself to the workers at the Marian Sanctuary of Chiquinquirá, he stated: "By their dignity as persons and the work that they do, they **[the workers] deserve to be guaranteed legal forms of access to land ownership.** It is necessary to review those ob-

[83] 34th General Assembly, "Servidores de la Missión de Cristo," *Congregación General 34*, March 21, 1995 (Rome: Oficina de Prensa e Información), p. 4.

[84] *Medellin Document*, n. 1.14.

[85] John Paul II, Speech to the indigenous peoples of Latacunga, *L'Osservatore Romano*, January 31, 1985, Supplement, p. XXVI.

jectively unjust situations to which many of them are often sub-
jected, **above all in the case of the rural workers who see
themselves obliged to cultivate the land of others and are
exploited by the large landowners.**"[86]

§ 90 It is not a loss of time to pause a moment at this pas-
sage, "workers who see themselves obliged to cultivate the
land of others and are exploited by the large landowners." John
Paul II seemed to lend support to the egalitarian goals of the
Socialists who never stop proclaiming that the land should be-
long to those who work it. From this perspective, the system of
salaried workers would be unjust and opposed to human dig-
nity. Hence a worker who depends on his employer for a living
would be a man subject to a humiliating servitude and an intol-
erable "exploitation."

Now then, according to the social doctrine of the Catho-
lic Church traditionally taught by the Popes, the salary system
is just in itself, because it respects the legitimate rights of the
proprietor and the workers.

§ 91 In direct opposition to the thesis of John Paul II, one
can cite Pius XI in the Encyclical *Quadragesimo anno*, which
quotes arguments from *Rerum novarum* of Leo XIII. In fact,
Pius XI taught: "Those who declare that a contract of hiring
and being hired is unjust of its own nature, and hence a part-
nership-contract must take its place, are certainly in error and
gravely misrepresent our predecessor whose Encyclical not
only accepts working for wages or salaries but deals at some
length with its regulations in accordance with the rules of jus-
tice (n. 64)." [87]

§ 92 Pius XI also condemned the error of those who say that
it is "exploitation" not to pay the worker all the profit that his
work produces: "For they are greatly in error who do not hesi-
tate to spread the principle that labor is worth and must be paid
as much as its products are worth, and that consequently the
worker has the right to demand all that is produced through his
labor. How far this is from the truth is evident from what we

[86] Homily in John Paul II Park at Chiquinquirá, on July 3, 1986,
Mensajes de S.S. Juan Pablo II a los Colombianos (Bogotá: SPEC,
1986), p. 79.

[87] Pius XI, Encyclical *Quadragesimo anno*, *Doctrina Pontificia - III -
Documentos Sociales* (Madrid: BAC, 1959), pp. 725-6.

have already explained in treating of property and labor (n. 68)." [88]

§ 93 With this one sees that the exhortation of John Paul II did more than stimulate agrarian reform. It fostered class struggle and clashed profoundly with the previous Papal Magisterium.

§ 94 Directing himself to the farm workers in Bogotá, John Paul II again praised land reform: "**How many of you spend your lives in hard work in the fields** …. **without hope of obtaining the smallest piece of land of your own and without receiving the benefits of an audacious and effective land reform?**"[89]

§ 95 The "benefits of land reform…" One could ask what exactly are these benefits? In Communist countries the compulsory collectivization of the countryside only produced hunger and misery. In the free nations of the West, especially in Latin America, the results of land reform have resulted in a dizzying carousel of fiascoes, as in Mexico, El Salvador, Venezuela, Chile, Peru, Ecuador, and Bolivia.[90]

§ 96 In Brazil, attempts to force an agrarian reform have given the immediate fruit of transforming the supposed beneficiaries into slum-dwellers. The lands violently taken from the landlords and demagogically distributed among the workers

[88] *Ibid.*, p. 726.
Regarding the various objections of the agrarian reformers, as well as the unanimous and constant defense that the Popes have made of anti-egalitarian principles, see Plinio Corrêa de Oliveira, Archbishop Geraldo de Proença Sigaud, Bishop Antônio de Castro Mayer, and Luis Mendonça de Freitas, *Reforma Agrária - Questão de Consciência* (São Paulo: Vera Cruz, 1960), pp. 62-106.

[89] John Paul II, Speech in El Tunal Park on July 3, 1986, *Mensajes de S.S. Juan Pablo II a los Colombianos*, p. 91.

[90] The cases are fully demonstrated in Carlos Patricio Del Campo, *A Reforma Agrária socialista e confiscatória - Considerações econômicas* (São Paulo: Vera Cruz, 1985); Plinio Corrêa de Oliveira, *A Reforma Agrária socialista e confiscatória - A propriedade privada e a livre iniciativa, no tufão agro-reformista* (São Paulo: Vera Cruz, 1985), pp. 139-45; Carlos Patricio Del Campo, *Is Brazil sliding toward the extreme left? - Notes on the Land Reform Program in South America's largest and most populous Country* (New York: American Society for the Defense of Tradition, Family and Property, 1986), pp. 113-18.

were soon transformed into *countryside-favelas*. Instead of the promised progress what happened was a multiplication of misery.[91]

§ 97 In 1986 John Paul II received the President of Brazil, José Sarney, in Rome. In a homily delivered before the President, the Pontiff again advocated land reform. Such a reform was even demanded, according to him, by the challenges of poverty and economic imbalances: "Let us pray for all Brazil... that solidarity and social love, animated by charity, may lead to the remedy and prevention of situations of poverty and economic imbalances in this immense and beloved country In this moment of change, as in other times of impasse, may their good will and efforts work together to respond to the challenges facing the great Brazilian family **Let us implore that the initiatives and reforms that these challenges demand, such as land reform, be carried out with courage.**"[92]

§ 98 Visiting Bolivia, John Paul II made another strong attack against the proprietors and defended agrarian reform. Addressing the farm workers in Oruro, he said: "**With regard to land distribution, I know that Bolivia was one of the first Latin American countries to carry out a land reform that initially allowed many of you to acquire at least a small piece of property.** But the **drawbacks of a small property –** in an immense and sparsely populated territory – **and the existence of vast** *latifúndios* [large farms] **have continued to create serious problems** for farm workers. **They are very grave and well-known problems that demand bold solutions that will make justice prevail** The Church herself has always preached the just distribution of cultivatable lands in diverse forms and ways so as to give the farm workers the possibility of a dignified life." [93]

§ 99 During a week-long-conference of Latin American Missionaries in the city of Salvador (Brazil) in January 1990, ecclesiastical representatives from various countries issued this statement in their final document:

[91] See Atilio Guilherme Faoro, *Reforma Agrária: 'terra prometida', favela rural ou 'kolkhozes'? Mistério que a TFP desvenda* (São Paulo: Vera Cruz, 1987), 174 pp.

[92] Marcio Braga, "Papa diz a Sarney que reforma agrária não pode fracassar,"*Jornal do Brasil*, July 11, 1986.

[93] *L'Osservatore Romano*, May 13, 1988, p. 6.

"We are facing grave situations of social injustice such as the exploitation of millions of persons by a part of the *First World* (including Europe and Italy) which creates and defends structures of oppression. **The principal cause for this situation of poverty is the unjust social-political system that provokes an incalculable series of other evils, among them the *latifúndio* [large farm], which, in the name of the absolute right of private property, expels the poor from the land,** depriving them of work, housing, dignity, and a future, creating the agglomeration of millions of persons on the outskirts of the cities. **For this reason, agrarian reform is an absolute priority for our peoples.**"[94]

§ 100 On a visit to the city of St. Luiz (State of Maranhão, Brazil), John Paul pronounced these words supporting land reform in the homily of the Mass he celebrated there: "It is a matter of distributing properties that are insufficiently cultivated to those who can make them productive. In this sense, **land ownership becomes illegitimate when the land is not improved or when it impedes others from working it. Rather, its aim is to make a profit that does not come from the global expansion of human work and social wealth, but from repression, illicit exploitation, speculation, and a rupture of solidarity in the world of labor.**

"From this point of view, **one can speak of the high concentration of land ownership in a few hands in Brazil, a situation that demands a just land reform. This kind of property holding cannot be justified, and constitutes an abuse before God and men.**"[95]

§ 101 In January 1996, the 6th National Conference of the Clergy took place in Itaici (State of São Paulo, Brazil), where 428 priests met for six days. There they approved a motion of solidarity for the landless, and in particular for the MST (*Movimento dos Sem-Terra* – Movement for the Landless), linked to the Pastoral Land Commission, an official organ of the Brazilian Episcopate.

[94] Conference of Latin American Missionaries, Final Document, *apud* Verona Fedele, *La sfida di Salvador – Il camino della Chiesa in America Latina, Il Regno*, December 30, 1990.

[95] John Paul II, Homily of October 14, 1991, *apud O Estado de São Paulo*, "Pontífice defende reforma agrária," October 15, 1991; Walter Falceta, "Homilía faz defesa da reforma agrária," *ibid.*

Even though it included a theoretical condemnation of violence, this motion was made at the moment when the land invasions in Brazil were reaching a climax of violence. In fact, the next months saw the MST stimulating, with ecclesiastical support, land invasions that frequently involved bloodshed.[96]

§ 102 The news item of the meeting of priests was reported by a São Paulo daily newspaper: **"The priests,** who speak in the name of the National Commission of Clergy, subordinate to the Conference of Brazilian Bishops, **urgently demand land reform** and a just agricultural policy. **The struggle for land, they affirm, is just** 'We repudiate all violence and injustice in the land and **we reaffirm our promise of support for the just fight for land reform.'"**[97]

§ 103 In March of 1996, John Paul II again affirmed his support, basing himself on the new conciliar social doctrine of the Church: "The land problem has become a permanent concern of the Brazilian Episcopate in the last decades. **The principle of the universal destination of goods, especially of land, is fundamental in the social doctrine of the Church.**"[98]

§ 104 Further in his talk, the Pontiff repeated his critique of owners of unproductive lands: **"It is necessary to say that land ownership becomes illegitimate when the land is not improved or when it impedes others from working it. Rather, its aim is to make a profit that does not come from the global expansion of human work and social wealth.**"[99]

§ 105 One month after this papal pronouncement, the Cardinal-Primate of Brazil, Lucas Moreira Neves, intervened in the Brazilian plenary election to lobby for land reform. A news item reported: "The president of the National Conference of Brazilian Bishops [NCBB], **Cardinal Lucas Moreira Neves, stated** yesterday that **the Church would instruct her faithful**

[96] Pictures of those invasions can be found in *Previews of the New Papacy* by A.S. Guimarães and M.T. Horvat, pp.123-32.

[97] José Maria Mayrink, "Padres aprovam moção em defesa dos sem-terra," *Jornal do Brasil*, February 7, 1996.

[98] John Paul II, Speech to the Brazilian Bishops in the Southern Region-1, on March 21, 1996, published under the title "Discurso do Papa dirigido a Bispos paulistas," *O Estado de São Paulo*, March 22, 1996.

[99] *Ibid.*; see also Hugo Marques – Isabel de Paula, "Papa apoia denúncia de corrupção no Brasil," *O Globo*, March 22, 1995.

to vote in the next elections for candidates who support land reform and other social programs The statement of Cardinal Lucas officially marks the beginning of a more politicized action of the NCBB."[100]

§ 106 The NCBB lost no opportunity to accelerate the implementation of agrarian reform. This news item reflects their policy bent: "Yesterday **the National Conference of Brazilian Bishops (NCBB) rallied the government to greater courage in carrying out land reform. And it called on the Congress to take more responsibility and move quickly to vote for the program that would accelerate the process of re-appropriating farm lands.** The critiques to the government were made at the request of the NCBB Social Pastoral, Bishop Demetrius Valentine, and the statements directed to the Congress came from the president of NCBB himself, Cardinal Lucas Moreira Neves."[101]

§ 107 Thus have the Pontiff and Prelates attacked the regime of rural private property in Latin America, a primarily agricultural continent. Doing this, the religious authorities have fostered the establishment of Socialist structures, which necessarily generate greater hunger and more marked misery among the people.

§ 108 The road of these reforms often led to violence, which has also found the support of high Prelates. Cardinal Joseph Ratzinger confirmed this:

"**Catholic social doctrine** does not acknowledge the utopia, but develops some models, within a certain historical situation, to achieve the organization of human affairs in the best possible way. For this, it also rejects the myth of revolution and **tries to find the road of reforms, without completely excluding the road of violent resistance in extreme situations**, refusing, however, to accept revolution as a *deus ex machina* [an automatic solution], from which some day the new man and the new society would inexplicably result."[102]

[100] *O Globo*, "CNBB pedirá votos para quem apoie a reforma agrária," April 27, 1996.

[101] *O Globo*, "Igreja Católica cobra coragem do governo," June 28, 1996.

[102] Joseph Ratzinger, "Liberdade e libertação," *Atualização*, Belo Horizonte (Brazil), September- October 1986, pp. 425-6.

What are these extreme situations when the road of re-
form can apply violence? Cardinal Ratzinger did not explain.
Or, rather, he left the door open for the revolution to enter, de-
spite his half-hearted denial.

This theme of social revolution introduces the next
Item.

c. Stimulating social revolution

§ 109 Along with the vast list of authors and documents that
directly or indirectly combat the social-political-economic
structures of the Western world, there are many theologians
who have taken the combat against the Modern State even fur-
ther.

§ 110 Enumerating factors behind the Church's change of po-
sition regarding the temporal order, Yves Congar manifested
his support for movements that preach revolution: "In the same
general context, **it is also necessary to allow room for cri-
tique of certain ideas and behaviors of past centuries,** above
all the 19th century. **These would include an overly simple
justification of economic and social inequalities, a steady
support for things favoring the established order that were
often used to maintain privileges at the cost of oppressing
the little people**, and, finally, **the generally weak interest
shown for** human advancement, liberty, and **the struggle
against injustices**

"**We would like to unburden ourselves of so many of
these flaws of yesterday's Catholicism. In the conversion of
so many Christians to revolution today, isn't there the de-
sire to make up for what happened in the past or, more re-
cently, for what was not done for the Jews?** We envy Bon-
hoeffer and Camilo Torres.[103] **In the end we want to be on the
side of good: their side.**

"**These movements were nurtured by a lucid critical
development of the basic conditions,** not only **of our options,
but also of our capacity to understand. They were nurtured
by our economic, social, and cultural situation.** 'Each one

[103] Dietrich Bonhoeffer, a Protestant pastor, died in a Nazi concentra-
tion camp. Camilo Torres, a Communist guerrilla priest, died in com-
bat against the government forces of Colombia.

has the theology that corresponds to his own way of life.' This was expounded in Karl Mannhein's 'sociology of knowledge' with a Marxist bend, and by P.A. Sorokin who followed a more 'idealistic' inspiration

"**We can find a more eloquent illustration of this [sociology of knowledge] in Latin American liberation theologians, a Hugo Assmann, a Gustavo Gutiérrez, a Joseph Comblin.** They show that the revolutionary *praxis*, that is, a solidarity of living and thinking with the oppressed, **and an active engagement in the liberating action, constitute the *place* from which, in which, and thanks to which, a valid Liberation Theology can be elaborated. If, therefore, temporal liberation depends on salvation, then we are involved in it.**"[104]

§ 111 Invoking the authority of *Gaudium et spes*, Fr. Chenu made a general defense of contestation: "**The whole matter of contestation, when it is extended to all levels, to thought as well as institutions, where even man himself is called into question, can appear disconcerting.** But in these efforts **the overall picture is one filled with hope** to the degree that its theology finds salvation, vigor, lucidity, and happiness in the fundamental discernment of the signs of the Spirit. For this [God's] Spirit, as the Council says, 'which directs the unfolding of time and renews the face of the earth, is not absent from this development' (*Gaudium et spes*, 26)."[105]

§ 112 Hans Küng tried to justify the Conciliar Church's contestation of the Modern State: "**How could [the Church] commit** herself unconditionally and without any criteria **to a** certain **economic, social, cultural, political, or philosophical system or vision of the world? Shouldn't her revolutionary message perchance cause disquiet and shock? And call into question the existing powers and systems of the world, and thus expose herself precisely to their attacks and resistance?**"[106]

§ 113 In another work, Küng focused the hope of resurrection under an intensely revolutionary light: "**Hope in resurrection,**

[104] Y. Congar, *Un peuple messianique*, pp. 151-2.

[105] Mare-Dominique Chenu, "Omelia tenuta nel corso della celebrazione eucaristica [from the Congress of the Council of Brussels]," V.A., *L'avvenire della Chiesa*, p. 65.

[106] H. Küng, *Veracidade*, p. 29.

resurrection from the dead, thus **constitutes the critical coun-
terpoint of a society marked by death, in which 'lords'** –
both great and small, secular and religious – **can exploit their
'slaves'** with impunity. This is because these 'lords' set them-
selves up as the authority, norm, and truth on earth so that al-
most no higher form of justice in practice exists for them
**Hope of resurrection denounces this kind of justice and
sows a critical, liberating unrest among men. It destabilizes
situations of dominion,** which here and there are held to be
definitive, **and makes new relations of mutual service arise,
in the full sense, where only he who 'humbles himself will
be exalted.'"**[107]

§ 114 Fr. Johann Baptist Metz, father of European Political
Theology and precursor of Latin American Liberation Theol-
ogy, was very clear about the need to finish with the Western
political structures: **"How can a revision that touches the
spiritual foundation of bourgeois life be made? I only see
one way: the way that passes through the complete reorien-
tation of the universal Church, all of society, and world
politics."**[108]

§ 115 Metz defended subverting the established order, which
he presented as being the mission of the Church: "I want to lay
this thesis as the theological foundation for our topic: **the
Church must understand herself and show herself as a pub-
lic witness that transmits a** *subversive memory of liberty*
**through the 'systems' of our society turned toward
emancipation."**[109]

§ 116 Further on, he continued: **"This** *memory of Jesus
Christ* **is not one that falsely dispenses one from the audac-
ities of the future. It does not present itself as a type of
bourgeois counter-image of hope.** On the contrary, it is real-
ized in an anticipation of the future, a future for the hopeless,
the failures, and the oppressed. Thus does **she [the Church]
reveal herself as a** *subversive and liberating memory*, **which
threatens and calls into question our times."**[110]

[107] H. Küng, *Vida eterna?* (Madrid: Cristiandad, 1983), p. 199.

[108] Johann Baptist Metz, *Mas allá de la religión burguesa* (Sala-
manca: Sígueme, 1982), p. 18.

[109] J.B. Metz, "Sulla presenza della Chiesa nella società," V.A.,
L'avvenire della Chiesa, p. 132.

[110] *Ibid.*

§ 117 Fr. Luiz Maldonado, professor at the University of Salamanca, summarized the thinking of Metz: **"In his 1972 essays about the *memory of passion*, Metz sought to show that this has a singular function: to liberate us from society and the scientific, technological, and technocratic world that increasingly stifles and mutilates us; to liberate us also from a logical-dialectical thinking that threatens us with new absolutisms."**[111]

§ 118 Fr. Alfonso Garcia Rubio pointed to what the liberation theologians expect from the Hierarchy in the march toward Communism: **"What does Liberation Theology want from the Church Hierarchy? That it effectively remove itself from an inoperative system and admit within itself clearly revolutionary options In the great majority of Latin American countries this would naturally mean a political option for the left, an option that opposes the dominant system, considered oppressing and anti-human."**[112]

These are samples of the progressivists' hostility toward the Modern State. This current of thinking in effect preaches its eradication by means of revolution.

4. Progressivist support for Socialism and Communism

§ 119 Who have been the chief beneficiaries of the progressivist combat against the Western civil structures composed of remnants of the old Catholic State along with much of the Modern State born in 1789? None other than the followers of Socialism and Communism. The maneuver of conciliar secularization, as the Reader has noted, follows the lines of Socialist and Communist ideas. In practice, progressivists, Socialists, and Communists form a common front as "fellow travelers," vigorously fighting against both the Christendom of the past and the Modern State of the present.

[111] Luis Maldonado, *La violencia de lo sagrado* (Salamanca: Sígueme, 1974), p. 280.

[112] Alfonso Garcia Rubio, *Teologia da Libertação: Política ou Profetismo?* (São Paulo: Loyola, 1977), p. 31, *apud* G. A. Solimeo and L. S. Solimeo, *As CEBs... das quais muito se fala, pouco se conhece*, part II, p. 156.

§ 120 In addition to their united fight against Capitalism, these progressivists, Socialists, and Communists share many other affinities in their philosophical, political, and social thinking. They also converge in certain methods of action. Item 4 will examine these points.

A. Support for Marxist philosophy

§ 121 In 1993, John Paul II affirmed that the social doctrine of the Church was the soul of Marxism – a statement certainly contrary to the former Pontifical Magisterium.[113] In the city of Riga, Latvia, he made this praise of Marxism: "The conditions that gave rise historically to this system [Marxism] were very real and serious. **The system of exploitation, to which an inhuman Capitalism had submitted the proletariat since the beginning of the industrial revolution, represented a true iniquity that the social doctrine of the Church openly condemned. At depth the latter was the *soul of truth* of Marxism, thanks to which it can present itself in a fascinating way in Western societies themselves."[114]**

§ 122 Not a few commentators favorable to John Paul II have considered him Socialist. Such is the case of Fr. João Batista Libânio, professor at the Center of Higher Studies of the Company of Jesus. These words of the Jesuit scholar are particularly expressive: **"From the aspect of social doctrine, John Paul II is the most *avant-garde* Pope of History. An attentive reading of the Encyclical *Laborem exercens* of 1981 reveals that the Pope defends types of socialization of the means of production on a Socialist basis."[115]**

§ 123 On points of affinity between progressivists and Marxists, Fr. Hans Küng presented this concise and eloquent paragraph: **"A Marxist will answer the question 'What do you**

[113] See Vol. I, *In the Murky Waters of Vatican II*, Chap. I, footnote 14.

[114] John Paul II, Speech to the academic and cultural world representatives, in *Riga*, September 9, 1993, published under the title "La dottrina sociale della Chiesa indica i principi che devono orientare una società degna dell'uomo," *L'Osservatore Romano*, September 11, 1993.

[115] João Batista Libânio, "Teólogo condena falta de democracia na Igreja," interview by Roldão de Arruda, *O Estado de São Paulo*, April 21, 1996.

want?' with various responses: the world revolution, the dictatorship of the proletariat, the new man, the classless society. The Christian can also respond in diverse ways: faith and conversion, justification, liberty, love, life in the Spirit, **the new man, the kingdom of God. Although varied responses are given in both Marxism and Christianity nonetheless, the message, the plan, the final goal,** in short, **the reality at stake, is** *the same.* **To be authentic, the different responses must thus reflect the same message, the same plan, the same reality."**[116]

§ 124 Cardinal Henri de Lubac, so close to John Paul II,[117] expressed his enthusiasm for the goals of Marxism and their possibility of being projected onto metaphysics. In one of his works, he wrote: **"The myth that Marx conceived is certainly grandiose Although he is Socialist, Marx is not a utopist.** He was the first to break with the old tradition of the 'Utopias' [a non existent place] and the 'Ucronias' [a non existent time] that obstructed the Socialist movement in its beginnings **Because of this, some conclude with all sincerity that the faithful can adopt Marxism entirely, with the condition of projecting it,** should it be the case, **onto the plane of metaphysics."**[118]

§ 125 A revealing commentary about a possible convergence between the "absolute" of the progressivists and the "absolute future" of the Marxists was made by Fr. Schoonenberg, S.J., professor of Dogma at the University of Nijmegen. He proposed that Catholics reflect on changing the notion of God to facilitate dialogue with the Marxists: **"In this kind of ecumenism [that is, a Christian and universal dialogue about belief**

[116] H. Küng, "Qual è il messaggio cristiano?," V.A., *L'avvenire della Chiesa*, pp. 114-15.

[117] De Lubac wrote the preface to one of the editions of *Love and Responsibility* by Karol Wojtyla, then Archbishop of Krakow. In 1983 John Paul II repaid the favor giving to de Lubac the Cardinal's hat. One sees their high esteem for each other.

[118] a. Henri de Lubac, *L'idée chrétienne de l'homme et la recherche d'un homme nouveau* (Liège: La Penseé Catholique, 1948), pp. 32-3.

b. Further on, de Lubac made a weak criticism of the "absolute" of Marxism, which, according to him, despite its similarity to the Absolute that Christians believe in, would be at the same time antagonistic.

in eternal life], we begin by asking the meaning of the fact that God is the one who gives us hope (which implies reflection on the meaning and the idea that we have of 'God'). This is also the foundation for dialogue with the Marxists, for whom the notion of an 'absolute future' plays a important role."[119]

§ 126 Cardinal de Lubac praised Marxism for its merit in finding a complete solution for man: "The Marxist idea of man and his destiny. It is worthwhile for us to pause a moment here because, **more than any other contemporary doctrine, Marxism tries to take on this 'new man'** **More than any other, Marxism views itself as heir to every scientific and social movement of these last centuries. More than any other, it also understands how to frame the problem of man in its entirety and how to find a total solution for it.**"[120]

§ 127 De Lubac praised Marx in the same breath with Freud: **"There is certainly much that is true in the psychoanalysis of a Marx or a Freud, to cite only two great parallel examples** **One of the signs of a mature mind is precisely the fact of renouncing mystical fantasies and false transcendencies.**"[121]

§ 128 Cardinal Urs von Balthasar also described affinities between personalism, the basis of progressivist doctrine,[122] and the doctrine of Marx and Feuerbach[123]:

[119] Piet Schoonenberg, "Creio na vida eterna," *Concilium,* 1969/1, p. 88.

[120] H. de Lubac, *L'idée chrétienne de l'homme,* p. 28.

[121] *Ibid.,* p. 24.

[122] For more on personalism as the basis for progressivist doctrine, see Vol. VII, *Destructio Dei,* Chap. IV.3.C.

[123] a. In his work *The Essence of Christianity* (1841), Ludwig Feuerbach, a 19th-century atheist philosopher, defended the notion that God was only an idea, a mirror image of human essence itself. God would be nothing more than a projection of man. Feuerbach wrote: "The absolute essence, the God of man, is his own essence. And, consequently, the power of the object [God] over him [man] is simply the power of man's own essence (L. Feuerbach, *Das Wesen des Christentums,* Berlin: W. Schuffenbauer, 1956, p. 51, *apud* H. Kúng, *Vida eterna?,* p. 57).

b. Based on Feuerbach's theory, Marx affirmed that religion would be the "opium of the people." Friedrich Engels, the one who put in order

"Only in love for others, only in leaving the sphere of the 'I' and passing to the sphere of the 'you' **does man find the road that leads from man to humanity. This is the departure point for Marx as well as religious personalists and Socialists (Christian or not) of the 20**[th] **century**: Ferdinand Ebner, Martin Buber, Leonhard Ragaz. **Man is fully realized and only becomes himself in this encounter. In this event the truth reveals itself and manifests itself** spontaneously, freely, gratuitously, **in the depths of man's being, which is so abyssal that Feuerbach, and after him, Scheler, equate it with the divine."**[124]

§ 129 Affinities between Progressivism and the thinking of Marx were pointed out by Fr. Metz: **"In its emphasis on the 'creative' character of Christian hope, the development of a creative eschatology can possibly lead to an easy association** with Prometheus or **with the young Marx."**[125]

These quotes give the Reader a sample of the bad orientation of Progressivism. Without material like this, it is difficult to realize the affinities between the two systems of thought – Progressivism and Marxism.

§ 130 The naïve objection that Marxism is atheist and therefore could not be accepted by progressivists, who profess belief in God, is unfounded. Since Progressivism and Marxism both believe in a universal evolution, the entire evolutionary process is accepted by both without problems. The discussion of the existence of God for both is related to one single point. Progressivists think that God is the end of evolution, because God is immanent in all creation, and the end of evolution is the "lib-

the confused thinking of Marx, attested to the great influence that Feuerbach exercised over Marx: "Then Feuerbach's *The Essence of Christianity* appeared One would need to have personally experienced the liberating effects of this book to be able to have an idea of this. The enthusiasm was general: we were all Feuerbachians. Marx's book *The Second Family* reflects how enthusiastically he greeted this new concept and how much he was influenced by it" (F. Engels, *Feuerbach und der Ausgang der Klassischen deutschen Philosophie*, in *Marx-Engels Werke*, Berlin, 1962, vol. 21, p. 272, *apud ibid.*, pp. 55-6).

[124] H. U. von Balthasar, *Solo l'amore è credibile* (Turin: Borla, 1965), pp. 45-6.

[125] J. B. Metz, "La 'teologia politica' in discussione," V.A., *Dibattito sulla 'teologia politica'* (Brescia: Queriniana, 1972), p. 268.

eration" of the divinity in creation. They say that the Marxists, who admit the same evolutionary process, fail to describe what will come at the end of the process, which they vaguely designate as the "future." If Marxists would make this final point explicit, they would realize that their "future" is none other than what the progressivists call God. Therefore, the critique of atheism presented to make Progressivism appear different from Marxism is reduced to a mere question of words.

B. Support for the political-social struggles of the Communists

§ 131 Along with the *la politique de la main tendue* [the extended hand policy], the Communist maneuver launched in France by Maurice Thorez in 1936, the progressivists of that time supported a front that brought together Catholics and Communists who shared "common ground."[126] With this policy, progressivists and Communists would work together on innumerable concrete occasions and in various far-ranging maneuvers.[127]

[126] André Moine, a French Communist writer, recalled the origins of the "dialogue" that exists today between progressivists and Communists in his country. In the pages of *L'Humanité,* he affirmed: "It is well known that in 1936 the appeal of Maurice Thorez for '*la main tendue*' [the extended hand] was a bold turnaround that broke with the fundamental anticlericalism of the worker movement. In 1937 Thorez made this policy explicit and broadened his thinking. He opened a new way by showing the positive sides of the social encyclicals. Pointing to the historical values offered by Christianity, he integrated the worker movement with these values, such as charity, giving it a progressivist meaning. The character of 'religion as opium of the people' was relativized" ("Échanges avec un croyant - De la main tendue au dialogue en vérité," *L'Humanité,* April 26, 1983).

[127] a. In the book-interview, Fr. Chenu chronicled the collaboration of Catholics in France with the Communists since the time of the rise of the *Popular Front* (1936) until the beginning of the 1950s. He told how a group of progressivist priests, the Dominicans of Juvisy, had launched the Catholic periodical *Sept* in 1934. Chenu continued to detail the process of collaboration:

"This weekly [*Sept*] had an extraordinary impact on public opinion. We soon fell under suspicion The year 1935 arrived, and the *Popular Front* was raising fear, almost panic, even among the Chris-

tian people: Communism appeared suddenly as a monstrous phenomenon that would destroy the Church. One day, Cardinal Verdier, Archbishop of Paris, published a short open letter to the popular movement. This was the time when the *Jocists* (members of JOC, a Catholic workers youth movement) were participating in factory sit-ins. After first informing the Cardinal, we, at *Sept*, resolved to interview [the Socialist first minister] Léon Blum to ask him how he viewed relations with the Christians, because some Catholics were working with him. This was done. Blum's response was sympathetic. But, on the Catholic side, what indignation!

b. "In 1937 an order from Rome came [for the periodical] to close. We decided to continue, but to change the name. The subtitle of *Sept* was *Hebdomadaire duTemps Présent* [Weekly magazine of the present times], so we gave the new paper the title of *Temps Présent* and passed the initiative to laymen. Jacques Maritain and Stanislas Fumet took charge. We were present and in communion with them, obviously. This procedure became routine: when the clergy became too involved, they were asked to retire and cede place to laymen so that the initiative might be independent, administratively and financially, from organisms of the Church

c. "In 1944 *Masses Ouvrières* [Worker Masses] appeared, prepared by Fr. Bouche, the famous worker-priest and chaplain of JOC This magazine expressed the coming of age of the *Jocists*. The small committee that directed the operation was invited to participate It was precisely at this time that my teaching came under suspicion in the Church. I was linked to the small groups of the epoch, the worker basic communities, and maintained a dialogue with these popular cells

"There was also *Économie et Humanisme* [Economy and Humanism], founded in 1941 by Fr. Lebret You know the influence that he had and how Lebret inspired the writing of the Encyclical of Paul VI on development [*Populorum progressio*] It was Fr. Lebret who prepared me to understand the revolutionary reach, including in Christianity, of the economic and political emancipation of the new nations

"The year 1945 saw the launching of *La Vie Catholique* by Georges Hourdin and collaborators of *Sept* and *Temps Présent* I was also at home there There were Fr. Boisselot, Mme. Sauvageot (a long-time militant radical Socialist who had converted to Catholicism and had become a prominent entrepreneur of the French Catholic press), and the team's main column, Joseph Folliet There was also Hubert Beuve-Mérry (director of *Le Monde*, who in 1945 wrote that 'the Slavic hour – that is, the Soviet hour – will tone in the time clock of History'), who I met in 1925. He made up part of a group of

§ 132 The most symbolic of these was the well-known politi-
cal strategy of the Italian Christian Democratic Party (CDP),
notably of its leaders Giorgio La Pira and Amintore Fanfani,
whereby Catholics marched in step politically with Commu-
nists as "fellow travelers." In 1946 the ties became official

writers, intellectuals, and publishers animated by Fr. Janvier"
(*Jacques Duquesne interroge le Père Chenu*, pp. 87-91).

d. After referring to the liturgical magazine *Maison-Dieu*, Chenu men-
tioned *La Quinzaine*, a bulletin founded in November 1950 under the
direction of Madame Sauvageot with the objective of taking this col-
laboration with the Communists as far as possible:

"In a certain sense, one can say that it [*La Quinzaine*] continued the
previous *Temps Présent*, which was re-launched after the war only
to disappear in 1946 for lack of a public. But there were notable dif-
ferences. The team was much younger and the worker combat
had much greater density It had become conscious of the intoler-
able misery of the underdeveloped peoples. Above all, there was the
Cold War, accompanied by the great theme of the struggle for
peace. Another difference was that the team was more strongly
linked to popular movements, through the labor unions, the worker-
priests, etc. I published some articles in *La Quinzaine* signed 'Apos-
tolus', which tried to discern evangelical values in the most obscure
combats

"The three principal themes addressed by this bulletin – the workers'
combat, the struggle for peace, and de-colonization – provided occa-
sion for dialogue with Marxist theories and policies. The groundwork,
therefore, was laid. But Christian opinion on the whole was still not
entirely prepared" (*ibid.*, pp. 94-5).

e. In the political arena, there was the significant appearance of
Christian Democrat Francisque Gay and Communist Maurice Thorez
as simultaneous vice-presidents in the Cabinet of Charles de Gaulle
(Harvard de la Montagne, *Historia de la Democracia Cristiana – De
Lamennais à Georges Bidault*, Madrid: Ed. Tradicionalista, 1950, p.
254). In 1946 ten Communists held ministries in the coalition gov-
ernment under the presidency of Christian Democrat Georges Bi-
dault (*ibid.*, pp. 258-9).

f. About the collaboration of the French progressivists with Commu-
nism in the 1940s to mid 1950s, see the books of Jean Madiran, *Ils
ne savent pas ce qu'ils font* (Paris: Nouvelles Éditions Latines,
1952); *Ils ne savent pas ce qu'ils disent*, (Paris: Nouvelles Éditions
Latines, 1955); as well as the article of Cunha Alvarenga, "Eles não
sabem o que fazem - Maquinações que expõem a riscos e angústias
a causa católica," *Catolicismo*, December 1955, which comments on
the first book of Madiran cited above.

when the Italian CDP joined with the Italian Communist Party
(ICP) in a coalition government.[128]

[128] a. In 1946 Palmiro Togliatti (Italian Communist Party - ICP) be-
came the Minister of Justice in the government headed by Alcide de
Gasperi (Christian Democratic Party - CDP) (Francisco Leone, *La
storia dei Partiti Politici Italiani*, Naples: Guida Ed., 1971, p. 334).

b. Some noteworthy strategies of the Italian Christian Democrats'
collaboration with the Communists would include:

- The election of La Pira as prefect of Florence (1951-
 1958) and the "Catholic-Communism" policy that he devel-
 oped (Baget Bozzo, "A longa viagem da baleia branca," in-
 terview by Andrea Tornielli, *30 Dias*, July-August, 1993, p.
 54);

- The official adoption of the center-left position by the
 Christian Democrats at the Congress of Naples in 1962
 (*ibid.*, p. 55);

- In 1976, under the direction of Aldo Moro, the Italian Chris-
 tian Democrats joined the Communists to form a coalition
 government (Giulio Andreotti, "A arte de mediar," interview
 by Gianni Valente, *30 Dias*, July-August 1993, p. 49; Baget
 Bozzo, *op. cit.*, p. 51).

c. In Italy the progressivist-Communist collaboration was candidly
described by Alessandro Nata, secretary-general of the Italian
Communist Pary, in his book-interview *I tre tempi del presente* [The
Three Tenses of the Present] (Turin: Paoline, 1989, 379 pp.). Ac-
cording to the Rome correspondent for the *Jornal do Brasil*, almost a
third of what Nata presented was "revelations and unedited docu-
ments that expose and confirm old suspicions about the spirit of col-
laboration that for more than 40 years has unceasingly oriented the
dialogue between the Communists and the Vatican – even in the
worst days of the 'cold war.'

"This understanding was facilitated by the short distance in Rome
that separated the *Via delle Botteghe Oscure*, the ICP headquarters,
from the doors and walls of Vatican City. But it was facilitated, above
all, by the idea shared by Italian Catholics and Communists that in
today's complex societies no one can do anything alone – a notion
affirmed by Msgr. Piero Rossano, rector of the Pontifical Lateran
University and one of the most enthusiastic fans and publicists for
the book-interview of the Communist leader" (*Jornal do Brasil*, April
9, 1989).

By 1989, the progressivist-Communist dialogue had reached such a
point that Alessandro Nata could state in his book: "Today we con-
sider Catholics as harbingers of messages, cultures, and values that

§ *133* Even more than these political and diplomatic alliances, it was the Vatican's launching of dialogue with the Communists, who were included along with Freemasons in the category of "non-believers," that constituted a new and important mark of affinity.[129] This dialogue consolidated progressivist support for the Marxists at many different levels.

"Communism is the enemy of the Church, but the Church does not have enemies," said John XXIII.[130] With this symbolic phrase, the Conciliar Church officially initiated the thaw with the Communist movement.

§ *134* In the Encyclical *Mater et Magistra* of May 15, 1961, John XXIII opened the door for Catholics to collaborate with other men who do not share their view of life, which would include the Communists. Although he warned the faithful "not to compromise in Religion and Morals," the Pontiff then added:

"Yet at the same time they **[the faithful] should show themselves animated by a spirit of understanding** and unselfishness, **ready to co-operate loyally** in achieving objectives which are good in themselves, or can be turned to the good."[131]

§ *135* Two years later, in the Encyclical *Pacem in terris,* John XXIII went a step further. He established a distinction between a false philosophy and eventual good movements that could come from it. This distinction permitted the progressivists to draw nearer to the Communists. The Pontiff wrote:

"It is not possible to identify a false philosophy of the nature, origin, and purpose of men and the world, with economic, social, cultural and political movements, even when such movements draw their origin and inspiration from that philosophy. Thedoctrine does not change once it has been set down in precise terms. But a movement cannot avoid being profoundly influenced by the continuously changing conditions in which it has to operate It may sometimes happen, therefore, that meetings arranged for

we could call our own, and not just as a different reality that we must confront" (*ibid.*, p. 306).

[129] See *Gaudium et spes*, 21f, 92e; *Nostra aetate*, 5c.

[130] *Apud* Y. Congar, *Église Catholique et France moderne*, p. 251.

[131] John XXIII, Encyclical *Mater et Magistra* of May 15, 1961, n. 239.

some practical end – though hitherto they were thought to be altogether useless – may in fact be fruitful at the present time, or at least offer prospects of success."[132]

§ 136 The application of these principles of John XXIII to Communism was more or less inevitable. Cardinal Yves Congar understood this quite well in his commentary on the passages cited above:

"The atheism of Marx is not theoretical. From the standpoint of scientific research, it is only the consequence of an overthrow of Capitalism. It should not be either understood or criticized in terms of an 'idealist' philosophy. It was established – for it really has been established – that Marx sought not the elaboration of an economic theory, but the well-being and the development of concrete men. In fact, the Communists whom I know personally have sought justice, the abolishment of misery."[133]

§ 137 With this distinction between theory and practice, the progressivists tried to dodge the innumerable condemnations of Communism pronounced by the Popes who had gone before John XXIII.[134] They alleged that the condemnations should only be applied to the philosophical character of Marx's ideas.[135] Hence the political-economic-social collaboration be-

[132] John XXIII, Encyclical *Pacem in terris*, of April 11, 1963, nn. 159-60.

[133] Y. Congar, *Église Catholique et France moderne*, p. 253.

[134] See Vol. I, *In the Murky Waters of Vatican II*, Chap. I, footnote 14.

[135] Only in passing do we point out the weakness of this progressivist sophism. It is just a new rendition of an old theme, the well-known distinction between "thesis" [theory] and "hypothesis" [practice] by which Msgr. Dupanloup, Bishop of Orleans and well known liberal, interpreted the *Syllabus* (1864). The aim of this distinction was to stimulate adaptation of the French liberal Catholic to the laic and revolutionary *status quo* of mid-19th century France, permeated with the errors condemned by the *Syllabus*. That is to say, while Bishop Dupanloup said that he was entirely favorable to the *Syllabus* in theory (thesis), in practice (hypothesis) he allowed Catholics to integrate themselves into the liberal context in which they lived. He was unconcerned about issuing condemnations, since it was "impossible" to change the state of affairs (see the four-year series of articles by Fernando Furquim de Almeida, *Os católicos franceses no século XIX, Catolicismo*, February 1951- August 1955).

tween Catholics and Communists was baptized with the afore-
mentioned passages of *Pacem in terris* and *Mater et Magis-
tra...*[136]

The next excerpts intend to show how the Conciliar
Church understands the Catholic-Marxist relations.

§ 138 In the 1960s Fr. Congar engaged in a dialogue with Fr.
Girardi, one of the founders of the Christians for Socialism
movement. In this friendly exchange, Congar's position of
support for the so-called "conversion to Socialism," as well as
his admiration for the Socialist State, became clear:

"Fr. Girardi: Dialogue is, in fact, one of the ways to
pose the problem. **The meeting of Christians and Marxists
has led us to discover great convergences and even the pos-
sibility of joint collaboration in an historic plan**

"Fr. Congar: **You speak of the discovery Christians
made of the political dimension. It is a discovery that is still
not fully explicit, but holds promises for the future. It is one
of the values for the future linked to what we call the inevi-
table conversion to Socialism,** a new fact for us that takes
place calmly.

"For part of my life, I kept in mind texts of Pius XI say-
ing that it was impossible to be Socialist and Christian. **I would
not go so far as to say that I would give my life for Social-
ism but I can say that intellectually I consider that the**

The application of this distinction between the Marxist theory, which
would be bad, and its practice, which would be acceptable, is no less
pernicious for contemporary Catholic milieus. This sophism was op-
posed by the Holy Church when she condemned the "common
ground" tactic advocated by the Modernists (see St. Pius X, *Notre
charge apostolique*, nn. 30-32).

[136] The secretary-general of the Italian Communist Party Alessandro
Nata acknowledged the importance of this revolutionary passage in
Pacem in terris: "John XXIII, as Togliatti has observed, had to face
this crisis [isolation of the Church vis-à-vis the progress of the world]
and tried to emerge from it with a vision that values the historical
process, recognizing that non-Catholic movements could also be
protectors of values. From this came the explosive statement of
Pacem in terris, which stated that 'encounters with such movements
may in fact be fruitful at present, or at least offer prospects of future
success,' clearly referring to movements of Marxist inspiration" (*I tre
tempi del presente*, p. 307).

Socialist structure is as Christian, or more so, than the Capitalist structure."[137]

§ 139 In another work, Congar maintained that Catholics can accept an open Socialism: **"In this domain [the options of political militancy], the key word is 'pluralism.' This is the position of the French Episcopate, and even of the last Popes. Concretely, this becomes the green light for a 'Socialist option.' Obviously a Christian cannot be at ease with just any Socialism, but only an open and humanist Socialism."**[138]

§ 140 Fr. Metz explained the regard of the Conciliar Church for Marxism in its struggle on behalf of humanity: "We must seriously consider the demands of atheism as a facet of Humanism. In her encounter with atheism, the Church appreciates the fact that she is dealing first of all with a polemic about the human being. **The Church is trying to steal the message from contemporary atheism with its humanitarian claims, admitting at the same time her solidarity in the struggle in favor of the human being. This is the idea that prevails today in society**, based on the concept of peace and universal justice."[139]

§ 141 Otto Baumhauer summarized the thinking of Metz: "In May 1966, **when Christians and Catholic theologians were seated around the same table with Communists** at a meeting of the Pauline Society [*Paulus Gesellschaft*], **they joined together in defense of an integral Humanism, taking the word from the Marxists, who aspire to the same object although by different roads."**[140]

§ 142 Fr. Chenu considered Marx a true prophet of social problems. The French Dominican justified progressivist support for Marxism in the social terrain by invoking Paul VI's *Populorum progressio*: "Four centuries ago the Christian world, master of the economy and civilization, began to organ-

[137] Y. Congar – G. Girardi, "1960-1970: Dez anos decisivos para a Igreja e o mundo," V.A., *Credo para amanhã* (Petrópolis: Vozes, 1971), pp. 146-7.

[138] Y. Congar, *Église Catholique et France moderne*, pp. 239-40.

[139] J. B. Metz, "Los cristianos en el mundo de hoy - I," V.A., *La reforma que llega de Roma* (Barcelona: Plaza – Janes, 1970), p. 81.

[140] Otto Baumhauer, "Los cristianos en el mundo de hoy - II," *ibid.*, p. 87.

ize a regime in Europe that considered 'profit as the chief spur to economic progress, free competition as the guiding norm of economics, and private ownership of the means of production as an absolute right' (Paul VI, *Populorum progressio*, 26).

"In the end, **capital and work were separated – whereby workers were deprived of participating in the profit, affirming their human values and responsibility for their work. This became the law of the economic world.**

"**Who rebelled against this 'alienation'? Even before 1850, Marx not only stirred up revolutionary uprisings, but also elaborated a whole philosophy of man and the human aspect of work, a philosophy that resurrected the truth of the principle of the universal ownership of goods. This truth today has a tragic dimension, because two-thirds of humanity is in a state of misery,** at times both a physical and moral indigence, **while the other one-third monopolizes all the profits. It is an intolerable situation, one which Paul VI denounced in the Encyclical *Populorum progressio* Everyone knows the favorable reception the document has had among Marxists.** And, in fact, it was destined for all men, including the non-believers.

"**While the thoughts and actions of Christians were turned toward other matters, Marx, already more than a century ago, prophetically denounced this dramatic situation. His analysis can be disputed.** His philosophical and religious approaches may be erroneous. **But his vision of things continues to be valid.**"[141]

§ 143　　　　And what has been the reaction of the Marxists to this closer relationship advocated by the progressivists? Do they view it as a loss of ground for their cause? By no means. Rather, they express their satisfaction even as they reaffirm their Communist convictions.

§ 144　　　　This can be seen, for example, in the text of Gilbert Mury, a French Communist Party member and an expert on religious matters. Mury explained that this collaboration with believers was an artifice that has been employed to the advantage of the Communist cause since the time of Lenin:

[141] M.D. Chenu, "O comunismo é uma idéia cristã enlouquecida?," V.A., *Os maiores teólogos respondem* (São Paulo: Paulinas, 1968), p. 158.

"During the construction period of Socialism and Communism, a practical cooperation was sought with certain practicing believers, an amiable dialogue without equivocation or compromise, following Lenin's thesis: **'Unity in this truly revolutionary struggle of the oppressed class to create a paradise on earth is more important to us than unity of opinion among the proletariats about the paradise in heaven.'"**[142]

§ 145 On the dialogue of Vatican II, Gilbert Mury had this to say: **"If the freedom to believe or not believe in God defined by the Roman Church is truly recognized by the Council, with all the consequences that such a decision entails, then this initiative permits us to hope for a real** *rapprochement* **between the faithful and atheists. If the Vatican truly ceases to insist on private property of the means of production then there is no longer a doctrinal obstacle standing in the way of the Christian's active collaboration in the establishment and construction of Socialism."**[143]

§ 146 Roger Garaudy, an acclaimed Communist intellectual of France, also expressed his delight with the establishment of this dialogue. He affirmed: "But what remains, **what is essential is that dialogue go forward even when it passes through confrontations and acknowledgment of tough philosophical differences. Thus it** can break out of the borderline zones of a 'natural morality' and **come to find a common means to construct a common future, among men who all acknowledge their interlocutor as one who speaks for authentic human values".**[144]

§ 147 Dom Helder Câmara, *the Red Archbishop* of Recife, Brazil, announced that a goal of the Conciliar Church was to condemn Capitalism as being "an intrinsically evil regime." Obviously Garaudy expressed his affinity with the goal of the revolutionary progressivist leader:

"My meetings with Dom Helder Câmara, Archbishop of Olinda and Recife, as well as his fraternal letters, were indispensable for me in overcoming my dogmatisms and old sec-

[142] Gilberto Mury, p. 137, *apud* Ph. de La Trinité, *Dialogue avec le marxisme?*, p. 58.

[143] *Ibid.*, p. 66.

[144] Roger Garaudy, *apud* Ph. de La Trinité, *Dialogue avec le marxisme?*, pp. 78-9.

tarianisms, above all when he set before me this fundamental problem: '**The next step for us Christians is that of publicly proclaiming that it is not Socialism, but Capitalism, that is *intrinsically evil*, and that Socialism can only be condemned in its perversions.**

"**And for you, Roger, the next step is to show that the [Communist] revolution is not linked by an essential bond**, but only a historic one, **to philosophical materialism and atheism, and that, on the contrary, it is co-substantial with Christianity.**' Dom Helder opened up this plan to me six years ago, and has never ceased to help me carry it out."[145]

The advantages, therefore, are great that can be reaped by the Communists with the conciliar initiative of dialogue and the "common ground" tactic that preceded it...

C. Support for Communist regimes

§ 148
Beyond the political-social goals of Communism, many progressivists defend the Marxist regimes themselves. The following examples will help to present the general lines of this scenario.

§ 149
In Chile, before the Marxist regime of Salvador Allende rose to power, clearly revolutionary options had been adopted by a large part of the Chilean Hierarchy, led by the Archbishop of Santiago, Cardinal Raúl Silva Henriquez. This ecclesiastical policy was followed throughout Allende's presidency (1970-1973). The crucial support that Communism received from the Cardinal, as well as numerous Chilean Bishops and priests, constitutes a dark page in the History of the country. Such a support, which should have been vigorously censured by Rome, was allowed free reign. It can even be said that it counted on the approval of Paul VI.[146]

[145] Roger Garaudy, *Parole d'homme* (Paris: Laffont, 1975), p. 118.

[146] This hypothesis was raised by the Chilean TFP in the manifesto *The auto-demolition of the Church, a factor in the demolition of Chile.* In it, the organization posed this question:

"How is it possible to think that the hierarchical structures of the Church in Chile acted as they did without the full approval of Paul VI? " This question became inevitable considering that Cardinal Silva Henriquez was in permanent contact with the Vatican. Furthermore,

The support of the Chilean Cardinal and Episcopate for Communism can be noted before, during, and after the election of Salvador Allende. In numerous ways it favored the rise of the Marxist regime to power and, once established, its maintenance.

§ 150 Statements of Cardinal Silva Henriquez and other ecclesiastics effectively paved the way for the Marxists to take power in Chile. For example, in 1962, soon after receiving the Cardinal's hat from John XXIII, Silva Henriquez exalted Communism: **"It is shameful to deny everything that is Communist just because it is Communist. They [the Communists] have made positive contributions in the public moral order**, which is a very significant thing and is being neglected here." [147]

§ 151 In August 1969, acting in his capacity as Grand Chancellor of the Catholic University, Silva Henriquez granted the title of *Doctor Scientiae et Honoris Causa* to Pablo Neruda, a poet and active militant of the Chilean Communist Party. The Cardinal justified the gesture with these words:

"This action reflects values of extraordinary importance The first is to show, once and for all, that the Church

Chile counted on the constant presence of an Apostolic Nuncio who represented the Vatican before both the Chilean government as well as the Episcopate. The position of Nuncio had ready means at hand to transmit any directives of Paul VI to Msgr. Silva Henriquez, the Episcopate, and the general Clergy.

"It is unthinkable," continued the manifesto, "that this approval did not exist, be it through the Cardinal's chains of communication, the hierarchical structure of the Church in general, or even the amplitude and consistency of this unusual policy of the Clergy in Chile. However, during that period there is no record of any expression, even a veiled one, of any coldness or displeasure on the part of the Vatican regarding the attitudes of the Clergy that benefited Allende's Marxist regime" (*La Tercera de la Hora*, Santiago do Chile, February 2, 1973).

The manifesto cited numerous facts demonstrating the complacency of Paul VI toward the Marxist revolution that took place in Chile in 1970.

[147] *La Nación*, Santiago do Chile, February 25, 1962, *apud* Sociedad Chilena de la Defensa de la Tradición, Família e Propiedad, *La Iglesia del Silencio en Chile - La TFP proclama la verdad entera*, (Santiago, 1976), p. 30.

appreciates truth, goodness, and beauty, even when it is represented by those who do not belong to her religious conviction. In other words, the Catholic Church, by its nature, and Christianity, by its nature, cannot be sectarian, since sectarianism is opposed to our very essence. **With this action the existence of a sound pluralism is established**.

"What does this mean? Can there be a chair of atheism or Marxism in a Catholic University? I reply that yes, there can be, because we Christians are convinced that all of these sciences or doctrines have a part of the truth. And, at times they make criticisms that are extremely useful for us to know."[148]

§ 152 During the 1969 electoral campaign for the country's president, Cardinal Silva Henriquez was questioned by a journalist: Does the Church permit a Catholic to vote for a Marxist candidate? His response certainly favored the rise of Salvador Allende:

"If the Catholic votes in accordance with his conscience, it is fine. The important thing is that he thinks in good conscience that he is doing the right thing."[149]

§ 153 Allende received only a 1.4 % advantage in the general election over his opponent Jorge Alessandri. Given this meager difference, according to the Chilean Constitution the final choice between the two candidates with the most votes had to be made by Congress. Once again, the Marxist candidate received both the veiled and open support of the Catholic Hierarchy.[150] This support determined the choice of Allende, and launched Chile on one of the great tragedies of its history. In this emergency, a word from Paul VI would have been decisive.[151] Such a word, however, was not pronounced. [152]

[148] *Ultimas Noticias*, Santiago de Chile, August 21, 1969; *Iglesia de Santiago*, Boletim Informativo Arquidiocesano, July 1969, n. 38, *apud La Iglesia del Silencio en Chile*, pp. 90-91.

[149] *Ultima Hora*, Santiago de Chile, December 24, 1969, *apud La Iglesia del Silencio en Chile*, p. 123.

[150] *La Iglesia del Silencio en Chile*, pp. 136-8.

[151] In face of the imminent threat that the Christian-Democratic representatives would vote for Allende, the Chilean TFP sent Paul VI a letter with this plea: "In this dramatic hour, let your voice be heard. There is still time to save a Catholic nation that is already at the edge of the abyss." The letter was sent October 8, 1970 and published in

§ 154 As Allende was sworn in, Silva Henriquez celebrated a *Te Deum* in the Cathedral of Santiago in thanksgiving for the Marxist victory.[153]

§ 155 A short time later, he made this statement to Cuban journalists: **"The majority of the reforms proposed by the Popular Front** [the coalition of leftist parties that elected Allende] **coincide with the desires and proposals of the Church. Thus they have our clear support** **I believe that Socialism has enormous Christian values,** and from many points of view, it is much superior to Capitalism. The value it gives to work, to the person over capital. **It seems to me that it is an extraordinary value to break with the demand for profit, the tyranny of profit, the hunger for profit, and the power to organize all of production. All these ideas that they seek seem to be very similar to what the Church wants for the organization of society."**[154]

§ 156 It seems opportune here to present an analysis of the situation by Prof. Corrêa de Oliveira, who attributed the election of the Communist Allende to the omission of Pope Paul VI. Shortly after the choice of Allende was confirmed by the Chilean Congress, the well-known Catholic Brazilian leader declared:

"How it is possible not to be perplexed? Just a word from the Supreme Pontiff would have sufficed to have the

the newspaper *La Tercera de la Hora* with the title, *The autodemolition of the Church, a factor in the demolition of Chile.* The response was silence.

[152] Prof. Plinio Corrêa de Oliveira showed that Allende's victory in the elections did not signify that the Communist electorate had increased. On the contrary, the actual party numbers had decreased.

Before the final choice by the Chilean Congress, the Brazilian intellectual directed an appeal to the Vatican: "Again we turn our gaze to Rome. There is only one voice in the world that can prevent this evil. It is the august voice of Paul VI. Will he continue to maintain a silence, avoiding the official, clear, provident, strong, and paternal pronouncement that can still save everything, even though it wavers at the edge of the cliff? With our whole soul, we implore Providence for this redeeming word" ("Toda a verdade sobre as eleições no Chile," *Folha de São Paulo,* September 10, 1970).

[153] *La Iglesia del Silencio en Chile,* pp. 145-6.

[154] *Ultima Hora,* Santiago de Chile, November 12, 1970, *apud ibid.,* p. 148.

Chilean Episcopate direct Catholics not to vote for the Marxist candidate. This word would have prevented the victory of Allende, whose advantage – of only 1.4% – over the nationalist Alessandri could easily have been overcome. History will say that the Holy Father did not speak this word, and, for this reason, Allende – with the scandalous *placet* of the Cardinal-Archbishop of Santiago – won the election. It is painful to say this. But it is obvious.

"Only one exit remained for the Chilean nation after the electoral results. It was for the Holy Father, acting through the Episcopate, to recommend that the Christian-Democrat representatives not give their votes to the Marxist candidate in the Congressional election that followed. History will say that even in this emergency, Paul VI was silent. And even before Alessandri had been put aside, the Christian Democrats had made an agreement with the Communists before the eyes of the entire world, promising their support to the Marxist candidate.

"A few days after his victory in Congress, Silva Henriquez officially announced that Chile would soon begin its '*via dolorosa*' toward Communism. Notwithstanding, he was one of the first to visit the future president, assuring him of the support of the Hierarchy and transmitting, on the part of Pope Paul VI, special congratulations along with good wishes

"In view of all this, a question inevitably presents itself. I phrase it in very measured terms: Had Paul VI foreseen from the beginning, without apprehension or repulsion, Allende's victory? Everything that happened leads one to respond that in effect, he had foreseen it without, moreover, giving any sign of apprehension or repulsion.

"These are the facts. They speak for themselves.

"At this point, I cannot refrain from placing another question: Would this fatal action of Paul VI be only in regard to Chile? Or also for other parts of Latin America? More precisely, also for Brazil? In this case, what future is awaiting us?"[155]

157 Ecclesiastical support for the Chilean Marxist government of the Popular Front was acknowledged by Allende himself in a statement to the *New York Times*:

[155] Plinio Corrêa de Oliveira, "Entre lobos e ovelhas: novo estilo de relações," *Folha de São Paulo*, November 1, 1970.

"The Catholic Church has undergone fundamental changes. For centuries, the Catholic Church defended the interests of the powerful. Today, after John XXIII, it is oriented toward transforming the Gospel of Christ into reality **I had the occasion to read the Declaration of the Bishops in Medellin,** where in 1968, the Latin American Episcopate met together in the presence of Paul VI. **The language it employed is the same that we have used since the beginning of our political life thirty years ago. In that epoch, we were condemned for such language, which today is used by Catholic Bishops. I think that the Church will not be a factor of opposition to the government of the Popular Front. On the contrary, it will be an element in our favor."[156]**

This support lasted until the vespers of the fall of Allende on November 11, 1973.[157]

§ 158 Another shocking example of the support of the Catholic Hierarchy for Communist regimes took place behind the *Iron Curtain.* Cardinal Lazlo Lekai, Primate of Hungary, described the fruit of the installation of the Communist regime in his country as a Christian restoration of society. The *Jornal do Brasil* summarized the disconcerting statements of the Cardinal:

"The Communist regime in Hungary has taken the proposal of the Encyclical *Quadragesimo anno* of Pope Pius XI and turned it into a reality. It asked for 'the Christian restoration' of society through the cooperation of the classes Cardinal Lekai, Archbishop of Esztergom affirmed that Communism had done 'many good things' in his country. 'We, that is, we who are from the Church, did not carry out *Quadragesimo anno.* Marxism did."[158]

§ 159 When he was Archbishop of Medellin, Cardinal Lopez Trujillo expressed unmistakable sympathy for the part the Church played in the Communist regime's rise to power in Nicaragua:

[156] *Apud* P. Corrêa de Oliveira, "Religião a serviço da irreligião," *Folha de São Paulo,* July 11, 1971.

[157] *La Iglesia del Silencio en Chile,* Part III, pp. 141-221. See a summary of this book in P. Corrêa de Oliveira, *A Igreja ante a escalada da ameaça comunista - Apelo aos Bispos silenciosos.*

[158] *Jornal do Brasil,* December 22, 1980

"The Church in Nicaragua denounced the abuses of Somoza's dictatorship with prophetic force. This is well known. Without the Church, without her moral force and capacity to recruit in the country, the revolution would have been impossible, or at least very difficult." [159]

§ 160 Further on, Lopez Trujillo expressed resentment over the Sandinista government's behavior toward the Church. Notwithstanding, he maintained that the Church would be disposed to continue her support of Communism provided she were granted the liberty to make critiques. He stated:

"The Hierarchy formulated serious critiques of the Sandinista ideological program with regard to religion, which it dealt with following the normal canons of Marxism-Leninism. These critiques did not please the regime. Nor did the warning that while **the Church was disposed to give her support to the revolutionary process in everything that could help the Nicaraguan man,** she would not abandon her role of criticizing in face of deviations."[160]

The Colombian Cardinal concluded his statement auguring the reestablishment of dialogue between the Church and the Communist regime of Nicaragua.

§ 161 When the Association of German Editors conferred its award on Fr. Ernesto Cardenal, SJ, a member of the Sandinista government, theologian Johann Baptist Metz was jubilant over the gesture. He highly praised the role played by the Jesuit in installing the Nicaraguan Communist regime:

"A revolution can always be evaluated by the personalities that come to surface in it. In Nicaragua, the physiognomies that have appeared are not those of generals, government officials, and bureaucrats, but those of poets, priests, and pedagogues Thus do I say that **in Nicaragua a new relationship between culture and political society is being forged It seems that it is extremely important to see and honor Ernesto Cardenal as part of this political-cultural process because it [the work of Fr. Cardenal] expresses a plan for a popular culture that will help the people acquire a religious and political-social identity,** especially through language

[159] Alfonso Lopez Trujillo, "Nicarágua, Chiesa e sandinismo," *L'Osservatore Romano*, July 30-31, 1984, p. 5.

[160] *Ibid.*

"Today a free [Communist] Nicaragua is trying to realize this popular culture through the method of social teaching known as *literacy*."[161]

§ 162 Fr. Cardenal's conception of the Church expresses well the progressivist's general support for the political-social goals of Communism. Actually, in the next passage, he defended the strange notion that the Church's mission is to preach Communism, which he called the kingdom of God on earth:

"At this moment in Latin America, [the Church's mission] is above all to preach Communism Communism is profoundly Christian. Even more, it is the essence of Christianity. The word communion is the same as Communism. Communism, according to Marx, is the society where there is no longer any kind of egoism or injustice. It is the same thing that we Christians understand as the kingdom of God on earth. Communism, as Marx understood it was the social system of the first Christians."[162]

§ 163 One can also find Cardinal Congar indirectly praising the Russian Communist regime, through the testimony of a French economist:

"A Marxist liberates as much as a Christian. Certainly we have some criticisms to make of him [the Marxist]. We will say that the Marxist does not respect the liberty of man, his full dignity of person, that he cuts off the absolute hope of eternal life and resurrection. All this is true.

"But, [in a contrary sense], I am going to read three lines written by a man considered one of the best French economists and a very good Christian, François Perroux. On his return from a study trip to Soviet Russia, he wrote: '**If you visit Moscow, you will not receive the impression of an indigent city. You will observe an austere life,** dangerous perhaps, certainly a police State. **Its exterior, however, will make you think of a Christian society that takes seriously the fundamental articles of faith.'"[163]**

[161] Johann Baptist Metz, *Mas allá de la religión burguesa*, pp. 95-6.

[162] Ernesto Cardenal, interview for the magazine *Crisis* (Buenos Aires), *apud Movimento*, São Paulo, August 6-12, 1979.

[163] Y. Congar, "Salvación y liberación," V.A., *Teología de la liberación - Conversaciones de Toledo* (Burgos: Aldecoa, 1974), p. 191.

§ 164 What Fr. Congar did not dare to say directly, Leonardo Boff affirmed without embarrassment after a 15-day stay in Russia: **"The majority of them [Communist countries] have managed to attain a society where no one is begging in the streets, where there are no abandoned children, in short, where there is not an impoverished majority as in the Capitalist countries Socialist societies are highly ethical, physically and morally clean.** Were it not for the materialist doctrine of the parties, **one could say that they carry out the ethical ideas of the social teaching of the Church."**[164]

§ 165 Boff explained his thinking further in another interview printed in the *Folha de São Paulo*. He stated that **in Communist Russia he found "signs of the kingdom of God revealed in the infrastructure that the Soviet people had constructed and that we are struggling to achieve in Brazil."** He added that **"the Soviet Communists were promoting a cause in which we [Catholics] are united."**[165]

§ 166 Friar Betto, one of the main leaders of the Basic Christian Communities in South America, had much the same to say about the Socialist society: **"By creating better living conditions for the people, the Socialist society,** from the standpoint of the Gospel, **unconsciously carries out what we, men of Faith, call the plans of God in History."**[166]

§ 167 When he was Archbishop of São Paulo, Cardinal Paulo Evaristo Arns sent a letter to Fidel Castro on the occasion of the 30th anniversary of the Communist takeover in Cuba. In that document, the Cardinal transmitted warm congratulations for the conquests of the Revolution and a fraternal embrace. These are excerpts from the letter:

 "My very dear Fidel,

 "Peace and good will.

 "I take advantage of Friar Betto's trip to send an embrace and salute the Cuban people on the occasion of this 30th anniversary of the Revolution. **We all know the heroism and sacrifice of the people of your Country in** resisting internal aggressions and **eradicating misery, illiteracy, and chronic**

[164] *Folha de São Paulo*, July 14, 1987.

[165] *Folha de São Paulo*, July 15, 1987.

[166] *Fidel e a Religião - Conversas com Frei Betto* (São Paulo: Brasiliense, 1985), p. 260.

social problems. Today Cuba can feel proud to be an example of social justice on our Continent, so impoverished by external debt.

"In the conquests of the [Cuban] Revolution, the Christian Faith discovers the signs of the kingdom of God that manifests itself in our hearts and **in structures that allow us to make our political conviviality a work of love**

"Unfortunately, favorable conditions still do not exist for a meeting to take place between us I have you present daily in my prayers, and **I ask the Father that he grant you always the grace of steering the destinies of your country.**

"Receive my fraternal embrace on the festivities for the 30th anniversary of the Cuban Revolution

"Fraternally, Paulo Evaristo Cardinal Arns."[167]

§ 168 The same considerations made above, regarding the indirect support Paul VI gave to Cardinal Silva Henriquez when he praised Allende, can be applied here regarding the indirect support John Paul II gave to Cardinal Arns when he praised Castro. That is, both Popes respectively endorsed these praises.

From these examples, it is clear that the Conciliar Church offered an expressive and important support for Communist regimes. This work found no record of serious censure from the Holy See for such actions.[168]

D. Support for the class struggle

§ 169 In their preaching, progressivists also praise the Marxist method of class struggle as a means to overthrow the bourgeois establishment. The expression class struggle is holy in Communist jargon, and its meaning is unequivocally revolutionary.

§ 170 Cardinal Congar considered class struggle a veritable obligation for workers: "Going beyond the affirmations of an

[167] *O Estado de São Paulo*, January 19, 1989.

[168] The initial plan of this Volume included the publication of an appendix on the Vatican *Ostpolitik*. The appendix reports the main events that marked this politics. Its publication was postponed in order to add an update of the last years. When possible, it will be published as a Special Edition to the Collection *Eli, Eli lamma sabacthani?* This appendix will show the surprising support of the conciliar Popes for Communist regimes.

outdated idealism about the harmony of complementary functions, **we recognize and admit class struggle as an obligation of workers to undertake together in order to liberate themselves from a situation of oppression and alienation.**"[169]

§ 171 In his memoires, Congar related that Fr. Chenu was also an ardent defender of class struggle, which he considered one of the places where the "incarnation of grace" takes place. Here Congar quotes Chenu:

"I owe, therefore, to JOC [*Jeunesse Ouvrière Catholique* - Young Catholic Workers] and to our meetings with the chaplains for the Lille workers this thought that undoubtedly would need to be nuanced: the Mystical Body of Christ in the workplace. Fr. Chenu developed this theme for reflection in innumerable articles: **the word of God and grace are incarnate in humanity, in humanity taken in its historical dimension, its future and its dynamism. And also in its social dimension, insists Fr. Chenu, in the conditions of class struggle, in movements of liberation.**"[170]

§ 172 Chenu himself confirmed his support for class struggle: "A priest of *Compteurs de Montrouge* [Fr. Screpel] used to say: 'I hold the strong conviction that it is necessary to lose everything of my culture, mentality, and internal behavior in order to allow myself to be taken over by the work and hope of the working class.' This word, hope, is quite cogent. **The workers have a hope, and it is this that animates everything, beginning with their class struggle.**"[171]

§ 173 In a conversation between Fr. Metz and Fr. Rahner, Metz admitted that Christianity's potential for hope had moved into the terrain of the revolutionary social struggle:

"J.B. Metz - If Teilhard de Chardin can describe today's Christians by saying that they have the message of the kingdom of God on their lips, but deep down, they have no hope, then **Christianity should really ask itself if a great part of its capital of hope, its capital of desires, has not migrated to the *front* of the social struggle, where men of the**

[169] Y. Congar, *Église Catholique et France moderne*, p. 256.

[170] *Jean Puyo interroge le Père Congar*, p. 53.

[171] *Jacques Duquesne interroge le Père Chenu*, p. 147.

most varied origins have become revolutionaries because they have greater desires and love more than the others."[172]

§ 174 Fr. Joseph Comblin, a well-known Belgian author, who moved to Brazil and became an important forerunner of Liberation Theology in South America, went even further. He preached social revolution as a necessary consequence of the teachings of Vatican II. In 1968, Comblin elaborated a plan for revolutionary groups to take power. This plan was later published by the press.[173]

These were some of the main principles of the Belgian theologian: **"It would be naïve to think that ecclesiastic institutions, parishes, works of education and assistance, religious orders, etc. can really be transformed according to conciliar dispositions without paying the price of a true social revolution.** Naturally, the generation formed before the Council cannot make **these reforms.** They **will be the work of Christians born after 1945. They will see that the changes, while appearing to be purely 'pastoral,' imply many changes of attitudes in the economic, social, and political fields, which will make a revolution necessary."**[174]

§ 175 Further on, Comblin insisted that conciliar changes contain revolutionary principles: "The Council was necessary so that the true doctrine of St. Thomas on the universal ownership of goods and the right of the poor could be re-established and taught. The former Encyclicals still taught the divine right of private property. Should this be attributed to the carelessness of the theologians who counseled Leo XIII and his successors?

[172] K. Rahner – J. B. Metz, Dialogue, V.A., *Cinco problemas que desafiam a Igreja hoje*, p. 175.

[173] In the widely publicized *Comblin Document*, the Belgian theologian said that "it was necessary to make alliances [with the Communists], to make compromises, to soil our hands with dirty alliances."

This document caused the TFP to undertake a signature campaign in 1968 in which 1.6 million Brazilians asked Paul VI to take measures against the Communist infiltration into Catholic milieus. For more on this campaign, see the General Introduction of the Collection *Lamma Sabacthani?*, Vol. I, *In the Murky Waters of Vatican II*, footnote 16a.

[174] Joseph Comblin, *Théologie de la révolution* (Paris: Ed. Universitaires, 1970), p. 59.

Such carelessness, in any case, certainly served the interests of the bourgeoisie

"Conciliar transformations contain revolutionary principles. It is a matter of defining the relationship between the Church and society in an entirely new way. The refusal [of Vatican II] to introduce a new condemnation of Communism into the conciliar texts, a request made by a good number of Bishops, **is a sign that it wanted to define the relations between the Church and the social classes in a new way."**[175]

§ 176 Comblin returned to the idea of the need for a social revolution to impose conciliar changes: "We conclude that a vision of a necessary renewal presently exists in the Church, that this renewal is imposed by the Council, and that it has been taken up verbally by Christians in all stations of life. Nevertheless, **the changes demanded by this renewal are such that they are necessarily linked to a social revolution.** On one hand, **these changes in the Church suppose changes in society, because the latter will not allow them to take place spontaneously.** On the other hand, these changes in the Church would have considerable repercussions in the equilibrium of the social forces. Both processes, therefore, are linked together. **As obstacles rise to conciliar renewal, it will become increasingly clear that the Council included,** even though it did not foresee, **profound economic and material transformations.** It is true that **many conciliar Fathers felt as if they were being dragged into a movement of evangelical poverty**[176] **They did not clearly perceive to what point the practical realization of the conciliar decrees would demand, in fact and concretely, the implementation of the spirit of poverty, in order to de-solidarize the historic figure of the Church away from the traditional ruling classes, its own longtime allies, and particularly the present day Western system."**[177]

[175] *Ibid.*, p. 61.

[176] Here he refers to the Pact of the Catacombs, made by about 40 Council Fathers on November 16, 1965 in the Catacombs of Saint Domitilla. For more on this pact, see Vol. IV, *Animus delendi I*, Chap. VI, § 49.

[177] J. Comblin, *Théologie de la révolution*, p. 67.

With this sampling of documents, one can clearly see that important sectors of conciliar progressivism approve the Marxist brand of class struggle.

*

Thus Chapter V concludes after an analysis of innumerable demonstrations of progressivist support for Communist and Socialist ideas, methods, and political regimes. To the degree that this support was either stimulated or tolerated by Church authorities, it indisputably reflects an important facet of the spirit of the Council.

* * *

Chapter VI

ELEMENTS OF
A NEO-SOCIALIST THEOCRACY?

§ 1 Thus far the analysis of conciliar thinking about adaptation of the Church to the modern world has demonstrated that progressivist antipathies are directed *en bloc* against the Catholic State, and also the Modern State. Private property, free initiative, and the Capitalist social-economic system are leading targets of their attacks. On the other hand, the highest praise and sympathy are reserved for Socialism and Communism, even though at times a few critiques of secondary characteristics are made.

Their harsh combat against essential aspects of Capitalism and their complacent eulogies of essential characteristics of Socialism and Communism indicate the direction the new Church is heading.

§ 2 So would the Conciliar Church be tending toward a Communist State?

Yes and no.

§ 3 Yes, to the measure that the methods of Communism help it to overthrow the Western structures qualified as "structures of sin." Toward this end, the Conciliar Church strives to make a united front with the left. It will even support the installation of Communist regimes, as it did in the Chile of Allende and the Nicaragua of Ortega, and as it tried to do in Uruguay with the Tupamaros,[1] and in various experiments in Brazil.[2]

[1] Ecclesiastical support for the Tupamaro urban-guerrilla movement, which made a show of violence in an attempt to seize power, was pointed out in the articles of Plinio Corrêa de Oliveira in the *Folha de São Paulo*: "O 'show,'" January 13, 1977; "O 'show' feito de três 'shows,'" January 29,1977; "O fim dos três 'shows,'" February 7, 1977.

[2] a. The rise of Communism in Nicaragua in 1979 typifies how progressivism gave life to a politically stressed Communist guerrilla Sandinista movement. Based on the Nicaraguan experiment, innumerable Latin American progressivists, including those in Brazil, tried to repeat it in their own countries. This was the driving force behind

Yes, to the measure that the Communist methods coincide with their own in abolishing social inequalities, redistributing wealth, collectivizing the means of production, and socializing education.

Yes, to the measure that the Communist ideals and those of the Conciliar Church harmonize in their preaching on the "new man," the paradise on earth, and a universal evolution in the cosmos and in History.

§ 4 No, because the Communist State curtails liberty, infringes upon human rights, and restricts the full realization of "the person," as understood by the followers of existentialist philosophy.

No, because the progressivists do not think the Communists are sufficiently advanced in their conception of History. They do not discern the "eschatological phase" of evolution that would be divine or Christified.[3]

No, because the progressivists consider the very notion of the State as outdated.[4] They advocate substituting the State

the Fourth International Ecumenical Conference of Theology that took place in February 1980 in the Paul VI Institute under the sponsorship of the Cardinal-Archbishop of São Paulo, Paulo Evaristo Arns. The Congress, which counted on the participation of Liberation Theology leaders brought together 160 Bishops, priests, nuns, lay people of both sexes, Protestant pastors from 42 countries, as well as the president of Nicaragua Daniel Ortega, his minister Fr. d'Escoto, and Nicaraguan guerrillas. One of the high points of its sessions was when Bishop Pedro Casaldáliga put on the uniform of a Sandinista guerrilla. The Prelate then declared that he would try to give thanks for that "sacrament of liberation" that he had just received "with deeds and, if necessary, with blood." He added that "dressed as a guerrilla, "he felt as if he were in priestly vestments for Mass. At the end of the Conference, Cardinal Arns – satisfied with the results – stated, "The thing has only begun ..." (*O São Paulo*, March 7-13, 1980).

b. For photographs of this event, see A. S. Guimarães and M. T. Horvat, *Previews of the New Papacy*, pp. 126-8.

c. For the analysis and complete documentation of this Conference of Theology, see P. Corrêa de Oliveira, *Na noite sandinista: o incitamento à guerrilha*, Catolicismo, July-August 1980.

[3] See Vol. VII, *Destructio Dei*, Chap. II. 2.

[4] Even when the evidence of the facts obliges them to acknowledge the failure of the Communist regime, progressivists still try to salvage

with small self-managed groups, or communities, without any defined institutional form.

As for this anti-Capitalist, trans-Communist, and neo-Socialist amorphous entity that rejects the very notion of State that is coming into being, what would it actually be? Is it possible to study its principal elements?

By presenting the following testimonies of conciliar theologians, this Chapter will attempt to respond to these questions.

§ 5 Cardinal Congar, for example, showed how progressivism, with which he identifies himself,[5] desires an evolution of Communism:

"Communism is not destined to remain the way it was in its opposition to a society and a Church that sacralized inequalities. In a global society of progress, in its relations with Christians who are truly committed to man, **the Communists will end by modifying their historic movement in the sense of an opening [to Christians]. Georges Hourdin believes that this is what is taking place now and that the Communists have (almost) arrived at our positions."[6]**

§ 6 Cardinal Karol Wojtyla also thought the Marxist methods would naturally be replaced by an action that would not have been understood by the hard-line Communists. Analyzing the thinking of Wojtyla, Prof. Rocco Buttiglione related that for Wojtyla, **"Marxism will be authentically superceded by a reinvigorated Christian philosophy capable of fully and adequately developing the theme of *praxis* that Marx pointed to but was unable to understand in a fully human way."[7]**

§ 7 In an interview granted to the Author of this Work, Msgr. Carlo Cafarra, then Dean of the Pontifical Lateran University expressed his enthusiasm for this superceding of Capitalism and Marxism. He did not, however, explain the new sys-

essential aspects, as demonstrated in Part I, Chap. V, §§ 119-176 of this Volume.

[5] See Vol. I, *In the Murky Waters of Vatican II*, General Introduction, footnote 23.

[6] Y. Congar, *Église Catholique et France moderne*, p. 260.

[7] R. Buttiglione, *Il pensiero di Karol Wojtyla* (Milan: Jaca Book, 1982), p. 330.

tem Progressivism had prepared as a replacement for the future. He would only say that such a formula would be based on the liberation of man:

"We Christians would have to find the way to supercede Capitalism and Marxism – even if we did not know that the **historical realization of Marxism and Capitalism is dying** One can see that they are systems that do not respect men. **We should not be ingenuous to the point of still believing in a possibility of the liberation of man by means of these two systems."** [8]

In the same interview, Msgr. Cafarra added: "One of the things that moves me most is this thought: **one or two thousand years from now, no will be talking about the Kremlin. No one will remember the White House.**"[9]

§ 8 For us to understand this enigmatic and messianic liberation of man that Cafarra talks about, the cornerstone of the new regime to be installed in the world by the Conciliar Church, it is useful to know how Congar explains this liberation. According to him, this would be the key word of present day Progressivism:

"'Liberation' is the key word of the last third of the [20th] century. It speaks of more than 'liberty.' The former even tends to displace the latter, as Marcel Merle recently observed. This is because liberty seems abstract, static, and individual, above all after the critique [of it] made by Marxism. 'Liberation' is collective and dynamic. **It corresponds to a process of historic dimensions that implies becoming conscious of a situation of oppression, which could be called slavery, and the will to escape it, which translates into combat** ...

"Without pretension of being a complete listing, these, then, are the places for liberation:

- **"Social-economic liberation: that the worker** be fully a person; that he **have not only the rights of man, but those of citizen in the workplace that employs him**

[8] Interview, Rome, February 4, 1983.

[9] *Ibid.*

- **"Liberation of the colonized peoples, and not only liberation from a political, but also an economic and cultural colonization**
- **"Liberation of women, whom Marx qualified as the proletariat of man.....**
- **"Sexual liberation from so-called 'taboos'**

"Since 1968 (Medellin) we have seen a proliferation of 'liberation theologies' that have followed the 'theologies of development' and 'theologies of revolution.' The *Revue Nouvelle* (May-June 1972 issue) featured an article titled '**Liberation, the new name of salvation'** **In the name of 'liberation' it called for everything that went against order and authority, whatever it might be, so long as it be *against*!**

"**Obviously, we are not dealing with this here, but with authentic liberation from real oppressions, which prevent man from being man,** which wound his dignity or impede the development of his humanity in all its personal and social dimensions."[10]

§ 9 One can see that "liberation" is in the very essence of the formula for the future society. According to these definitions, however, it would be preponderantly an element of destruction, and not of construction. And after having destroyed the Capitalist "structures of sin," where would this liberation lead?

§ 10 Speaking of liberation as the formula for the future, American theologian Joe Holland, who writes for *Concilium*, presented a broader panorama than normally shown of Liberation Theology, where he mixed the concepts of Church and State, the sacred and profane.

To describe the structure of the future society, Holland evoked a "post-Marxist metaphor" of rooted communities. The vitality of such a society would be represented by the Charismatic groups situated at the root of the Church. There would be, then, a charismatic theocracy that seeks to transcend Marxism itself. Holland explained:

"**In short, the new metaphor suggests what might be called a communal society, carrying a mixed economy, linking the creativity of rooted communities in solidarity, with**

[10] Y. Congar, *Un peuple messianique*, pp. 165-7.

the State playing a secondary and facilitating role Small communities are the central agents of this new metaphor.

"This brings us then to the religious side of the new metaphor, or to the questions of what theology, what spirituality, and what model of evangelization flow implicitly from the preceding social model Because of the depth of the social crisis upon us, religious energies are central.

"The leading expression of theology addressing the social side and coming from the new metaphor is, in my judgment, Latin America's 'liberation theology,' especially what might be called its second stage of engagement with popular culture and popular religion.

"Liberation theology has been strongly attacked from some quarters as being Marxist. Indeed it **has learned much from the Marxist tradition. But I believe it can best be seen as a post-modern theology. This means also that it is 'post-Marxist'** – that is, transcending the limitations of Marxism even while learning from its insights. Thus, **I would argue, by its special stress on communities rather than the State, by its rooting class conflict in the richer framework of the community and popular struggle,** by tapping the cultural and religious tradition of the community, and by drawing energy from prayer and worship of the living God, **it represents something well beyond Marxism, and much deeper**

"The spirituality coming from the new root metaphor offers fundamental challenge to the present social system Post-modern spirituality challenges the system by opening itself to prophetic and transformative spiritual energies. This new spirituality is communal;** the small group (basic community) is the mediator of the spiritual dynamics.

"The mode of the small group may be described as charismatic. By this I mean something broader than what is termed the 'charismatic movement,' although that is not excluded **In the post-modern mode, however, while office and competence still remain important, priority passes to charism, to the presence of spiritual energy whenever, wherever, and in whomever it appears.** The Spirit blows where it will within the world."[11]

[11] J. Holland, "Linking Social Analysis and Theological Reflection: The Place of Root Metaphors in Social and Religious Experience," in J. Hug, *Tracing the Spirit*, pp. 186-88.

§ 11 Congar provided a few more elements of the future society when he pointed to a new style of life that is beginning to appear in informal small groups inside the Church:

"A community cannot operate without some structures or laws, but it [the future community] transcends the spheres of 'society' **and legislation.** In a much broader sense, **it is 'a being together' that is less controlled and touches on life, going beyond a productive or profit-minded utility**. This is the case of the parish community. One can join the term 'community' to that of 'communion,' adopted by Boquen. It would undoubtedly equally apply to the group of Légaut, which is a community without a common life, except occasionally."[12]

§ 12 In a footnote, Congar explained what the group of Légaut is: "Without speaking about his group, Légaut gave an outline of his ideal in his work *Introduction to Understanding Christianity's Past and Future*:

"Contrary to religions of authority, the religion of appeal does not become incarnate first in a collective that develops among men using principally sociological means. It spreads through individual contact, through personal influence that requires a response. It spreads with a discretion that contrasts with the spectacular impact of the mass demonstrations and propaganda tools used by religions of authority.

"The members of the religion of appeal are not isolated, but are always in solidarity, and they become all the more conscious of this solidarity as they better understand the nature of their intimate appeal. The more they correspond to liberty of spirit and persevere with tenacity, the **more they advance on the road of fidelity**..."[13]

§ 13 Increasingly, analysts of the progressivist Church are presenting this communal experience – with something of the spontaneity of a tribe of aborigines – as test ground for tomorrow's society.

[12] Y. Congar, "Os grupos informais na Igreja," V.A, *Comunidades eclesiais de base - utopia ou realidade?* (Petropolis: Vozes, 1973), pp. 124-5.

[13] M. Légaut, *Introduction à l'inteligence du passé et de l'avenir du Christianisme* (Paris: Aubier, 1970), p. 227, *apud* Y. Congar, *ibid.*, p. 125.

§ 14 Metz considered the informal groups pioneers of the new political culture. He imagined a system where morals and politics, as well as the public and the private, are all mixed together. He wrote:

"The dimensions of the crisis of survival have increasingly caused moral and pedagogical theories to flow into politics, that is, again uniting politics and morals The classical bourgeois distinction between the public and the private is being questioned in a new way. Certainly, not to abolish it... but to give it a new form. This new form has to be taken to its end, keeping clearly in mind its social foundation. It is in place where political life, with its new claims, becomes personal and where personal concerns become political

"Among us exists a growing number of groups on the social foundation that are already seeking or practicing alternative forms of life in face of the challenge of the crisis of survival. Among them, **there are not a few that take refuge in an a-political life and try to live in a candid counter-culture of political innocence. But there are many others that have joined together to fight for a new form of life with political responsibility, working with a 'day-to-day politics' to find a new relation between private and public interests It seems important to me to see these groups and initiatives as the pioneers of a new political culture, which is not yet clearly enunciated."**[14]

§ 15 In these excerpts the progressivist plan for the future undoubtedly reveals itself. The search for new formulas for society – where everything that was understood in the past by Church and State, religious sphere and temporal sphere, sacred and profane, morals and politics – is passing through a complete revolution. We would be on the threshold of a new social era that properly could be called "theocratic," moved by effluvia of the "Spirit" in the interior of each informal group.

It seems quite worthwhile here to point out two new experiments of this society being born that have counted on the entire support of the ecclesiastical authorities.

*

[14] J. B. Metz, *Mas allá de la religión burguesa*, pp. 48-9.

§ 16 An example representing a charismatic informal group is the community of Nomadélfia in Italy.

On a trip to Grosseto in Tuscany, John Paul II blessed the new type of life of this community as a model for the future society. Visiting the nucleus of families of Nomadélfia (in Greek the word means *law of fraternity*) the Pontiff declared that the experiment being carried out there was "a seed destined to give fruit"[15] and that "the Church loved and appreciated your experiment, the model of love that you want to incarnate."[16]

§ 17 He pointed to it again as an example when he affirmed that to "a world at times hostile to and distant from the Faith, it is necessary to respond with the witness of one's life, with works and visible signs of fraternal love. Nomadélfia can do this and knows how to do so, because it is a people inspired by the law of fraternity."[17]

He closed his speech giving the Apostolic Blessing to all the members of Nomadélfia. After watching a presentation of two dances executed by members of the "city of fraternity," John Paul II spoke again, and could not contain an enthused final cry of "*Viva* Nomadélfia!"[18]

§ 18 The experimental community had already received the official support of the post-Conciliar Church for some time. The Vatican had named Cardinal Pietro Palazzini as representative of the Holy See for Nomadélfia, conferring on the nucleus of families this prestigious honor. Further, John Paul II had already visited Nomadélfia in Tuscany and received the group twice and assisted at their presentations. One of these was a session of songs and dances for him at the Vatican.[19] Significantly, Msgr. Bruno Bassi, who was a secretary of Paul VI, left that office to become a member of the "city of fraternity" and has lived there for some years.[20]

[15] Mario Ponzi, "Il battesimo di un neonato nomadelfo per uno stile di vita che non muore," *L'Osservatore Romano*, May 22-3, 1989, p. 8.

[16] *Ibid.*

[17] *Ibid.*

[18] *Ibid.*

[19] *Ibid.*

[20] *Ibid.*

§ 19 What is Nomadélfia and why has it inspired the enthusiasm, support, and blessings of John Paul II?

In an article published in *L'Osservatore Romano*, one of the paper's correspondents who accompanied John Paul II on his visit related the origin, objectives, and way of life of the singular Nomadélfia.

§ 20 In 1931, the young priest Zeno Saltini adopted a 17-year-old ex-prisoner who did not know what to do with his life as his "son." Others who sought out Fr. Zeno were also adopted as "sons." To these was added a young woman who had run away from her home. She came to be the "mother" of the "sons" of Zeno Saltini. Thus, "father, mother, and sons" came to constitute a "family" that was called the "new people of Nomadélfia."

This "new people" went to live on a 4 km² property on the outskirts of Grosseto. Their objective was ambitious: to create a new society.

§ 21 Toward that end, they formed many nuclei of four or five families. Each one of these groups lives together in a single building, sharing a common refectory, kitchen, and working quarters. Each person has a determined function, but without a salary or seeking any kind of profit.

§ 22 No money circulates in the "city," no private property exists. Any type of individual benefit is categorically prohibited. "Everything in common," says one of its members. In the morning a truck drops off the food necessary for the day to each family nucleus. As for clothing, each one takes what he needs from a common storehouse. Communal work is given preference to individual labor. In this way, the work also is shared.

§ 23 The children can be born in marriages or can be adopted. The tendency is to think – and this is my commentary – that since everything is shared in community, the same would take place with the children. Parental power, it would seem, also does not exist and the children of some can be adopted by others. No one belongs to anyone.

Children sent there by the juvenile court are also considered "sons and daughters" The president elect of Nomadélfia chooses which family should adopt each new child, without the need for the consent of the "parents," since in this respect also, everyone in Nomadélfia serves the common good.

§ 24 No difference exists in Nomadélfia between men and women. The women who go to work – often to plow the fields – leave their "children" in the care of other "mothers."

The experiment of Nomadélfia seems, therefore, something essentially Communist, without, however, the formal title. Even more, it transcends Communism. It is no longer the stage of "antithesis" represented by the Communist regimes that have existed from 1917 until today. Rather, it seems to approach the "synthesis" dreamed of by Marx.

§ 25 The external activity of Nomadélfia consists of trips made throughout Italy. On these trips, the members make exhibitions of song and dance.

§ 26 The reporter for *L'Osservatore Romano* closed his article with these words: "We think that the presence of Nomadélfia is extremely significant and important as the symbol of something toward which humanity should look – with nostalgia perhaps, with hope certainly.

"We want to conclude this article on the 'city of fraternity' with the words spoken by John Paul II when he greeted the families of Nomadélfia in August of 1980 in Castelgandolfo at the end of a show offered to him at the Pontifical Palace: 'If we are called to be sons of God and brothers of each other, **then the law called Nomadélfia [law of fraternity] is a preview and announcement of that future world to which we are all called.**' Yes, Nomadélfia is perhaps a 'preview,' an 'announcement.' It is a beautiful thing that opens the heart to hope: to live with all as brothers is possible."[21]

§ 27 **Receiving John Paul II** on his visit to Grosseto, **the Nomadélfians "sang his song, the hymn to universal fraternity, which denies differences among men, rejects masters**, and calls each one to be the servant of the others."[22]

It was for this strange "new people" that John Paul II expressed such enthusiasm, giving them his support and blessing so that it might come to be "the seed that gives fruit." According to the Pontiff, this experimental community would provide a preview of the future society.

[21] Mario Ponzi, "Nomadelfia: Preavviso e preannuncio di un mondo futuro dove tutti siamo chiamati," *L'Osservatore Romano*, May 19, 1989, Supplement, p. VI.

[22] Mario Ponzi, "Il battesimo di un neonato," *L'Osservatore Romano*, May 22-23, 1989, p. 8.

§ 28 In a conversation with Fr. Zeno Saltini, John Paul II made this statement: **"You are giving a testimony of** your life, your fraternity, your experiment, **which is perhaps a small seed, but it must grow and perhaps permeate the civilization of the future world."**[23]

Here one has, then, what appears to be a glimpse of the Neo-Socialism that is prepared to replace Communism with the blessing of the Conciliar Church.

*

§ 29 As around the world traces of the future society are appearing in Charismatic groups without formal structure, in Brazil the new form of anarchism had reached one of its more audacious consequences. Indians are being considered by the Conciliar Church as models for the future men and their tribal "structure" pointed to as an ideal for the society of tomorrow.[24]

§ 30 In the conclusions of the First National Assembly of the Indigenous Pastoral, subordinate to the National Conference of Brazilian Bishops (NCBB), one can read the following statement:

"Indians are still not corrupted by the system in which we live. The Church needs to offer a real hope for the oppressed. 'They are our brothers, they share everything in common.' This responds to the needs of the poor. **The Indians already live the beatitudes. They do not know private property, profit, or competition. They live an essentially communal life in perfect equilibrium with nature The indigenous communities are an example for the future regarding a new way of living, where man is most important."**[25]

[23] John Paul II, in Castelgandolfo, August 12, 1980, *apud* Pier Francesco Borgia, "Nomadelfia: la città dove non esistono ricchi e poveri, orfani e privilegiati," *L'Osservatore Romano*, October 24, 1991, p. 3.

[24] About the neo-tribal tendency in Catholic milieus, see Plinio Corrêa de Oliveira, *Tribalismo indígena, Ideal comuno-missionário para o Brasil no século.*

[25] *CIMI Bulletin*, n. 22, July-August 1975, *apud* P, Corrêa de Oliveira, *ibid.*, p. 59.

§ 31 A bulletin of the Indigenous Missionary Council, IMC, another organ of the NCBB, affirmed the prophetic sign for the Church in the Indian's struggle for liberation: **"The Indians here in the South, reduced to a handful after centuries of ex**termination and exploitation, are now becoming aware of their situation as a people and beginning the fight for liberation. For us, they **are a prophetic sign, helping us to question the whole structure of the Church and society, and demanding a radical transformation."**[26]

§ 32 Fr. Egydio Schwade, a IMC aide, made the same critique of Western Civilization and praise for tribal society: **"It is our civilization that is bankrupt and doomed, not the Indian's Comparing the values of the indigenous society with those of our so-called civilized society, we see that we have much to learn from them. The irreversible march of History shows that human societies are opening up to those values the Indians have always had, such as the communal spirit, solidarity, and respect for one's neighbor."**[27]

§ 33 What are the basic lines of progressivist thinking on this topic? They delineate a new "community" prepared to replace the State and the Church. Its general lines include:

- It would be an evolution of Marxism, based on the exaltation of man;
- In this evolution, the boundaries between the spiritual and temporal would erode. The religious terrain would slide into the temporal ground and take up the political fight;
- This political struggle against Capitalist society would seek principally the abolishment of private property and liberation from social and economic inequalities;
- It would try to implant a new social cell – the "community" – which would be, to the degree possible, self-managing and devoid of laws and authority;
- This cell would be governed by a mystical appeal coming from the "Spirit." Such an appeal would break forth from the interior of each individual of the community;

[26] *CIMI Bulletin,* n. 25, January-February 1976, *apud ibid.*, pp. 118-9.
[27] *O Estado de São Paulo*, November 29,1975, *apud ibid.*, p. 79-80.

- The very concepts of public and private would merge in this "community," which would represent a religious, social, political, and economic amalgam;
- Finally, this new model would represent a return to the primitive stage of the aborigines. By this "prophetic" way of living, the dreams of the most far-seeing progressivists would be fulfilled...

This provides a general outline of progressivist "theocratic" Neo-Socialism, whose experiments are being applied more or less everywhere.

§ 34 The words of Msgr. Laurean Rugambwa, the first black Cardinal in the History of Church, about a future re-evangelization of Europe by Africa seems to point toward this neo-tribalism being prepared for the West. Such a prediction had already been made by John XXIII and Paul VI. Here is a question of a journalist and Cardinal Rugambwa's reply:

"*Question*: What were your relations with the Popes of the Council, John XXIII and Paul VI?

"*Answer*: As I had the grace to draw closer to John XXIII as well as Paul VI, I noted their paternal interest for the evangelization in African lands to be developed extensively and in depth. **I always had a holy pride united with a sense of responsibility when they predicted that one day the Africans would have to re-evangelize old Europe.**"[28]

Who can say if the often repeated and enigmatic references of John Paul II to a new "civilization of love"[29] are insinuations to prepare Catholics to accept the models of a new anarchical society of the type presented in this Item?

Chapter VI thus concludes with the affirmation that the progressivists are fighting against the Catholic State as well as the Modern State, to the degree that the latter still conforms to the natural order. They are preaching a new social concept of a

[28] Laurean Rugambwa, "L'arcobaleno nella Chiesa," interview by Silvano Stracca, *Avvenire*, November 20, 1992.

[29] "Civilization of love," "reconciliation," "solidarity" – these expressions already employed by Paul VI are terms that constantly appear in the documents of John Paul II. See, for example, the Encyclical *Sollicitudo rei socialis*, of December 30, 1987 (nn. IV, 33; V, 38-9; VI, 45).

self-managing and tribal nature. Such a community would be more radical than Communism in various aspects, and would seem to be heading in the direction of a trans-Socialist theocratic society.

* * *

Part II

ECUMENISM:

NEGATION OF
THE UNITY[1] OF THE FAITH;
AND THE UNICITY OF THE CHURCH;
DESTRUCTION OF HER
MILITANT AND MISSIONARY CHARACTER; AND
AFFIRMATION OF A PAN-RELIGION

[1] **Unity** is a characteristic whereby the Catholic Faith is indivisible. The Faith is composed of an ensemble of truths revealed by God and taught by the legitimate Magisterium. This ensemble is so harmonious and inter-related that to deny one point is to deny the whole.

Unicity, oneness or **uniqueness** is a characteristic whereby the Catholic Faith is the only true faith. Analogously, unicity of the Catholic Church is a characteristic whereby she is the only true heir of the treasures of Revelation.

PREMISES

§ 1 By allowing concepts of the progressivist current into its texts,[1] Vatican II launched two *Kraftideen* [power ideas] that seem to form the foundation for all conciliar and post-conciliar ecumenism.

§ 2 The *first Kraftidee* is the notion of *Ecclesia semper reformanda* [Church always being reformed] – the Church in a continuous state of reform.[2] This notion is based on several presuppositions. The Church should be continuously reforming because she would be essentially human and, as such, subject to error. The search for truth and the process of achieving moral perfection should be a constant pilgrimage. This gave rise to the subsidiary notion of "Pilgrim Church." That is, amid the desert of errors and sin, she should search everywhere for those sparse elements to be found of truth and goodness. Such a pilgrimage, therefore, would require the Church to seek these supposed "elements of sanctification"[3] in other religions.

§ 3 One consequence of the acceptance of "Pilgrim Church" is the notion of "Sinning Church."[4] According to the progressivist thinking, the Church would have erred in seeking truth, and sinned in her moral conduct through the centuries. For this reason, today she would need to be reformed, ask pardon, and do penance for her past faults.[5]

§ 4 The acceptance of "Sinning Church" generates, as a more audacious consequence, the concept of "Prostitute Church." According to this notion, so dear to Progressivism and so akin to heresies, the Church would have lost her evangelical virginity when she decided to not only be spiritual, but also material: to establish a visible institution, to take on properties, to have pomp and ceremony. This would have been a vile imitation of the temporal courts. In other words she would

[1] Vol. I, *In the Murky Waters of Vatican II*, Chap. IV, §§ 1-7.

[2] *LG* 15a, 48c; *UR* 4f, 6a.

[3] *Ibid.*, 8b.

[4] Vol. II, *Animus injuriandi I*, Chap. IV, Appendix II; Vol. IV, *Animus delendi I*, Chap. VI, §§ 3-29; Vol. XI, *Ecclesia*, Chap. IV.

[5] *UR* 3a, 7b; *NA* 3b, 4g.

have sold her spiritual honor, prostituting herself with that decision. Today, therefore, she would contain in her very essence – in her material aspect – elements of prostitution for which she should also need to do penance. This is not the moment to describe in detail this strange theory, which is analyzed in another place in this Collection.[6]

§ 5 One can note, therefore, that the concept of *Ecclesia semper reformanda* in itself, its presuppositions, and its consequences openly denies the divine nature and divine origin of the Church, along with her simultaneously material and spiritual essence. Further, it denies her very mission, her end, and the means to attain it, all equally divine.[7]

§ 6 The **second Kraftidee** serving as a basis for conciliar ecumenism is a singular notion of "Church of Christ," which is mentioned in various documents of Vatican II.[8]

§ 7 The prior notion of *Ecclesia semper reformanda* frontally attacks the sanctity and divinity of the Church and, from this point of view, could be qualified as an *impact-idea*. This second notion of "Church of Christ" has the effect of a breach in the dam, which grows larger as the force of the water increases. From this point of view, it could be called an *eroding-idea*.

§ 8 In the conciliar texts the progressivists introduced the notion of a "Church of Christ" that is different from the Catholic Church. They say that **the "Church of Christ" is no longer**

[6] Vol. II, *Animus injuriandi I*, Appendix II. See also the series of articles by Atila S. Guimarães in *Catholic Family News*, "The 'Miserablist Church' and von Balthasar's work *Casta Meretrix*" (January 2000); "The Miserablist Church: Doctrinal and Historical Overview" (February 2000); "The Miserablist Church: Contradictions and Inconsistencies in the Book *Casta Meretrix*" (March 2000); "Unfounded Generalizations in von Balthasar's work *Casta Meretrix*" (April 2000); "Von Balthasar Avoids the Real 'Prostitution' of the Chosen People – The Deicide" (May 2000); "Final Omission of von Balthasar: The Divinity of the Catholic Church" (June 2000).

[7] About the human-divine nature of the Catholic Church, see Vol. II, *Animus Injuriandi I*, Appendix II, Chap. II.5. 6th; Vol. XI, *Ecclesia*, Chap. I.2.B.

[8] *LG* 8b, 9c; *UR* 3b, 4c.

identified with the Catholic Church, but only *subsists in her*.[9]

§ 9 Now, the doctrine always accepted up to Vatican II teaches that **the Catholic Church is the Church of Christ**: **"Upon this rock I will build my Church"** (Mt 16:18), said Our Lord. The novelty of *subsistit in* is, then, the breach in the dam of the perennial teaching of Catholic dogma. For if the "Church of Christ" subsists in the Catholic Church, the former is more ample than the latter, and the Catholic Church would only be one participator in the "Church of Christ," a supposedly more complete and perfect entity.[10]

§ 10 Probing the deepest sense of what the progressivists understand by "Church of Christ," one sees that they imagine a vague and ethereal Church, without defined limits, subsisting also in other so-called "Christian" religions. Thus, Schismatics and Protestants – situated in the most diverse azimuths of doctrinal fragmentation and disciplinary revolt, in the most repulsive extremes of moral laxity and subservience to temporal regimes – also would participate in the "Church of Christ." By simply accepting some principles preached by Our Lord and "being baptized," one could thus be integrated into this ghostly "Church of Christ," "receive grace," have "elements of sanctity," and be "led to eternal salvation."

§ 11 As the force of the water increases, the breach in the dam grows and weakens it. Thus also, to the measure that this concept of "Church of Christ" is admitted and used, it opens in the direction of yet another concept likewise distorted by the progressivists, the "Church of God."[11] The "Church of God" would be another ethereal entity even broader than the "Church of Christ," and would encompass Jews, Muslims, Buddhists,

[9] * **"This Church of Christ** constituted and organized as a society in the present world **subsists in the Catholic Church**, which is governed by the successor of Peter and the Bishops" (*LG* 8b).

* "As the obstacles to perfect ecclesiastical communion are overcome, all Christians will be gathered, in a common celebration of the Eucharist, into that **unity of the** one and only **Church which Christ bestowed on His Church** from the beginning. **This unity**, we believe, **subsists in the Catholic Church** (*UR* 4c).

[10] Vol. I, *In the Murky Waters of Vatican II*, Chap. I, pp. 55-8.

[11] *UR* 1b, 12, 15a; *NA* 1b.

Hindus, and others who say they believe in God or in some god.

Finally, as the breach widens further, the progressivist notion of the "messianic people" appears.[12] The "messianic people" would be comprised of even more than the above members – of the Catholic Church, the "Church of Christ," and the "Church of God." It would also include *in germen* atheists and Communists coming from the various schools of thought that desire some good or something in the way of good for mankind. For example: peace, abolishing suffering, pain, and hunger in the world, an improved state of humanity, etc.[13]

[12] *LG* 9b.

[13] a. The messianic people would be a seed of unity latent in all men: "So it is that this messianic people, although it does not actually include all men, and may more than once look like a small flock, is nonetheless a lasting and sure seed of unity, hope, and salvation for the whole human race" (*LG* 9b).

b. Dialogue would be the way to activate this latent unity present in all men. Upon describing the ever widening concentric circles to be reached by dialogue, *Gaudium et spes* explains the amplitude of the reality described above as messianic people, which would even include atheists and Communists:

"By virtue of her mission to unify under one Spirit all men of whatever nation, race, or culture, the Church stands forth as a sign of that fraternity which allows honest dialogue and invigorates it. Thus all those who compose the one people of God, both pastors and general faithful, can engage in dialogue with ever-abounding fruitfulness Our hearts embrace also those brothers and communities not yet living with us in full communion. To them we are linked nonetheless by our profession of the Father and the Son and the Holy Spirit, and by the bond of charity

"We also turn our thoughts to all who acknowledge God, and who preserve in their traditions precious elements of religion and humanity. We want frank conversation to compel us all to receive the inspirations of the Spirit faithfully and to measure up to them energetically. The desire for such dialogue, which can lead to truth through love alone, excludes no one, though an appropriate measure of prudence must undoubtedly be exercised. We include those who cultivate beautiful qualities of the human spirit, but do not yet acknowledge the Source of these qualities.

"We include those who oppress the Church and harass her in manifold ways. Since God the Father is the origin and purpose of all men, we are all called to be brothers. Therefore, if we have been sum-

moned to the same destiny, which is both human and divine, we can and we should work together without violence and deceit in order to build up the world in genuine peace" (*GS* 92).

c. Cardinal Raúl Silva Henríquez confirmed the notion of "people of God" in its more radical conception, that is, embracing all men. Referring to *Lumen gentium*, he affirmed that it proposed: "as the doctrinal definition of Catholicism the idea of the people of God, an entity that prefigures and promises peace and that includes all men without exception" (*Memórias*, p. 41).

d. For more about "messianic people," see Vol. XI, *Ecclesia*, Chap. I.3.D.

f. At the end of the 19th century, a Gnostic Church was established in France, which pretended to be the continuation of Valentine, a heretic in the early History of the Church, and the medieval Cathars. In 1907, this Gnostic Church began to publish the magazine *Réveil gnostique* [Gnostic awakening], which exposed the movement's goals and program, curiously similar to those of the Conciliar Church. This is how the magazine described one of its aims: "An essential objective of the Gnostic Catholic Church is to restore to humanity its original religious unity, that is to say, to make it reject the errors that issued from the different religions, and to establish and spread a religion, truly catholic, in accordance with universal tradition.

"It [the Gnostic Church] would not impose itself on consciences through the force of civil or military power, nor by empty threats of punishments in the afterlife or false promises of future rewards. On one hand, it bases itself on the tradition of all civilized peoples and on the other, on philosophy and modern sciences. Therefore, its truths present themselves not only as objects of faith, but as the object of philosophical and scientific demonstrations. It directs itself to reason, which is the same in all men.

"The Gnostic Catholic Church is broad and tolerant. It respects the customs and laws of all peoples, and allows admittance to all men – of all nationalities, languages, and races, born and educated in any religion" (*apud* Emmanuel Barbier, *Les infiltrations maçonniques dans l'Église*, Lille: Desclée de Brouwer, 1910, pp. 91-2).

g. Various points of what we recognize as the ecumenical desires of the Conciliar Church also coincide with the ideal of Modernism. Eulogizing certain German intellectuals of liberal Protestantism, Ernesto Buonaiuti, perhaps the most important Italian Modernist, presented the "dream" of the current of thought to which he belonged. Buonaiuti wrote: "As it matures, the dream of Modernism is showing itself increasing to be what it always was: the ideal of the rebirth of Christianity and the reconciliation of the different Christian confessions, based on elementary experiences that religiosity in

§ 13 It should be noted that the progressivist concept of "people of God" is presented as the common denominator of all the various stages. Better said, it acts as a *chameleon-concept*, capable of taking on the characteristics of each stage. Thus, "people of God" can be understood as the Catholic Church; later it is analogous to "Church of Christ;" it can also be understood as the "Church of God;" finally, the concept of "people of God" would be synonymous with "messianic people."

Such are the various degrees of erosion in the unity of the Catholic Church worked by the Conciliar Church to corrode the ordinary and extraordinary teaching of the Magisterium.

*

general and Christianity in particular continually offer to the human spirit, transcending all the dogmatic and disciplinary elaborations that the needs of collective life create in space and time" (*Le modernisme catholique*, Paris: Ed. Rieder, 1927, p. 165).

First Premise

TRADITIONAL CATHOLIC TEACHING ON THE UNICITY OF THE FAITH AND CONDEMNATIONS OF ECUMENISM

§ 1 On the unique character of the Catholic Church, identified as the Church of Christ, Pope Boniface VIII taught: **"Urged by Faith, we are obliged to believe and to maintain that the Church is One, Holy, Catholic, and Apostolic. We believe in her firmly and we confess with simplicity that outside of her there is neither salvation nor the remission of sins**, as the Spouse in the Canticles proclaims: **'One is my dove, my perfect one. She is the only one, the chosen of her who bore her,'** and she represents one sole mystical body whose Head is Christ and the head of Christ is God. **In her, then, is one Lord, one Faith, one baptism**.

"There was at the time of the deluge only one ark of Noah, prefiguring the one Church, and this ark had only one pilot and guide, i.e., Noah, and we read that, outside of this ark, all that subsisted on the earth was destroyed. We venerate this Church as one, the Lord having said by the mouth of the prophet: 'Deliver, O God, my soul from the sword and my only one from the hand of the dog.' He has prayed for His soul that is for Himself, heart and body; and this body is the Church. **This is the tunic of the Lord, the seamless tunic, which was not rent."**[1]

§ 2 In the same sense, Leo XIII wrote: **"Dispersed and separated members cannot be united with one and the same head to form one single body. St. Paul tells us, 'All the members of the body, whereas they are many, yet are one body; so also is Christ'** (1 Cor 12:12). Wherefore this body, he further states, is united and joined together. 'Christ is the

[1] Boniface VIII, Bull *Unam Sanctam*, in Giorgio Balladore Pallieri - Giulio Vismara, *Acta Pontificia Juris Gentium* (Milan: Società Editrice Vita e Pensiero, 1946), p. 8, n. 27.

head, from whom the whole body, being compacted and fitly joined together, by what every joint supplieth, according to the operation in the measure of every part' (Eph 4:15,16).

"And so, therefore, **if some member becomes separated and detached from the other members, it cannot belong to the same head to which the rest of the body belongs.** St. Cyprian says: 'There is only one God, only one Christ, only one Church of Christ, only one Faith, only one people, joined together in the solid unity of a single body by the bond of concord. **This unity cannot be broken: a body that remains whole cannot be divided by the separation of its constituent parts.**'[2] To establish more clearly the unity of the Church, God presents it to us under the image of a living body, **whose members cannot live unless united to the head and drawing incessantly from it their vital force. Separated from the head, they must die.** 'The Church cannot be divided into parts by the separation and cutting asunder of her members. Everything that is separated from her center of life cannot live or breathe apart from her'[3]

"One seeks, therefore, another head similar to Christ, one seeks another Christ, if one wants to imagine another Church outside of that which is His body. 'See what you must beware of; see what you must avoid; see what you must dread. At times it happens that some member may be cut off from the human body, that is, be separated from the body: a hand, a finger, a foot. **Does the soul follow the amputated member? So long as it was on the body, it lived; separated, it lost its life. Thus the man, so long as he lives on the body of the Church, he is a Christian Catholic; separated from her, he becomes a heretic. The life of the soul does not follow the amputated member.**'[4]

"**The Church of Christ, therefore, is one** and the same forever. **Whoever leaves her departs from the will and command of Our Lord Jesus Christ; leaving the path of salvation, he enters that of perdition.** 'Whosoever is separated from the Church is united to an adulteress. He has cut himself off from the promises of the Church. **Whosoever leaves the Church of Christ cannot arrive at the rewards of**

[2] St. Cyprian, *De Catholicae Ecclesiae unitate*, n. 23.

[3] *Ibid.*

[4] St. Augustine, *Sermo 267*, n. 4.

Christ Whosoever observes not this unity observes not the law of God; whosoever holds not the faith of the Father and the Son, holds not to life and salvation.'[5]'[6]

§ 3 Addressing the unicity and unity of the Church and the Faith, Leo XIII continued: "**He who instituted this one Church also gave her unity, that is, He made her such that all who are to be her members must be united by the closest bonds, so as to form together one people, one kingdom, one body**: 'One body and one spirit, as you are called in one hope of your calling' (Eph 4:4). Jesus Christ desired that this bond of unity should be so closely knit and so perfect among His followers that it might in some measure imitate the union between Himself and His Father: 'I pray that they all may be one, as Thou, Father, in Me, and I in Thee' (Jo 17:21).

"Now, such concord, such absolute concord between men, should have as necessary foundation the agreement and union of minds; from this harmony of will and agreement of action are the natural results. Wherefore, according to His divine plan, **Jesus ordained that unity of Faith exist in His Church, because the Faith is the first of all the bonds that unite man to God, and whence we receive the name of the faithful**: 'One Lord, one faith, one baptism' (Eph 4:5). That is, as there is one Lord and one baptism, **so should all Christians, without exception, have but one Faith**."[7]

§ 4 Further on, Leo XIII set forth the perennial position of the Church in defending the Catholic Faith against heretics: "**Founded on these principles and mindful of her office, the Church has done nothing with greater zeal and endeavor than she has displayed in conserving in the most perfect manner the integrity of the Faith.**

"**Hence she regarded as declared rebels and expelled from the ranks of her children all who held beliefs on any point of doctrine different from her own. The Arians, the Montanists, the Novatians, the Quartodecimans, the Eutychians, certainly did not reject all of Catholic doctrine, but only this or that part of it. Still, who does not know that they were declared heretics and banished from the bosom**

[5] St. Cyprian, *De Catholicae Ecclesiae unitate.*

[6] Leo XIII, Encyclical *Satis cognitum*, of June 29, 1896 (Petrópolis: Vozes, 1960), n. 10.

[7] *Ibid.*, n. 11.

of the Church? In like manner were condemned all authors of erroneous doctrine who followed them in subsequent ages of History. 'There can be nothing more dangerous than those heretics who, conserving in almost everything the integrity of doctrine, by one word, as with a drop of poison, corrupt the purity and simplicity of the Faith that we receive from Our Lord and handed down by apostolic tradition.'[8]

"Such was always the practice of the Church, as is shown by the unanimous teaching of the Holy Fathers, who always considered as excluded from Catholic communion and outside the Church whoever would recede in the least degree from any point of doctrine taught by the authentic Magisterium. Epiphanius, Augustine, Theodoret drew up a long list of the heresies of their times. St. Augustine noted that yet other heresies could spring up, and that should anyone give his assent to a single one of them, he is by the very fact cut off from Catholic unity. He said: 'By the mere fact that someone does not believe these errors [the heresies he had just listed], it does not follow that he can for that reason regard himself as a Catholic or call himself one. For there may be or may arise some other heresies, which are not set out in this work of ours, and anyone who holds to a single one of these, he is not a Catholic.'[9],[10]

§ 5 Leo XIII also recalled the luminous words of St. Hilary: "And so St. Hilary wrote, 'Christ teaching from the ship signifies that those who are outside the Church can never grasp the divine teaching. For the ship represents the Church, the only place where the word of life is deposited and preached. Those who are outside and remain there, sterile and worthless like the sand on the beach, cannot understand Him.'[11],[12]

§ 6 The same Pontiff identified Christianity with the Catholic Church: "The return to Christianity will not be a true and efficacious remedy unless it signifies the return to and love for the One, Holy, Catholic, and Apostolic Church.

[8] *Tractatus de Fide Orthodoxa contra Arianos.*

[9] *De Haeresibus*, n. 88.

[10] Leo XIII, *Satis cognitum*, n. 18.

[11] *Comment. In Matth, XIII*, n. 1.

[12] Leo XIII, *Satis cognitum*, n. 19.

Yes, because Christianity acts and identifies with the Catholic Church, the supremely spiritual and perfect society, which is the Mystical Body of Christ, and has as visible head the Roman Pontiff, successor of the Prince of Apostles."[13]

§ 7 Echoing the perennial doctrine of the Magisterium, Pius IX, together with Vatican Council I, taught that the Faith is found only in the bosom of the Holy Church. The Pontiff emphasized the separation of the false religions: "**Only the Catholic Church has all the marks, so numerous and so admirably established by God, to make evident the credibility of the Christian Faith.** Beyond this, the Church in herself, by her admirable propagation, her exquisite holiness, and her inexhaustible fecundity in all her goods, by her Catholic unity and unconquerable stability, provides a serious and perpetual motive for credibility, and an irrefutable testimony to her divine mission. Whence it comes that the same Church, like 'a standard set up unto the nations' (Is 11:12), not only invites the unbelieving to enter into her body, but also guarantees her children that the Faith that they profess is based on the most firm foundation

 "**So that in no way is the condition the same for those who, by the celestial gift of Faith, embrace the Catholic truth as for those who, led by human opinions, follow a false religion.** Because those who receive the Faith under the Magisterium of the Church never can have just cause to change or place in doubt that same Faith. And for this reason, 'giving thanks to God the Father, Who hath made us worthy to be partakers of the lot of the saints in light' (Col 1:12), we do not underrate such a great benefit, but 'looking on Jesus, the author and finisher of Faith' (Heb 12:2), 'let us hold fast the confession of our hope without wavering' (Heb 10:23)."[14]

§ 8 Pius XII clearly identified the Church of Christ with the Catholic Church. Basing himself on Vatican Council I, he wrote: "Now, in order to define and describe **this true Church of Christ, which is the Holy, Catholic, Apostolic, Roman Church,**[15] there is nothing more noble, more excellent, or more

[13] Leo XIII, Encyclical *Parvenu* (Petrópolis: Vozes, 1952), n. 26.

[14] Vatican Council I, Dogmatic Constitution on the Catholic Faith, session 3, April 1794, n. 1794 (Petrópolis: Vozes, 1953), pp. 7-8.

[15] *Ibid.*, chap. 1.

divine than the concept expressed in the name 'Mystical Body of Christ.'"[16]

§ 9 In his celebrated Encyclical *Pascendi Dominici gregis*, St. Pius X described and anathematized the basis for the Modernist religious conception. In the text below, the Reader can see the extraordinary similarities that appear between Modernism and conciliar Progressivism. This is the condemned thinking:

"It is thus that **the religious sense, which emerges from the lurking-places of the *subconsciousness*, is the germ of all religion, and the explanation of everything that has been or ever will be in any religion**. This same *sense*, which was at first only rudimentary and almost formless, under the influence of that mysterious principle from which it originated, gradually matured with the progress of human life, of which, as has been said, it is a certain form. **This, then, is the origin of all, even of supernatural religion. For religions are mere developments of this *religious sense*. Nor is the Catholic religion an exception; it is on the same level with the rest; for it was engendered by the process of *vital immanence*, and by no other way, in the consciousness of Christ,** who was a man of the choicest nature, whose like has never been, nor will be.

"**In hearing these things, we shudder indeed at so great an audacity of assertion and so great a sacrilege!** And yet, Venerable Brethren, these are not merely the foolish babblings of unbelievers. There are Catholics, yea, and priests too, who say these things openly; and they boast that they are going to reform the Church by these ravings! The question is no longer one of the old errors which claimed for human nature a sort of right to the supernatural. It has gone far beyond that, and **has reached the point when it is affirmed that our most holy Religion, in the man Jesus Christ as in us, emanated from nature spontaneously and of itself.** Nothing assuredly could be more utterly destructive of the whole supernatural order. For this reason, the [First] Vatican Council most justly decreed: 'If anyone says that man cannot be raised by God to a knowledge and perfection which surpasses nature, but that he can and should, by his own efforts and by a constant develop-

[16] Pius XII, Encyclical *Mystici Corporis Christi* (Petrópolis: Vozes, 1960), n. 9.

ment, attain finally to the possession of all truth and good, let him be anathema."[17],[18]

§ 10 To dodge this anathema, progressivists have adopted a terminology with some mention of the "supernatural," even though their doctrine in general preaches the same errors of the Modernists.[19]

In effect, the notions of "Church of Christ," "Church of God," "messianic people," and "people of God" present in the Council documents seem to rely on the same thesis of a religious sentiment immanent in man. And this would be the common denominator of all the ecumenical attempts for union with other creeds – the "Christians," non-Christians, and non-believers.

§ 11 Combating religious Indifferentism, Gregory XVI discerned the germs of what would later be called ecumenism. He taught: "We reach now another cause for the evils that unhappily afflict the Church at this time. That is, **we arrive at this 'Indifferentism,' or this perverse opinion that has spread everywhere as the work of evil ones, according to which it would be possible to achieve eternal salvation by means of any profession of faith,** so long as the practices be upright and honest. **It will not be difficult,** in such a clear and evident matter, **to reject from the bosom of the peoples who are confided to your care this fatal error. Given that the Apostle warns us that there is only 'one Lord, one Faith, one baptism'** (Eph 4:5), **these people should fear those who imagine that every religion offers the means to arrive at eternal happiness and should understand that, according to the testimony of the Savior Himself, 'he that is not with me, is against me'** (Lk 11:23), and that they unhappily scatter since they do not gather with Him. **Consequently, 'it is not to be doubted that they will perish eternally if they do not profess the Catholic Faith and if they do not guard it entire and inviolate.'**[20],[21]

[17] First Vatican Council, *De Revel.*, can. III.

[18] Encyclical *Pascendi Dominici gregis*, n. 10.

[19] See Vol. I, *In the Murky Waters of Vatican II*, General Introduction, footnote 23; Chap. IV, § 3, footnotes 3, 5-7, Chap. VI §§ 2-8; Vol. IV, *Animus delendi I*, Chap. II, § 10.

[20] Symbol of St. Athanasius.

§ 12 In 1846, Pius IX pronounced severe words against religious Indifferentism, which apply opportunely to the ecumenism of Vatican II and the conciliar Popes. After condemning the "biblical societies" that induced careless Catholics to adopt free examination and fall into the "abyss of the most terrible errors," the Pontiff censured religious Indifferentism:

"Also perverse is the shocking theory that it makes no difference to which religion one belongs, a theory which is greatly at variance even with reason. By means of this theory, those crafty men remove all distinction between virtue and vice, truth and error, honorable and vile action. They pretend that men can gain eternal salvation by the practice of any religion, as if there could ever be any sharing between justice and iniquity, any collaboration between light and darkness, or any agreement between Christ and Belial."[22]

§ 13 In 1848, the same Pontiff hurled yet another condemnation against Indifferentism: **"Many enemies of the Catholic truth, above all in our time, direct their efforts to spreading the most monstrous opinions of equality of conditions with the doctrine of Christ, or confuse them with His teaching. Thus do they strive with increasing energy to propagate this impious system of indifference in face of all religion."[23]**

§ 14 In a document against the Peruvian priest Francisco Vigil, Pius IX denounced one of the foundations for contemporary ecumenism: "Even though he calls himself Catholic and is engaged in the holy militia [of the divine ministry] **the author [Fr. Vigil], in order to sustain with more assurance and impunity the Indifferentism and Rationalism with which he shows himself to be infected, denies to the Church the power to formulate dogmatic definitions. So also does he deny to her the exclusive title of true Religion. Hence he says that each one has the liberty to take up and profess the**

[21] Gregory XVI, Encyclical *Mirari vos*, August 15, 1832, *Recueil des allocutions*, p. 163.

[22] Pius IX, Encyclical *Qui pluribus*, November 9, 1846, *Recueil des allocutions*, p. 181.

[23] Pius IX, Allocution *Ubi primum*, December 17, 1848, *Recueil des allocutions*, p. 205.

religion that he judges true according to the light of his reason."[24]

§ 15 Responding to the first ecumenical encounters in Catholic ambiences, Pope Pius XI published the Encyclical *Mortalium animos* in 1928. In it he ratified the immutable position of the Pontifical Magisterium in defense of the unity of the Faith and the unicity of the Catholic Church. He reaffirmed the position of fight that Catholics must take in face of ecumenical endeavors. He qualified such initiatives as "pan-Christian," "blasphemous," and destructive of the true Faith. Further, he held them to be trailblazers of religious Indifferentism and Modernism.

§ 16 Pius XI analyzed the nascent ecumenical attempts in this way: "Knowing perfectly that there exist few men who are entirely devoid of the religious sense, they **[the men who are trying to introduce a sentiment of universal fraternity into the Church] nourish the hope that all the peoples, despite their religious differences, may yet, without great difficulty, be united in the profession of certain doctrines admitted as a common basis of the spiritual life.**

"With this object, they promote congresses, meetings, and conferences, attended by a considerable number of hearers. To join in the discussion they invite all, without distinction, unbelievers of every kind as well as the faithful, and even those who have disgracefully separated themselves from Christ or rudely and obstinately denied the divinity of His nature and mission. **Such efforts can meet with no kind of approval among Catholics, because they support the erroneous opinion that all the religions are more or less good and praiseworthy Those who hold such a view fall into an open error; they also reject the true Religion; they distort its tenets and fall gradually into Naturalism and Atheism. Therefore, it is perfectly evident that one who joins with the partisans and propagators of similar doctrine abandons entirely the divinely revealed Religion."[25]**

§ 17 The same Pontiff analyzed the ecumenical argumentation in order to more easily point out its innumerable errors:

[24] Pius IX, Apostolic Letter *Multiplices inter*, June 10, 1851, *Recueil des allocutions*, p. 287.

[25] Pius XI, Encyclical *Mortalium animos*, of January 6, 1928 (Paris: Bonne Presse, 1928), vol. 4, pp. 64-5.

"And here it is opportune to expound and to refute an error which lies at the root of this whole question and from which proceeds the activity and multiple efforts of non-Catholics to bring about the union of Christian churches. Toward this aim, the authors of that project have the habit of quoting the words of Christ, 'that they all may be one [*ut unum sint*] and there shall be one fold and one shepherd (Jn 17:21),' as if, to their understanding, the prayer and the desire of Christ had not yet been carried out until today. **For they hold that the unity of Faith and government, which is the note of the one true Church, has up to the present time hardly ever existed, and does not exist today**; that this unity is indeed to be desired and realized, at times by a common understanding of wills, but that it is necessary, notwithstanding, to consider it as a type of utopia.

"**They add that the Church by her nature is divided, that is, composed of innumerable churches or distinct communities** which still remain separate, **and although they hold in common some points of doctrine, nevertheless they differ concerning the remainder. Each church, according to them, enjoys the same rights** Hence, they say, **controversies, even long-standing ones, and doctrinal differences, which still today continue to divide them must be forgotten and set aside. And, with regard to other doctrinal truths, it is necessary to propose and draw up a certain rule of common faith. In this profession of faith they may feel themselves to be true brothers**

"Such, Venerable Brethren, is the common contention But **they immediately go on to say that this Roman Church, too, has erred and corrupted the primitive religion** by adding to it a certain number of doctrines not only foreign but contrary to the Gospel, and imposing them on the Faith of the faithful. Chief among these they cite that of the primacy of jurisdiction granted to Peter and to his successors in the See of Rome [and they praise secondary aspects of the Papacy] However, even while you may hear many non-Catholics loudly preaching brotherly communion in Jesus Christ, yet **not one will you find who thinks of submitting to the Vicar of Christ in what he teaches or of obeying what he commands. They assert that they prefer to deal with the Church of Rome on equal terms, as equals with an equal. In reality, however, if they propose some eventual accord, it is not with the intention of renouncing those same opinions that**

hold them, still today, **in their errors and deviations, outside the one fold of Christ.**

"In these conditions, **it is evident that the Apostolic See cannot under any pretext take part in these [inter-confessional] assemblies; nor do Catholics have any right to favor such enterprises by their support or action. If they did so, they would be attributing authority to a false religion, entirely alien to the one Church of Christ. How could we tolerate that the truth, above all the revealed truth, be made a subject for compromise? This would be the height of iniquity** How can it be allowed that the object of Faith become in the process of time so dim and uncertain that we should tolerate these contradictory opinions? If this were so, then we should have to admit that the coming of the Holy Ghost upon the Apostles, the perpetual indwelling of the same Spirit in the Church, and even the preaching of Jesus Christ Himself many centuries ago would have lost all their efficacy and value. To affirm this would be blasphemy

"**These pan-Christians** who **strive for the union of the churches** would appear to pursue the noblest of ideals in promoting charity among all Christians. But how can one imagine that this growth of charity be made to the detriment of the Faith? Everyone knows that **St. John himself, the Apostle of charity** **absolutely forbade any relationship with those who did not profess the doctrine of Christ pure and entire**: 'If any man come to you, and bring not this doctrine, receive him not into the house, nor say to him, God speed you' (Jn 1:10). Therefore, **since the foundation of charity is Faith pure and inviolate, unity of Faith should be, as a consequence, the principal bond that unites the disciples of Christ.**

"**How, then, can one conceive of the possibility of a Christian pact, in which each member would have the right, even in questions of Faith, to retain his own way of seeing and thinking, even when it would be in contradiction with the opinions of the others?**"[26]

§ 18 Pope Pius XI continued by predicting that partisans of ecumenism could easily fall into Indifferentism and Modernism: "**In these profound differences of opinion, we no**

[26] *Ibid.*

longer perceive the unity of the Church, because this unity results necessarily only from one single teaching on the Faith and from one law of belief of all Christians. On the contrary, we perceive clearly that from such a state of affairs it is but an easy step to the neglect of religion, or Indifferentism, and to the error of the modernists. Those unfortunate ones infected with these errors hold that dogmatic truth is not *absolute*, but *relative*, that is, that it should adapt to the varying necessities of time and place and to the diverse tendencies of the mind; that it is not contained in an immutable Revelation, but by its nature can be altered to suit the needs of human life."[27]

§ 19 Pius XI closed his Encyclical prohibiting ecumenism and refuting the thesis of *Ecclesia semper reformanda* and the "Sinning Church," today defended by conciliar progressivists: "Thus, Venerable Brethren, it is clear why **this Apostolic See has never allowed its subjects to take part in the assemblies of non-Catholics. There is but one way in which the unity of Christians may be fostered, and that is by furthering the return to the one true Church of Christ of those who are separated from it; for from that one true Church they have in the past fallen away. The one Church of Christ is visible to all, and will remain, according to the will of its Author, exactly the same as He instituted her.**

"**The mystical Spouse of Christ has never in the course of centuries been contaminated, nor in the future can she ever be,** as Cyprian bears witness: 'The Bride of Christ cannot become false to her Spouse, she is inviolate and pure. She knows but one dwelling and chastely and modestly she guards the sanctity of the nuptial chamber.'[28] The same holy martyr marveled that anyone could believe that 'this unity [of the Church], fruit of divine stability and consolidated by the heavenly Sacraments, could ever be broken by the shock of discordant wills.'[29] **For since the Mystical Body of Christ, like His physical body, is one** (1 Cor. 12:12), **compacted, and fitly joined together** (Eph 4:16), **it is foolish to say that the Mystical Body is composed of disjointed and scattered members. Whosoever therefore is not united with**

[27] *Ibid.*, pp. 76-7.

[28] *De Cath. Ecclesiae unitate*, 6.

[29] Pius XI, Encyclical *Mortalium animos*, p. 77.

the body is no member thereof, neither is he in communion with Christ her Head."[30]

The Catholic doctrine presented here clearly demonstrates the constant teaching of the pontifical Magisterium prior to Vatican II. [31]

<div align="center">*</div>

[30] *Ibid.*, pp. 78-9.

[31] For more examples of doctrine against ecumenism pronounced by Popes prior to Vatican II, see:

Against Ecumenism and religious Indifferentism, Leo XII, Encyclical *Ubi primum*, of May 5, 1824 (DS 2720); Gregory XVI, Encyclical *Mirari vos*, of August 15, 1832 (DS 2730-1); Pius IX, Encyclical *Quanto conficiamur moerore*, of August 10, 1863 (DS 2865-6.); *Syllabus*, of December 8, 1864 (DS 2915, 2918, 2921, 2977-8.); St. Pius X, Letter *Notre Charge Apostolique*, of August 25, 1910 (nn. 30-1, 34-5).

Against those who admit salvation outside the Church: 16th Council of Toledo, *Symbolum*, of May 2, 693 (DS 575); *Fourth Lateran Council*, of November 11-30, 1215 (DS 802); Boniface VIII, Bull *Unam sanctam*, of November 18, 1302 (DS 870); Council of Florence, Bull *Cantate Domino*, of February 4, 1442 (DS 1351); Pius IX, Encyclical *Qui pluribus*, of November 9, 1846 (DS 2785); *Syllabus*, of December 8, 1864 (DS 2916-7); Pius XII, Encyclical *Mystici corporis*, of June 29, 1943 (DS 3821); Letter from the Holy Office to the Archbishop of Boston, of August 8, 1949 (DS 3866-7, 3869-72).

EXCERPTS FROM VATICAN II ON ECUMENISM IN APPARENT CONTRADICTION TO FORMER CATHOLIC TEACHING

With regard to the unicity of the Catholic Church and the unity of the Faith, some excerpts from Vatican Council II, by way of example, are presented below that would seem to contradict the formerly cited pontifical teachings.

1. Concerning the notion of *Ecclesia semper reformanda*

§ 1

* "Christ, 'holy, innocent, and undefiled' (Heb 7:26), knew nothing of sin (2 Cor 5:21), but came only to expiate the sins of the people (Heb 2:17). **The Church, however, clasping sinners to her bosom, at once holy and always in need of purification, follows constantly the path of penance and renewal.**" (*LG* 8c)

* "**Every renewal of the Church essentially consists of an increase of fidelity to her own calling.** Undoubtedly this explains the dynamism of the movement toward unity. **Christ summons the Church as she goes her pilgrim way, to that continual reformation of which she always has need,** insofar as she is an institution of men here on earth. Consequently, **if,** in various times and circumstances, **there have been deficiencies in moral conduct or in Church discipline, or even in the way that Church teaching has been formulated these should be set right at the opportune moment and in the proper way.**" (*UR* 6a)

* "**Every Catholic must** therefore aim at Christian perfection and **play his part, that the Church,** which bears in her own body the humility and dying of Jesus, **may daily be more purified and renewed,** against the day when Christ will present her to Himself in all her glory without spot or wrinkle." (*UR* 4f)

* **"The pilgrim Church, in her sacraments and insti-
tutions, which belong to the present age, carries the mark
of this world which will pass,** and she herself takes her place
among the creatures which groan and travail yet and await the
revelation of the sons of God (Rom 8:19-22)." (*LG* 48c)

2. Concerning the notion of the "Sinning Church"

§ 2 * **"Large communities became separated from full
communion with the Catholic Church – for which, often
enough, men of both sides were to blame."** (*UR* 3a)

* **"St.** John has testified: **'If we say we have not
sinned, we make him a liar, and his word is not in us'** (Jn
1:10). **This holds good for sins against unity. Thus, in hum-
ble prayer we beg pardon of God and of our separated
brethren,** just as we forgive them that offend us." (*UR* 7b)

* "Remembering, then, her common heritage with the
Jews **the Church deplores all hatreds, persecutions, dis-
plays of anti-Semitism leveled at any time or from any
source against the Jews."** (*NA* 4g)

3. The true Faith would exist outside the Catholic Church

§ 3 * **"In the study of revealed truth,** [the Schismatic]
East and [the Catholic] **West have used different methods
and approaches in understanding and confessing divine
things. It is hardly surprising, then, if sometimes one tradi-
tion has come nearer to a full appreciation of some aspects
of a mystery of revelation than the other, or has expressed
them better. In such cases, these various theological formu-
lations are often to be considered complementary rather
than conflicting."** (*UR* 17a)

* "Everyone knows with what love the Eastern Chris-
tians celebrate the sacred liturgy, especially the eucharistic
mystery, source of the Church's life and pledge of future glory.
In this mystery the faithful, united with their bishops, have ac-
cess to God the Father through the Son And so, made 'shar-

ers of the divine nature' (2 Pet 1:14), they enter into communion with the most holy Trinity. **Hence, through the celebration of the Eucharist of the Lord in each of these** [Schismatic] **Churches, the Church of God is built up and grows in stature,** and through concelebration, their communion with one another is made manifest." (*UR* 15a)

 * **"From their very origins the [Schismatic] Churches of the East have had a treasury from which the Church of the West has drawn largely for its liturgy, spiritual tradition, and jurisprudence.** Nor must we underestimate the fact that the basic dogmas of the Christian faith concerning the Trinity and the Word of God made flesh from the Virgin Mary were defined in Ecumenical Councils held in the East. **To preserve this faith, these Churches have suffered, and still suffer much."** (*UR* 14b)

4. Grace would act normally independent of the Catholic Church

§ 4

 * "Without doubt, the differences that exist in varying degrees between them [the Protestants] and the Catholic Church – whether in doctrine and sometimes in discipline, or concerning the structure of the Church – do indeed create many obstacles, sometimes serious ones, to full ecclesiastical communion. The ecumenical movement is striving to overcome these obstacles. But even in spite of them, **it remains true that all [the Protestants] who have been justified by faith in baptism are incorporated into Christ; they therefore have a right to be called Christians, and with good reason are accepted as brothers by the children of the Catholic Church.**

 "Moreover, **some, even very many, of the most significant elements and endowments, which together go to build up and give life to the Church herself, can exist outside the visible boundaries of the Catholic Church**: the written Word of God, **the life of grace; faith, hope, and charity, with the other interior gifts of the Holy spirit as well as visible elements**

 "The brethren divided from us also carry out many liturgical actions of the Christian religion. In ways that vary according to the condition of each Church or community, **these**

liturgical actions most certainly can truly engender a life of grace." (*UR* 3a,b,c)

* "Nor should we forget that anything, wrought by the grace of the Holy Spirit in the hearts of our separated brethren can contribute to our own edification." (*UR* 4i)

* "The Lord of ages nevertheless wisely and patiently follows out the plan of grace on our behalf, sinners that we are. In recent times he has begun to bestow more generously upon divided Christians remorse over their divisions and longing for unity." (*UR* 1b)

* "The Catholic Church rejects nothing of what is true and holy in these [non-Christian] religions." (*NA* 2b)

5. There would be salvation outside of the Catholic Church

§ 5

* "This Church [of Christ], constituted and organized as a society in the present world, subsists in the Catholic Church Nevertheless, many elements of sanctification and of truth are found outside its visible confines." (*LG* 8b)

* "The brethren divided from us also carry out many liturgical actions of the Christian religion These liturgical actions most certainly can truly engender a life of grace and, one must say, can aptly give access to the communion of salvation." (*UR* 3c)

* "It follows that these separated churches and communities as such, though we believe they suffer from the defects already mentioned, have been by no means deprived of significance and importance in the mystery of salvation. For the Spirit of Christ has not refrained from using them as means of salvation." (*UR* 3d)

6. *Communicatio in sacris* [worship in common] should be made with heretics and schismatics [1]

§ 6

 * "In certain circumstances, such as in prayer services 'for unity' and during ecumenical gatherings, **it is allowable, indeed desirable, that Catholics should join in prayer with their separated brethren. Such prayers in common are certainly a very effective means of petitioning for the grace of unity, and they are a genuine expression of the ties, which still bind Catholics to their separated brethren.** 'For where two or three are gathered together in my name, there am I in the midst of them' (Mt 18:20).

"Yet worship in common [*communicatio in sacris*] is not to be considered as a means to be used indiscriminately for the restoration of unity among Christians. There are two main principles upon which the practice of such common worship depends: *first*, that of the unity of the Church which ought to be expressed; and *second*, that of the sharing in the means of grace. The expression of unity very generally forbids common worship. **Grace to be obtained sometimes commends it**" (*UR* 8c, d).

 * "**These** [Greek Schismatic] **Churches, although separated from us, yet posses true sacraments, above all –** by apostolic succession – **the priesthood and the Eucharist, whereby they are still joined to us in closest intimacy. Therefore some worship in common** [*communicatio in sacris*), given suitable circumstances and the approval of Church

[1] a. *Communicatio in sacris*, that is, worship in common, signifies the participation of Catholics in ceremonies of false religions. Such participation was formally prohibited by the *Code of Canon Law* of 1917 (canons 1258 and 2316).

b. It seems, therefore, that the cited texts from the conciliar Decree *Unitatis redintegratio* would fall under suspicion of heresy, since the Pius-Benedictine *Code of Canon Law* was in force when the document was approved by the majority of the conciliar Bishops (November 21, 1964).

c. On the question of whether this suspicion would still be incurred after the *Code of Canon Law* of John Paul II was published in 1983 – in which the above-mentioned canons were eliminated – see Vol. III, *Animus injuriandi II*, Chap. I.1.A.

authority, **is not merely possible but is encouraged**." (*UR* 15c)

 * "**In ecumenical work, Catholics must assuredly be concerned for their separated brethren,** praying for them, **keeping them informed** about the Church, **making the first approaches** toward them." (*UR* 4c)

* * *

Chapter I

THEOLOGICAL PLURALISM
SUPPOSES THE DENIAL OF
THE UNITY AND THE UNICITY OF THE FAITH

§ 1 The notion of *Ecclesia semper reformanda* is the *first kraftidee* of conciliar ecumenism.[1] It supposes a constant modification in doctrine and the ecclesiastic institution. What is the principal instrument for this reform? The establishment of theological pluralism.

§ 2 Theological pluralism is a term that has been used quite often since the Council. Now, there is a good theological pluralism, which the Church has always employed, and there is a bad theological pluralism, which is what the progressivists desire. Here the two types will be differentiated, and the applications studied.

Even though in essence theological pluralism is a single phenomenon, the expression has different applications, which it is worthwhile to know.

§ 3 **Essentially**, theological pluralism can be explained as expressions of the same theological truth by means of different formulations. This is quite common in the Church in the stage of intellectual development that corresponds to *quaestiones disputatae* [the questions open to dispute]. That is, when the Church still has not defined her doctrine on a determined question, she allows her children the liberty to discuss it freely. This phase is followed by another, during which theological pluralism is still fitting. In this phase, while the Church is already inclining toward a solution to the problem under discussion, she still has not chosen the precise terminology to define it.

§ 4 In the *first phase*, the investigations in general are about the substance of the subject matter; in the *second phase*, they are more often hermeneutic discussions about the better terminology to define the doctrine that has already been established. In the *third phase*, the Church, assisted by the Holy Ghost, uses

[1] See Part II, Premises, §§ 1-13.

her power to teach and define the matter in question. **With this, legitimate pluralism in the substance of theological investigation ceases, and the legitimate hermeneutic discussion about the best way to formulate the doctrine ends. Thenceforth obedience is enforced.** Thus begins a phase of accommodation as the new defined truth settles in to the body of Dogma and Morals. During this *fourth phase*, then, co-relations are established with the other defined truths.

§ 5 By improperly using the expression *theological pluralism*, the progressivists distorted its legitimate meaning and gave it a spurious and relativist sense. Their use of the term implies that there is no such thing as a unique dogmatic truth or a sole moral rule that can be defined in an immutable formula, even after the Church has pronounced her definitive decision. For progressivists, there would always be facts that influenced and conditioned the research of truth and dogmatic definitions, which would make them uncertain and imprecise by nature.[2] Hence the need, they claim, for a theological pluralism that constantly debates dogmatic and moral definitions with an obstinately critical spirit. This pluralism, one sees, denies the unity of the Catholic Faith and tries to establish in the very bosom of the Church a free interpretation of defined teaching that is relativist, rebellious, and Protestant by nature.

§ 6 In its *first application* of the expression theological pluralism, Conciliar Church grants right of citizenship to internal currents that dissent from the traditional Catholic teaching. This causes the relativization of dogma, be it in its substance, the definition of the truth, or its formulation. Something similar takes place with regard to Morals. This free interpretation of both Dogma and Morals creates a relativist climate regarding past teaching.

§ 7 In a way parallel to this admission of Protestant free interpretation of Dogma and Morals, the Conciliar Church employs the expression theological pluralism to grant admittance to an even more radical relativism: the freedom of thought and conscience proper to the modern world. With this, it intends to create an internal public opinion that would be composed of different, and even antagonistic currents that would transform the ecclesiastical milieu into something more similar to the modern civil democratic republics. According to progressivists,

[2] See Vol. IV, *Animus delendi I*, Chap V.4.

this would achieve the goal of *aggiornamento*.[3] The first application in the Church, then, is *ad intra* [turned toward the inside].

§ 8 The **second application** adapts Church doctrine to the doctrines of the false religions. Thus, the second application in the Church is *ad extra* [turned toward the outside].

Chapter I will analyze both applications of theological pluralism by the Conciliar Church.

*

§ 9 According to progressivists, their theological pluralism was introduced in the Church with the Decree *Unitatis redintegratio* of Vatican II. Cardinal Suenens, one of the principal political articulators of the Council, explained how far-reaching the thesis of "hierarchy of truths" would be in the post-Conciliar period:

"In the Decree on ecumenism, a small phrase was inserted almost in passing that must be examined in depth. Article II [Chap II, n. 11] says: '**In ecumenical dialogue, the Catholic theologians**, standing fast by the teaching of the Church yet searching together with the separated brethren into the divine mysteries, should act with love for the truth, with charity, and with humility. **When comparing doctrines, they should remember that in Catholic doctrine there exists an order, or 'hierarchy' of truths, since they vary in their relationship to the foundation of the Christian faith. Thus the way will be opened for this kind of 'fraternal rivalry' to incite all to a deeper realization and a clearer expression of the unfathomable riches of Christ.'**

"Explaining how they came to formulate this passage," Suenens continued, "the authors of the document clarified that 'although all revealed truths must, without any doubt, be believed as divine faith, their importance and weight differ according to their bearing upon the history of salvation and the mystery of Christ.'

"**How precious, indeed, is that phrase which speaks of a 'hierarchy of truths.'** Yes, every truth is true, but every

[3] See in this Volume, Introduction, §§ 1-5; Part I, Chap IV.1, 2; Vol. VI, *Inveniet Fidem?* Chap V.5.A.

truth is not equally central and vital to the Christian mystery. Was it by chance that Our Lord said that He is 'the way, the truth, and the life?' **For all Christians to converge around the truths closest to Our Lord** and the mystery of salvation **.... has a considerable importance in ecumenism.**

"What is central and vital in the Revelation of Our Lord? What is central to the indispensable communion of faith, preliminary to an ecumenical arrangement? The question is of prime importance: within it the whole hope of ecumenism lies.

"Here also Vatican II did not give the last word on the topic. What it gave was a germ of life, a mustard seed that could become the great tree of which Scripture speaks, in which all the birds of heaven could gather together."[4]

§ 10 Theological pluralism *ad extra* as well as *ad intra* were consequences of this notion of a "hierarchy of truths." With it came the "liberation" of Catholic theologians from the tutelage of the Magisterium, and especially the Holy Office. Symbolic of this "liberation" was the founding of the International Theological Commission (ITC), a pluralist organ[5] that was quick to officially announce its "autonomous research," in the words of Fr. Chenu.[6]

[4] a. L. J. Suenens, "Discorso ufficiale d'apertura. Alcuni compiti della teologia oggi," V.A., *L'avvenire della Chiesa*, pp. 50-1.

b. No one can deny that there are truths more central than others in the deposit of Faith. In this sense, the expression "hierarchy in truths," or "hierarchy of truths," is legitimate and even somewhat banal.

c. However, there is nothing legitimate or banal about the application made by Suenens and the authors of the Decree *Unitatis redintegratio*. What this application reveals is the desire to put aside or "forget" the dogmas of Faith and disciplinary principles that are not accepted by heretics and schismatics in order to facilitate the way for ecumenism. For the progressivists, then, these essential dogmas and principles could be viewed as "non-central" in the "hierarchy of truths."

[5] At the end of two interviews granted to the author of these lines in Louvain-la-Neuve (February 28 and March 1, 1983), Msgr. Phillipe Delhaye, Secretary-General of ITC, affirmed in a tone of content: "When the ITC was founded, its 30 members shared only one thinking; today there are 30 different thinkings in it."

For more about the ITC, see Vol. IV, *Animus delendi I*, Introduction, footnote 5.

[6] See excerpt in *ibid.*, footnote 5f.

§ 11 Belgian theologian Fr. Joseph Comblin provided this brief history of the "liberation" of theologians from the censure of the Magisterium: "The Council's most decisive influence on the evolution of theology undoubtedly came from the changes that the Conciliar spirit introduced in the relationship between the Magisterium and theologians. This influence of the Council was already evident in the report of the doctrinal commission of the 1967 Synod. **In it theologians were referred to in liberating terms: 'So that they may carry out their task in a normal manner, they must assuredly be allowed the just liberty to follow new trails, as well as make old acquisitions more precise'**

"In the meantime, the signs of the new times were becoming more and more clear. In his inaugural Encyclical [*Ecclesiam suam*, of August 6, 1964], **Pope Paul VI baptized the theme of dialogue. In a** *motu proprio* of December 6, 1965, **the Pope decided to reform the Holy Office and its methods. He then went on to give it a new direction.** And even while timorous voices denounced the dangers of the new theology, the Synod of 1967 showed itself liberal and confident. **At the end of 1968, theologians from** *Concilium* **[magazine] published a letter, to which many signatures were rapidly affixed, denouncing appeals for doctrinal repression. On April 30, 1969, the list was published of the 30 members of the Theological Commission named by the Pope in response to a suggestion made at the 1967 Synod by Cardinal Suenens."**[7]

§ 12 In an interview, Fr. Chenu confirmed Comblin's overview: "They asked me to situate the theologian in relation to the Bishop. I tried to neatly define the two functions of the theologian: service to the Episcopate as an expert, but autonomous in his research. Some years later Paul VI cited my text, which had been published in the meantime

"*Question:* What year did he quote you?"

"*Response:* When the theological commission [ITC] was established. And this is very significant. **You know that it was based on a desire of the Council,** after many episodes, **that had it in mind to create a theological commission. Now,**

[7] Joseph Comblin, "La théologie catholique depuis le pontificat de Pie XII," V.A., *Bilan de la théologie du XXe siècle* (Tournai-Paris: Casterman, 1970), pp. 480-1, vol. 1.

the Pope already had his own theological commission, the **Congregation for the Doctrine of the Faith,** the Holy Office, as it used to be called. **They were his experts, entirely at his service. To create another theological commission was, therefore, to show the autonomy of research.** And the Pope was not very favorable, or at least he expressed reservations. **When Cardinal Suenens, who was one of the initiators of this project, spoke to him on the topic, Paul VI at first responded: 'You know that the theologians have already given us some bad surprises...' But he allowed it to be made."[8]**

§ 13 Launched by the Council and officially established by Paul VI, theological pluralism has also counted on more recent papal endorsements. English theologian Fr. Edward Yarnold, SJ, detailed important support of Popes John Paul II and Paul VI:

"Likewise, **the present day Pope [John Paul II] and Pope Paul VI have spoken on many occasions of pluralism in doctrinal expressions as something not only to be tolerated, but to be positively desired. Thus, Pope Paul VI,** preaching in the Lateran Basilica before a delegation of the ecumenical patriarchate of Constantinople on January 24, 1972, **referred to the body of the Church as 'a composite and coordinated body whose parts and groups can take on their own characteristic forms and whose functions can be different, even while they are fraternal and convergent. Here, in the heart of unity and the center of catholicity, we evoke the living beauty of the Spouse of Christ,** the Church, 'dressed in multi-colored brocade' (Ps 44: 15), that is, **assuming a legitimate pluralism of traditional expressions.'[9]**

"The words 'traditional expressions,' it is true, do not refer simply to doctrinal formulations, but they cannot fail to include them. **Speaking about 'characteristic forms,' Pope Paul VI used his authority to substantiate Cardinal Willebrands' vision of 'a plurality of *typoi*[10] in the communion of the one Church of Christ.'** The Cardinal-president of the Se-

[8] *Jacques Duquesne interroge le Père Chenu*, p. 15.

[9] *A.A.S.* 64, 1972, pp. 197-8.

[10] About the concept of "plurality of *typoi* in the Church of Christ" defended by Cardinal Willebrands, see also Chap. V, § 18 of this Volume.

cretariat for the Union of Christians expounded this view in a sermon preached at Cambridge in January 1970. **He explained that a *typoi* is 'a harmonious and organic body of complementary elements' that includes liturgy, spirituality, and Canon Law.** On this list of elements mentioned by the Cardinal, he gave prime place to a theologically characteristic [pluralist] method and approach. **He did not expressly conclude that this variety of methods and theological approaches would necessarily result in a plurality of doctrinal formulations, but this conclusion seems inevitable.**

"**The present Pope [John Paul II] has spoken in the same sense.** For example, speaking about dialogue to a delegation of the Coptic church, he affirmed: 'In that dialogue, **it is fundamental to acknowledge that the richness of this unity of faith and spiritual life must be expressed in a diversity of forms.** Unity, on a universal as well as local level, does not signify uniformity or absorption of one group by another. It is much more the service of all groups helping each one to better live its own gifts received from the Spirit of God'[11]

"**The application of these two principles permitted the two Popes to affirm on many occasions that Catholics and 'Monophysites'** (Coptics, Syrians, Orthodox, Armenians, and Ethiopians) **share the same faith with regard to the full humanity and full divinity of Jesus, even though the 'Monophysites' reject the definition of the Council of Chalcedonia which attributed two natures to Christ, that of God and that of man.** For example, in the mid-1980s, **Pope John Paul II, addressing the Syrian-Orthodox patriarch of Antioch, referred to a common declaration made nine years before by the patriarch [the schismatic Athenagoras] and Pope Paul VI, in which the two heads of Churches recognized that 'even though difficulties have risen through the centuries caused by different theological expressions used to express our faith in the Word of God made flesh and truly become man, the faith that we want to proclaim is the same.'**[12]

"**The surprising ecumenical implications of such language were generally not understood. By applying the hermeneutics of unity, the two Popes could conclude that**

[11] *A.A.S.* 71, 1979, pp. 1000-1.
[12] *A.A.S.* 72, 1980, p. 395.

Catholics have the same faith as other Christians who do not recognize the dogmatic definitions of a Council, which Catholics consider obligatory."[13]

§ 14 Fr. Germano Pattaro, professor of Theology and Ecumenism at the Patriarchal Seminary of Venice, gave a series of conferences broadcast by Vatican Radio, which implies his good standing with the Curia. In them he explained:

"**Pluralism means being open to an available search.** If this were not the case, the theology that reflects upon the deposit of Faith would be simply a theology of repetition – perhaps always more refined – but turned only to the past. The future would be the inert place to deposit formulations for merely pedagogical purposes. Yes, a certain and secure theology, which is just, but only in part. **Theology is also the research of truth, the hope to comprehend, the search for new understandings, the revision of judgments, a growing conversion and deepening of the faith.**[14] **It must have the temperament of one walking along the street, of one on a pathway,** of one who has hope as his constitutive vocation. **All this means, in concrete, that the theologian needs the convergent contribution of all reflections, and, for this reason, he must articulate himself in open conceptual compositions, always penultimate and never definitive**

"**Today we are seeing a revision of yesterday's theology, and it can be stated** with all tranquility **that it must be reoriented. The Council firmly calls for this. It suffices to think of the impressive transformation** the Council made **with regard to ecclesiology. This is pluralism through the axis of time: pluralism in a successive progression. One should note, however, that the adoption of this principle**

[13] Edward Yarnold, "La pluralité des formulations de la doctrine," *La Documentation Catholique*, September 2, 1984, pp. 868-7.

[14] Fr. Germano Pattaro characteristically applied here the deviation pointed out above (§§ 3-8) to justify progressivist theological pluralism. That is, he presented good sense arguments about the need for research, perfectly valid for the phase in which the Church still has not dogmatically defined a given question. But then he jumped forward to apply those arguments to the phase where the truths have already been defined. This is inadmissible from the standpoint of intellectual honesty and, above all, from the standpoint of the unity of the Faith, which is thus undermined at its very foundation: the immutable character of revealed truth.

supposes another: that which **demands a pluralism of contemporaneousness. That is to say, theology has the duty to express itself in different ways at the same time and with the same men**

"The importance of what was said above comes from Paul VI's speech to members of the *Theological Commission*: 'There is only one primacy: that of revealed truth, that of the Faith, to which theology as well as the ecclesiastical Magisterium want to give a different but convergent suffrage.' Paul VI concluded: 'Be confident in the possibility of developing them [aspects of the mentioned primacy] according to their own demands and according to your personal genius. This means that **we willingly admit the development and diversity of the theological sciences, of that pluralism that seems to characterize modern culture.**'"[15]

§ 15 A clear and unabashed defense of theological pluralism was made by Fr. Hans Küng: **"As a pilgrim, the Church must always be traveling along the road; so also in her doctrine. Many new formulations of the same faith are possible through the course of history, and even in the same epoch itself.** But the whole truth does not fit into a single proposition, and opening up to an ever-greater truth is essential for the Church. This does not mean to say that the form of confessions [of faith] and ecclesiastical definitions should be submitted to always-new changes. It would be utopist to think that the Church could begin her formulations of faith from ground zero, or one beautiful day make them all pass through the sieve of a general revision. **Any business company thinks ten times before changing the packaging, logo, and even name of any of its popular (but perhaps antiquated) products.**"[16]

§ 16 While the more important applications of pluralism are those pointed out above,[17] it does not restrict itself to the ambit of doctrinal studies, but also extends to the field of education. John Paul II confirmed this application in a speech to Catholic professors in Canada.

The Pontiff said: "Since individualism is frequently alienating, **Catholic schools should transmit and strengthen**

[15] Germano Pattaro, *Riflesioni sulla teologia post-conciliare* (Rome: A.V.E., 1970), pp. 199-201.

[16] H. Küng, *Veracidade*, p. 156.

[17] §§ 3-8.

the sense of community, concern for social problems, and acceptance **of the differences and diversities in pluralist societies. By professing an institutional compromising with the word of God, as this is proclaimed by the Catholic Church, they [Catholic schools] should stress a profound respect for the conscience of others and a deep desire for Christian unity.**"[18]

In short, the progressivist conception of "theological pluralism" studied in this Chapter was launched by the Council, applied by Paul VI, reinforced by John Paul II, and interpreted by various theologians. This conception clearly appears to transgress the unity and unicity of the Catholic Faith.

* * *

[18] John Paul II, Allocution to Catholic educators in the Cathedral-Basilica of St. John in Nova Scotia, Canada, *L'Osservatore Romano*, September 14, 1984, Supplement, p. XX.

Chapter II

FOR PROGRESSIVIST ECUMENISM THE "CHURCH OF CHRIST" IS DIFFERENT FROM THE CATHOLIC CHURCH

The notion that the "Church of Christ" is different from the Catholic Church is the *second Kraftidee* of conciliar ecumenism.[1] It will be studied in this Chapter.

1. Introductory sophism of a psychological-doctrinal nature

§ 1

The constant teaching of the Magisterium clearly states that outside the Catholic Church there is no salvation. The wise reasons that provide the foundation for this dogma have already been given.[2] This truth of primordial importance, however, does not exclude the fact that in extraordinary circumstances there have been souls outside the institution of the Church who have received graces that predisposed them to know her and be saved.[3]

[1] See Part II, Premises, §§ 1-7.

[2] See Part II, Premise 1.

[3] a. This is what St. Thomas taught: "It falls to Divine Providence to provide all men with the means necessary for salvation, so long as they do not place obstacles in the way. In effect, if someone raised in the wilds or among savage animals is led by natural reason to follow the appetite for good and to flee evil, it should be considered most certain that God will reveal to him by internal inspiration the things necessary to believe, or that He would command some preacher of the Faith to go to him, as he sent St. Peter to Cornelius (Act 10)" (*De veritate*, q. 14, a. 11, ad 1).

b. Pius IX confirmed this traditional teaching in a clear and balanced statement in the Encyclical *Quanto conficiamur* (August 10, 1883). In it he explained the dogma *extra Ecclesia nulla salus* and its exception: "Here too, our beloved sons and Venerable Brethren, it is again necessary to mention and censure a very grave error that is unfortunately entrapping some Catholics who profess that is possible for men to arrive at eternal salvation although they live in error and are

§ 2 There is, for example, a famous case of a Brazilian In-
dian who, having lived uprightly following natural law, felt
attracted by something perfect that he did not know how to de-
fine but that, with the approach of death, he ardently desired to
know. Divine Providence did not want to leave such fidelity
unrewarded and caused Blessed José de Anchieta, 16th century
Apostle of Brazil, to find the Indian dying in the wilds and, to
the native's great joy, baptize him.[4] Such souls who, *in extre-*

alienated from the true Faith and Catholic unity. Such opinion is ab-
solutely opposed to Catholic teaching. We know and you know that
there are those who are struggling with invincible ignorance about
our most holy Religion. Uprightly observing the natural law and its
precepts inscribed by God on all hearts and ready to obey God, they
live honest lives and are able to attain eternal life by the efficacious
virtue of divine light and grace. Because God knows, searches, and
clearly understands the minds, hearts, thoughts, and nature of all,
His supreme goodness and clemency do not permit those who are
not guilty of deliberate sin to suffer eternal punishment.

"Also well-known is the Catholic dogma that no one can be saved
outside the Catholic Church. Eternal salvation cannot be obtained by
those who with contumacy oppose the authority and definitions of the
same Church, as well as with contumacy oppose her unity and the
successor of Peter, the Roman Pontiff, to whom 'the custody of the
vineyard has been committed by the Savior' (Ecumenical Council of
Chalcedon)" (*Recueil des allocutions,* pp. 480-1).

[4] At the beginning of the 17th century, Fr. Pero Roiz related the event
in his book *Anchieta:* "I find one case, with authentic documentation
.... in which one sees the extraordinary mode in which God operated
in a soul the effect of His predestination. It happened in this way:
Walking along a beach, Father [Anchieta] deviated from the path and
wandered further into the forest, for no special reason, but as if he
were being led by another. There he found an old Indian sitting at the
foot of a tree who called out to him, saying: 'Come quickly, Father,
for I have been waiting a long time for you here.'

"The priest asked his name, land, and village. The Indian responded
that his village was near the sea, and other things by which the priest
clearly understood that this Indian was not native to the district of
São Vicente and that he had been led there by a hand more than
human. The priest asked him why he had come and what he wanted,
since he said that he had been waiting for him there. The Indian re-
sponded that he had come to hear about the 'good life' (which is an
expression the Indians used to signify the law of God and the road of
salvation).

mis, in the absence of a missionary, could enter into the Church by the baptism of desire,[5] were considered as belonging to her soul, even though still not united to her body.[6]

§ 3 Although the designs of Divine Providence are beyond the scope of human intelligence and understanding, it could be said that this extraordinary economy of grace would diminish to the measure that the Church expands and her principles became known throughout the entire world.

§ 4 It is upon this precise and extraordinary situation, however, that the progressivist sophism bases itself.

This sophism employs a doctrinal ruse and takes advantage of an emotional psychological situation. A description of each follows:

"The priest examined his life in minute detail and found that he had never had multiple wives, that he had never waged war except in self-defense, and other similar things. With this, the priest judged that the native had never sinned mortally against natural law and that he had much natural knowledge about things, as well as the Author of nature.

"As the priest expounded to him the principal mysteries of our Faith, the Indian responded that he agreed and had known these things in his heart, but without knowing how to state them. Finally, after the priest had sufficiently instructed him, he baptized him with rainwater that he took from the leaves of bushes nearby and gave him the name Adam. As soon as he saw himself reborn in Jesus Christ through holy Baptism, joining his hands together and raising his eyes to heaven, the Indian gave many thanks to God, his face radiant with joy. He also thanked the priest for the charity that he had shown him.

"Then, like one who had awaited nothing except this fortunate hour and now had nothing more to do in this life, he delivered his blessed soul to God in the hands of the same priest, and went to heaven. The priest buried his body, covering it with sand. This is a case certainly rare and worthy of admiration, for which great praise should be given to the Creator and Redeemer of men" (Salvador, Brazil: Liv. Progresso, 1955, pp. 115-7).

[5] On the Magisterium of the Church with regard to baptism *in voto* or baptism of fire, see DR 388, 413, 796; "Letter of the Holy Office to the Archbishop of Boston," July 8, 1949 (DS 3869-3872).

[6] In this sense, Joachim Salaverri in his *De Ecclesia Christi* (*Sacra Theologiae Summa,* Madrid: BAC, 1958) cites St. Robert Bellarmine, *De Ecclesia Militante,* lib. 3, c. 2.

§ 5 ***Doctrinally***, regarding salvation outside the Church, innumerable progressivists avoid focusing on what the rule clearly says and what is its exception. Shuffling together the exception and the rule they are able to more comfortably emphasize the exception, presenting it as if it were the rule.

Thus stressing the exception, some progressivists distinguish different degrees of belonging to the Church, basing themselves abusively on Franzelin, who admitted a "partial" (*ex parte*) belonging.[7] Others, with an also abusive interpretation of the doctrine of the Encyclical *Mystici Corporis* of Pius XII, say that the Mystical Body of Christ extends beyond the borders of the Catholic Church and the fact of belonging to the visible Church.[8] Still others, like Cardinal Yves Congar, emphasize an "*in voto*" [by desire] incorporation into the Church, distinct from a complete and concrete incorporation, or like Fr. A. Liégé, stress an invisible belonging to the Church.[9] At the Council this matter was addressed by Cardinal Suenens in the famous speech in which his expression *Lumen gentium* was taken as the title for the *Constitution on the Church*.[10] The Belgian Cardinal distinguished between an *Ecclesia ad intra* and an *Ecclesia ad extra*, the first being turned toward Catholics, and the second, vaster than the first, turned toward all men, believers and nonbelievers.[11] Finally, the definitive expression that the Council adopted which endorsed the sophism was the conception of "Church of Christ," which would be distinct from and broader than the Catholic Church.[12]

§ 6 ***Emotionally***, certain progressivsts have spoken so much about the pretended "just souls" who exist outside the bosom of the Catholic Church that this question, which before had always been viewed calmly and serenely in the Catholic milieu, took on an overexcited emotional tone that stirred up a romantic compassion for those outside the Church. This excita-

[7] "Dalla 'società perfetta' alla Chiesa 'mistero,'" *La Civiltà Cattolica*, 3230, January 19, 1985, p. 112

[8] *Ibid.*

[9] *Ibid.*

[10] Gerard Philips, *La Chiesa e il suo mistero – Storia, testo e commento della 'Lumen gentium'* (Milan: Jaca Books, 1982), p. 19.

[11] *Ibid.*

[12] *LG* 8b; *UR* 1b, 4c, 15a. See above Part II, Premises, § 6, and Item 2 of this Chapter.

tion was the same type that the "social" and "liberation" movements have raised over the topic of the rich and the poor. That is to say, it created the imbalanced impression that it would be "shameful" to be rich when so many poor exist. In like manner, a contrived emotional imbalance created a climate of "shame" for Catholics over the dogma that stated there was no salvation outside the Church. In this emotionally over-charged climate, it would not be "charitable" to think like this, and it would even be "egotist" to defend such a position.

Thus, by artificially creating and taking advantage of this emotional climate, progressivists strongly influenced the psychology of uncountable Catholics, who felt pressured to abandon their position of obedience to the teaching of the Church and to assume a more "sympathetic" and "modern" position.

These are the principal factors that sustain the progressivist sophism of a "Church of Christ" distinct from the Catholic Church.

2. Elements that define the progressivist notion of "Church of Christ" as distinct from the Catholic Church.

The documents presented in this Item will provide the Reader with elements to help him understand what is the "Church of Christ" of the Council.

§ 7
Fr. Edward Schillebeeckx was very clear in dealing with the supposed difference between the "Church of Christ" and the Catholic Church. He affirmed: **"Now that the ecclesiality of the other churches has been officially recognized [by Vatican II], it is clear that the position can no longer be held that the Roman Church is, purely and simply, the Church of Christ. Other Christian communities also are called church, and therefore, Church of Christ. Then what happens to the affirmation that she is absolute, which is claimed by the [Catholic] Church? In any case, it is a pretension that should be shared with, one might say divided among these various Churches. It is an attribute of them all."[13]**

[13] E. Schillebeeckx, "Introdução," V.A., *Cinco problemas que desafiam a Igreja hoje*, p. 25.

§ 8 In addition to Catholics, the "mystical body" would incorporate Protestants and Schismatics. This is what Cardinal Congar affirmed in a critique on the work of Fr. Sebastien Tromp, SJ:

"The works of the sub-commission [preparatory to the Council] were strongly oriented in a certain direction. The secretary was Dutch, a Jesuit from the Gregorian [University], Fr. Sebastian Tromp. During the pontificate of Pius XII, he was at the top of the theological field. He was one of the authors of the encyclical on the Mystical Body in 1943, as well as the encyclical about the liturgy in 1947. **Authoritarian and categorical, he** directed everything carefully and obviously **tried to make the theses of Pius XII triumph, in particular that which consisted of establishing an identity between the Mystical Body and the Catholic Church to the exclusion of the other Christian churches. According to this, a Protestant or an Orthodox, having faith and charity and loved by God, would not make up part of the Mystical Body! Incredible!**"[14]

§ 9 In an interview granted in Tübingen to the Author of this Volume, Fr. Hans Küng plainly expressed his notion of ecumenical participation of Catholics and Protestants in the Mystical Body of Christ.

"*Question:* What would be the concept of belonging to the Mystical Body of Christ?

"*Response:* I think **there are different belongings: Catholic, Protestant, Orthodox. But I don't like to say that 'all belong *virtualilter et impliciter* to the Church'** For me the juridical aspect is not the most important, but rather the aspect of faith What is most important is for someone to say, 'I believe in Jesus Christ.' It does not matter so much to me, in this sense, whether a person is a Catholic or a Mormon, for example

"**You belong to this universal church which is the Church of Christ. The Roman Catholic Church is a part of this, but it is not everything.** I think that **this is the line of the Council, because there was a huge debate at the Council about whether the Church of Jesus Christ *is* [*est*] the Roman Catholic Church. Then many of the Fathers corrected this and now it is said that the Church of Christ *subsistit in.***

[14] *Jean Puyo interroge le Père Congar*, pp. 126-7.

Subsist in Ecclesia Romana Catholica. **That is to say, it exists there, but there are others."**[15]

§ 10 This opinion of Küng can be found and confirmed in an account he made of the Council. Speaking about ecumenism with the so-called Christian religions, he wrote: **"Although some obscure questions still remain, Vatican Council II reexamined the attitude of the Catholic Church with relation to other Christian churches on very important points The Catholic Church no longer identifies herself purely and simply with the Church of Christ.**

"In relation to one point at least, an explicit revision was made **In place of the formula of identification first proposed by the commission: 'The sole Church that we, in the symbol of the Faith, confess as One, Holy, Catholic and Apostolic is** *(est)* **the Catholic Church,** governed by the successor of Peter and by the Bishops who remain in communion with him,' **this other formula was admitted: '** *subsists in* **the Catholic Church (***subsistit in***)'** LG 8.

"To justify the formula of identification being rejected for the first time, a transcendent fact that can entail important consequences, **the commission added: 'So that this expression may be more in accordance with the affirmation that elements of the Church also exist in other parts.' The commission was referring here to the 'churches or ecclesial communities' mentioned in LG 15. The new formula was consciously kept as vague as possible** so as not to obstruct beforehand a broader theological implication, absolutely necessary in this difficult question."[16]

§ 11 One of the best-known American theologians, Cardinal Avery Dulles, SJ, professor of Systematic Theology at the Catholic University of Washington, D.C., explained the "Church of Christ" according to progressivist thinking:

"The Church of Jesus Christ is not identified exclusively with the Roman Catholic Church. Certainly, it subsists in Roman Catholicism, but it is also present, in various ways and in various degrees, in other Christian communities in so far as they are also faithful to that which God initiated in Jesus and they obey the inspiration of the Spirit of Christ.

[15] H. Küng, Interview with the author, Tübingen, February 2, 1983.

[16] H. Küng, *A Igreja*, vol. 2, pp. 39-40.

"As a result of a their common participation in the reality of the single Church, the various Christian communities already have among themselves a real, but imperfect, communion. The relations among the churches, therefore, are not simply 'exterior relations,' like that which exists among distinct sovereign states, but 'domestic relations,' similar to that which exists between groups within a single political society. From certain aspects, the relationship is even more intimate, because all Christians are incorporated into the single body of Christ, animated by His Spirit."[17]

§ 12 Fr. Bernard Sesboué, member of the International Theological Commission, clearly defended the non-identification of the "Church of Christ" with the Catholic Church: **"The Council also implicitly recognizes that outside of the Catholic Church there are other ecclesial communities that belong to the mystery of the Church, even given the deficiencies they may have. The boundaries of the Church of Christ are far from coinciding with the boundaries of the Roman Catholic Church."[18]**

This sample of testimonies seems sufficient to establish that for innumerable progressivists, the "Church of Christ" is a reality distinct from and more ample than the Catholic Church.

*

§ 13 Following the logic of the same principles adopted to affirm that the "Church of Christ" is distinct from the Catholic Church, it is also claimed that the "Church of Christ" would extend beyond the confines where we find those who, in some form or another, believe in Jesus Christ. In ever wider concentric circles, this "Church of Christ" would also encompass those who believe in only one god, and then those who believe in some god, and finally, those who do not believe in any divinity. It seems opportune before closing this Chapter to give some testimonies of this "totalizing" development.

[17] Avery Dulles, "Ecumenismo: problemi e possibilità per il futuro," V.A., *Verso la Chiesa del terzo millennio* (Brescia: Queriniana, 1979), pp. 108-9.

[18] Bernard Sesboué, *O Evangelho na Igreja* (São Paulo: Paulinas, 1977), p. 82.

§ 14 Msgr. Gerard Philips, final author of the Constitution *Lumen gentium*, granted entrance of the great mass of those who are not linked to the Church into the communion of saints. The emotional emphasis that Philips placed on the fact that many are not saved tends to stir up a revolt against the Catholic dogma of *extra Ecclesiam nulla salus*, which he subtly presents as absurd.

Philips stated: "**The foundation of the Church as an institution of salvation**, a channel to dispense grace, **does not prevent the entrance of a vast multitude deprived of all visible contact with the Christian hierarchical society into the communion of saints. For they are also united to the Church, since ecclesial perspectives extend *ad infinitum*,** transcending time and space, finding completion by flowing into full eternity.

"**If the Council thus places a heavy accent on this 'totalizing' aspect of the Church**, without, however dissolving its lines into something ethereal, **it is because our epoch is the first to truly become aware of the astonishing number of generations who lived before Christ and the enormity of contemporary masses who have never heard of Him.** How many of them will we find in the universal Church Triumphant? This is the secret of the last day."[19]

§ 15 In an acclaimed work, Fr. Antonio Acerbi spoke also of "degrees of intensity" in the "communion of the goods of salvation": "**The foundation of a Church as the necessary institution of salvation does not restrict, either spatially or socially, the work of redemption** that Christ carries out through it in the world. **The communion in salvific goods admits diverse degrees of intensity, since all categories of men and their various communities are intimately linked to the Church.**"[20]

§ 16 Commenting on Paul VI's Encyclical *Ecclesiam suam*, Cardinal Paul Poupard spoke of the "concentric circles" that the Conciliar Church would encompass: "*Ecclesiam suam* **expands into three concentric circles that open up 'around the center in which the hand of God placed us: the Chris-**

[19] G. Philips, *La chiesa e il suo mistero*, p. 82.

[20] Antonio Acerbi, *Due ecclesiologia – Ecclesiologia giuridica ed ecclesiologia di communione nella 'Lumen gentium'* (Bologna: Dehoniane, 1975), p. 360.

tian brethren, the believing brethren, and the non-believing brethren, which includes atheists and communists.' The encyclical points out these clear developments." [21]

§ 17 Symmetrical to this conciliar conception of the Church is that which describes all humanity as composed of concentric circles that successively become wider and less religious. In this respect, Prof. Rocco Buttiglione described the thinking of Cardinal Karol Wojtyla:

"The Council presents humanity as a series of concentric circles. Its nucleus is made up of believers in Christ gathered together in the Catholic Church instituted by Him. Then comes the Christians not united to the visible Church, those belonging to the great religions of humanity. And finally, there are also those who have not arrived at a clear knowledge and recognition of God, who strive, not without divine grace, to live an upright life." [22]

§ 18 It can thus be affirmed that the "Church of Christ" itself would not have defined limits encompassing only those who believe in Our Lord. It would tend to further extend to include monotheists, and then those who believe in some divinity, and finally those who do not believe in a first creator.

*

§ 19 As this Chapter has shown, the progressivist definition of "Church of Christ" is quite broad. In effect, it denies the classic definition of the Church assumed by official Catholic teaching, a definition first given by St. Robert Bellarmine.

§ 20 The definition of St. Robert Bellarmine may be found in his *Controversies*, which he began to write in 1586. The great Jesuit theologian demonstrated how the true Church is the "ensemble of men united by the profession of the same Christian Faith and the communion of the same sacraments, under

[21] Paul Poupard, "Un Papa: Paolo VI; un'Enciclica: *Ecclesiam suam*," *L'Osservatore Romano*, August 6-7, 1984, p. 1.

[22] R. Buttiglione, *Il pensiero di Karol Wojtyla*, p. 244.

the government of legitimate pastors and principally the one Vicar of Christ on earth, the Roman Pontiff."[23]

St. Robert Bellarmine also summarized this definition with these words: "The Church is the assembly and congregation of baptized men who profess the same Faith and law of Christ under the obedience of the Roman Pontiff."[24]

This definition was assumed by the ordinary and universal Magisterium as the official definition the Catholic hurch has of herself.

§ 21

The acceptance of the "Church of Christ" thesis has this consequence: the Conciliar Church explicitly denies the prior definition of the Catholic Church. The two following examples seem sufficient, for the moment, to prove the progressivist goal.

§ 22

Hans Küng considered this definition as a "non-biblical restriction," because it excludes heretics and schismatics from the Catholic Church: **"The New Testament does not permit us, following our own whims, to include too many elements and conditions in the definition of what the Church is, lest we become victims of a non-biblical restrictive notion of the Church (as can be seen, for example, with Bellarmine who inserted submission to the papal primacy into the definition of the Church,** thereby logically refusing to recognize as Church even the orthodox churches.)

"According to our exposition of the fundamental structure of the Church, **it is both theologically correct and ecumenically fruitful to start from a general concept of a minimum but fundamental framework. In this case, one could call Church every community organized on the basis of Holy Scriptures and composed of baptized Christians who believe in Christ** the Lord, **who want to celebrate the Lord's supper and strive to live in conformity with the Gospel, and whose desire is to be called Church."[25]**

[23] "Controversiarum," lib. 3: *De Ecclesia Militante*, c. 2, *Opera Omnia* (Naples: Pedoni, 1857), vol. 2, p. 75, *apud* Y. Congar, *Le Concile de Vatican II*, p. 147.

[24] *Christianae doctrinae latior explicatio* (Kempten, 1728), p. 57, *apud* Y. Congar, *ibid.*

[25] H. Küng, *A Igreja*, vol. 2, p. 45.

§ 23 In a much more subtle manner, Msgr. Philips employed a "moderate" language that nonetheless likewise undermines the definition of St. Robert Bellarmine and arrives at results similar to those of the polemical Hans Küng.

He affirmed: "The conditions of belonging to the Church – supposing the gift of the Holy Spirit as being present – are pointed out in the Constitution [*Lumen gentium*] following the classical triple division. In effect, the recognition of her whole organization and all the means of salvation instituted in her, as well as union with the visible organization, implies the following: the bond of the one profession of Faith, the acceptance of all the sacraments, and communion with the ecclesial hierarchy

"In these words, the reader will certainly have recognized the celebrated statement of St. Robert Bellarmine that defines the Church as 'an ensemble of men united by the profession of the same Christian Faith and the communion of the same sacraments, under the government of legitimate pastors and principally the one Vicar of Christ on earth, the Roman Pontiff.' **It would be an injustice to the venerable Doctor to interpret his statement as a description of the intimate essence of the Church. In fact, he did not want to propose a 'definition' properly speaking of the Church [sic!], since he made no mention of her divine origin or of her final end**, two indispensable constitutive elements for a scholar dealing with an 'essence.' He simply enumerated the exterior signs that permit one to discern if a man belongs to the true Church of Christ, that is, the Roman Church. In other words, **we must be cautious when we take phrases from Bellarmine's *Controversies* out of context. In this matter, later apologetics frequently erred by treating affirmations of the kind described here as absolute and by neglecting dogmatic exposition.**

"From this perspective, what should be thought of those who receive a valid baptism in the bosom of a dissident community? Further, a solution is lacking for another obscure point: those who receive baptism in a separated community not only possess the *votum sacramenti* [desire for the sacrament], but the sacrament itself."[26]

[26] G. Philips, *La Chiesa e il suo mistero*, pp. 177-8.

These are some of the elements that characterize the "Church of Christ" preached by Vatican II as a church different from the Catholic Church.

* * *

Chapter III

CONCILIAR ECUMENISM DENIES
THE UNICITY OF THE CHURCH AND
THE UNITY OF THE FAITH

§ 1 By the very nature of ecumenism, the theme of Part II, its consequences are cumulative, that is to say, its later effects are already contained *in germen* in its earlier stages. These consequences, therefore, are different from the type that extend from a single nucleus to different fields of application, as was largely the case with the theme of Part I of this Volume, adaptation of the Church to the modern world. With ecumenism, the consequences are different not because they apply to different fields, but because they delve ever deeper into the same topic – the destruction of the unicity of the Church and the unity of the Faith. Thus, the following material will not repeat what has been said, but rather will confirm it and delve deeper into the topic.

This Chapter will study the two principal theories that serve as basis for conciliar ecumenism: the theory of the "seeds of the Word" and the thesis of "anonymous Christianity."

1. The theory of "the seeds of the Word"

§ 2 "*Logos spermatikos*" (the Divine Word as sower), and "*sperma tou Logou*" (the seeds of the Divine Word) are two different expressions to refer to a doctrine in vogue today that is attributed to St. Justin, a 2nd century Church Father.[1] Accord-

[1] a. I say that the theory is attributed to St. Justin because nowhere in his work does such a doctrine appear *ex professo*. I solicited a Brazilian ecclesiastical specialist in Greek who carefully researched the original of St. Justin's work to see how and when the expressions "Word as sower" and "seeds of the Word" appear, as well as any correlative concepts used by the great Catholic apologist. The result of this meticulous research was that in the excerpts from St. Justin's works habitually referred to by progressivists, the expressions *Logos*

spermatikos and *sperma tou Logou* were not found in relation to the Second Person of the Holy Trinity.

b. These were the only expressions found:

* *dia to* **sperma ton cristianon** (because of the seed of the Christians), having no relation to the Divine Word (PG 6, col. 456);

* *panti genei antropon* **sperma tou logou** (in the whole human race, a seed of reason), (*ibid.*, col. 458); the term *logos*, used here in the genitive, *logou*, does not refer to the Second Person of the Trinity, but to the thinking or reason proper to human nature.

These were the two passages found in the places habitually cited by progressivists as St. Justin's *ex professo* treatment of the topic.

c. Leaving aside the expression itself, and seeking the concept attributed to St. Justin, indirect mention of it can be found in two passages of the same work. They are the following:

* Speaking about the fragments of truth that one can find in Plato and in pagan poets and historians, St. Justin affirmed: "The more each one saw **a part of the divine reason** that he knew **disseminated** [*merous tou spermatikou Theiou Logou*], the more he spoke correctly" (*ibid.*, col. 465). If in some other place St. Justin would have formulated the aforementioned theory, this excerpt could be understood as a confirmation of it. However, he did not. It would seem quite exaggerated and dishonest, then, to derive from this one excerpt the entire theory that the progressivists attribute to the Saint.

* In another place, St. Justin set forth a similar thinking, without using the word *sperma*: "Everything that the philosophers and legislators wrote or excogitated about beauty, they did by the discovery and contemplation of **a part of the Word** [*kate logou meros eureseos*]" (*ibid.*, col. 460). Once again, it appears exaggerated to conclude from this the progressivist theory of "*logos spermatikos*," which will be exposed in this Item.

These were the only mentions found of the concept in the mentioned work of St. Justin.

d. One sees, therefore, that the theory created by progressivists on the "seeds of the Word" does not correspond to the expressions used by the Greek Father. Nor is his use of an analogous concept frequent or precise enough to provide sufficient foundation for such a theory to be honestly attributed to him.

e. Finding no basis, then, in the specifically mentioned references or the whole *Second Apology of the Christians* [*Apologia II pro Christianis*], which is the work normally cited by progressivists to justify their theory, I requested a more extensive research in the complete set of works of St. Justin of indisputable authenticity, as well as in works of his disciples attributed to him, but whose authenticity is not

ing to this concept, there are "seeds of the Word" planted in the souls of all men. What would be these "seeds"?

§ 3 One can understand the concept of the "seeds of the Word" as being the characteristics of the image and likeness of God imprinted on the being of every man. That is, there are some ontological similarities that attract the creature to be unified with the Creator. These "seeds," according to Catholic Doctrine, would develop as the soul moves toward the Church, in order to completely blossom later inside her bosom.

certain. Both can be found in J.P. Migne's edition of *Patrologia Greca*. There also, nothing decisive was found that could honestly justify the alleged theory. The works researched were: *Oratio ad gentes; Cohartatio ad Grecos; Liber de Monarchia; Apologia I pro Christianis; Apologia II pro Christianis.*

f. Surprised by the lack of a serious basis for a theory so widespread and important, I directed myself to two competent Patristic scholars, Catholic professors in higher institutes of study in Rome. I asked them to confirm the results of my research. I also inquired of them what was the real basis for the theory of the "seeds of the Word." They responded that my research had been well made, and that St. Justin never dealt *ex professo* with the theory of "the seeds of the Word." They further affirmed that in the ambiences that knew Patristics, it was not rare to hear the term "intellectual forgery" used when this theory is attributed to St. Justin.

g. Despite this, the progressivist theory of the "seeds of the Word" gained ground and was assumed by the Council itself, which refers to it twice in the Decree *Ad gentes*:

* "That they [the sons of the Church] may be able to give this witness to Christ fruitfully, let them be joined to those men by esteem and love, and acknowledge themselves to be members of the group of men among whom they live. Let them share in cultural and social life by the various exchanges and enterprises of human living. Let them be familiar with their national and religious traditions, gladly and reverently **laying bare the seeds of the Word which lie hidden in them** [*detegant semina Verbi in eis latentia*]" (AG 11b).

* "The Holy Spirit, who calls all men to Christ **by the seeds of the Word** and by the preaching of the Gospel" (AG 15a).

h. Notwithstanding such observations, which speak for themselves about the lack of honesty of progressivist intellectual allegations, I will analyze the theory of the "seeds of the Word" in this Item. *First*, I will look at its good meaning, pointing out its honest sense that is rightly considered Catholic Doctrine. *Second*, I will expose the distorted usage made by the progressivists.

In a certain way this notion further develops another that has already been analyzed, which is the existence of just souls outside the Catholic Church.[2]

§ 4 The mere existence of such "seeds" in the souls of man, however, cannot be deemed sufficient for salvation. They are only natural elements of similarities to God, which cannot *per se* be the subject of merit. They do not characterize a moral fidelity. Such fidelity begins when man develops these similarities and desires to unite himself with God. When this process begins, God gives the soul an initial supernatural help – the sufficient grace – to bring it closer to Him. Does this mean a direct access to salvation? Not necessarily.

From the time of Adam to Our Lord Jesus Christ, it never sufficed that the just men simply have the "seeds of the Word" and develop them in order to achieve celestial happiness after death. Even the just men of those times, who explicitly followed the Ten Commandments and received greater supernatural help, were not able to achieve salvation. They gained this salvation only after Our Lord Jesus Christ, through His Passion and Death, opened to them the gates of heaven, until then closed by original sin.

The Word made Flesh founded His Church and established her as the sole mediator and depositary of the graces of Redemption.[3] Therefore, as the righteous souls of the Old Testament could not enter heaven until after they received the fruits of the Redemption, neither can men born after the Incarnation be saved unless they receive those fruits distributed by the Catholic Church. When a just man exists outside of the Church, God gives him His grace to lead the person toward her. So one sees that the *per se* fact of the existence of "seeds of the Word" in all men does not bestow on them any right or merit independent of the Redemption and the Catholic Church.

This, then, is the theory of the "seeds of the Word" taken in its Catholic interpretation. The progressivist interpretation, expounded below, is quite different.

Many progressivists affirm:

[2] Part II, Chap. II §§ 1-6.

[3] Jn 6:66, 15:4; Lk 6:43-45, 9:5; Mk 5:11; 16:15-16; Mt 10:14-15; 21:42-44.

§ 5 *First*, that there is a parallel road of salvation independent of the Catholic Church, and Redemption. The "seeds of the Word" would be developed on this pathway as well, and man would receive from Christ – habitually, directly and entirely – the needed help to achieve salvation.

§ 6 *Second*, some go even further, saying that such salvation does not depend on the moral development of those "seeds." They imagine that the simple ontological existence of these "seeds of the Word" in the soul of a man is already a guarantee of salvation.

§ 7 The *first position* is false because it fails to consider that the "seeds of the Word" were given to men only in view, or as a consequence, of the Incarnation of the Second Divine Person, and His Redemption. It is also false because it denies that the Holy Catholic Church is the necessary channel through which the graces of the Redemption flow. Finally, it denies that the graces God gives outside of the Catholic Church are given to conduct those souls to her.

§ 8 The *second position* is false because it is absurd. If ontological similarities of the creatures with the Creator – "seeds of the Word" – were sufficient to achieve salvation without the need of moral merit, then Lucifer would not have fallen, rather, he would have the highest throne in heaven, because he is the most perfect creature, with more ontological similarities to God.

2. Principal characteristics of the doctrine of "anonymous Christianity" as set out by Rahner's disciples

Although progressivists frequently use the distorted version of the "seeds of the Word" thesis for their ecumenical designs, there is another theory that is even more characteristic of their thinking. It is that of the German Jesuit, Karl Rahner, who named it "anonymous Christianity."

§ 9 Essentially, the theory of "anonymous Christianity" is another distortion of the teaching on belonging to the Church *in voto* [by desire] analyzed above.[4]

Paradoxical as it may seem, for Rahner every man is already a "Christian" even if he does not know it, and even if he

[4] Part II, Chap. II, §§ 1-6.

calls himself anti-Christian. Every man would be a constant target of the most excellent kind of graces, the sanctifying grace, which would act in his soul without the mediation of the Catholic Church. Finally, every man would be faithful to that grace by the simple fact of loving something other than himself: his neighbor, humanity, some philosophical or moral value, etc. Such love, even unbeknownst to him, would already be a true love of God, and would merit eternal salvation.

These "anonymous Christians" do not need to acknowledge Our Lord Jesus Christ and the Holy Catholic Church. To be saved, they do not even need to be baptized – a condition which less radical ecumenists still consider indispensable for participation in the "Church of Christ." According to Rahner, the "Church of Christ" need not pass through the intermediary stages mentioned before: the Catholic Church, the "Church of Christ," the "Church of God, the "messianic people," and the "people of God." With only a single colossal step, all of humanity would be included in it.

§ 10 Rahner's theory provides the possibility to understand the *arrière-fond* [background] of ecumenical progressivist thinking. According to it, every man would have a divine immanence in the depth of his soul. To sanctify himself, to unite with God, the only thing asked of him would be for him to liberate and develop this hidden immanence. This secret interior experimental contact with God would be more important than anything else. Provided that a religion helps to liberate this immanence, it is good – whatever this religion might be. For this reason, the unicity of the Catholic Church has to be denied and the unity of Catholic Faith done away with. This thinking is heir to the immanentist conceptions of Modernism.[5]

§ 11 Some progressivists pretend to find Rahner's theory exaggerated. They feign a superficial opposition ungrounded by any serious objections. As it will be shown,[6] their disagreement is nothing more in fact than a friendly methodological dispute. It does nothing to diminish Rahner's renown or halt the honors paid to him. On the contrary, even official organs of the Holy

[5] St. Pius X, *Pascendi Dominici gregis,* nn. 10, 19, 20, 32.

[6] See Item 7 of this Chapter.

See, habitual defenders of "moderation," sing the praises of the German Jesuit.[7]

<p style="text-align:center">*</p>

The following exposition of the doctrine of "anonymous Christianity" will observe this schema: *first,* it will present a summary by Fr. Luis Maldonado of what Rahner's theory is, as well as other data that help to identify the origins of his thinking.

Second, it will present documents of Vatican II in which analogous concepts can be found.

Third, it will show how Rahner's thesis aims to destroy the dogma of the unity of the Catholic Faith and the unicity of the Church.

Fourth, it will cite excerpts from important progressivists who think like Rahner.

Finally, *fifth,* documents of the conciliar Popes or Vatican personages who have also aligned themselves with Rahner's thesis will be provided.

§ 12 Fr. Luis Maldonado, professor of the University of Salamanca and a disciple of Rahner, made a satisfactory, although somewhat unclear, summary of what his master understood by "anonymous Christianity." Points of major interest follow:

"The presence of Christ and His grace in the non-believer received from Rahner himself a concrete name that became famous: anonymous Christianity. It is Christianity because it is an influx that comes from the dynamics of Christ Our Lord and the dynamics of grace. But it is

[7] For example, journalist Alfredo Marranzini, on the editorial board of *L'Osservatore Romano*, wrote: "Even before Paul VI's Encyclical *Ecclesiam suam* on the different dimensions of dialogue, and much before this term had become inflated, Rahner made a *theologia viatoris* [theology of the traveler] in genuine fraternity with the world, accepted in its spiritual and social pluralism Ecumenism finds a valid defender in him" ("Karl Rahner ha avvicinato la teologia alle necessità spirituali dei contemporanei," April 6, 1984, p. 3).

anonymous because it is hidden and nameless, buried in the density and ambiguity of secular reality. Rahner also gave various phenomenological [practical] descriptions. Some excerpts follow.

"The man who accepts himself fully, showing patience toward the evil and decisiveness toward the good, implicitly accepts Christ under the impulse of grace. [8] When a man freely chooses to make a positive moral action, he carries out an act that has a supernatural value [9] When he takes a position that accepts what is absolute in Morals, he also existentially [in practice] establishes a relationship with God, which can coexist with theoretical concepts opposed to his existential act. [10]

"He who valorously accepts life, even if he is a positivist, has already accepted God as He is in Himself, as He wants to be for us, in love and liberty, the God of eternal life, of divine self-communication. Because he who really accepts himself, accepts the mystery of this infinite emptiness that is man tacitly accepts, beforehand and without calculation, the One who resolved to fill this infinity of emptiness with the infinity of His plenitude, that is to say, with the mystery whose name is God.

"These are times when Christianity is no longer understood in Europe and the world. But this should not discourage us. Why? Because everywhere an anonymous Christianity can be perceived. There is no man who is not Christian in some way: a man of desire, a man of love, a man who, in the depths of his soul, rejoices more in truth than in the lie. For not even the worst positivist, materialist, or skeptic can avoid seeing and perceiving in his existence some exigency, some calling.

"Alongside this anonymous Christianity, what is the Christian, pure and simple, that is, one who consciously assumes the name of Christian? What is Christianity next to the

[8] Straub, *De analysi fidei* (Innsbruck, 1922). See also the study of A. Aubert, *Le problème de l'acte de foi* (Louvain, 1950), p. 581.

[9] K. Rahner, "Sobre la unidad del amor al prójimo y el amor a Dios," *Escritos de Teología VI*, German edition, 1965, pp. 277-98, 295-6.

[10] K. Rahner, *El cristiano y sus parientes descreídos*, *Escritos de Teología III* (Madrid, 1961), pp. 395-415.

hidden pulsations of the most profound and authentic movements produced by humanity?

"**Christianity is no more than the open enunciation of what man obscurely experiences in his concrete existence, since the latter is,** in the present historical order, something more than mere nature.[11] **The baptized Christian can be described as the man who,** in a visible, historic, and tangible dimension, that is, from the word and the sacrament, **is what other men are in the silence of their deepest and undiscovered personal realities.**[12] At depth, **the apostolic action is an exhumation of Christianity implanted by God, in His grace, inside hearts** (Rom 11:32).[13] **When the Christian who preaches reaches the pagan man, the word of God only acts to awaken him,** to lead him to make explicit that which existed in the depths of his soul, not because of his nature, but grace

"All this should not be understood as an explanation and way to make the mission and missionary action superfluous.[14] 'No one should say: Because of this, the Church and baptism are superfluous. On the contrary, we should think: let us take care lest our Christian lives, despite being explicitly such, radiate Christ less than the life of a Simone Weil and others who we think bear on their foreheads the sign of Christ without knowing it.'[15]

"Now **we are beginning to verify the point of contact between Christians and the rest of humanity, their religious congenitality. All are animated by only one and the same Christianity.**

"Based on this finding, a new light is also shed on the relation that exists between the Church and the world. **The**

[11] K. Rahner, *Sobre la posibilidad de la fé hoy, Escritos de Teología V* (Madrid, 1964), pp. 11-32.

[12] K. Rahner, *Erlösungswirklichkeit in der Schöpfungswirklichkeit,* in *Sendung und Gnade* (Innsbruck, 1959), p. 80; *Grundsätzliches zur Einheit von Schöpfungs-und Erlösungswirklichkeit,* in *Handbuch der Pastoraltheologie,* II, 2 (Freiburg im Breisgau, 1966), pp. 208-38.

[13] K. Rahner, *El cristiano y sus parientes descreídos, Escritos de Teología V,* p. 410.

[14] K. Rahner, *Los cristianos anónimos, Escritos de Teología VI,* pp. 522, 545-54.

[15] K. Rahner, *El fundamento sacramental del laicato en la Iglesia, Escritos de Teología VII,* German ed., 1965, pp. 342.

Church is not a community exclusive to those who aspire to salvation, but rather it is the historically perceptible anticipation of this salvation in the social dimension, the tangible dimension

"Rahner also emphasized the expression placed at the beginning of the conciliar *Constitution on the Church* [*Lumen gentium*]. **The Church is the Sacrament, the sign of the world's salvation, that is, the manifestation of what is latent outside of her.** He comments that the time is over for **the mentality that saw humanity situated outside the Church as *massa damnata* [the ensemble of the damned] and that interpreted *extra Ecclesiam nulla salus* with excessive pessimism.**

"Even if the Church sees herself reduced in some years to a tiny minority, Christians will continue living her, no longer as one small group, but as a flock of those who, in fact, are ahead of their time, leading the movement of humanity. Christians will not be so dependent on statistics as they seem to be today. **They will view their non-Christian neighbor as a brother, an anonymous Christian. Their missionary action will consist of telling him: 'Be what you are,' rather than repeating to him as in certain epochs: 'Destroy what you are.'**

"Here is the task of the missionary and the theologian: to present grace not as a few intermittent opportunities for individual salvation, but as the final dynamics of the life of man and humanity."[16],[17]

§ 13 It should be noted that in the Constitution *Lumen gentium*, the Council in large measure assumed the concept of the Church as Sacrament of the world – similar to the thesis of "anonymous Christianity" as explained by Maldonado.[18] It is known that Rahner was one of the inspirers of this concept,

[16] K. Rahner, *La doctrina conciliar sobre la Iglesia y la realidad futura de la via cristiana*, *Escritos de Teología VI*, German ed., 1965, pp. 477-498.

[17] Luis Maldonado, *La nueva secularidad* (Nueva Terra, Barcelona, 1968), pp. 59-60.

[18] For more on how the notion of sacramentality relates to "anonymous Christianity," see the document of E. Schillebeeckx presented in § 26.

which was presented by the German Episcopate at the beginning of Vatican II.[19]

§ 14 Another characteristic of "anonymous Christianity" is an openness to a new mysticism that would replace Catholic spirituality. Fr. Harvey Egan, SJ, professor of Systematic and Mystical Theology at Boston College, also drew this consequence from Rahner's theory:

"Because of God's universal salvific will and radical self-communication to all persons, everyone is called to the immediacy of God's presence, a call which, of course, can be rejected. **A supernatural, graced, 'anonymously Christian' mysticism may, according to Rahner, exist outside of an explicit Christianity.** He writes: '**In all human being** **There is something like an anonymous,** unthematic [non theoretical], perhaps repressed, **basic experience of being orientated to God,** which is constitutive of man in his concrete make-up (of nature and grace), which can be repressed but not destroyed, **which is 'mystical'** or (if you prefer a more cautious terminology) **has its climax in what the older teachers called infused contemplation.**[20]

"Man is, therefore, mystical man, experientially referred to a holy, loving Mystery. **Even non-Christian religions, for Rahner, may contain and nurture a graced mysticism. Even if the mystical experience** of one's reference to the God of love **is not interpreted in Christian terms, Rahner maintains that this does not necessarily means that we are dealing with 'natural,' 'pagan,' or 'demonic' mysticism.**"[21]

§ 15 Rahner's concept of "anonymous Christianity" opened the door for ecumenical encounters that included the most diverse kinds of mystical experiences, not excluding the demonic, explicitly mentioned above with a certain sympathy. It seems superfluous to comment that this conception destroys Catholic spirituality and is opposed to the doctrine of the Church.

[19] A. Acerbi, *Due ecclesiologie*, pp. 177, 194.

[20] K. Rahner, *Teresa of Avila: Doctor of the Church* (New York: Seabury, 1970), pp. 125.

[21] Harvey D. Egan, *What are they saying about mysticism?* (New York: Paulist Press, 1982), pp. 99-100.

§ 16 Helmunt Kuhn explained the theological affiliation of Rahner's doctrine of "anonymous Christian." He understood it as a theological application of the theses of existentialist philosopher Martin Heidegger: "Karl Rahner translated the analysis of Heidegger's 'being there' [*Dasein*] into theological language. He attributed an effective 'sense of being fundamentally situated in the supernatural' to all men **With this Rahner made them all (except for those who explicitly say they belong to Christ) 'anonymous Christians.'"**[22]

3. Rahner's texts confirm the thesis

To confirm this general thesis, citations taken directly from the works of Rahner will be presented in this Item.

§ 17 Imbued with naturalist principles, the Jesuit theologian considered that the simple opening of oneself to the love of men would already characterize openness to divine grace and the love of God. Thus Rahner preached doctrinal relativism and confirmed the progressivist plans to promote the cult of man.[23] To this end, he wrote:

"**Whenever man**, with true personal liberty, **opens himself up to his neighbor, he has already done more than simply love his neighbor, since this love is already encompassed by the grace of God. He has loved his neighbor and, in him, he has loved God.** This is because **no one can truly love unless the dynamism of spiritual liberty**, which is supported by the grace of God, **is a dynamism turned to the sacred and ineffable mystery that we call God** And **divine grace gives every man this interior dynamism**, this possibility of expressly developing himself in God's love

"It happens that **there are many men who are redeemed and sanctified by the grace of God without knowing it.** And it happens that **what we as Christians** believe about ourselves, what we hope and thankfully **acknowledge, is something given to all men, something they can accept even though many do not see themselves as Christians or even believers. They can, however, be so in their souls if they**

[22] Helmut Kuhn, "La phénomenologie," V.A., *Bilan de la théologie du XXe. siècle*, vol. 1, p. 279.

[23] See Part I, Chap. I.

have truly managed, with their whole hearts and in total forgetfulness of self, **to love the neighbor whom they see.**"[24]

§ 18 In the same work, Rahner affirmed: "**If a person, in the fundamental act of the fulfillment of his existence, maintains an attitude of love toward his neighbor, this** fundamental **act of his life already comes from the will of God, who divinizes everything, even beyond the visible limits of the Church.** It is the work of the Holy Spirit of God and from his grace. **And it is really, even if not expressly, a true act of charity and love of God.**"[25]

§ 19 Rahner re-emphasized the same notion further on: "**When a man**, with authentic generosity, absolute disinterest, and the true spirit of self-denial, **consumes himself unconditionally in the 'I' of his neighbor** **he is already loving God, even without knowing it,** even without confessing it, **even without having** concretely and objectively **realized that which he calls God as the cause for his love of neighbor.** This thesis leads us to conclude that **when man truly loves his neighbor the object of his love is already**, mysteriously, **the God of eternal salvation.**"[26]

§ 20 Having presented these principles under the light of love, Rahner went on to generalize them in philosophical terms: "**He who accepts his own human being** (which is incredibly costly, and it is not clear whether we are really capable of this) **has already accepted the Son of Man,** and in him God has accepted man."[27]

For the German theologian, then, every man who, relying on natural reason, thinks about the profundities of his own being and existence would already be *ipso facto* unconsciously practicing Religion and possessing grace. By thus abolishing the difference between nature and grace, the author concurs with Modernist Immanentism.[28]

§ 21 Rahner wrote: "**The unfathomable depths of man, which in a thousand ways is the theme of philosophy, is the abyss that the grace of God opens and which deepens fur-**

[24] K. Rahner, *Graça divina em abismos humanos*, pp. 124-5.

[25] *Ibid.*, p. 123.

[26] *Ibid.*, p. 119.

[27] *Ibid.*, p. 41.

[28] See St. Pius X, *Pascendi Dominici gregis*, nn. 7-10.

ther in the abyss of God Himself. **This takes place precisely when and where the man who thinks is not able to** reflect exactly upon the fact of his spiritual existence, or **to distinguish nature and grace in the realization of his spiritual existence.**

"From this we can conclude: **When official revelation,** explicitly Christian, **presupposes philosophy as a necessary condition** and freely accepts it, **this happens** not as a *pure* [abstract] possibility, but already **as a philosophy** to some degree **realized Christian-ly in practice.** And this takes place **not only when men who are conscious of being Christians practice philosophy, but also when it is exercised by men whom we may call anonymous Christians. This applies in principle to** *all* **men who do not explicitly call themselves Christians. In truth, these men, whether they know it or not, whether they distinguish this from the light of natural reason or not, are illuminated by the light of grace,** which God refuses to no man.

"We may now set forth this thesis: **In every philosophy, theology is already practiced inevitably in a** non-thematic [**spontaneous**] **way,** because it falls outside the power of any man to be pursued by the grace of God, whether he desires it or not. In general, **we Christians are blind and lazy in discerning this Christianity hidden in the history of existence, religion in general, and philosophy.** More often **we live unconsciously with the narrow notion of those who think that their [Catholic] knowledge is more precious and has more the character of a gift of grace, even when it is possessed by a small number. We foolishly imagine that God with His truth does not come to men unless** *we* **ourselves approach this man, presenting the** thematic [systematized] **and sociologically official expression of this truth.**"[29]

§ 22 The author proceeded to defend the need for opening the *Philosophia Perennis* – the classical name by which the Scholastic Philosophy is known – to the pagan or neo-pagan philosophies, moving toward a pan-philosophy or, if you will, a universal Gnosis... Rahner wrote:

"We have already said that **no philosophy exists that can be simply a-Christian** In his travel toward new fron-

[29] K. Rahner, *O dogma repensado* (São Paulo: Paulinas, 1970), pp. 16-8.

tiers, the Western Christian finds a world where the grace of Christ has already been acting for a long time, even if it is not called by that name. Likewise, the reverse should necessarily and normally take place. **The anonymous Christian of non-Western philosophy can illuminate and overcome mutilations in the essence of Western Christian philosophy, and liberate the possibilities latent in its essence which, despite its Christian name, are far from being realized.**

"In summary, **the West itself, which announces the Christian message, can become more Christian, more philosophical, and more intelligible to itself by listening to others. Will a philosophy that is [simultaneously] Christian and common world-over thus be born?** To what extent? Or perhaps by means of this, national and historic individuals will extend themselves and assume many philosophies that do not necessarily contradict one another, even though they really are different. This depends upon the question that we cannot respond to here: Can the unity and intervention of historic regions separated until now engender a homogeneous yet nonetheless highly differentiated world civilization? And how will this be done?"[30]

The documents of Rahner himself thus confirm the essential outline of "anonymous Christianity" traced by other authors in the previous Item. Both Items clearly demonstrate the basis for ecumenical thinking.

§ 23
 A simple comparison of Rahner's thesis with the immutable doctrine of the Holy Church set out in the First Premise of Part II will allow the Reader to conclude that the theory of "anonymous Christianity" frontally clashes with Catholic teaching, and especially assails the unicity of the Church and the unity of the Catholic Faith.

[30] *Ibid.*, p. 20.

4. The documents of Vatican II supporting this theory

§ 24
 The basis for the thesis of "anonymous Christianity" is found in texts of Vatican II. This is confirmed by Rahner himself, who comments on certain conciliar documents.[31]

Based on documents of the Council, the author defended the new doctrine that the atheist is not guilty for his incredulity and can be saved. These were Rahner's words: "It is not our intention to analyze here all the [conciliar] texts different from Scholastic Theology or to restructure it. In the present study, two elements seem especially new and surprising in the doctrine on Atheism:

"*First*, **the Council**, while it deals with Atheism in detail, **ignores the traditional Scholastic thesis, according to which guilt necessarily is accrued by a person**, of a normally evolved intelligence, **who takes a position of positive Atheism**. Furthermore, **it can be affirmed that the Council** not only ignores this thesis, but *presupposes the opposite thesis,* **that is, it is of the opinion that a normal adult can explicitly profess Atheism for a long time (even to the end of his life) without this being proof of moral guilt on his part**

"*[Second,]* **another attitude of the Council with regard to Atheism that may appear strange is the conviction that an atheist also is not excluded from salvation so long as, in his Atheism, he has not acted against his moral conscience** Thus the *Constitution on the Church, Lumen gentium* (n. 16), states: '**Nor does Divine Providence deny the help necessary for salvation to those who, without blame on their part, have not yet arrived at an explicit knowledge of God**, but who strive to lead a good life, thanks to His grace.'

"In n. 22 of the *Pastoral Constitution [Gaudium et spes]*, it is affirmed: 'All this **[the Resurrection] holds true not only for Christians but also for all men of good will in whose hearts the grace of God works in unseen ways.** For since Christ died for all men, and since the ultimate vocation of man is in fact one, and divine, **we ought to believe that the Holy Spirit in a manner known only to God offers to every**

[31] Rahner comments on these documents: *Gaudium et spes* (nn. 19-22); *Lumen gentium* (n. 16); *Ad gentes* (n. 7); *Christus Dominus* (nn. 11, 13); *Presbyterorum ordinis* (n. 4).

man the possibility of being associated with this paschal mystery.'

"**There is absolutely no reason to exclude an atheist from what is affirmed in this statement.** Indeed, it points expressly to n. 16 of the *Constitution on the Church*, in which reference is made precisely to those who have not yet arrived at an explicit knowledge of God. Moreover, **the expression 'in a manner known only to God' is also found in the *Decree on the Missions* [*Ad gentes*] (n. 7), which recognizes that those who still have not been reached by the Gospel may have, in this state, a real supernatural possibility for faith and salvation.**

"**Obviously, these texts do not deal with the possibility that before he dies the atheist might yet become an explicit theist and, by this, be saved.** If they did, these texts would only contain the commonplace knowledge that the atheist can attain salvation when and to the degree that he ceases being an atheist. **Such an interpretation would take from the texts all seriousness**

"**With these two points, something new really was said in the doctrine of the conciliar magisterium.**"[32]

Thus, according to Rahner's analysis, the Council itself provides the basis for his "anonymous Christianity," indirectly expressed here as the absence of guilt and possibility of salvation of atheists.

5. The thesis of "anonymous Christianity" denies that the Catholic Church is the exclusive depositary of the graces of salvation

§ 25

The testimonies presented up to now on "anonymous Christianity" have demonstrated quite explicitly its opposition to the unity of the Church and her character as exclusive custodian of the truth contained in Revelation. It nonetheless seems opportune to bring to the Reader's attention one last document of a clarity that leaves no margin for doubt. Rahner wrote:

"One cannot expect religious pluralism to disappear in the near future. On the other hand, there are also reasons to

[32] K. Rahner, "*A doutrina do Vaticano II sobre o ateísmo*," *Concilium*, 1967/3, pp. 10-12.

admit that **Christianity itself may come to be considered by Christians as an 'anonymous Christianity,' that is, a Christianity that will become ever more explicit and clear**. This leads one to admit that **today the Church should not consider herself the sole depositary of salvation nor should she consider herself the only religious society in whose ambit one can find those who have already achieved salvation.** Above all, the Church should consider herself a historically visible point of arrival, a social expression of that reality of grace and salvation that Christianity admits as also being present outside the visible boundaries of the organized Church.

"For this reason, **the Church should not be seen as a society of those who possess grace as opposed to those who are deprived of it. She must be seen as a society on the way to explicitly recognizing that she will become more herself as she accepts others who now only implicitly possess the grace of salvation.**"[33]

6. Important theologians adhere to the principles of "anonymous Christianity"

§ 26 Assuming the same doctrine of Rahner, Fr. Edward Schillebeeckx, an important *perito* of Vatican II, described what he imagines as grace in Paganism. The professor of Nijmegen concluded by admitting the "legitimacy" of the essence of pagan myths:

"**The sacramental Church was already present, in a vague** but visible **way, in the life of all of religious humanity. All humanity is the object of the interior call of God,** who invited it to the community of grace with Him. **In Paganism, this vague appeal,** to the degree that it is heeded by a sincere heart, **already stirs up an obscure presentiment of God the redeemer,** who is personally concerned about the salvation of men. **But this interior religious experience, worked by grace, has not yet attained the visible form of this grace, which remains, so to speak, hidden in an unknown way in the innermost depths of the human heart**

[33] K. Rahner, "Religione assoluta?," V.A., *Incontro tra le religione* (Verona: Mondadori, 1969) pp. 104-5.

"**The created world makes itself an element (still undoubtedly anonymous) of interior dialogue with God.** Now, the God who desires to establish personal relations with us is the Creator of heaven and earth. This implies that our relationship with the world, our existence in the world, will speak to us about the living God more vividly than the world by itself could do. We will become aware that God is not only the Creator of all that exists, but **life itself in the world belongs to the contents of the interior word of God. It vaguely translates something that the living God personally suggests to our listening hearts by means of His grace that attracts us. Even though it is vague, we have there a true, supernatural, exterior revelation where the creature speaks the language of salvation to us**, becoming the sign of higher realities. Natural things, human life in and with the world, find in this interior word of God much greater capacity and propriety of expression than they have in themselves. To all this, a particular, even personal plan is added, a plan that goes beyond created possibilities common to nature and life in the world. In this way, **interior grace can also come to be visibly manifested in Paganism. For religious Paganism also sought to give an exterior form to its interior expectancy**

"In its visible realization, first, by the godly men of Israel, and later in its definitive perfection by the man Jesus, the contents of truth are manifested, hidden in the distorted myths of the pagan religions. The distorted expressions [in the Old Testament] **in these myths** – projections of human experiences where grace still worked obscurely – were pallid prefigures of future realities. Their true form was attained in the visible exteriority of tangible sanctity with Israel, and later with Christ. **The pagan religious community** that community that governed and nourished the life of the religious man, **was the first, providential sketch of the future Church, the Church of Christ. Thus, the 'Church,' the presence of visible grace, is a reality as vast as the world.** Even more, **it is a fragment of unconscious Christianity**, as the early Church Fathers used to say

"But **the visibility of this presence of grace in Paganism is cloaked in cogent anonymity. This applies as well to**

the religiosity that perchance exists among the modern pa-
gans."[34]

§ 27 In like manner, Cardinal Urs von Balthasar, dealing
with the cults of Paganism, considered that in them salvation is
in a state of "shadow" and grace is already acting in a "hidden"
way.

Von Balthasar wrote: "**If we would examine the vari-
ous ways that serve humanity as means to seek salvation**,
that is, for its relationship with God, **we must say** first of all
**that, both in the intuition that discovers them as well as in
their lived realization** (*praxis*), **they are the most daring and
elevated undertakings of the human spirit. Further, they
have been engendered throughout History by individuals or
peoples**, because life itself is at stake. It is never permitted to
see there [in the diverse ways of salvation] shimmers of the
demon or to discredit the **human spirit that conceived them
by calling them** *'fabrica idolorum'* [factory of idols] **even
when it becomes visible that these ways are fragmentary
and that** none of them can achieve total, objectively indivisible
salvation. This is why **they remain hidden in a kind of
shadow: because they make human efforts turn seriously
toward salvation, they can contain a hidden redeeming
grace.**"[35]

§ 28 In another passage, von Balthasar again identified with
Rahner, affirming that acceptance of "loving one's brother" is
already, unconsciously, the recognition of the love of God. He
said: "**To recognize this love [of one's brother] means, con-
sciously or unconsciously, to recognize that the love of God
took on human form. It is to acknowledge Jesus Christ,
whether one knows of His existence or not.** It is to acknowl-
edge Him without more ado, inasmuch as one admits that love
of God – true love *of God* – is an obligation for me as a man.
**Whoever does this is a member of the Church, visibly or
secretly**, since the Church is the communion of saints that is
built with fraternal love."[36]

[34] E. Schillebeeckx, *Cristo, sacramento dell'incontro con Dio* (Rome:
Paoline, 1970), pp. 19-23.

[35] H. U. von Balthasar, *De l'intégration*, p. 66.

[36] H. U. von Balthasar, *El problema de Dios en el hombre actual*
(Madrid: Guadarrama, 1960), p. 299.

§ 29 Cardinal Yves Congar stated that one cannot establish the superiority of the Catholic Church over other religions, even pagan ones. In his exposition he implicitly approached the thesis of Rahner: "Men today recognize **other religions. They know that these also claim some revelation for themselves. They all propose a myth about their origins, and for the most part [also] about their final end.** It is understood that **we cannot establish**, by way of comparison, **the superiority and absolutization of Christianity. We are neither entitled to do this, nor, more emphatically, capable of it My Christian and Catholic faith are legitimate for this sole reason: If I love a woman, I do not look at others**; if I am happy in my country, why search for another home?"[37]

§ 30 Anyone who is not satisfied with this image of a beloved woman as proof of Congar's adhesion to the essence of "anonymous Christianity," let him read the following excerpt. In his responses, the Dominican theologian affirmed that graces of revelation act normally through non-Christian religions:

"*Question:* **Do you believe in the revelation of God through ways other than Christianity?**

"*Answer*: **To me this seems completely evident.** In the beginning there was the natural knowledge of God What followed was the gathering **of the great religions, which have not only insights of genius and authentic religious experiences, but also**, I am convinced of this, **graces of God, graces of revelation. It is** not the Revelation proper to the people of God as such by the Covenant, but **a true unveiling of God to souls – and revelation means nothing other than this unveiling. I see this revelation addressed to peoples, enriched by its insertion into rites and religious traditions, and,** finally, **constituting a collective message of great value.**"[38]

§ 31 Bishop Emile Marcus of Nantes clearly adhered to Rahner's doctrine: "**Evangelization consists of making explicit what already lies in the interior of each man** The nonbeliever can be called a '**Christian without knowing it,**' a

[37] Y. Congar, *Église Catholique et France moderne*, p. 120.

[38] *Jean Puyo interroge le Père Congar*, pp. 173-4.

man living an 'invisible,' 'implicit,' 'underground,' or 'embryonic' Christianity."[39]

§ 32 In a note, Msgr. Marcus showed the source of his thinking by making reference to others who adopted this thinking: "**Fr. Liège** ("Le salut des autres," in *Lumière et vie*, n. 18, November 1954) **speaks of an 'embryonic Christianity' in which the unbeliever belongs 'tendentially,' 'virtually,' 'implicitly,' or 'anonymously' to the Church**.

"**Rahner** (*XXe. siècle, siècle de grâce*, vol. I, p. 213) **deals with salvation 'outside the Church,' an invisible Christianity**."[40]

§ 33 Fr. Germano Pattaro explicitly adhered to this theory in a lecture broadcast by Vatican Radio: "**Present day theology elaborated the category of 'incognito,' defining these somewhat unclear but always Christian situations as 'Christianly anonymous,' and the men who live in them as 'anonymous Christians.'** Although objectionable, **these theses have a basis, and they open authentic and not arbitrary perspectives,** always open to debate in the sense that they provoke arguments, but in the right direction."[41]

Directly or indirectly, other famous theologians have drawn consequences from the thesis of "anonymous Christianity." Not all of them attribute the origin of the theory to Rahner. Some find it more comfortable to protect themselves under the authority of Vatican II, which, in various excerpts,[42] indirectly assumed the ideas of the German theologian.

§ 34 Thus, Cardinal Avery Dulles, SJ, affirmed that the "United Church" of the future – which he calls *una sancta* [one holy church] – will come about by an agreement among all religions, without any having to concede its convictions: "**Vatican II recognized that the life and truth of Christ operate in the other communities. Consequently, they should not think about abandoning anything that the grace of the Holy Spirit has worked in their midst** (UR 4).

[39] Emile Marcus, "O que é evangelizar?," V. A., *A Igreja do futuro*, p. 106.

[40] *Ibid*, p. 117, footnote 4.

[41] G. Pattaro, *Riflessioni sulla teologia post-conciliare*, p. 111.

[42] See Part II, Premise 2, §§ 3-5; Items 3, 4 of this Chapter.

"In consideration of these two principles, **it can be defended that the Council implicitly taught that the united church of the future will not come about by a capitulation of the other churches and their absorption into Roman Catholicism. The desired *una sancta* can be a joint creation, which will simultaneously complete and transform all the churches that enter it. The Catholic Church,** without being dissolved in any way, **would modify herself by entering this embracing unity."[43]**

§ 35 Departing from the same principles, Fr. Mario von Galli, SJ, conciliar *perito* and director of the Zurich magazine *Orientierung*, concluded that there should be no more missions,[44] which he considered "spiritual colonization." He wrote: **"The Council declared that it is possible for every human being, whether he knows the Church or not, to enter the kingdom of God We have to start thinking about spiritual de-colonization,** that is, **not to impose our Western** European **or Latin ways on countries we catechize."[45]**

§ 36 Theologian Richard de Smet applied the principles of "anonymous Christianity" to Hinduism: "It was suggested that **the Hindu tradition could be considered an implicit Christian revelation destined to be clarified by an explicit Christian revelation. If this means that the Word has always inclined Hindu minds and hearts in an interior way toward the full salvific truth, and that Christian grace in its diverse forms,** from which no man is excluded, **was mysteriously accessible to them and was the hidden element of their secular search and intense religious life; and if, furthermore it is affirmed that a large number of the concepts and practices of Hinduism could be the messengers of this grace, then one is authentically stating the universality of Christian redemption."[46]**

§ 37 Based on the "direct calling of God" to men and the exaltation of humanity, Fr. Alting von Geusau, director of *Concil-*

[43] Avery Dulles, "Ecumenismo: problemi e possibilità per il futuro," V.A., *Verso la Chiesa del terzo millennio*, pp. 112-3.

[44] On the missionary action of the Church, see Chap. IV, footnote 6.

[45] Mario von Galli, "Misión sin colonialismo," V.A., *La reforma que llega de Roma*, pp. 77-8.

[46] Richard de Smet, "La théologie en Inde," V.A., *Bilan de la théologie du XXe. siècle*, vol. 2, p. 370.

ium, denied to Holy Church her mark as exclusive depositary of the graces of Revelation. Following Rahner's thinking, he stated: "**Any attempt to establish a security system or one of human certainties with a pretension to be eternal, which could thus** condition or **channel God's salvific action, be it individual or collective, always runs the risk of becoming a denial of the call of God.**

"Thus it can be said that **the departure point for the call of God**, seen in the context of his plan of salvation, **lies in the solidarity of the whole human race** and tends in an absolute way toward universality **The time in which we live seems to demonstrate more clearly than ever before how much old Judaism** [of the Old Testament] **or ghetto Christianity** [in the New Testament] **failed to understand this fundamental point.**"[47]

7. The Vatican implicitly assumes Rahner's ideas

§ 38
It is not difficult to see the connection between the notion of "Church of Christ" analyzed above [48] and that of "anonymous Christianity." We have seen how the "Church of Christ," for the progressivists, would be a vaster reality than the Catholic Church. To have a clear picture, one could imagine a first circle, that is the Catholic Church. The "Church of Christ" would be a second circle around it, more ample than the Catholic Church and encompassing those who separated themselves from her. The name of Christians, improperly applied to heretics and schismatics, is the basis progressivists use to call this ecumenical union they aim to realize the "Church of Christ."

Going further, progressivists suppose a third concentric circle, which would encompass those who believe in some god. This is what they call the "Church of God." A fourth circle would enfold all men, even atheists. This would be the "messianic people." These successive degrees of tolerance, which assail the unicity of the Catholic Church and the unity of the

[47] Leo Alting von Geusau, "La Chiesa 'scandalo' del mondo," V.A., *La fine della Chiesa come società perfetta* (Verona: Mondad, 1968), pp. 165-6.
[48] Part II, Chap. II, §§ 1-12.

Faith, appear to have been officially assumed by the Council in its final documents.[49]

§ 39 Confirmation of this concentric visualization of ecumenism is also found in the three ecumenical Secretariats created by John XXIII and Paul VI – the Secretariat for the Union of Christians (1960); the Secretariat for Non-Christians (1964); and the Secretariat for Non-Believers (1965). Establishing them, the Pontiffs gave institutional status to the aforementioned degrees of religious tolerance.

§ 40 With regard to ecumenism, the notions assumed by Vatican II and later by the post-conciliar Popes, do not differ essentially from the theory of "anonymous Christianity." The Council, the conciliar Popes, and Rahner all essentially deny to the Catholic Church her unicity, the role of sole and necessary mediatrix of the graces of Redemption.

§ 41 The difference between the Vatican conception and Rahner's is accidental. It is simply a difference of terms. Rahner gives the name "Christians" to baptized men, believers, or atheists, seeking the union of all in one single church. For the Vatican, "Christians" are only the baptized; the followers of the non-Christian religion are "believers," and atheists are "non-believers." Notwithstanding this difference in the names, the essence of the two theses is the same: the denial of the unicity of the Church. The method is the same: religious relativism. And the goal is the same: to form one universal religion. On these points the doctrine of Vatican II and that of Rahner coincide.

§ 42 Furthermore, the central idea of Vatican II about the Church is the notion of the Church as Sacrament. This concept is so elastic that it also stretches to fit all men.[50] It is interesting to note that one of the principal defenders of this conception of the Church, which was presented at the Council by the German Episcopate, was Karl Rahner.[51]

In view of these facts, it can be affirmed without any exaggeration that the Vatican appears to have assumed the greater part of Rahner's thesis.

[49] See Part II, Premise 2, §§ 3-4; Chap. II, §§ 7-12.

[50] See Vol. XI, *Ecclesia*, Chap. I.3.

[51] A. Acerbi, *Due ecclesiologie*, pp. 177, 194.

§ 43 The "official line" of the Vatican is moderate. But in this moderation of the post-conciliar Vatican, ambiguity and contradiction often appear. This can be seen in the first two texts cited below.

In these two texts, Cardinal Julius Döpfner, one of the Moderators who directed the plenary assemblies of Vatican II, "defended" the dogma *extra Ecclesia nulla salus*. Paradoxically, in this "defense," Döpfner affirmed the opposite of what the dogma teaches, that is, he affirmed that there is salvation outside the Catholic Church. Trying to make a bridge between the two opposed statements, Döpfner appealed to the notion of "Church of Christ." He declared that *extra Ecclesiam nulla salus* must be understood in relation to the "Church of Christ" instead of the Catholic Church. One would like to ask the Cardinal about the salvation of pagans, Jews, and atheists, since in the language of the Council, they are not part of the "Church of Christ." Would they also be admitted to the broad eternal salvation offered by the Council? If this were the case, Rahner and Döpfner would share the same thinking, defending that the "Church of Christ" encompasses all of humanity. Since this would seem to be the case, the following document is offered as proof of the tacit acceptance by a high-ranking official representative of Vatican II of the thesis of "anonymous Christians."

Döpfner stated: "The Council gave us a new vision of the Church: a more dynamic concept of Church seen as people of God, the community of salvation reunited around the glorious Lord to which all men are called and already related in various ways and different degrees Thus, it appears evident that **the Church as community of those who have attained salvation in Christ extends well beyond the confines of the Catholic Church. Thus the principle** formulated in the second century by Cyprian, the Bishop-martyr of Carthage, and defined in the year 1215 by the Fourth Lateran Council – '**outside the Church there is no salvation**' – **takes on a much more profound meaning. It does not exclude non-Catholic Christians from salvation, but rather imparts the understanding that,** as redeemed and saved souls, **they belong** along with us **to the one Church of Christ.** For the Church is where the salvation of Christ is truly given. Certainly **this concept had already been affirmed long before the Council; but it is the first time that it was solemnly proclaimed by the Magisterium of the Catholic Church.**

"From all this, it can be deduced that much of what is essential we share in common, that we are united by a kind of subterranean communication, that is, in the new life given by Christ. **And it is not by mere courtesy that we call ourselves brothers, but because we really are**

"We come closer to unity only if each one moves away from his respective position and we all move toward the center of these efforts, that is, to Christ, with fidelity to His message as each one understands it, but conscious – and this is essential – that we will never be able to deceive Him or do away with Him. This will continually call us to new openings and goals. *Union in faith* constitutes one of these goals: we see before us the next step to be taken, but the darkness still shrouds it from our eyes."[52]

§ 44 In the same work, Döpfner had already tried to explain the contradiction between the new and the perennial teachings on salvation:

"*Extra Ecclesiam nulla salus.* In precisely this field it has become evident that, without renouncing the essential, it is possible to enunciate the truth in a way that does not wound those who think differently, making them understand our intention. The Church cannot annul that phrase without renouncing what she is, since it is linked to the will of the Lord, who wants to extend His own action by means of a visible institution. But **today we know that the word and salvation of Our Lord work among men in many ways and degrees, and also outside of the Catholic Church. The fact that this has been recognized explicitly in a declaration of the supreme Magisterium of the Church** [in Vatican Council II] **undoubtedly constitutes a novelty that was inconceivable in the past,** when persons of another faith were considered almost exclusively from the standpoint of formal heresy. **But if one must admit an action of the Spirit outside the Catholic Church that can be explained in various ways,** then from this admission, very concrete consequences can be drawn. **So it is that an intimate cohesion and union between the separated brethren and ourselves exist."**[53]

[52] Julius Döpfner, *La Chiesa vivente oggi* (Bari: Paoline, 1972), pp. 426-8.

[53] *Ibid.*, pp. 51-2.

§ 45 The statements of the Council itself and those of the Cardinal Emeritus of Vienna, Franz König, can be understood in the same sense. J. Mouroux referred to both: "In the Declaration on the relation of the Church with non-Christian religions [*Nostra aetate*], **the Council indicates that the Church 'rejects nothing of what is true and holy in these religions'** (NA 2); **and, as Cardinal König wrote, this is 'one of the fundamental truths' of the 'new reflections' of the Council, that is, 'the recognition of the moral and religious values that exist everywhere in the world.'"**[54]

§ 46 In his *Creed of the People of God*, published after the Council, Paul VI also spoke of "elements of sanctification" outside the "Church of Christ." It should be noted that the Pontiff did not limit himself to refer only to "elements of sanctification" outside the Catholic Church, as is normally done by progressivists, as Döpfner, for example, in the excerpts quoted above. Rather, when he used the expression "Church of Christ," he supposed as certain that "the Christians" – be they Catholics, Schismatics, or Protestants – have open access to sanctification. Therefore, by the "elements of truth and sanctification **outside of the Church of Christ,"** he was referring to Jews and pagans. With this, he closely approached the ideas of "anonymous Christianity."

These are his words: "**Also recognizing, outside the organism of the Church of Christ, the existence of numerous elements of truth and sanctification, which properly belong to her as well as to Catholic unity** (LG 8), **and believing in the action of the Holy Spirit, which stirs in the hearts of the disciples of Christ love for this unity** (LG 15), we have the hope that **Christians [anonymous Christians?] who are still not in full communion with the one Church will someday reunite in one single flock** with one single Shepherd.

"We believe that the Church is necessary for salvation, since Christ, who is the sole Mediator and way of salvation, becomes present for us in his Body, which is the Church (LG 14). But **the divine plan of salvation extends to all men; and those who**, without guilt on their part, **are ignorant of the Gospel of Christ and his Church but sincerely seek God and, under the influx of grace, strive to fulfill his will, as**

[54] J. Mouroux, "Sur la dignité de la personne humaine," V.A., *L'Église dans le monde de ce temps*, vol. 2, p. 252.

recognized by the dictates of their consciences, can, in a number known only to the same God, obtain salvation (LG 16)."[55]

§ 47 Cardinal Karol Wojtyla also seemed to assume Rahner's criteria when he supposed the existence of an "implicit faith" in the non-Christian religions. In a speech on the evangelization of the contemporary world presented at the 9th General Assembly of the Synod of Bishops on October 8, 1974, he affirmed:

"The significance and force of this mandate [to preach the Gospel] does not permit us to limit ourselves to the simple outlines of the first evangelization. This, however, does not diminish, but rather increases that esteem which Vatican Council II showed to non-Christian religions. **Independent of any criticism made of [the theories of] 'anonymous Christian' and so-called 'implicit faith,' what remains always clear is the responsibility of making the implicit faith ever more explicit."**[56]

§ 48 In an official document titled "The position of the Church toward the followers of other religions," the Secretariat for Non-Christians considered that there could be "impulses from the Spirit" and "precious religious elements" even among those who persecute the Church: **"We thus turn our thoughts to all who admit God and maintain in their traditions precious religious** and human **elements, and we desire that an open dialogue may lead us all to faithfully accept the impulses of the Spirit** and fulfill them with enthusiasm.

"On our part, with due prudence, **the desire for such a dialogue guided only by love of the truth, excludes no one, not even those who, while honoring the admirable goods of human ingenuity, nonetheless do not admit their Author, or those who oppose the Church and persecute it in various ways."**[57]

[55] Paul VI, *O Credo do povo de Deus* (São Paulo: Paulinas, 1968), pp. 13-4.

[56] *Karol Wojtyla e il Sinodo dei Vescovi* (Libreria Editrice Vaticana, 1980), p. 196.

[57] Secretariat for the Non-Christians, *L'atteggiamento della Chiesa di fronti ai seguaci di altre religioni* (Typis Polyglottis Vaticanis, 1984), n. 42.

§ 49 This document of the Secretariat for Non-Christians also listed the conciliar statements that admit principles analogous to those of "anonymous Christianity": "**This vision [that the Church is not the kingdom of God, but only its 'seed and beginning' (LG 5, 9)] led the fathers of Vatican Council II to affirm that in non-Christian religious traditions, there can exist 'elements of goodness and truth' (OT 16), 'precious elements of religion and humanity' (GS 92), 'elements of truth and grace' (AG 9), 'seeds of the Word' (AG 11, 15), and 'rays of that truth which enlightens all men' (NA 2).**

"**According to explicit conciliar indications, these values are found condensed in the great religious traditions of humanity.** Hence they deserve the attention and esteem of Christians, **and their spiritual patrimony is an effective invitation to dialogue (NA 2, 3; AG 11), not only on converging elements, but also on those that diverge.**"[58]

In conclusion, the documentation presented in this Chapter is sufficient to show the essence of two fundamental doctrines of ecumenism: the theory of the "seeds of the Word" and the thesis of "anonymous Christianity."

They also clearly explain that these theories, as understood by the progressivists, go against the dogmas of the unicity of the Catholic Church and the unity of the Faith. Further, the documentation shows the support of other conciliar theologians for the same notions. Finally, it offers evidence that many testimonies from official Vatican sources, including Paul VI, John Paul II, and the Council, have lent their support to these theses.

* * *

[58] *Ibid.*, n. 26.

Chapter IV

ECUMENISM: DENIAL OF THE MILITANT AND MISSIONARY CHARACTER OF THE CHURCH

§ 1 The Conciliar Church's admission of the basic principles of ecumenism entails other consequences no less grave than those already analyzed. That is, ecumenism causes the destruction of the militant and missionary character of the Church.

§ 2 The militancy of Holy Church comes from the notion of opposition between truth and error, good and evil. Our Lord Jesus Christ founded the Catholic Church to be the guardian of the integrity of the truth and the Faith, the source of all good and all holiness.[1] Thus it was natural for her to fight against the error and evil that rose up against her: "*Mala molitur impius justo, et frendit contra eum dentibus suis* [The sinner shall conspire to do evil to the just man; and shall gnash his teeth

[1] a. Commenting on Psalm 103, symbolic of the firm foundation of the Catholic Church – "*Fundavit terram super firmitatem ejus, non inclinabitur in saeculum saeculi*" [Who hast founded the earth upon its own bases: it shall not be moved for ever and ever] – St. Augustine showed that the Church, in Jesus Christ (1 Cor 3:11), will always remain unshakeable since she is the column of truth. He said: "She will not decay through the centuries. She herself is the predestined pillar and the foundation of truth" (1 Tim 3:15) (*Enarr. in Ps 103*, 17, PL 37, col 1350, *apud* E. Dublancy, entry "*Église*," Dictionnaire de Théologie Catholique, col. 2179).

b. For this reason, the Catholic Church will never be vanquished by any of the heresies she combats, since, according to St. Augustine, "she is the Holy Church, the One Church, the True Church, the Catholic Church. In her fight against all the heresies, she can be combated, but never conquered. All the heretics will fall from her like the useless branches from the trimmed vines. However, she herself remains in her roots, her life, and her charity. The gates of hell will not prevail against her (Mt. 16:18)" (*De symb. serm. ad catech.*, c. 6, n. 14, in *PL* 40, col. 635, *apud ibid.*).

against him]."[2] To fulfill her mission to preserve the integrity of the message of Revelation, the Church must be militant.[3]

[2] Ps 36:12.

[3] a. Speaking on militancy as a principal characteristic of the mission of the Roman Pontiffs, Pius IX declared in the Encyclical *Quanta cura* (December 8, 1864): "And those our predecessors, who were the guardians and avengers of the august Catholic Religion, of truth and justice, being as they were chiefly solicitous for the salvation of souls, held nothing to be of so great importance as the duty of exposing and condemning all heresies and errors which are hostile to moral honesty and to the eternal salvation of mankind, and which have frequently stirred up terrible commotion and have damaged both the Christian and civil commonwealths in a disastrous manner" (*Recueil des allocutions*, p. 3).

b. Speaking on militancy as a principal characteristic of the mission shared by Popes and Bishops, Pius IX splendidly taught the following in the Allocution *Si semper antea* (May 20, 1850): "And here, directing ourselves to our Venerable Brethren, the Bishops of the Catholic world called to participate in our concerns in this terrible war against our divine Religion, we encourage them to rise up [and] strengthened in Our Lord and the power of His virtue, wielding the unconquerable sword of Faith, girded with the dagger of the spirit which is the Word of God, to intrepidly combat in favor of our most holy Religion with an ever more ardent zeal in order to oppose the efforts of the enemies, repel their attacks, break their impetus, and defend against their ambushes and aggressions the flock that was confided to them so that they might lead them along the ways of salvation" (*ibid.*, p. 271).

c. Speaking on militancy as a principal characteristic of the mission of the Bishops, Pius VII emphatically recommended this in the Encyclical *Diu satis* (May 15, 1800): "We exhort you, we warn you, and finally, we order that you leave nothing to desire in the matter of vigilance, dedication, application, and effort in order to guard the deposit of the doctrine of Christ. A deposit against which a great conspiracy has formed; you know this conspiracy and by whom it is made" (*ibid.*, p. 117).

In the same encyclical, he recommended vigilance to the Bishops: "Keep your eyes on everything. Expel, repel far from you the rapacious wolves that do not spare the flock of innocent sheep. If they infiltrate, expel them as soon as possible without pity by virtue of the power that Our Lord gave you for the edification of all" (*ibid.*).

d. Speaking about bad books, Pius VII counseled: "The books that we desire to see snatched from all hands, removed from all eyes, and destroyed by fire are not only those that openly attack the doc-

§ 3 Such militancy must not be merely defensive. According to the divine mandate, "Going therefore, teach ye all nations, baptizing them in the name of the Father, and of the Son, and of the Holy Ghost, teaching them to observe all things whatsoever I have commanded you" (Mt 28:19-20), the Church must also be one who conquers, for he who evangelizes, conquers. Also, one who evangelizes has to face the battles that must be fought to achieve the victory of the true Faith. Hence, in this special sense, the militancy of the Church must also take the offensive. So it was, for example, that St. Raymond of Peñafort, in his zeal to spread the Faith to the Muslims, asked St. Thomas Aquinas for a work refuting the errors of the infidels. This gave birth to the magnificent work of apologetics that is the *Summa contra gentiles*.[4] From this one sees that the

trine of Jesus Christ, but also, and above all, those which attack it in a more veiled way and employ astuteness In this matter, Venerable Brethren, we cannot be convivial, nor dissimulate or be soft. Because if it is not stopped, if such license of thinking, words, writings, and lectures is not suffocated if we do not pull it out by the roots, destroying even its seed the evil will continue to grow, becoming stronger and spreading throughout the land, and then neither army squadrons, nor garrisons, nor the eyes of the police, nor the walls of the city, nor the lines of defense of empires will be sufficient to stop it" (*ibid.*, pp. 117-9).

e. Pius VII also recommended that the Bishops vigilantly enforce the laws of the Church: "There is, Venerable Brethren, yet another deposit confided to your protection and that requests for its defense much strength of soul and perseverance. It is the deposit of the holy laws of the Church, laws by which she – the only one capable of making them – established her own discipline. Laws that invariably make piety and virtue flourish, and make the Spouse of Christ 'terrible as an army set in battle array'" (*ibid.*).

f. More Pontifical documents on the militancy of the Catholic Church can be found in Vol. II, *Animus injuriandi I*, Chap. II.

[4] Fr. Pedro Marsílio, OP, a counselor to King James II of Aragon (1264-1327), recorded this episode: "Ardently desiring the conversion of the infidels, he [Raymond Peñafort] asked his brother of the same order, Thomas Aquinas, an eminent scholar of Sacred Scriptures and professor of Theology who was considered, after the philosopher [St.] Albert, the most learned of all clerics, to write a book against the errors of the infidels that might banish the darkness and illuminate with the doctrine of the true sun those who did not want to believe" (Franciscus Balme and Ceslaus Paban, *Raymundiana seu documenta quae pertinent ad S. Raimundi de Pennaforti vitam et*

missionary aspect of the Church is intimately linked to her militant and apologetic character.

By denying the unicity of the Church and the unity of the Faith, conciliar ecumenism also necessarily denies her militant[5] and missionary[6] character. This Chapter will try to clarify these two points.

scripta, in *Monumenta Ordinis Fratrum Praedicatorum Historica*, vol. 6, fasc. 1, p. 12, *apud* José M. de Garganta, "Introducción general," in *Summa contra los gentiles*, Madrid: BAC, 1953, p. 13).

[5] On progressivist hatred for the militant character of the Church, see Vol. II, *Animus injuriandi I*, Chap. II, of this Collection.

[6] For the Reader's convenience, we reproduce here the distinction between true Catholic missionary action and the false progressivist one, taken from Vol. I, *In the Murky Waters of Vatican II*, Chap. IX, footnote 2:

a. It is necessary to distinguish two concepts of missionary Church and the missions. Until Vatican II, the goal of the missions was to convert heretics, schismatics, Jews, and pagans from the errors they professed in order to bring them into the bosom of the Church.

b. After Vatican II, the "missions" came to signify a movement of the Church toward the heretics, schismatics, Jews, and pagans without asking any conversion of them. What prevails is the orientation made explicit by Msgr. Louis Pelatre, Apostolic Vicar of Constantinople: "Proselytism is banned" ("Islam: la paura ingiustificata," interview with Francesco Strazzari, *Il Regno*, March 15, 1993, p. 147).

c. This Work refers to the perennial missionary character of the Church, which it deems as the exclusive fountain of all truth. It is the one that precedes the Council and is based on the mandate of the Savior: "Go ye into the whole world, and preach the Gospel to every creature. He that believeth and is baptized, shall be saved, but he that believeth not shall be condemned" (Mk 16:15-16).

d. On the clash between the missions' traditional character with the neo-missiology *aggiornata*, see the work by Plinio Corrêa de Oliveira, *Tribalismo indígena: Ideal comuno-missionário para o Brasil do século XXI*.

1. Heretics do not need to be converted

§ 4 Few things can be more expressive of the progressivist intent to do away with militancy and the missionary character of the Church than the affirmation that heretics do not need to be converted. Indeed, heresies were declared as such because they denied one or various points of the Catholic Faith. Throughout History, a brilliant pleiad of Catholic apologists, counting many saints among them, has risen up against the various heresies. In her endeavor to re-conquer those who followed heretics, the Church exercised the most sublime apostolic efforts, where the courage of her children was often crowned with the palm of martyrdom. The affirmation that heretics do not need to convert not only makes a *tabula rasa* of the unicity of the Church and the unity of the Catholic Faith, but also it completely denies the militant and missionary past of the Church, which it tacitly judges as erroneous and calls for its destruction.

§ 5 Edward Schillebeeckx clearly explained a presupposition of conciliar ecumenism as a denial of the unity of the Church: **"By admitting that other Christian communities are also Church, the Council made a judgment on the incapacity of the Church herself to realize the plenitude and unity desired by Christ. It is difficult to say that the Catholic Church is still one**, the one, Catholic, Apostolic Church, **when one says that others are equally one, catholic, and apostolic**, although to a lesser degree.

"While maintaining the conviction that the Church of Christ is essential for salvation, at Vatican Council II the Roman Catholic Church officially abandoned her monopoly over the Christian religion. In the conciliar documents, belonging to the Church no longer has an univocal meaning, but an analogous one. Now the whole problem is to know whether one should continue to view this analogy of the Church as the Roman Catholic Church as the *princeps analogatum* [the criterion of comparison], while the other Churches are mere *analogata* [analogies], called churches only to the degree that they draw near the Roman Catholic Church.

"To me it would seem better to say that all the churches, and therefore also the Roman Catholic one, are *analogata* [analogies] in relation to that which in the Bible **is**

called the 'Church of Christ.' They are all local churches of Christ. **The criterion for comparison is no longer the Roman Catholic Church as such, but apostolic plenitude, the plenitude of the messianic promise**. This is the perspective of Vatican Council II. In the *Dogmatic Constitution on Divine Revelation* [*Dei Verbum*], the whole Church is placed, more consciously than before, primarily under the critical authority of the primitive apostolic Church and its Scriptures (DV 21)."[7]

§ 6 In the same work, Schillebeeckx set forth a similar thesis: "Here **we can appeal to Vatican Council II itself. At it the [Catholic] Church officially abandoned her religious monopoly and affirmed that there is something untouchable in all religions, that is, their spiritual, moral, and socio-cultural values, which the Church not only recognizes but even wishes to promote.**"[8]

§ 7 Fr. von Geusau showed the foundation for ecumenism's demand to abandon the concept of the Holy Church as a perfect society. He noted that it would be "untenable" to demand the conversion of heretics, which is equivalent to denying the missionary character of the Church. He affirmed: "**The mystery of the Church does not fall within the sociological or juridical confines of the Roman Catholic Church**. The true nature of the Church, her concrete existence, the various ways to conceive the belonging to the Church, are comprehensible or debatable only in biblical terms. **To want to sustain a purely juridical point of view, which no longer corresponds to the actual situation after the separation of the Eastern and Protestant churches, means to condemn oneself to sustaining a series of absurd positions.**

"**The logical consequence of the conception of 'Church as perfect society' was the ecumenical movement, conceived as a 'return' of the separated brethren to the Roman Catholic Church** as it exists today 'in concrete.' **This position [demanding conversions] obviously became untenable, and its abandonment by the ecumenical movement was the first step on a road that can lead to a new vision of the Church.** Even if we satisfy ourselves with thinking of a solution to the ecumenical problem in terms of a 'reintegration'

[7] E. Schillebeeckx, "Introdução," V.A., *Cinco problemas que desafiam a Igreja hoje*, pp. 26-7.

[8] *Ibid.*, p. 21.

or 're-composition' of the Church, **it must be admitted that she is no longer something precise, defined, and sufficient unto herself.**

"With the conciliar decree on ecumenism, it is no longer possible to speak of the Church without also understanding [included in this notion], in one way or another, **the churches of the East or the Reformation.** Nor can one speak of these churches in purely juridical terms of validity, rights, and duties if one wants to respect their dignity. One is obliged to use concepts derived from the vocabulary of the history of salvation, such as 'people of God,' 'brothers in Christ,' and others that seek to express the complex reality of a unity lived in separation, without mutilating it."[9]

§ 8 Fr. Germano Pattaro affirmed that Vatican II closed the era in which the Church strove for the conversion of heretics, which is the missionary vocation of the Church. He stated: "It remains to clarify what is the unity that Christians are seeking. **Yesterday's doctrine taught, on the Catholic part, that ecumenism should be understood as the conversion of non-Catholic confessions to the Catholic Church.** It was the doctrine of the 'open flock,' the 'father's house open to all.' In fact, **the theme proposed an ecumenism with only one direction: from non-Catholic Christian confessions to the Church of Rome**

"This thinking was clarified in the Council in this way: Ecumenism does not propose conversion from one church to another. If this were the case, confessionalism would be inevitable. [On the contrary, persons are no longer converted to the Catholic Church.] Persons are converted to Christ. That is to say, the churches are disposed to seek unity, coming together to ask the Lord to heal their divisions, striving reciprocally in a competition of sanctification where the faith, hope, and charity of one is a stimulus to the faith, hope, and charity of the other."[10]

§ 9 Cardinal Döpfner, an official personage of the Conciliar Church under various titles, wrote: "**Catholic ecumenism is not an invitation to conversion** formulated with self-assurance, but the insistent prayer and humble effort to do all

[9] L. A. von Geusau, "La Chiesa, 'scandalo' del mondo," *ibid.*, pp. 155-6.

[10] G. Pattaro, *Riflessioni sulla teologia post-conciliare*, pp. 104-5.

we can so that the Lord may bring about humility in his own way."[11]

§ 10 Cardinal Congar, honored in 1984 with the "Unity of Christians Award" in recognition for his contribution to ecumenism, expressed his ardent wishes that the Church would no longer try to convert the Schismatics: "**The Orthodox are jealous of Latin influence in the Near East, which they consider an aggression, a bad proselytizing.** This certainly has taken place. For example, in Egypt, Catholics have converted Coptics [Monophysites], even while the Coptics had the immense merit of resisting Islam. It was the only Christianity of a certain importance that resisted Islam.[12] The Coptic Church counted many millions of faithful among the approximately forty million Egyptians. **Thus there were attempts, which I judge lamentable, to convert Copts. I hope that today this has definitively come to an end.**"[13]

§ 11 In a work that counted on the help of Joseph Ratzinger, theologian Hans Küng showed the same aversion to the conversion of heretics: "**The road leading to unity does not consist of 'the return' of one church to the other,** nor in 'the exit' of one from another, **but rather in 'the turnaround,' in the common conversion of all to Christ and thus, to one another. It is not the subjection of one church to another, but the transformation of all and the reciprocal acceptance of communion, through a mutual giving and receiving.**"[14]

§ 12 In the same work, Küng took up the defense of the heretical sects and schismatic fragmentations. For him, it would

[11] J. Döpfner, *La Chiesa viventi oggi*, p. 35.

[12] It seems debatable whether Fr. Congar sincerely believed it "an immense merit" for the Coptics to have resisted Islam. This would presuppose that he considered the Islamic religion erroneous – as indeed it is – and, consequently, a false faith. In the same book, however, the French Dominican praised Fr. Chenu, who preached Islamism to Muslims imprisoned in France during the Algerian conflict: "During the Algerian war Fr. Chenu regularly visited Algerian prisoners in Fresnes. He revealed the Muslim religion to them and taught them the history of Arab philosophy" (*Jean Puyo interroge le Père Congar*, p. 45). It is very difficult to imagine that the same one who praised Chenu for preaching Islam to prisoners would sincerely consider resisting Islam "an immense merit."

[13] *Jean Puyo interroge le Père Congar*, p. 148.

[14] H. Küng, *A Igreja*, vol. 2, p. 55.

be inconceivable that they should return to the Catholic Church. He exclaimed: "**It would be against an authentically historical thinking to imagine it possible that one day these older, autonomous daughters [Schismatic churches and heretic sects] could return to the maternal bosom [of the Catholic Church]! This would be contrary to the laws of life,** which recognize no exception regarding such a return"

"**The daughters fear being absorbed For this mother [the Catholic Church],** despite her incontestable grandeur and historical experience, **not only has become old and torpid, backward and petty of spirit, but also confused and dispersed. Her gaze seems to have become cloudy, exactly when turned to that which is essential and decisive. Her faith has become too superstitious, her love too legalist, and her hope too earthly.** For her daughters, she is no longer what she was before, the same as she was in the beginning."[15]

§ 13 Küng was even clearer when he affirmed that the Holy Church should no longer be the norm for conciliar ecumenism: "**What will be the norm for the unification of the churches? This norm is not the Church; nor is it the churches. Because such a norm would eternalize the division.** The norm we are seeking is the Gospel of Jesus Christ."[16]

§ 14 Another condition exacted for the success of ecumenism is that the Church ought to abandon her militant position against heretics. As Congar affirmed, there must be a "dismantling of the walls of separation": "**To free ourselves from the weight of the past, to find ourselves rejuvenated, to finally understand whose incomprehension caused the drama [of separation]** – these are the benefits we draw from the studies of a Dvornik or a de Vries with regard to the [Schismatic] **East, of a Lortz regarding Luther, of a Ganoczy regarding Calvin. Little by little the debris is carted away, the walls of separation are slowly dismantled.**

"Dialogue here is essential. It is an exchange; it closes up a distance. It is something very different from two alternating monologues. A dialogue wants one to listen to the other with the disposition of understanding him, to change something in oneself in accordance with what was received from the other. Ecumenism implies a resolution to reform oneself, as the

[15] *Ibid.,* p. 76.

[16] *Ibid.,* p. 53

conciliar decree [*Unitatis redintegratio*] of April 21, 1964 states (nn. 6, 7), and as the Catholic Church incontestably strives to do."[17]

§ 15
 Treating the topic of conciliar ecumenism, Küng established the main condition for its success: the Holy Church must abandon her prior position with regard to heretics, that is, abandon her militancy. He made this bold statement: "Now comes the question: **How can this reconciliation take place?** Not as many Christians, in particular Evangelicals, uphold: by organizing inter-confessional discussions and conferences with the heads, since the problems are at the roots, far beyond organized discussions. And **not as many Christians, especially Catholics, would like: by tranquilly calling the others to their own Church (as if the others had something to apologize for), or through simple individual conversions (as if union with the separated Christian communities could thus be re-established)**, or even simply by a general reform of customs

 "**Vatican II saw its mission in a very different way: reconciliation with the separated brethren will only take place on the basis of a *renewal of the Catholic Church herself*.** The renewal of the Catholic Church in the direction of reconciliation: this great task can be carried out if the renewal is made not with a method, but by the realization of the legitimate desires of the others, of the legitimate desires of the Orthodox, Evangelicals, Anglican, and independent churches, according to the light of the Gospel of Jesus Christ, who judges what is – and is not – truly legitimate in these desires."[18]

§ 16
 Fr. Bernard Sesboué welcomed the abolishment of religious divisions as the necessary response to the "universal call of God": "**The old religious**, political, and social **divisions** that seemed to correspond to an almost natural state of things **are suddenly relativized as entirely secondary judgments in face of the only reality that has value, the universal call of God, in the sense that only one body is formed, and in it all these difference are abolished.**"[19]

[17] Y. Congar, *Église Catholique et France moderne*, pp. 141-2.

[18] H. Küng, "La riforma litrugica del Concilio Vaticano II e la riunione con i cristiani separati," V.A., *I grandi temi del Concilio*, p. 104.

[19] B. Sesboué, *O Evangelho na Igreja*, p. 134.

These documents clearly show that the progressivists promoting conciliar ecumenism want the militant and missionary characters of the Church to disappear.

2. A demand of ecumenism: "The Catholic Faith must die"

§ 17 Although the breaking of the unity of the Catholic Faith has already been studied in Part II, this Item will focus on it as a progressivist demand for attaining "unity" among all religions. The unequivocal texts presented below will show the intent of conciliar ecumenism to demolish Catholic militancy and missiology.

§ 18 It was Fr. Bernard Sesboué, a member of the International Theological Commission, who made the shocking statement that inspired the heading above. Chronicling the longings of the ecumenical movement, the theologian imagined the death of Faith and the institutional Church as an imperative to attain "unity."

According to Sesboué, ecumenical unity also supposes the death of the militancy of the Church. Or, more radically said, Catholic militancy would be replaced with a militancy against those who remain militant...

He affirmed: "Since the first ecumenical initiatives at the end of the 19th century, a considerable stretch of road has been traveled. A *conversion of hearts* is already far along that road This conversion of hearts, which produced a first reconciliation, has made possible another, a *conversion of minds,* which followed in its footsteps We also recognize another, on the level of great Christian communities, a *conversion of mentalities*, that is, the crystallization of acts of the intelligence and the will that takes place in every social group. But it is still far behind in comparison with the conversion of hearts

"**This new stage supposes a continual progression of conversions** and requires yet another that we could call *confessional conversion*. **This would be actions that are the fruit of decisions capable of creating a new situation by combating the resisting strongholds [that want to maintain the old situation] of confessional separation.**

"**These actions will entail a truly ecclesial process of reconciliation, leading gradually to unity of the whole faith and all the realities that belong to the mystery of the**

Church, especially that which pertains to her basic structure and the announcement of the word, such as the sacraments and ministries.

"**Such a conversion may seem like a death, but this also is in accordance with the Gospel. It is necessary that each Church die to the part of its egoism that is profoundly united to its confessional identity, be it institutional egoism or doctrinal egoism, so that all may live together from the same Gospel of Christ.**"[20]

§ 19 Bishop Boaventura Kloppenburg, also a member of the International Theological Commission, criticized the anti-heretical doctrines of the Church. In his view, the militant character of the Church disappeared in Vatican II: "Quite often **certain emphatically stressed doctrines** (only because they were denied by some) **led the post-Tridentine Church to adopt doubtful and pastorally problematic liturgical practices All this had produced a Church somewhat unbalanced in accentuating doctrines and practices. In this anti-heretical and anti-Protestant Church,** which **lasted officially until November 21, 1962,**[21] all of us were born, educated, and formed. We all identified with her."[22]

§ 20 Jesuit theologian Cardinal Avery Dulles, stated that inter-confessional unity required that the Faith be relegated to a secondary plane: "If the Church is conceived more in terms of an answer and a process, and less in terms of substance and conservation, then greater possibilities will open for diversity and innovation If this dynamic vision of the Church is valid, it indicates the way to a third style of ecumenism.[23]

[20] *Ibid.*, pp. 173-5.

[21] In a note, Kloppenburg explained the symbolism of this date: "On November 21, 1962, at the 24th General Assembly of Vatican II, Pope John XXIII canceled the votes of 1,368 conciliar fathers (*contra* 822), rejecting the still typically post-Tridentine schema *De fontibus Revelationes* [see Vol. I, *In the Murky Waters of Vatican II*, Chap. IV § 2, footnote 2; Chap. VI, §§ 49-53, 83], and along with it, all the other theological schemas prepared by the pre-conciliar Theological Commission" (Boaventura Kloppenburg, *A eclesiologia do Vaticano II*, Petrópolis: Vozes, 1971, p. 13).

[22] *Ibid.*

[23] According to Fr. Dulles, the other two styles of ecumenism would be the one that comes from "above" and tries to convert schismatics and heretics to the Catholic Church, and the other coming from "be-

"According to this conception, **it is not essential for the Churches to remain perpetually attached to a supposed apostolic patrimony or bound to a universally binding series of normative doctrines, ministries, or sacramental rites, because all these forms can be changed according to the inspiration of the Spirit. Christian unity does not mean uniformity. Ecumenism demands that the churches avoid hostilities and reciprocal indifference.**"[24]

§ 21 Fr. Hans Küng was even more categorical than his colleagues in his attacks against the Holy Church. In the document below, he enumerated controversial points of Catholic doctrine that should be set aside for the sake of ecumenism.

Küng wrote: "The classical doctrinal controversies that can no longer justify a division among the churches [are]:

"*Scripture and Tradition.* Irreconcilable oppositions over the question of the relationship between Scripture and Tradition no longer exist among the churches. **The primacy of Scripture over all later traditions is today recognized in principle also by the Catholic Church.** Today the other churches recognize that her [the Catholic Church's] *special* tradition was also of extremely great importance to them, as a decisive factor of interpretation. The fact that the binding character and concrete function of certain eminent traditions (such as, for example, conciliar definitions) has not been conclusively discussed in the Catholic ambit[25] signifies **that it presents the occasion for the Catholic Church to correct unilateral emphases.**

"*Grace and justification.* For centuries the relationship between faith and works was a central and decisive point in the controversy between the Catholic Church and the Reformed churches. Today, on the contrary, understanding among the churches has advanced in this point more than others. **Hence-**

low,'" the ecumenism of "communion," which considers the Protestant sects and Schismatic fragmentations as "local churches" that all belong – together with the Catholic Church – to the so-called "Universal Church."

[24] A. Dulles, "Ecumenismo: problemi e possibilità per il futuro," V. A., *Verso la Chiesa del terzo millennio*, p. 118.

[25] Speaking generically, Küng appears to be referring principally to the definitions of the Council of Trent against Protestants, which establish Tradition as the source of Revelation alongside Scripture.

forth the discussion will unfold on an absolutely supra-confessional level. The classic themes of the topic can no longer be considered the exclusive possession of certain churches. This is the most evident sign that, on this decisive point, theological reflection world-over has entered a post-ecumenical stage.

"*The Church and the sacraments.* Today there are no longer insurmountable differences over the basic image of the Church with respect to her origin, her various dimensions, and her diverse missions, in particular regarding her eschatological character and need for constant renewal. Scriptures is considered the normative measure of ecclesiology. Ecumenical understanding extends even to the problems of ministry.

"Decisive doctrinal differences in understanding the sacraments, above all in determining their relationship with the word as well as their origins, number, and efficacy can be considered outdated. In principle, this is valid also for the problem of the Eucharist."[26]

§ 22 Küng set out this principle: "From the standpoint of the New Testament, it is certain that we do not need any uniform Church, much less any uniform theology; doctrinal and practical multiplicity, as well as disagreements, are possible and necessary in a certain sense."[27]

The documents presented in this Item and the innumerable facts that each Reader could adduce with regard to ecumenism after Vatican II permit the affirmation that the Conciliar Church seeks the destruction of the unity of the Catholic Faith, militancy, and missionary action.

3. The Church needs to learn from heretics, pagans, and atheists

§ 23 The deliberate intent of conciliar progressivists to destroy the militant and missionary characteristics of the Holy Church becomes even more evident in their claim that the Church needs to learn from the false religions.

[26] H. Küng, "Vaticano III: problemi e prospettive per il futuro," V. A., *Verso la Chiesa del terzo millènnio*, pp. 77-8.

[27] H. Küng, *Veracidade*, p. 78.

§ 24
From the Catholic dogmatic standpoint, this proposition is absolutely unacceptable since it once again denies that the Catholic Church is the exclusive guardian of the treasures of Revelation. It also denies the unity of the Faith and, in the final analysis, the very existence of a distinction between good and evil.

§ 25
From the standpoint of the institution of the Church, the proposition that Catholics should be taught by heretics strikes at the very foundation of Catholic militancy. How can what was always considered as deadly poison for souls now be considered as a source of living water from which Catholics and the Church herself should drink to grow in wisdom?

§ 26
Such a proposition – to learn from heretics – also denies the missionary character of the Church, since it implies that the false religions already possess, in essence, the fruits of Redemption, that is, sanctifying grace and the normal access to eternal salvation.

§ 27
The denial of the militant and missionary character of the Holy Church is so complete that one must ask if the implementation of this ecumenism could be qualified as one of the most radical blows in History against the Catholic Faith and the Holy Church.

Basing themselves on conciliar documents,[28] innumerable progressivists want the Catholic Church to receive what is "good" and "holy" in the false religions.

§ 28
For example, Fr. J. H. Walgrave, professor at the Catholic University of Louvain and a member of the International Theological Commission, assuming the presuppositions of "anonymous Christianity," concluded that the Catholic Church can learn from other religions to have a better understanding of her own Faith. Fr. Walgrave noted: "**The humanity that is interiorly attracted by the Holy Spirit to Christ is already a religious humanity, which lives its religiosity in diverse ways and cults We should expect that non-Christian religions also radiate an aurora of truth and grace whose plenitude lives in Christ, whose rays we all receive, including non-Christians, although in different ways....**

[28] Part II, Premise 2, §§ 3-6.

"Hence our conclusion that **the Church**, in her missionary work, **should not vigorously reject the other religions as darkness in face of the light of our Faith. There is a true religiosity in them enkindled by the Holy Spirit, which the Church must explore and recognize**

"For this reason, **it is necessary for the Church to open herself to everything worth learning from the other religions. Evidently,** this would not be to open herself to a truth fuller than that which is already perfectly present in Christ; **it is a matter of acquiring a better and more complete notion of our Faith.**"[29]

§ 29 Cardinal Jean Danielou, a conciliar *perito* and well-known Jesuit theologian, also affirmed that the Catholic Church must learn from other religions, and even Atheism: **"Another important aspect of respect in dialogue is that we must be receptive to every value that the other may have to offer us.** After the Council of Trent, for example, due to the antagonism between Catholics and Protestants, there was a clear tendency on the Catholic side to reject anything coming from Protestantism; Protestants had the same attitude toward Catholicism. In other words, the tendency was to accentuate the elements that separated and fed the antagonism, rather than those that might unite.

"On the contrary, [today] we can say that **'dialogue' means a capacity to receive something from the other, that we fully understand that among our Protestant brethren we may find things that can enrich us considerably.** There is, for example, the admirable work they have done in relation to Holy Scriptures.

"Our Eastern brethren have preserved in their liturgies an admirable abundance of precious things that can enrich us. **Elements of value exist in all the religions of the world, even in atheist Humanism. We must be completely open to receive them.**"[30]

§ 30 Dealing with the relations between Catholics and heretics, Bishop Alberto Ablondi of Livorno, President of the Commission for Ecumenism and Dialogue of the Italian Bish-

[29] Jan Walgrave, "Relazioni sacro-storiche tra la Chiesa e i culti con non cristiani," V.A., *I grandi temi del Concilio*, pp. 933-4.

[30] Jean Danielou, Untitled, V.A., *Cinco problemas que desafiam a Igreja hoje*, pp. 133-4.

ops Conference, gave a good example of the sentimental language used to fool the faithful into accepting ecumenism. He stated: "Truly we are passing from [a position of] 'power' to [one of] 'welcoming' every time that the need to enter into the life of another becomes a means and an occasion to understand how those who ask for help offer great riches to their benefactors

"But passing from power to welcoming also means we must really know how to 'welcome.' **One who truly welcomes makes the other [the heretic] enter into his own life, allowing him to grow. Not to grow as a guest, but to grow as if he were in his own house, favoring the full development of his personality and the plenitude of his mission. Welcoming, then, becomes not 'a being present' but 'a continual drawing back' to watch the growth of the other, that is, of the other confession in ecumenism It is a grand moment that surpasses power: it is to know how to draw back before the growth of the life of another**

"**Could perchance this attitude of 'allowing one to be a guest' be what we should desire in relations among the churches? The centuries of separation should not create a vacuum. They help us to discover diverse ethnic origins and roads taken in different historical circumstances. They give truth much vaster and more complete tonalities that today can reciprocally enrich those who have the courage and heart to place themselves in poverty.**"[31]

§ 31 Fr. Mario von Galli affirmed that the Catholic Church must learn to freely inter-relate with the other religions: "The Council established very clearly the special relation of the Catholic Church with other Christians, a position that necessarily leads to other special facts and actions. **This special thing is that all of them ['Christians'] constitute the Church of Jesus Christ.**

"The Catholic Church says I am the Church of Jesus Christ in all its magnitude and totality. Granted. But she must admit – as she admitted at the Council – that **there is also a Church of Jesus Christ outside of her, which is why the Catholic Church concedes to others the honorific title of 'churches'** (referring thus to the Church of Jesus Christ). They

[31] Alberto Ablondi, "Meditando il Magnificat...," V. A., *L'annuncio del Regno ai poveri* (Turin: Elle Di Ci, 1978), pp. 153-5.

are churches of Jesus Christ insofar as they have baptism, show elements of organization instituted by Jesus Christ, etc. Thus **there is an *ecclesiastical* community between the Catholic Church and the other Christian churches. What is more, the differences complete themselves in community. The Council also recognized this when it attributed *an historic importance in the aspect of salvation* to these other churches. That is to say, they can perfect certain Christian elements better than we do in the Catholic Church**"[32]

§ 32

Fr. Edward Schillebeeckx explained that the Church must hear the "prophecy" of other religions to be faithful to her own mission: "We must also take into consideration these [non-Christian] religions, as well as secularization, which equally has its function within the economy of salvation. **All these different elements – secularism, the religions of the world, the Christian churches – have something to say about the mystery of the Church of Christ. This 'foreign prophecy'** (*fremdprophetie*, that is, foreign in the sense of 'coming from outside' the Church, or at least outside the Roman Church) **present in the other churches and religions also speaks to us in a certain way of the Church. If the Church wants to be faithful to her mission in the world, she must listen attentively to this prophetic voice.**"[33]

§ 33

In the same work, Schillebeeckx said that the Catholic Church should see herself reflected in the heretical religions, and that the errors of the latter in matters of Faith should be accepted as legitimate and enriching elements. He affirmed: **"The final objective [of ecumenism] must be that all the churches recognize themselves and their own faiths in the other churches, and not that all the churches turn to the Catholic Church.**

"Unity implies that the Roman Catholic Church see herself reflected in what we call the Protestant church To discover oneself in the others is already unity. From the moment we understand that differences in faith are in reality not differences in *faith*, but only theological differences, it will become clear that differentiations and multiple

[32] Mario von Galli, "Dialogo con los protestantes," V.A., *La reforma que llega de Roma*, pp. 136-7.
[33] E. Schillebeeckx, "Introdução," *Cinco problemas que desafiam a Igreja hoje*, p. 25.

forms can be kept. In fact, the many forms of the other churches constitute an enrichment for all the parts."[34]

§ 34 On this same topic, the book by Rocco Buttiglione on the thinking of Msgr. Karol Wojtyla showed how the latter considers that Catholics could be greatly enriched in their own Faith from the experiences of not only followers of other religions, but also from atheists. Summarizing the ideas of Cardinal Wojtyla, Buttiglione wrote: "**An atheist, a believer, a non-Christian, can have an experience of humanity richer than that of a Christian, and can, therefore, also live the human questions on a level of consciousness and truth higher than that attained by Christians. From an objective point of view, in order to enrich their own faith** and understand the full existential [practical] significance of the Christian response, **Christians have much to learn from those who adhere to other religions, and even from atheists.**"[35]

*

It only remains to ask: After this progressivist ecumenical assault, will anything still remain of the unity of the Catholic Faith or the unicity of the Holy Church, or her militant and missionary characteristics?

* * *

[34] *Ibid.*, p. 33. On this topic, see also Vittorino Grossi, "La Chiesa preconstantiniana di fronte alla povertà," V.A., *L'annuncio del regno ai poveri*, p. 70; H. Küng, *A Igreja*, vol. 1, pp. 366-8.

[35] R. Buttiglione, *Il pensiero di Karol Wojtyla*, p. 234.

Chapter V

CONCILIAR ECUMENISM
HEADS TOWARD A PAN-RELIGION

§ 1 In the previous Chapters of this Part, which deals with conciliar ecumenism, it was seen that the cited documents directly or indirectly lay the foundation for a universal religion. This foundation relativizes the Faith,[1] denies the sanctity and unicity of the Catholic Church,[2] establishes a doctrine that makes possible the union of all men despite their religious professions,[3] and creates a pacifist climate of dialogue among the different creeds, which implies a denial of the defense and expansion of the Catholic Faith.[4] It is not surprising, then, that such a foundation leads to a logical consequence: a Pan-religion.

§ 2 To evade earlier condemnations made by the Church,[5] progressivists avoid the actual word "Pan-religion," as well as expressions like "religious syncretism," "doctrinal eclecticism," and "irenic theology" that characterize it. They prefer to use terms from the New Testament or Tradition to express the same ideas. Thus, one sees the frequent use of the Scriptural phrase *"ut omnes unum sint"* [that they many all be one][6] and the theory of "communion" to justify the progressivist desire for a Pan-religion. They refer to the "new man" of St. Paul [7] to legitimize a supposed evolutionary change in the human race

[1] Theological pluralism was analyzed in Part II, Chap. I.

[2] The "Church of Christ" was studied in Part II, Chap. II.

[3] "Anonymous Christianity" was analyzed in Part II, Chap. III.

[4] The destruction of the militant and missionary character of the Church was shown in Chap. IV.

[5] See Part II, Premise 1, pp. §§ 1-19.

[6] Jn 17:21.

[7] Eph 4:24.

that would take place in the next stage of a universal religion that will supercede the age of individual religions, etc.[8]

As this Chapter will show, these semantic ruses do not change their goal of establishing a Pan-religion, in which the doctrine is syncretist and the emotional climate is one of a general irenic sentiment.

*

§ 3 The unity preached by Our Lord Jesus Christ when he foresaw "one fold and one shepherd" (Jn 10:16) does not contradict the rest of His divine teaching, which imparts a doctrine completely opposed to that of conciliar ecumenism. In fact, He clearly affirmed: "Every plant which my heavenly Father hath not planted shall be rooted up" (Mt 15:13). About those who do not accept His doctrine, He decreed: "And whomsoever shall not receive you nor hear your words; going forth out of that house or city, shake off the dust from your feet. Amen I say to you, it shall be more tolerable for the land of Sodom and Gomorrah in the day of judgment, than for that city" (Mt 10:14, 15).

To forewarn his disciples about the hatred that her enemies will always have for the Holy Church, Christ said: "Behold I send you as sheep in the midst of wolves. Be ye therefore wise as serpents and simple as doves. But beware of men. For they will deliver you up in councils, and they will scourge you in their synagogues. And you shall be brought before governors and before kings for my sake, for a testimony to them and to the Gentiles" (Mt 10:16-18). Further on, He added: "And you shall be hated by all men for my name's sake" (Mt 10:22).

Generalizing the hatred of the sons of the world for the sons of the Church, Our Lord asserted: "If the world hate you, know ye, that it hath hated me before you. If you had been of the world, the world would love its own; but because you are not of the world the world hateth you. Remember my word that I said to you: The servant is not greater than his master. If they have persecuted me, they will also persecute you But

[8] Such hermeneutic sleight-of-hand tricks are habitual in the progressivist strategy, as indicated in Vol. III, *Animus injuriandi II*, Chap. VII.

all these things they will do to you for my name's sake; because they know not him that sent me. If I had not come and spoken to them, they would not have sin; but now they have no excuse for their sin. He that hateth me, hateth my Father also. If I had not done among them the works that no other man hath done, they would not have sin, but now they have both seen and hated both me and my Father. But [this happened so] that the word may be fulfilled which is written in their law: 'They hated me without cause'" (Jn 15:18-25).

As for the danger of the infiltration of false doctrines, Our Lord cautioned: "Take heed and beware of the leaven of the Pharisees and Sadducees Then they understood that he said not that they should beware of the leaven of bread, but of the doctrine of the Pharisees and Sadducees" (Mt 16:6, 12).

Exhorting the Apostles to doctrinal vigilance, the Divine Master also warned: "Take heed that no man seduce you. For many will come in my name saying, I am Christ; and they will seduce many" (Mt 24:4, 5). Finally, He warned: "Then if any man shall say to you: Lo, here is Christ, or there, do not believe him" (Mt 24:23).

§ 4 Since the whole of the doctrine of Jesus Christ is in perfect harmony with its parts, His desire that "all be one" cannot ignore the hatred that the enemies of the Holy Church will have for His disciples. Conciliar ecumenism, however, sets aside the Gospel passages that speak of this hatred and the fight that the just must wage to be faithful. Leaving this out, Progressivism obliterates the true doctrine of the Church, putting an unbalanced and exaggerated emphasis on the desire for union and defending the establishment of a Pan-religion that is no longer linked to the true Faith.

§ 5 Progressivism strives to achieve the union of religions under two pretexts:

1. As an imperative of the "charity of Christ" – "ut omnes unum sint";
2. As a need to adapt to the world, which according to revolutionary mythology, would be moving rapidly toward universal unification.

Chapter V will study these two Items.

1. Pan-religion analyzed from the perspective of the union of religions

This Item will look *first* at the stages of the process adopted to establish the Pan-religion. *Second*, it will examine two roads being used to direct adepts of the Conciliar Church to this Pan-religion.

A. "Thawing," dialogue, and "communion": intermediary stages that lead to the Pan-religion

An analysis of progressivist behavior past and present unveils the various stages of ecumenism.

§ 6 The **"thawing"** of relations of the Church with the false began with John XXIII's invitation to heretic and schismatic representatives to participate at Vatican II as observers. The "thawing" was followed by **dialogue**, launched on a world scale with the Encyclical *Ecclesiam suam* of Paul VI (August 6, 1964).

§ 7 Much has been said about these two stages and how they changed the face of the Church, transforming her from the Church Militant to the Church Tolerant. Focusing on the transition between these phases are two books of opposed orientation, both with broad views and having international repercussions: *From anathema to dialogue* by Roger Garaudy [9] and *Unperceived ideological transshipment and dialogue* by Plinio Corrêa de Oliveira. [10]

§ 8 **"Communion"** followed dialogue. In this stage, unlike the previous two, the ecumenical relationship seeks more than a simple end to hostilities or the beginning of conversations. Rather, it hopes to establish an accord that will initiate a life in common with the followers of other creeds. In principle, this accord should deal with the doctrinal disagreements separating the different religions. In practice, however, ecumenical progress in the doctrinal field has been slow and ineffective.

[9] *Do anátema ao diálogo* (Rio de Janeiro: Paz e Terra, 1969).

[10] *Baldeação ideológica inadvertida e diálogo*, (São Paulo: Vera Cruz, 1974).

§ 9 For this reason, Progressivism has clearly diminished its emphasis on doctrinal accords and has tried to establish a practical ecumenism, an "existential" or a "happy-to-just-live-together" ecumenism. To this end, they have chosen various philanthropic goals – peace, the war against poverty, unemployment, environmental protection, etc. – that emphasize common points of a social or environmental nature. Around these points, they encourage joint efforts that permit them to work with the non-Catholics and to pray in common in order to realize *communion.*

§ 10 That only two symbols were acceptable to all the participants at the Assisi pan-religious encounter (January 24, 2002) is indicative of the meager doctrinal results that have been achieved in ecumenical dialogue among the various religions in the last 40 years. They were an olive tree, set in the center of the assembly gymnasium, and lighted candles, distributed to all those present. It is not surprising that only a tree and fire were accepted as common points at the bizarre gathering at Assisi, since among those present were Animists, who worship the devil. How would it be possible to find a religious symbol common to progressivist Catholics and their Animist "brothers"? Nonetheless, representatives of innumerable religions accepted the invitation of John Paul II to gather there to pray for world peace.

§ 11 Thus, "communion" is presented today as an ecumenism *per viam facti* [by way of the facts], which strives to accelerate the union of religions independent of doctrinal questions.

§ 12 The symbolic event that gave birth to "communion" was the kiss exchanged between Paul VI and the schismatic patriarch Athenagoras in the Garden of Olives (January 5, 1964). Was it by chance that the place chosen for this exchange was the same site where Judas, also with a kiss, delivered the Son of God to His enemies? The answer to that question is shrouded in mystery...

§ 13 Even though not all progressivists employ the term "communion," it would seem to indicate the common end point of them all. "Communion" has a kind of magic power to rally around it the whole gamut of progressivists: the *arditi,* the

"moderates," and even some who today might pass for "conservatives."[11]

So great is this progressivist desire for the union of all religions in an affective "communion" that they are willing to ignore that the false religions deny the true Faith. This can be seen in the documents presented below.

§ 14 On a visit to Brazil, John Paul II expressed his joy to meet with representatives of the schismatic church. The Pontiff asserted his hope that ecumenism would lead the two confessions "to full communion." The Pope said:

"Returning from my fraternal visit to the ecumenical patriarchate, I had the occasion to point out my concern that what has been quite aptly called **the dialogue of charity become a necessary component in the pastoral programs of both of our Churches, the Catholic and the orthodox. The deepening of this fraternal action, along with intensified mutual relations and collaboration between the Churches, create the vital ambience where theological dialogue can be born and develop until it reaches results the Christian people are prepared to accept.** No one is dispensed from this effort. Vatican Council II firmly stated this with regard to Catholics (*Unitatis redintegratio*, 4) **Both Catholics and the orthodox are called to contribute actively for the good success of this new phase of our journey toward full communion."**[12]

§ 15 Receiving Anglican hierarchs, the Pope also spoke of the "communion" that should exist between Catholics and Anglicans: "Dear brothers in Our Lord Jesus Christ In your deliberations at the Lambeth assembly, you will discuss difficult and delicate problems pertaining to essential aspects of your relations with the Catholic Church, as well as with your orthodox brothers and sisters. **While you are together, I pray**

[11] This position of synthesis assumed by "communion" seems to be reflected in a movement that some consider "conservative," Comunione e Liberazione [Communion and Liberation]. This movement has received support from Cardinals von Balthasar, de Lubac, and Ratzinger, as well as John Paul II himself. For more on Communion and Liberation, see Vol. II, *Animus injuriandi I*, Chap. IV.1, *in fine*.

[12] John Paul II, Meeting with the orthodox, São Paulo, July 3, 1980, in *A palavra de João Paulo II no Brasil* (São Paulo: Paulinas,1980), pp. 143-4.

**that you will consider carefully and completely the impor-
tance of maintaining and reinforcing the bonds of that real,**
although imperfect, **communion that unites Catholics and
Anglicans. The deepening of this communion and the quest
for full communion are fundamental.**"[13]

§ 16 Addressing Austrian youth at Vienna, John Paul II ex-
pressed his hope to achieve a Pan-religion: "From this time
forward, you can begin to make your contribution to the con-
struction of **the Church of tomorrow: a Church that will
know neither separation of confessions nor of genera-
tions.**"[14]

§ 17 Cardinal Bernardin Gantin considered the theme of
"communion" the key point of the pontificate of John Paul II.
In an article in the *L'Osservatore Romano,* the African Cardi-
nal called John Paul II the "**artisan of communion and unity
without borders.**"[15]

§ 18 Cardinal Jan Willebrands introduced an original classi-
fication by which the Anglican sect, for example, could be con-
sidered a characteristic expression of the "universal church" or
"Catholic church," understood as Pan-religion. It is worthy of
note that the new meaning he gave to "Catholic church" (from
the Greek *katholiké = universal*), has nothing to do with the
Holy Catholic Church, but rather is synonymous with Pan-
religion. It is a designation bound to create confusion. Ameri-
can Cardinal Avery Dulles described the thesis of Willebrands:

"This model of ecumenism [which considers the 'Uni-
versal Church' as a communion of all the churches] finds nota-
ble support in the language of Vatican II, which used the word
'communion' as a key concept. This concept appears to have
been favored by Paul VI, who spoke of Anglicanism as a 'sister
church.' In various important speeches, Cardinal Jan Wille-
brands, president of the Secretariat for the Union of Christians,
incorporated the concept of *typoi* [species, type] into this the-
ory.

"A group of local churches in a region or tradition, he
proposed, could constitute a *typos,* or expression characteristic

[13] *L'Osservatore Romano*, April 23, 1988, p. 5.

[14] John Paul II, Speech to the youth at Vienna Prater, *L'Osservatore Romano*, September 12-13, 1983, p. 4.

[15] This is title of the article by Cardinal Bernardin Gantin, *L'Osservatore Romano*, October 16, 1988, p. 7.

of the Universal Church. **The Catholic Church could then be considered to be composed of diverse distinct *typoi*, one of which would presumably be Roman Catholicism. The Anglican churches, as Cardinal Willebrands understood it, could finally become a *typos* inside an extended Catholic communion of churches.** His proposal was certainly greeted favorably in many Anglican circles, although it is too early to say whether it was equally well received in all sectors of the Anglican communion."[16]

§ 19 Like Cardinal Willebrands, Fr. Michael Rodrigo, a specialist in dialogue with Buddhists, emphasized the role of the local churches in ecumenical relations. Rodrigo, however, focused the question under a somewhat different light. According to him, ecumenism should be put into practice not only by the heads of religions, but principally by the grassroots. The goal of this ecumenism would be to find a minimum religious practice common to all religions that ignores doctrinal differences. Establishing this minimum religiosity would be indispensable for the rise of the "dawn of reciprocity in dialogue," which seems to be similar to the "communion" being discussed here. In the excerpt below, Fr. Rodrigo described the situation of dialogue with the Buddhists at Sri-Lanka:

"In the context of a Rome that is rapidly decentralizing, a new spiritual thinking should not be excluded from the higher circles of church politics. If our theology of the local church – both in and of the local church – were vital and real, our hope would be more vital and real. **More Christians should extend a friendly hand to their compatriots as co-religionists**, since religion is better than irreligion. **If we do not seek a basic religiosity, the result will be alienation and isolation.**

"Western fervor for ecumenism with other Christians should be transformed into fervor for what has been called an *even broader* ecumenism. **We consider this broader ecumenism more urgent because we are seeking the kingdom in a land [Sri-Lanka] where religions, living beliefs, and ideologies live together side by side, looking for a *pre*-existence more than a mere *co*-existence. Even the small amount of**

[16] A. Dulles, "Ecumenismo: problemi e possibilità per il futuro," V.A., *Verso la Chiesa del terzo millennio*, pp. 114-5.

continuity and confirmation that exist seems to have raised the dawn of reciprocity in dialogue."[17]

§ 20 A final document of the 14th Congress for Ecumenical Formation called ecumenical "communion" based on local churches "reconciliation in diversity." The conference was promoted by the Secretariat for Ecumenical Activities of the Italian Bishops Conference. Its document stated: "**Catholic is the Church founded on Christ and open to all men reconciled in Christ.** She is open to all values, all legitimate cultural, linguistic, and ethnic diversities.

"The theme of conciliarity better clarifies how **an authentic catholic communion does not mean uniformity or a denial of diversity In the end, it raises the possibility of a coexistence of confessional families in which each conserve its specific traditions, even while it enters into communion with the other churches. This could be defined as 'reconciliation in diversity.'"**[18]

§ 21 According to Italian Bishop Alberto Ablondi, conciliar ecumenism needs to abandon the stage of dialogue and go straight to the phase of "communion." Attempting to make a more profound explanation of "communion," the Prelate defended a strange "Trinitarian co-substantiality" that would supposedly exist between Catholics and heretics. It should be noted that Ablondi completely ignored the doctrinal disputes that separate heretics from the Catholic Church. With more enthusiasm than clarity, he affirmed:

"I think that **ecumenism should help the churches pass from community to communion.** It is true that **we have already traveled the road from anathema to dialogue. But there is still the whole road that goes from cooperation to communion that remains open.** In fact, when we exchange experiences among ourselves, when we meet together, when we create occasions for a deeper relationship all this makes us pass from community to communion. **We need an ecumen-**

[17] Michael Rodrigo, "Diálogo budista-cristão no Sri Lanka," *Concilium,* 1978/6, p. 111.

[18] Giovanni Cereti, "Regno e conciliarità ecumenica," V.A., *Il regno di Dio che viene – Atti della 14th sessione di formazione ecumenica organizata dal Segretariato di Attività Ecumeniche* (Turin: Elle Di Ci, 1977), pp. 310-1.

ism that is not satisfied with community, but is famished for communion.

"In this tension of ecumenical communion, **an appeal must be made that ecumenism in the Catholic world not be confined only to a group of specialized persons, but that it become a dimension of the local church** On this road from satisfaction with community to hunger for communion, **as this spirit enters the veins** of the community and develops steadily with its sights on the future, **the pastoral council, the liturgical commission, and the catechetics office should all become involved in the ecumenical work of the Dioceses. They should promote courses on ecumenism for the formation of sisters, priests, and the laity.**

"**All this is, therefore, a healthy tension, but I believe that we must truly overcome the danger of the community's stagnation in satiety and wealth, and move toward a continuous hunger for communion. Then we will no longer be content with our inter-confessional meetings.**

"Oh! How beautiful the word 'inter-confessional' is as I read it on the cover of the translation of the New Testament! But **I believe that we must go beyond this 'inter-confessional' relationship and move toward a greater reality where each one participates in the reality, sufferings, poverty, and separation of the others.** I believe that **the only image that can move this road beyond the 'inter-confessional' step is that of solidarity in co-substantiality.**

"Someone once said: 'We should no longer call ourselves separated brethren.' I agree, because **if I define my brother as separated, I also say that I am separated** In order to affirm and understand this reality that profoundly unites us, **we must go beyond the word 'inter-confessional.' We must also go beyond the word 'brothers'** **In fact, when I say 'brothers,' I leave room for adjectives that can separate the good brother from the bad one, the close brother from the distant one. When I remember the words of Jesus:** 'Father, let them be one as you and I are one,' **then I feel that all of us, more than being brothers, we become co-substantially involved in the Trinitarian life that creates a constant communion.**"[19]

[19] Alberto Ablondi, "Messaggio di apertura," V.A., *L'annuncio del regno ai poveri*, pp. 20-22.

§ 22 Shortly after the Council, Joseph Ratzinger explained "communion" as the "fraternity of all Christians" among themselves and all men. In the excerpts below, the Cardinal seemed to pay tribute to the errors of inter-confessionalism and religious Indifferentism. In the first text, he indicated a messianic perspective of "communion" among men, linking it to the sacrament of the Eucharist. In the second, he gave this perspective a cosmic dimension.

"Because she is the body of Christ," Ratzinger affirmed, **"the Church defines her cosmic character as the passing of the human race from the enmity of egoism to the unity of Christ** The mystery of the body of Christ of believers explains itself here by its union with the Body of Christ in the sacrament The extraordinary new thing to which History is opening the road, that is, welcoming mankind in the unity of Christ, began with the life and passion of Our Lord.

"The unfolding of this beginning in the concrete history of each man takes place, then, in the offering of the Eucharist, based on Baptism. **At the table of the Lord, when men consume the body of Christ, they themselves become the body of Christ and are assimilated into the body of the New Adam** **The table of God** **is both the place of true communion of men among themselves and the place where men communicate with God**. And where men communicate with God, they also communicate among themselves and **all fuse together to form the new man."**[20].

§ 23 In a broad acceptation of the Eucharist, Catholic doctrine permits it to be said that Catholics unite to form the Mystical Body of Christ, taking the Eucharist as model. It is also correct to say that when Catholics receive the Eucharist they are intimately linked to the Body of Christ in the sacrament during the time that the real presence of the sacred species remains in their bodies. (The Roman rite stipulates ten minutes after Communion for the decomposition of the host and the cessation of the real presence.)

§ 24 Notwithstanding these points, there are three fundamental improprieties in Ratzinger's explanation. *First,* when he says that the faithful form the Mystical Body of Christ, he confuses the moral and supernatural presence that Christ has in the

[20] Joseph Ratzinger, "Il concetto della Chiesa nel pensiero patristico," V.A., *I grandi temi del Concilio*, pp. 145-7.

Church by means of grace with his real and physical presence in the sacrament of the Eucharist. According to Catholic doctrine they are two distinct presences.

Second, he does not limit the "incorporation" of the faithful into Christ to the brief period that the sacred species is present in the body of the faithful. Ratzinger's words induce one to think that the Eucharistic presence does not cease in the soul of the faithful, which is improper and wrong.

Third, it is also improper to say that all men "fuse together to form the new man." The notion of fusion normally implies a union of substances. This can in no way apply to the relation of the faithful with Christ – be it the Eucharistic relation or any other – and even less to the relation of the faithful among themselves. Thus, Ratzinger's terminology takes on tones of the language of Teilhard de Chardin, who imagined that the substance of his "Cosmic Christ" would be immanent in the substance of each man. [21]

§ 25 The ecumenical and "cosmic" consequences of these improprieties became even clearer when Ratzinger explained: "In their theology of the Eucharist, the Fathers began with the cosmic-universal aspect of the coming of Christ. Thus, their thinking went beyond the sphere of the act of cult. **The indiscriminate communion of Christians** in the Body and Blood of Christ **in the sacrament of the Eucharist only makes sense if Christians in their everyday lives also overcome their differences and live as brothers Fraternity of Christians with all men is the necessary consequence of this communion between men that is indissolubly linked to the sacrament of the Lord's supper.**

"**For this reason, 'communion' is at the same time an appeal to each one to set aside their separation, an appeal to lose oneself, to truly rediscover oneself in everything. The 'passing' [Paschal] that is the Church, is realized in each man with the passing of the egoism of his own 'I' [his own individuality] to the unity of the members of the body of Christ.** The command of Paschal, of the passing, is, in fact, the fundamental precept of Christianity, which is also deeply inscribed once and for all in the sacrament of the Eucharist, from which the Church lives. At this point, the vision of the Fathers about the union of humanity begins to take on truly

[21] See texts of Teilhard de Chardin in the pages that follow.

concrete contours: **in the network of the communities of communion that the Christian mission extended through the whole *oecumene*** [inhabited part of the world], **there is already the beginning of that communion of mankind with one another and with God, the ultimate end of the coming of Christ.** For each community of communion is a 'fraternity' that is intertwined in a single fraternal union with all the tables of God in this world."[22]

§ 26 Like Ratzinger, Fr. Teilhard de Chardin presented a theological explanation for an ecumenical "communion" that would be preparing the religion of the future. He wrote: "**The Heart of Christ**, the revealing synthesis of the love-energy in God that moves his Trinitarian activity and inspires his creating decision, clarifies the meaning of the universe and humanity, which has evolved for and by the Word Incarnate. Consequently, 'his being the alpha and the omega,' 'his being the way, the truth, and the life' **presents itself at the end of the History of the world as its point of convergence and encounter: *its living ecumenism.***

"**The universalized Eucharist is this point of encounter. The eucharistic sacrament, where the Man-God made his body and his blood the *substantial* bond that links humanity to his Divinity and introduces it into his Trinitarian life, makes itself at the same time the organic bond uniting all [Eucharist] communicants among themselves, constituting his Mystical Body or Universal Church.**

"**It is impossible,** therefore, **to work efficaciously in ecumenism without attracting [others] to the Host, raising it like a beacon above the sterile efforts and disordered activisms and errors, which all tend more or less to diminish the reality of the Resurrected One living and acting personally in the Host.**

"Neither authentic religion nor real convergence exists outside of Jesus present on this earth in the sacrament of unity and fulfilling there his function as integrator of creation.

"**A general convergence of all religions in the one Universal Christ that ultimately satisfies them all: this**

[22] *Ibid.*, pp. 148-9.

seems to me to be the only possible conversion of the world and the only imaginable form for a religion of the future."[23]

§ 27 Another document by Teilhard de Chardin gives an even broader interpretation of the Eucharist as the unifying element of the whole universe. This would seem to explain the meaning behind Ratzinger's statement that the Eucharist would have a cosmic aspect. This is the Teilhardian notion, which Ratzinger appeared to be basing himself on. Chardin stated:

"All the communions of our life in fact are only successive instants or episodes of one single communion, that is, of only one same process of Christification. But this is not all. What is true with respect to me is true with respect to every other living Christian, past or future. And, as we know from reason and through faith, all these Christians form in humanity and in God only one single whole, organically linked in a common super-life.

"If all my communions only form one single grand communion, then all the communions of all men of all times taken globally also make, in total, only one and even vaster communion, encompassing …. the History of humanity. **That is to say, the Eucharist taken in its whole action is only the expression of the manifestation of the unifying divine energy applying itself in detail to the spiritual atom of the universe [i.e., man]. In short, to adhere to Christ in the Eucharist is, inevitably and *ipso facto*, to incorporate ourselves more and more into a Christogenesis,[24] which is nothing else …. but the soul of the universal Cosmogenesis.**

"**For the Christian who understands this profound economy** and at the same time penetrates the meaning of the organic unity of the universe, **to communicate is not, therefore, a sporadic, localized, and fragmentary action. Receiving the Host, such a Christian is conscious of touching the very heart of evolution. Reciprocally, touching the heart of the Host, he perceives that it is indispensable that he communicate by accepting his whole life and feeling realized in it …. together with the whole body of the world in evolution.** This is sacrament of our life suffered and conquered, as

[23] J.M. Mortier, *Avec Teilhard de Chardin – "Vues ardentes"* (Paris: Seuil, 1967), pp. 54-5.

[24] About the concepts of Christogenesis and Cosmogenesis, see Part I, Chap. IV, footnote 4.

much in its individual circumstances as in its cosmic amplitude! The 'super-Communion'"[25]

§ 28 Commenting on excerpts of Teilhard de Chardin, Cardinal de Lubac defined "communion" as a process of "pan-love" and claimed this would be the basis of the religion of the future. De Lubac affirmed: "The same essential views [of Teilhard] receive their final expression in *Le Christique* [which are]:

- "Real possibilities of a love, of a *true* love of God attested to by Christian history: **'It is undeniable that the most ardent collective focus of love ever to appear in the world is burning *hic et nunc*** [here and now] **in the heart of the Church of God'**;

- **"The impossibility** for the human conscience, as strong as it may be or can become in each one, **to found a religion of love. This religion is as indispensable to the life of man in society as it is for the fulfillment of his highest ideal;**

- "On the contrary, **the extraordinary and significant power of pan-love (pan-*amor*ization) that Christianity has** is a power that must affirm its pivotal and governing place For it to be realized completely, it is necessary to penetrate to its heart.

"Then [Chardin said], 'In a world certainly open at its apex *in Christo Jesu*, we will no longer run the risk of suffocating to death! On the other hand, descending from these heights is the radiation of a love that lessens.'"[26]

§ 29 De Lubac added another excerpt from Teilhard about a "pantheism of love" that also seems to be applied in the progressivist notion of "communion": "What stands out first in the basic Christian vision and in the structure of dogma is the 'primacy of charity.' This consists of the 'love of God for the world and each one of its elements,' and, reciprocally, in the 'love of the elements of the world for themselves and God.' **In the end, what must take place is the unification of every-**

[25] J. M. Mortier, *Avec Teilhard de Chardin - "Vues ardentes,"* pp. 83-4.

[26] H. de Lubac, *L'Eternel Féminin - Étude sur un texte du Père Teilhard de Chardin* (Paris: Aubier-Montaigne, 1968), pp. 154-5.

thing in God, not by fusion,[27] but by a 'differentiating syn-
thesis' into a vast network of personal relations. It is this
vision of final unity to which Teilhard gives the name 'pan-
theism of love,' or 'Christian pantheism.'"[28]

§ 30 This time expounding his own ideas, Cardinal de Lubac
stated that this accord among all men – "communion" – should
take place around a new conceptualization of human nature...
Undoubtedly it is a quite radical demand. These were his
words: "**An understanding [of 'Christians'] with everyone –**
in today's language, we could call it an 'opening to the world'
**– is to be found in an idea of human nature that can equally
fit all, and that can be adopted as easily by a Christian as
by a Deist or an atheist.**"[29]

§ 31 Cardinal von Balthasar commented on the "unity" and
"coexistence of an eternal peace with all the elements of earth,"
which he attributed to St. Maximus, Confessor. That this is the
thinking of von Balthasar is certain. That it would be the think-
ing of St. Maximus is a point open to discussion. At any rate,
von Balthasar provided yet another confirmation of the pro-
gressivist notion of "communion":

"**The world is presently being transformed in God.
Its totality has penetrated the totality of God. Its unity has
re-encountered the Unity.** The splendor of God extinguishes
the brilliance of the world like the light of the sun eliminates
the light of the stars. **The parts disappear in the kingdom of
the whole. All self-will is suppressed because the creature
no longer wants to belong to himself.** There is no longer any
activity except one, *mia energéia* [primordial energy], which is
the activity of God Himself, and this will be supreme liberty.
The symbol of the burning bush will then be completely real-
ized: 'That ineffable and prodigious fire hidden in the essence
of things as in the bush' will reveal itself – not to consume the

[27] By saying that there is no fusion, but personal differentiation, de
Lubac is trying to defend Teilhard from the accusation of being a
pantheist, a charge frequently and objectively raised against him.
Actually, Pantheism supposes a fusion of substances between God
and man, as well as among men themselves. Ratzinger defended an
analogous fusion a few pages earlier.

[28] *Ibid.*, p. 155.

[29] H. de Lubac, *Atheisme et sens de l'homme*, p. 102.

world, because it needs no material fuel to burn. For it will be a fire of love burning inside all things, and this fire will be God.

"**This presence of God is peace. The philosophy and theology of the synthesis is, in the end, the coexistence of an eternal peace with all the antinomies of the world, which end by being dissolved in it like vapors in the sky of eternity. All discord and conflict will be only superficial.**"[30]

These excerpts present various components of "communion" now in vogue in progressivist ambiences.[31] They give the Reader a picture of the final phase of the "thawing – dialogue – communion" maneuver initiated by Vatican II.

It is difficult to avoid the conclusion that such "communion" coincides with the universal religion desired by the Utopists generally known by the name of Pan-religion.

B. Buddhism and Judaism: two models for this Pan-religion?

§ 32 Behind the progressivist arguments for a Pan-religion, one notes a mystical-religious ideal that can seem Buddhist, and an evolutionist messianism that approximates Jewish aspirations.

§ 33 Indeed, the mystical love that supposedly would unite all religions has syncretistic connotations and accents similar to Buddhism. For example, by stressing the experimental nature of religion to the detriment of doctrinal disputes relating to Faith and Morals, progressivist ecumenism seems to assume the experimental approach typical of Buddhism. Furthermore, progressivist ecumenism has tones of tolerance remindful of the Buddhist "goodness" that assimilates everything – be it good or bad.

§ 34 On the other hand, when one considers the progressivist doctrine of Christogenesis, with its indisputable evolutionary character and its goal to integrate all humanity into one single final whole, which would be the apotheosis of History, one sees that this theory is not so far removed from Judaic messian-

[30] H. U. von Balthasar, *Liturgie cosmique - Maxime le Confesseur* (Paris: Aubier-Montaigne, 1947), pp. 273-4.

[31] The Theology of Communion will be addressed, in Vol. VI, *Inveniet Fidem?*, Chap. IV.1.B; Chap. V.6.

ism. The latter, with similar foundations, also conceives a similar end. What the Jewish religion says – and what various progressivists omit – is that this final coming together of humanity to reach this dreamed-of apotheosis will take place under the aegis of the Jewish religion. This is the famous Jewish hegemony – defended by rabbis in the presence of John Paul II during his visit to the synagogue of Rome [32] – considered an indispensable condition for humanity to reach its plenitude.

These impressions that naturally rise in one who studies conciliar ecumenism can be confirmed by statements that have been made about ecumenical "communion."

a. The Buddhist-Hinduist road

§ 35

Hindus believe that all living beings pass through endless cycles of birth, death, and rebirth, and that good or bad behavior is rewarded or punished by reincarnation into either a higher or lower form of life. In their pantheistic all-god Brahma, the whole world of deities, spirits, and others objects of worship is contained. Hinduism embraces nature-worshippers, fetish-worshippers, and demon-worshippers, and it does not scruple to permit the most grotesque forms of idolatry and superstition.

§ 36

Buddhists seek to escape the cycles of rebirth by extinguishing all forms of desire, including attachment to conscious existence, thereby attaining the blissful state of *nirvana.* This demands the practice of self-negating meditation and asceticism. There are various sects of Buddhists, including some who worship Buddha as supreme personal deity and others whose deities are innumerable and idolatry unlimited. It is obvious that both the Buddhist and Hindu "roads" are irreconcilable with Catholic doctrine.

§ 37

Nonetheless, the drawing together of Buddhism and Catholicism was considered indispensable for today's theology by Fr. Harvey Egan, SJ, Professor of Mystical and Systematic Theology at Boston College. In a book on mysticism based on the doctrine of the "anonymous Christian," Fr. Egan wrote:

"As the intensification of authentic religion, **mysticism provides an excellent basis for today's ecumenism**. Because

[32] Vol. III, *Animus injuriandi II*, Chap. I.3.B.

deep speaks to deep, **the mystics of any tradition recognize a kindred spirit in other traditions. Vatican II has made the dialogue easier by acknowledging the values to be found in the world's great non-Christian religions.** Rahner's 'anonymous Christian' outlook, as well as the 'transcultural dimension' underscored by Merton, Johnston, and Lonergan, set the stage for a genuine East-West dialogue rooted in mysticism.

"We are living in a new age. And if one accepts Karl Rahner's insight that Vatican II's most important achievement was to transform the Church from a European into a world Church, then one has to be aware of comtemporary theology's new horizon. It seems impossible to do Christian theology today without paying attention to what the East has to offer. Because of this new horizon, moreover, new questions have arisen which can be answered only by a new mystical theology which learns from the secular sciences and the great non-Christian religions. Both Rahner and Lonergan seem to supply the requisite cutting-edge for a new and future mystical theology."[33]

§ 38 Applying the theory of "anonymous Christianity," Fr. Dominique Dubarle, dean of the Department of Philosophy at the Institut Catholique de Paris, thought that it would be possible for Catholics to accept Buddhism, since "grace" would also dwell within it: "Since I believe in the universal presence of God that acts in all of creation and in the life of the spirit, and since I believe in the providential divine plan for all humanity in its [different] forms of development in earthly history, **I think that it is possible that this presence and this providence dwell anonymously, without being discerned within that vigorous Buddhist florescence** in the human spiritual context.

"And why not? Why not consider Buddhism as a realization of that which God wanted to stimulate in the bosom of creation with the human creature? Further, since we speak of grace as a divine gift to man capable of working a spiritual transformation of his behavior, **why should we refuse to imagine Buddhism as being visited** – without realizing it – **by an authentic energy of grace, and precisely in the sense that Christian theology imparts it? Why couldn't** *nirvana*

[33] H. Egan, *What are they Saying about Mysticism?*, p. 120.

itself be a form of peaceful and silent union with the energy
of divine benevolence, which, nameless and formless, consti-
tutes a kind of retiring from all things, without rejecting any-
thing that comes to it with purity of soul?"[34]

§ 39 A specialist in ecumenism with Buddhists, Fr. Peter
Nemeshegyi, SJ, member of the International Theological
Commission and Professor of Fundamental and Dogmatic
Theology at Tokyo's Sophia University, enumerated character-
istics of the Buddhist divinity as compatible with "the God of
Christian revelation." He also maintained that the non-
Christian religions could help Catholics rediscover the true
God. In his analysis, he applied the criteria of spirituality of
Vatican II. Some of the characteristics of the Buddhist divinity
are quite similar to the progressivist aims for "communion." Fr.
Nemeshegyi wrote:

"The god of mystical experience that beatifies by
unity, the god that is the first principle of social humanism,
the graciously smiling god of original harmony – these are
the three grand aspects of the concept and experience of
god that the Asian world has lived for thousands of years
and continues to live. They are aspects that in no way con-
tradict the God of Christian revelation. It is the God who
united everything in himself. It is the love that embraces every-
thing. It is that single chord of beauty that expands in the thou-
sand sounds in the canticle of creation. This God reveals him-
self in Jesus, the '*universale concretum*' [universal concept re-
alized in a concrete example] (H. U. von Balthasar), in the
'chord that sings of our union' (Ignatius of Antioch). Our
Asian brothers can help us to always rediscover Him."[35]

§ 40 In 1974 India hosted a seminar on the theological value
of the non-Christian books. The final report of the conference,
according to the summary made by theologian and conciliar
perito Fr. Joseph Neuner, raised the thesis that the Holy Spirit
would have inspired the Buddhist religious books. The report
also proposed that Catholic theology and liturgy should incor-
porate those books into its doctrine and cult. Summarizing the
conclusions of the meeting, Neuner wrote:

[34] Dominique Dubarle, "Espiritualidade budista e o sentido cristão de
Deus," *Concilium*, 1978/6, p. 78.

[35] Peter Nemeshegyi, "Deus - seus conceitos e experiências da
Ásia," *Concilium*, 1977/3, p. 42.

"Even though Jesus Christ maintains a unique position for us (nn. 48-9), **we** also **believe in the action of the Holy Spirit in other religious experiences** (n. 50). **If the Spirit of God is working in these religions, it is also 'the action of the Holy Spirit that makes the experiences of such communities reflect in their books, giving them authority'** (n. 54) Once we recognize the activity of the Holy Spirit in other religions and their sacred books, **we cannot remain indifferent to them: 'We, the Christians of India,** sharing the same life and a common patrimony with our people, **need to relate to the religious experience that gave form to these sacred books'** (n. 51). **'The Holy Spirit is leading us to discern the gift that He offers us in these texts** We are all called to participate more profoundly in dialogue with our brothers of other religions. **From this perspective, we have to consider using non-Christian scriptures in our life and worship'** (n. 55)

"**This would lead gradually to the development of an Indian theology, because Christianity finds in the sacred writings of other religions 'a broader anthropological, theological, and cosmic perspective of the mystery proclaimed in Jesus'** (n. 61)." [36]

§ 41 Fr. Claude Geffré and Fr. Mariasusai Dhavamony, both well-known Jesuit specialists in ecumenism, presented Buddhism as a vehicle of special enrichment for Western man who has reached the phase of world unity. The priests presented the acceptation of Buddhism as a challenge for Western man:

"**Unity of the human race and creation of a single world are the grand ideals of modern man. Recent times have seen a broadening of the horizons, the dismantling of dividing barriers, and the drawing together of peoples who were once quite separated. This tendency has special relevance in view of the far-reaching changes that are affecting both the East and the West. The West has seen the quiet but effective influence of the Eastern religions, especially Buddhism. Here we have a vital challenge to every Christian: to accept the religious-moral values of Buddhism and enrich our own religious horizon,** or to pretend nothing of

[36] Josef Neuner, "Seminário de investigação sobre textos sagrados não-bíblicos," *Concilium*, 1976/2, p. 22.

value exists in it and even to raise a wall of defense against it."[37]

§ 42 An acceptance of Hinduism and Buddhism also came from the pen of Fr. Jan Henricus Walgrave, OP, member of the International Theological Commission. The Belgian theologian concluded that Catholics have much to learn from Hindus about the interior life: "**Different from Islam, Hinduism has nothing of a religion of prophetic revelation. What we have here is a religion that grew slowly based on human experience,** making unceasing efforts, exploring the very depths of things by constant metaphysical meditation, **always careful of remaining faithful to truth without losing any of the richness of experience**. It is, in short, an indefatigable search for truth.

"**From all this comes its character of simplicity** and complete nakedness, **its spirit of tolerance that tends to a syncretism where all values are taken into account without repudiating any by principle, where all differences appear without fighting. God is experienced as a source of universal vital energy, projecting all of itself into everything, penetrating everything, and, in addition to this, calling man's attention in everything. Thus, god is honored in everything**

"In the times of Jesus Christ a current of stronger religious orientation surged. **It fostered forms of practical monotheism that dominated the religious life of the great masses of India. From this current sprang torrents of religious poetry, a poetry of devotion to and love for Vishnu, or Siva which later became the object of a monotheist cult. This is, therefore,** *the way of love* that leads to salvation in a way different from the one laid out by the life of science and Yoga. **It is a way of abandonment, inspired by the belief we are entirely dependent on god and that only by his grace can we attain salvation. Here we come close, in a surprising way, to Christianity.**

"**Once again we discover how the Holy Spirit illuminates the hearts of men,** departing from a not-so-promising metaphysical base, **and guides them to the kingdom of Christ, to the kingdom of love What we can learn from**

[37] Claude Geffré – Mariaususai Dhavamony, Editorial, *Concilium*, 1978/6, p. 3.

the Hindu is the intense attention he pays to the interior life."[38]

§ 43 Fr. Joseph Spae, adviser to the Secretariat for Non-Christians and a specialist in Christian and Japanese culture, preached the union of Buddhism with Christianity as a guarantee of peace for humanity. He wrote: "**We can all agree with what lama Anagarika Govinda** **wrote** in the manual for the Tibetan Center of Nyingma Meditation in Berkeley, California: '**We can hope that when the followers of Christ and those of Buddha** again **find themselves on a terrain of mutual good will and understanding, we will see the day when the love that Buddha, like Christ, preached so eloquently will unite the world in a common effort to save humanity from destruction, guiding it to the light in which we all believe.**

"**Should we dare, then, to suppose that the day will come when Buddhism,** with its fullness and beauty, its calm and charm, **will no longer be considered something foreign and will makes its proper contribution to Christianity for the union of the East and the West?**"[39]

§ 44 As if foreseeing the conciliar advances of our days, early progressivist Romano Guardini affirmed that Buddha was like a John the Baptist of the East. Guardini wrote: "**There is only one man with conditions to inspire the thinking that draws one closer to Jesus: Buddha. This man is a great mystery. Gifted with truly surprising, almost super-human liberty, he had a powerful goodness in the way of universal energy.** Perhaps Buddha is the last one whom Christianity must confront. No one has said yet what Buddha means from the Christian point of view. **Perhaps, like the Baptist, his precursor in the Old Testament, Christ also had his precursor in the ancient world: Socrates. And He also had a third, who pronounced the final word of knowledge and renunciation of the Eastern religions: Buddha.**"[40]

[38] Jan Walgrave, "Relazioni sacro-storiche tra la Chiesa e i culti non-cristianni," V.A., *I grandi temi del Concilio*, pp. 937-9.

[39] Joseph Spae, "A influência do budismo na Europa e na América," *Concilium*, 1978/6, p. 131.

[40] Romano Guardini, *Der Herr*, Würgburg, 1961, p. 360, *apud* Hans Waldenfels, "Palavra e silêncio no budismo," *Concilium*, 1976/2, p. 41.

§ 45 Fr. Schoonenberg, a celebrated Dutch theologian, is one of many who think like Guardini: "**I also think that**, in a certain sense, **Buddha is the way to Christ.**"[41]

§ 46 De Lubac was a strong proponent for opening Christianity to Buddhism. He stated: "Are long explanations still needed to determine what should be the Christian attitude toward Buddhism? On one hand, it will frequently coincide with the humanist attitude, which we can understand without difficulty **Buddhist humanism, becoming better known today, can help to reach the end that our epoch proposes. And this is,** as René Grousset tells us **'a vaster humanism, amplified to the actual dimensions of humanity'**

 "**Like the humanist, the Christian can admire unrestrictedly the great number of human beauties that burgeon in Buddhism He [the Christian] can, without loss to the faith, fully taste the 'charm of Buddhism' The Christian has no reason to censure himself when he feels almost fraternal sentiments rise in his soul toward Buddhism.**"[42]

§ 47 De Lubac endorsed the thesis of a book published in the 19th century on the supposed complementary natures of Christianity and Buddhism. In an extravagant comparison between Christ and Buddha, the book imagined that the two would form a couple, with Jesus Christ as the woman and Buddha the man. De Lubac considered this comparison "good news" because it showed Catholics could "convert to Buddha without renouncing Jesus." The French Cardinal commented:

 "No sooner had Olcott's *Catechism* been published than **a new book came to light announcing the good news to the public: persons could convert to Buddha without renouncing Jesus.** This is the message of *La voie parfaite* [The perfect road], by an anonymous author published in 1882: '**Buddha and Jesus are necessary to each other Buddha is the mind, Jesus is the heart. Buddha is the general, Jesus is the particular. Buddha is the brother of the universe, Jesus is the brother of men. Buddha is the philosophy; Jesus is the religion. Buddha is the circumference; Jesus is the center. Buddha is the system; Jesus is the point of irradiation.**

[41] Piet Schoonenberg, untitled, *Cinco problemas que desafiam a Igreja hoje*, p. 82.

[42] H. de Lubac, *La rencontre du bouddhisme et de l'Occident* (Paris: Aubier-Montaigne, 1952), pp. 276-7.

Buddha is the manifestation; Jesus is the spirit. In a word, Buddha is the man, the intelligence, and Jesus is the woman, the intuition... No one can properly be Christian without also, and above all, being Buddhist."[43].

§ 48
On a visit to Thailand, John Paul II praised aspects of Buddhism[44] and admired the alleged "peaceful wisdom" of that religious confession. In the homily of the Mass he celebrated in Bangkok, he affirmed to the Catholics of that country: **"You find yourselves in a world where the majority of your co-citizens embrace Buddhism, that system of religious beliefs and philosophical ideas rooted in the history, culture, and psychology of the Thai people,** and that profoundly influences your identity as a nation. In a certain measure, one can say, therefore, that as the people of Thailand, **you are heirs to the ancient and venerable wisdom contained in it.** How can you, as members of the Catholic Church who recognize Christ as Savior of the world, respond to the call to be His disciples, living immersed in a religious ambience that is not your own?

"Sacred Scripture gives elements for a response to this question. The reading of the Epistle of St. James (3:17) speaks of an earthly wisdom that is opposed to the 'wisdom that is from above,' which is chaste, peaceable, easy to be persuaded, open to counsel, abounding in mercy and good fruits, without uncertainties and dissimulation. **Your cultural inheritance as Thai people is intimately linked to the native Buddhist tradition, which prepares a fertile ground for the seed of the Word of God to take root and grow. In the practice of Buddhism, one can discern a noble tendency to try to move away from 'earthly wisdom,' and a quest to uncover and effect an** *interior purification and liberation.* **This objective is sought by prayer and meditation, along with the practice of moral virtue.**

"As Vatican Council II so clearly indicated, the Church has a sincere respect for the religious wisdom contained in the non-Christian traditions and rejects nothing that is true and holy in them (NA 2). **The fruits of a 'peaceful' and 'obliging' wisdom are clearly seen in the Thai character, and are es-**

[43] *Ibid.*, p. 210.

[44] This text also demonstrates the adhesion of John Paul II to the theory of the "seeds of the Word." See Part II, Chap. III.1.

teemed and respected by those who have the good fortune to meet you and know this spiritual quality you have."[45]

It is difficult to find a more categorical eulogy than this of various aspects of Buddhism.

§ 49 In Seoul some days earlier, John Paul II also wished happiness to Buddhists: **"Can I direct a special greeting to members of the Buddhist tradition as they prepare for the festivity of Lord Buddha? May their joy be complete and their happiness full!"**[46]

§ 50 He also praised Buddhism as a vehicle of "holiness" when he greeted the Korean people: "Throughout history, **the Korean people have sought in the great ethnic and religious inspirations of Buddhism** and Confucianism **the way for the renewal of the individual and the consolidation of all people in holiness and noble aspirations."**[47]

§ 51 Directing himself to members of the Pontifical Council for Inter-Religious Dialogue in 1992, John Paul II stated: **"Contact with the religions of Asia, especially Hinduism and Buddhism, which are notable for their contemplative spirit, methods of meditation, and asceticism, can contribute greatly to the inculturation of the Gospel** on that Continent. **A greater interchange between Catholics and followers of other traditions can help to reveal points of affinity in the spiritual life and expression of religious creeds,** without ignoring the differences."[48]

These documents seem sufficient to demonstrate that the progressivist longing for the union of all men around love – ecumenism – follows many of the principles of the Buddhist religion. In fact, it increasingly appears that the adaptation of

[45] John Paul II, Homily at the Mass for world peace, Bangkok, May 10, 1984, *L'Osservatore Romano*, May 11, 1984, Supplement, pp. 1,4.

[46] John Paul II, Speech to the leaders of the principal religions in the Nunciature's chapel in Seoul, May 6, 1984, *L'Osservatore Romano* May 11, 1984, Supplement, p. 15.

[47] *Ibid.*, *L'Osservatore Romano*, May 7-8, 1984, p. 4.

[48] John Paul II, Speech to members of the Pontifical Council for Inter-Religious Dialogue, December 13, 1992, entitled "È necessario un comune impegno per eliminare le intolleranze," *L'Osservatore Romano*, December 14, 1992.

the Church to Buddhism has become one of the most important roads to reach the aims of the Conciliar Church.

b. The Jewish road

If the aims of Progressivism seem to approach the principles and methods of Buddhism and Hinduism, something similar and perhaps more important can be said of Judaism.

§ 52 Judaism or Jewish religion is at first glance a monotheistic system found in the Ten Commandments and many other precepts given by God. These precepts are included in the ensemble of books called the *Torah*.[49] Besides the written *Torah*, the Jews admit also an "oral" *Torah* composed of various parts.[50]

§ 53 Insofar as a Jew remains superficial in the practice of his religion, he limits himself to following some legal and moral precepts of the *Torah*. To the degree that he delves deeper into the Jewish religion he is invited to a mystical approach. There are innumerable theological currents of mysti-

[49] The title *Torah* is applied either in a strict sense to the five first books of the Bible, the Pentateuch, or in a broader sense to all the prophetic and hagiographic books before Jesus Christ that the present day Jewish religion accepts.

[50] The written parts include the *Talmud* (study), the public teaching and commentaries on the *Torah*; the *Mishnah* (repetition), older commentaries on the *Torah*; the *Guemarah* (complement), commentaries on the *Mishnah*; the *Midrashim* (exposés), rabbinical theses of significant thinkers; the *Haggadah* (narratives), explanations of traditional stories, legends and symbols of non-legislative parts of the latter two books.

The other important part of the "oral" *Torah* is the *Qabbalah*, or *Kabala* (secret oral tradition). The *Kabala* is supposedly comprised of the non-written parts of the revelation God gave to Moses. This revelation, would have been maintained complete throughout History until today by a chain of "wise" religious men, guarding it faithfully until the future coming of their messiah. Even this "oral" tradition has books: the *Zohar* (book of the splendor), the Y*etsirah* (book of the creation) etc.

cism inside Judaism for which scholars have found several common denominators.[51]

§ 54 Judaic religious mysticism considers creation as a substantial emanation of God. In other words, God would be substantially immanent in the whole universe.[52] One can distinguish two general matrixes in the Jewish religious mysticism.

§ 55 The *first matrix* is a monist doctrine by which creation would be an "organic" emanation of the first divine principle. This emanation supposes an intermediary zone between God and creation, composed of ten divine spheres, each one situated on a less noble level as it approaches creation – the theory of the *sephirot* (spheres). These spheres would also be an emanation of the first divine principle.

§ 56 The *second matrix* is dualist. It supposes a dialectic conflict in the very first divine principle. There would have been a mysterious contraction in God's own being – the theory of the *tsimtsum* (contraction). This diminution in the divinity would have caused a disastrous consequence, the creation of the universe.

§ 57 For each of these matrixes a different mysticism presents diverse ways to reintegrate the believers into the divinity. Both matrixes admit a universal evolutionary process that would permit the re-incorporation of all of creation to God. Both suppose, therefore, that this complete reintegration would be in the future, in a time that will shortly follow the coming of their messiah. That is to say the Jewish religion is turned toward the future; it has a fundamental horizontal perspective.

[51] Gershom Scholem, *Les grands courantes de la mystique juive*, Paris: Payot, 1983; Henri Serouya, *La Kabbale – Ses origines, sa psychologie mystique, sa metaphisique*, Paris: Grasset, 1947; Leo Schaya, *L'homme et l'absolu selon la Kabbale*, Paris: Dervy-Livres, 1977.

[52] a. "All is one and all is he; all is only one thing without distinction or separation" (*Zohar* III, 290a, 290b). "The Holy Venerable One is one, and all is one, and all the lights that come from him are only one, and they return to the one The Venerable of venerables contains all things; he is all" (*Zohar* I, 21a)," *apud* H. Serouya, *La Kabbale – Ses origins*, p. 224.

b. On the immanence of God in creation according to religious Judaism, see Vol. VIII, *Fumus Satanae*, Chap. VII.1.B.

§ 58 Regarding messianism, after experiencing the disillusion of the many pseudo messiahs throughout History, the Jewish religion tends to consider the religious hegemony of Israel over the world as the expected messiah.[53] Therefore, it would not be a person, but a religious-political situation.

§ 59 In short, the Jewish religion is in complete opposition to Catholic doctrine, because the latter condemns any kind of emmanatism in the origin of creation or a consequent immanentism in creatures. Holy Mother Church does not admit any mixture of substances between Creator and creature.

§ 60 For the Catholic the creation was made from nothing. God the Creator is Absolute, Omniscient, Eternal, and Impassible. The creatures are contingent, ignorant, finite, and subject to suffering. God does not depend on the development of History and the progress of the universe. He should be sought by creatures in His infinite transcendence. To know God, Catholics should raise their hearts to on high. Therefore, the Catholic perspective is fundamentally vertical.

§ 61 Moreover, Our Lord Jesus Christ is God. He is the Messiah. The messianic mission of Christ was the Redemption that freed man from the evil consequences of original sin and opened heaven to humankind. This Redemption was complete and universal. It is a mission that was fulfilled and closed. One can no longer speak, therefore, of a future Catholic messianism.

 For this reason, Catholic doctrine is in complete opposition to Jewish doctrine, be it in its philosophical fundaments or its theological conceptions.

 Notwithstanding, progressivists and Jews walk hand-in-hand in many fields, as this Item will show.

b.a. Documents of Vatican II and the Jewish road for the Church

§ 62 The Declaration *Nostra aetate* appears to try to "absolve" the Jews from the crime of Deicide. It also "asks pardon" for the perennial action of the Church in combating the errors of the Jewish religion. Flagrantly opposed to what the

[53] Some currents of the so-called orthodox Jews still await an individual messiah.

Jews themselves profess, the Vatican document declares that the Jews are united to Christ. In the following excerpts, these Vatican II attitudes are patent:

* "The Church believes that by His cross Christ reconciled Jew and Gentile, making them both one in Himself" (*NA* 4b).

* "The Jews should not be presented as repudiated or cursed by God, as if such views followed from the holy Scriptures" (*NA* 4f).

* "The Church deplores the hatred, persecutions, and displays of anti-Semitism directed against the Jews at any time and from any source" (*NA* 4g).

* "The Church rejects, as foreign to the mind of Christ, any discrimination against men or harassment of them because of religion" (*NA* 5c).

The Declaration *Nostra aetate* stimulated dialogue with the Jews:

* "Since the spiritual patrimony common to Christians and Jews is thus so great, this sacred Synod wishes to foster and recommend that mutual understanding and respect which is the fruit above all of biblical and theological studies, and of brotherly dialogues" (*NA* 4e).

§ 63 If one were to research the origin of the passages cited from *Nostra aetate*, one would discover the revealing and little known source that served as the basis for the conciliar declaration. This document was written by a group of ecclesiastics in which Dominican Fr. Burno Hussar, founder of the strange "Catholic-Jewish Church" was one of the main participants.

Journalist William Levi Wells of the Italian *Corriere della Sera* provided some important facts about this "Church" as well as unpublished statements of Fr. Hussar that help us understand how the conciliar document on the Jews was prepared. Levi Wells related:

§ 64 "Fr. Bruno Hussar is a Dominican, an Israeli citizen, founder of the Catholic-Judaic Church as well as 'Neve Schalom' (oasis of peace), the first village in the world where Catholic Jews, Muslims, and Hebrews live together and learn to love one another The first question I asked him was: 'Father, are you a Jew or Christian?' He responded, 'I am a Jew and a Christian.' Then he added, 'But so that there is no doubt,

I will tell you right from the beginning that everything I have done and am doing here in Jerusalem is with the permission of the superiors of my Order, the Dominican Order, which, as you know, is considered the most faithful defender of Catholic orthodoxy throughout the world'

§ 65 "In June of 1953, my superior told me to be ready, because the Order intended to create a center of Jewish studies in Jerusalem To resolve the problems of the Catholic Jews, I first established the Work of St. James in Jaffa. It was the nucleus of what would later become the Jewish [Catholic-Jewish] Church, today active and flourishing in four cities: Jerusalem, Tel Aviv, Haifa, and Beer-Sheva In those years, the two great protectors of the Work of St. James were Cardinal Eugène Tisserant, prefect of the Sacred Congregation for Eastern Churches, and Cardinal Agostino Bea, head of the Secretariat for the Union of Christians. Thanks to Cardinal Tisserant, under the pontificate of Pius XII I received permission to celebrate Mass in Hebrew

"In 1960 I finally saw my work rewarded with Rome's final recognition of the House of Isaiah, the official seat of the Jewish Church. In the time of the Inquisition, the Dominicans were specialized in anti-Jewish persecution, and now a Dominican had the privilege of bringing the two religions together

§ 66 "My hour arrived when, on January 25, 1959, Pope John XXIII announced to the world the grand news of the imminent convocation of the ecumenical Council. Some time afterward, I participated at two meetings of theologians in Holland, in Apeldoorn, under the presidency of Msgr. Ramselaar. On those occasions, we drafted a historical and theological plea addressed to the Council on the need to establish new relations between the Church and the Jewish people.

§ 67 "The following year, 1961, I returned to Rome to visit Cardinal Bea where I had the happiness to learn that our plea had been transformed by him, at the command of the Pope, into a text that would be submitted to the conciliar fathers. Cardinal Bea had me read his work. They were words filled with love, which expressed the contrition of the Church for the sins committed against the Jews But the battle had only begun. The text, prematurely divulged by the press, stirred up enormous indignation in the world and the ferocious opposition of vast Christian sectors

§ 68 "Pope John died in 1963 The next year, shortly before the opening of the third session of the Council, I learned that a second version of the 'Jewish text' had been 'cooked again in a different ecclesiastical cuisine.' Without the knowledge of John XXIII, it had totally revised the original document. The danger of it being adopted by the conciliar fathers was imminent. A small group of priests from the Work of St. James then decided to send me as a delegate to Rome to try to avert the catastrophe. My superiors gave their permission.

§ 69 "Arriving in Rome, I was invited by Cardinal Bea to participate as a *perito* in the works of the conciliar commission for the union of Christians, the proper forum for the composition and presentation of the 'Jewish text.' I was thus able to speak to many conciliar fathers, explaining to them the importance of the original text, the urgency of rejecting the second version and returning to the spirit of love in the original text

"From September 28 to 30, the general assembly of fathers discussed the matter, still without reaching a vote. They were the three most impassioned sessions of the Council. It was a triumph for our theses. The great majority of fathers reaffirmed the absolute need for a declaration that returned to the spirit and content of the original text. I had the honor of being named a member of a commission of three *periti* charged with rewriting the final text. Working with me were Fr. Gregory Baum and Msgr. Oesterreicher. Our text had to be submitted first to the members of the Secretariat for the Union of Christians, who were supposed to approve it.

§ 70 "When we were ready, the Bishops coming from the Arab countries tried to intimidate their colleagues, predicting terrible reprisals on the part of the Arab countries against the Church [should the text be accepted]. In two successive votes, we were quite near catastrophe. It was then that my two colleagues on the commission pressured me to speak [in the conciliar assembly] before the Bishops I played to the weak sides of the Arab psychology. Above all I expressed the conviction that the Council, by adopting the declaration, would strongly and serenely affirm its true thinking and could trust in God as to the consequences. If Christians were to suffer from it, this would lie within the logic of the Gospel. Then it would be necessary to help them and to accept the trial in this light. I concluded by saying that the eyes of Christians and Jews around the world were fixed on Rome, asking this question: Is

the Church really capable of affirming, despite all threats, what she considers true and just?

§ 71 "Finally, the vote. The text was approved by quite a large majority. It was then incorporated into the declaration *Nostra aetate* which was definitively approved by the Council on October 20, 1965,[54] with 96 percent of the votes

"In the years that followed, our initiatives multiplied. The most beautiful and glorious was the creation of 'Neve Shalom,' where Israeli citizens of the Jewish and Arabic races who belonged to the three religions (Christian, Muslim, and Jewish) resolved to live together, in equality and friendship, profoundly respecting the identity of one another

§ 72 "We are opposed to conversions. Each one can be saved remaining faithful to his own faith Are we wrong? Perhaps. But you forget that Israel is the country where utopia becomes reality. We in Israel have a word, *hagadah*. It means utopia, dream, fable. One day Theodor Herzl, the founder of Zionism, said: 'If you so desire it, it [Israel] will not just be *hagadah*' [but, it will become a reality]. I say: 'If God so desires, it will not just be *hagadah*.'"[55]

§ 73 This, then, is the little known origin of the conciliar document on the Jews. Born from the inter-confessional experiment of the "Catholic Jewish Church," its principal protagonist was Fr. Bruno Hussar, who calls himself Catholic and Jew, simultaneously.

This important experiment of a "Catholic-Jewish Church" seems to point to a similar route planned for the whole of the Conciliar Church.

[54] In fact, the Declaration *Nostra aetate* was approved by the assembly of conciliar fathers on October 15, 1965. Shortly after, it was taken to Paul VI, who decided to re-present it personally to the fathers in the public session of October 28, which he did. On this day, in the presence of Paul VI, *Nostra aetate* came up for a second and final vote: of the 2,312 present, 2,221 voted in favor, 88 against, and 3 abstained. (In the vote of October 15, of the 2,023 present, 1,763 were in favor, 250 against, and 10 abstained.) Right afterward, at the same October 28 session, Paul VI solemnly promulgated the document (Boaventura Kloppenburg, *Concílio Vaticano II*, Petrópolis: Vozes, 1966, vol.5, p. 386; René Laurentin, *Bilan du Concile*, Paris: Seuil, 1966, vol. 5, pp. 136-7).

[55] W. Levi Wells, Genesis of the Jewish section of *Nostrae aetate, La Domenica del Corriere*, July 7, 1984, pp. 33-5, 97.

b.b. Symptomatic affinities between progressivist and Jewish messianism

§ 74
 For the religious Jew, as was seen above, God is to be sought in the historical future. The Jewish messiah is a future hope. His religion has a fundamental horizontal perspective.

§ 75
 Progressivism takes a position different from the immutable Catholic doctrine. Trying to make a symbiosis between Catholicism and Judaism, innumerable progressivists try to unite the vertical perspective of the former and horizontal one of the latter. From this came the celebrated formula of Teilhard de Chardin: the God above us + the God before us = the Christ Dimension, "the basic equation of every future religion."[56]

§ 76
 Cardinal Congar implicitly considered Teilhard's Christ Omega[57] an acceptable messianic formula for progressivists and Jews. He commented: "Lehrmann suggests that the reason for this absence [of an ethics of change] derives from the fact that for Christians, the Messiah has come. For Judaism, he is awaited, in both the near and far future. A vision of Christ that is not turned toward the future is totally incomplete. It is the Omega point of Teilhard, *the Christ that is to be* of Tennyson the ordering of all things – the Church and the world – to the Kingdom..."[58]

§ 77
 The role of historical development in Jewish messianism was explained and praised highly by Cardinal de Lubac: **"The messianic hope of the chosen people [the present day religious Judaism] has far from dwindled in face of the discoveries that came with the development of civilization.** Nor has it been softened by the effects of the consequent resulting maturity. This hope is able to embrace everything: universalist views, cosmic speculations, improvements in the interior

[56] P. Teilhard de Chardin, *Le coeur de la matiére* (Paris: Seuil, 1976), p. 67.

[57] Teilhard de Chardin considered that the apex of evolution would be reached when the whole universe would be ready to move to a new stage and became divine. He imagined a point of convergence for this final step: Omega. According to him, when creation would reach this point it would coincide with what Catholic doctrine preaches on the second coming of Christ. Our Lord would be, therefore, the "Christ-Omega."

[58] Y. Congar, *Église Catholique et France moderne*, p. 173.

life, attempts to establish a humanist wisdom, which has become co-substantial to Jewish thinking. **It gives everything the form of history. It makes everything the work of its god and the instrument of his designs. And it eagerly awaits an event increasingly imminent and grandiose.**"[59]

§ 78 Von Balthasar spoke about the "historical period" when the glorious finishing of the terrestrial Jerusalem (the end of History) would take place – be it before or after the resurrection of the dead. He conferred an authority to Jewish messianism parallel to that given it by Teilhard de Chardin. He stated: "**There are serious reasons here that** **do not permit,** without profound reflection, **the rejection of the earthly and textual messianism of the Jews** until our days, be it in its biblical form or in its secularized and Communist form. Nor can the cosmic evolutionism of a Teilhard de Chardin be rejected."[60]

§ 79 Jewish messianism would thus appear to have two streams, as von Balthasar just pointed out. That is to say, there would be a biblical messianism, which would find its more contemporary expression in Zionism, which preaches the hegemony of the Jewish people established in Israel and the ascendancy of its religion over all peoples. And there would be a secular messianism, which finds its translation in the Communism of Marx, or in the socialist regime of the *kibbutzim* applied in Israel.

§ 80 At a meeting in Rome, the group Kingdom and Messianism reached some interesting conclusions regarding Jewish messianism.[61] The entity gathered together under the direction of three scholars: Fr. Cornelius A. Rijk, director of the International Service of Judeo-Christian Documents, rabbi Alfredo Ravena from Rome, and Protestant pastor Alberto Soggin. A

[59] H. de Lubac, *Catholicisme*, p. 131.

[60] H. U. von Balthasar, *De l'Intégration*, p. 142.

[61] The following analysis will deal only with the Biblical stream of Jewish messianism. This Collection will not examine the secularized stream of Jewish messianism, which includes as fruits the Latin American Liberation Theology and the German Political Theology proceeding from the Jewish School of Frankfurt. For more on this topic, see A. S. Guimarães, *The Biblical Commission on the Jews: Changes in Doctrine and New Anathemas* (Los Angeles: TIA, 2002), footnote 12.

simple comparison of the statements of this group with the excerpts of conciliar documents quoted above or the other citations in this Item, demonstrates that a certain uniformity of thought exists regarding Jewish messianism. These were the conclusions of the group Kingdom and Messianism:

"It is important on our part to accept the presence of the people of God, Israel which has a role to play in the history of salvation until the end of time. **This means we must accept Israel as it is,** with love, **without wanting to 'Christianize it.' It means we should not demand that the Jews stop being Jews.** It means that Christians need to urgently seek contact in order to reestablish the interrupted relations of love For Judaism, the coming of the messiah is the end of History For Christians, the Messiah already came in the figure of Jesus, the Jew from Nazareth of the house of David

"In the view of the participants of this group, it should be possible for Jews and Christians to wait together: the former, for the coming of the messiah; the latter, for the return of Christ. The result would be a lively tension for the full realization of the kingdom The common hope must be reflected in a common action. That is, it seems opportune to continue to work together for justice in the world and relations among men

"It is important for the Church to realize that her birth did not signify the substitution of the ancient people of God with a new one: herself. This was often affirmed in the past, in a way that was neither biblical nor responsible. In reality, the Jewish people and the Christian people coexist side by side in the economy of God in a fruitful tension awaiting the kingdom. This will permit Christians to reassume their own Jewish and Semitic matrix, a need recognized today as urgent by a great number of Christian theologians."[62]

§ 81 Von Balthasar proposed that a profound and intimate relationship exists between progressivist eschatology and Jewish eschatology: "I will say a word on the relations between Christian eschatology and Jewish eschatology, a secret but powerful reality today **At depth, the Jewish and Christian eschatologies are, in a profound sense, sisters in their des-**

[62] *Il regno di Dio che vienne*, pp. 249-251.

tiny, despite the tragic contradiction that seems to set them against each other in our concrete history."[63]

§ 82 The topic of both Catholic and Jewish messianism was revisited by the Pontifical Biblical Commission (PBC) in its book *The Hebrew People and its Holy Scriptures in the Christian Bible,*[64] with a Preface by Cardinal Joseph Ratzinger. In fact, the PBC is an organ of the Congregation for the Doctrine of the Faith, and Ratzinger is its official president.

The PBC spoke of the messianic mission of Our Lord Jesus Christ and compared it to the Jewish hope of a messiah. It stated: "The notion of the fulfillment [of the mystery of Christ] is extremely complex, and can be easily distorted if one insists unilaterally on either continuity or discontinuity [of the fulfillment of the prophecies of the Old Testament in the New Testament]. The Christian faith acknowledges the fulfillment of the Scriptures and the expectation of Israel in Christ, but it does not understand this fulfillment as a simple realization of what was written …. **Jesus does not limit himself to carrying out a pre-established role – that of Messiah.** Rather, He confers to the notion of Messiah and salvation a plentitude that was impossible to imagine before …

"**It is better,** for this reason, **not to insist excessively, as a certain apologetics does, upon the merit of the proofs attributed to the fulfillment of the prophecies. Such insistence has contributed to the Christians' severe judgment of the Hebrews.** According to this reading of the Old Testament, **the more the reference to Christ becomes evident in the old-testamentary texts, the more the incredulousness of the Hebrews becomes unjustifiable and obstinate.**

"The verification of a discontinuity between the two Testaments and an overemphasis on the old perspectives should not lead to a one-sided spiritualization. That which was already fulfilled in Christ should still be fulfilled in us and in the world. The definitive fulfillment will be that [which takes place] at the end, with the resurrection of the dead, the new heaven and the new earth. **The messianic hope of the He-**

[63] H. U. von Balthasar, "Eschatologie," V.A., *Questions théologiques d'aujourdjui* (Paris: Desclée de Brouwer, 1965-66), p. 295.

[64] Pontifical Biblical Commission, *Il popolo ebraico e le sue Sacre Scritture nella Bibbia cristiana,* Preface by Cardinal Joseph Ratzinger (Libreria Editrice Vaticana, 2001).

brews is not in vain. It can become for us a strong stimulus to keep alive the eschatological dimension of our faith. We also, like them [the Jews], are alive to the hope. The difference lies in the fact that for us He who will come will have the features of that Jesus who already came and is already present and active in us."[65]

§ 83 This very serious official statement by an organ of the Congregation for the Doctrine of the Faith requests a commentary. The fulfillment of the redemptive or messianic mission of Our Lord does not depend, contrary to what the PBC affirmed, on our response to it and the events at the end of the world. The universal Redemption effected by Our Lord was completed at the moment in which He expired on the cross with the words: *Consumatum est.* Correspondence to grace and the individual salvation of each one of us is a reality that exists as a consequence of the Redemption. There is nothing confusing or complex about it.

§ 84 The second coming of Our Lord is different from His redemptive mission. Jesus Christ will come at the end of the world as judge in order to close History. Creation, Redemption, and the end of History are three distinct realities. This is the Catholic thinking on the matter.[66] Therefore, the PBC's statement is wrong. And this error would be committed deliberately in order to favor the union between the Conciliar Church and the Jewish religion.

§ 85 To understand what the PBC text actually said, one has to have recourse to a theory quite different from Catholic doctrine. One has to imagine, as described above, the universe in a process of evolution. The whole of the universe would have no substantial distinctions among its parts, nor would it be substantially distinct from God, who would be immanent in the universe. The universe would be evolving from its first state of brute matter to one of spirit, passing through man. The phases of the process would be: matter, spirit, and finally, the universe would reach the divine stage.

§ 86 Jesus Christ would have been the first man in whom humanity would have become divine. He was the one who

[65] *Ibid.*, pp. 52-3.

[66] "Fruits of Christ's Passion," in *Catechism of the Council of Trent*, trans. by John McHugh and Charles Callan (NY: Joseph F. Wagner, Inc., 1962), pp. 59-60.

would have initiated a new stage of evolution. Each of us, however, in this divine stage of evolution would achieve different degrees of progress. A period of time would elapse before the full evolutionary process would be completed. But, in the end, everything would be divinized. With this doctrine, one can understand the PBC's enigmatic references to a "new heaven," and a "new earth," which in fact follows the false progressivist thinking.

§ 87 If these myths were to be taken seriously as truths, the "mission" of Christ would not have been that of making reparation to God for the offense of original sin and of opening the gates of heaven for mankind, as the Church teaches, but of announcing a new evolutionary phase for man. His "mission" would have been to plant the seed of the new divine stage. Beginning with him, "salvation" *already* exists, *but still is not* complete. This is the well-known progressivist doctrine of the *"already, but still not"* to which the PBC makes reference.[67] "Universal salvation" would only be fully realized at the end of the process. Then everyone would be conscious of the new divine stage into which we would have entered. For this reason, the progressivist doctrine visualizes the second coming of Christ as completing His "mission" by closing the present day evolutionary phase and making the whole of the universe pass to a new one.

§ 88 By assuming such a doctrine, the PBC affirmed that the messianic mission of Christ still has not been completely fulfilled. This is no longer Catholic doctrine. It is a Pantheist and Gnostic fable directly opposed to the perennial teaching of the Holy Church and very close to the myths of the Jewish religion.

§ 89 Along with this affinity existing between Progressivism and Judaism regarding messianism, there are countless progressivists who affirm that the Jews did not lose their status as chosen people. Such a statement certainly presupposes Progressivism's voluntary submission to the govern of the "elect people."

[67] "The theme of the reign of God is a central theme of the synoptic Gospels, because it forms the basis for the prophetic preaching of Jesus, His messianic mission, and His death and Resurrection. The old promise thus finds its realization in a fecund tension between the already but still not" (Pontifical Biblical Commission, *Il popolo ebraico e le sue Sacre Scritture nella Bibbia cristiana*, p. 142).

§ 90 Cardinal Congar, for example, affirmed: "All people fall under the Providence of God, but in Israel's case, this is due to her very constitution as a people. In this sense I say that Israel constitutes an essential part of the plan of God. It can be said, for example, that the French people exist as a people independent of the role that God intends it to exercise in His overall plan. **Israel**, however, has no meaning as a people except from the point of view of God's plan, **because it is the chosen people**, and chosen as a people. **It is the people loved by God as a people.**"[68]

§ 91 Cardinal von Balthasar considered Israel the "center of salvation" in the New Testament: "It is not enough to describe Israel as the one who holds the promise of salvation in which all peoples will participate in the messianic era. Beyond this appears **a divine government** over the whole of History which, in the biblical sense, can certainly not be described as 'natural providence' Above all, it **directs and governs the history of the world in function of the final salvation that has its center in Israel, but that concerns the world as a whole.**[69]

§ 92 Fr. Hans Küng defended the same thesis: "Did Israel lose its privileged position as people of God after the death of Jesus? By no means, says Paul. The fidelity of God does not abandon Israel, not even in its infidelity (Rom 3:3). The election of that people of God is permanent, irrevocable, impossible to annul. **The Jews are, and continue to be, the chosen people of God: his preferred people.**"[70]

§ 93 Küng continued: "The mystery of the Jews is the vocation of that people as the people of God among all other peoples **It is worthwhile today to reflect more on the permanent character of the Jewish people as the people of God, precisely so that we can determine in a positive way the Israel-Church relation.**"[71]

§ 94 Dutch theologian Fr. Cornelius Rijk wrote: "In their biblical faith, **the Jews, and with them, the Christians, whose roots lie in the Jewish tradition, cannot fail to believe in the singular role of Israel in the salvation of all human-**

[68] Y. Congar, *Chrétiens en dialogue – Contribuitions catholiques à l'Oecumenisme* (Paris: Cerf, 1964), p. 530.

[69] H. U. von Balthasar, *De l'integration*, p. 172.

[70] H. Küng, *A Igreja*, vol. 1, p. 201.

[71] *Ibid.*, pp.198-9.

ity. Furthermore, as Christians, we believe that the Jew Jesus of Nazareth fulfilled the Alliance of God with His people, thus inaugurating the messianic times, and that God the Father gave Him the incomprehensible plenitude of life."[72]

b.c. Fruits that the Conciliar Church reaps from its acceptance of Judaism

It seems opportune to point out changes that are being made in other fields of the Conciliar Church because of its acceptance of Judaism.

§ 95 Commenting on the use of texts of other religions in the Catholic liturgy, Fr. Rijk named some of the fruits that the acceptance of Judaism produces in the Conciliar Church: **"Examining this Jewish [liturgical] reality, we Christians, preaching the universal redemption already realized in Christ, could accentuate the sense of community This, then, could lead us to rediscover a religious solidarity with other peoples, based on God's action in human history. Praying in common presupposes the common life and a common spirit."[73]**

§ 96 Cardinal de Lubac presented Judaism as a model to eliminate the Church's notion of individual salvation and replace it with the "collective salvation" that the Cardinal so ardently defended. This would be another fruit of Judaism assumed by the Conciliar Church. In his well-known book *Catholicisme,* de Lubac wrote: **"Just as the Jews for so long have placed all their hope not in individual rewards after death, but in the collective destiny of their race and the glory of their terrestrial Jerusalem, likewise all the hopes of the Christian should tend toward the coming of the kingdom and glory of the one Jerusalem Spiritualized and universalized,** according to the words of the prophecies themselves, **Judaism transmits to Christianity its conception of an essentially social salvation."[74]**.

[72] C. Rijk, "As relações judeu-cristãs e o uso dos livros sagrados de outras religiões no culto cristão," *Concilium,* 1976/2, p. 92.

[73] *Ibid.,* p. 96.

[74] H. de Lubac, *Catholicisme – Les aspects sociaux du dogme* (Paris: Cerf, 1974), p. 36.

§ 97 Küng was quite clear in attributing the abolishment of Scholastics to Vatican's II's acceptance of Judaism: "**Today we recognize the importance rabbinism assumes for the New Testament**, which becomes more comprehensible in light of it. As Christians, we also compare Greek-Hellenistic thought to Judaic thinking. Today we have conditions to better evaluate the strong sides of Jewish thinking. **There is much more understanding due not only to a greater historical dynamics, a global perspective, and the opening of the faith to the world and the body,** but also because of a greater hunger and thirst for justice and stronger hope for the coming kingdom of God.

 "I sustain that **all this has helped to do away with the neo-Platonic, neo-Aristotelian, and Scholastic protuberance of the past.** At any rate, **since Vatican Council II,** in the Catholic Church ... **we have discovered the meaning of Judaism for Christianity.**"[75]

§ 98 Another Volume of this Collection will examine in greater detail how Judaism relates to other peoples and religions.[76] With regard to the topic at hand, it seems licit to pose this question here: Is the Conciliar Church following the model of the Jewish Synagogue in its ecumenism?

 The question is opportune, because in addition to the texts already presented, there are innumerable others that point to Judaism as the model for the union of all the religions.

§ 99 Fr. Cornelius Rijk, for example, defended the Jewish model for the union of religions. Rijk did not distinguish between the faithful Israel of the Old Testament and present-day Judaism, which opposes the Holy Catholic Church. His argument, which is objectively false, is a good example of what the progressivist current thinks. Rijk wrote: "The religion of **Israel** is an historical religion, with all the consequences of that fact: It **had, it has, and it will always have fundamental links to other religions.** Indeed, in this lies the existential reason why the choice of Israel has significance for the salvation of the Gentiles in the history of God with humanity. In final analysis, according to biblical faith, **there is a common religious foundation for Israel and the other world religions.**

[75] H. Küng – P. Lapide, *Gesù segno di contraddizione* (Brescia: Queriniana, 1980), p. 13.

[76] Vol. VIII, *Fumus Satanae*, Chap. VII, 1.B.b.ba.

"Two points should become very clear: the singularity of the religion of Israel, and its positive relationship with the religious world around it. With regard to the first, it is necessary to affirm that Israel, even while it shared many religious ideas and concepts with other peoples, was moving in the direction of – or being led toward – an absolutely monotheist faith in the one God [sic] In its experiences with this God, Israel accepted him as redeemer and creator, not only of Israel, but of all humanity **What, then, was the concrete attitude of Israel toward the other religions? One can say that it was a positive attitude that, more implicitly than explicitly, recognized the God of Israel acting equally in other peoples."**[77].

§ 100 The god of present day Judaism is a god immanent in creation, which in many ways is opposed to the true God. The Dutch theologian does not take into account this opposition and presents the god of Judaism as a model to be followed by all religions. Is this also the model of conciliar ecumenism?

Item 1 concludes affirming the theory of interconfessional "communion" calculated to embrace all the religions in a "cosmic eucharist" that would lead to a Pan-religion. The Buddhist and Jewish roads are the models most often referred to by progressivists for achieving this objective.

2. Pan-religion analyzed in function of world unification

§ 101 The revolutionary dream of the unification of mankind in a world independent of God is an age-old dream. Its proponents seem to imagine reestablishing the union lost during the construction of the Tower of Babel, that presumptuous monument of secular pride. And, because it was proud and secular, it was offensive to God: "Come let us make a city and a tower, the top whereof may reach to heaven: and let us make our name famous" (Gen 11:4).

§ 102 Chastising this first secular "universal republic," God dispersed the peoples hitherto united by geographic proximity and the same language: "And the Lord came down to see the city and the tower, which the children of Adam were building.

[77] C. Rijk, "As relações judeu-cristãs," pp. 93-4.

And he said, Behold, it is one people, and all have one tongue: and they have begun to do this, neither will they leave off from their designs, till they accomplish them in deed. Come ye, therefore, let us go down and there confound their tongues, that they may not understand one anothers speech. And so the Lord scattered them from that place into all lands, and they ceased to build the city" (Gen 11:5-8).

§ 103 Here is not the place to enumerate all the attempts throughout History when the evil have tried to restore in a secular way the union of peoples and the language lost at Babel. It serves to mention, however, the important influence of the Enlightenment and the French Revolution, explosions of pride and secularism. In the Modern and Contemporary Ages their adherents have striven to realize that ancient reverie of the children of the world. From then to our days, the secret societies[78] have kept the same torch of hope lighted and are trying, by means of artificial entities – such as the United Nations[79] – to fulfill the dream of the unification of peoples independently of God.

§ 104 Experiencing the bitterness of frequent defeats in face of the indifference of peoples regarding this desired unification, the forces of evil have nonetheless never had an epoch as favorable as the present one, which provides such numerous and efficient means to implement this union. The most efficient of these is the Conciliar Church, which, endorsing and vigorously supporting that ideal, tries to persuade the naïve that the unification of mankind independently of God can take place and is close on the horizon.

§ 105 Alleging this proximity, the progressivists claim that unless the various confessions unite in a universal religion, each one will confront an internal crisis. This would result in a complete stagnation caused by the increasing general indifference of its followers.

*

[78] About the revolutionary goal of installing a universal republic of a secular character, see Part I, Chap.V, footnote 4.

[79] A.S.Guimarães, *The Universal Republic Blessed by the Conciliar Popes*, pp. 9-10.

§ 106 Thus the modernist aspirations denounced at the beginning of the 20th century by Msgr. Henri Delassus seem to have been realized. It is opportune to recall his farsighted observations: "A new religion is planned and being formed. The religion of the future, say some; the religion of the 20th century, say the more impatient [It is] a humanitarian religion because the objective it pursues is to replace God with man. Numerous and active societies have been formed for this end and we find them everywhere. Their members are imbued with these ideas: that an absolutely universal religion should be a social religion, a humanitarian religion, a religion of human progress fulfilling man's quest for an earthly paradise. Such ideas are spread openly and are preparing public opinion to desire the new order of things." [80]

§ 107 A similar warning, which came from a higher place, can be found in the teaching of St. Pius X. The Pontiff asserted: "Even more strange, however, and at the same time alarming and distressing, are the audacity and levity of spirit of men who call themselves Catholics and dream of remaking society in the above-mentioned [inter-confessional] conditions, and of establishing on earth, independent of the Catholic Church, 'the kingdom of justice and love,' with workers coming from all parts, from all religions or even without religion, with or without creeds, provided they are willing to put aside what divides them

"And now, pierced by the greatest sadness, we ask ourselves, Venerable Brethren, where is the Catholicism of the Sillon? Ah! Already it is nothing but yet another deplorable current of the vast movement of apostasy organized in all countries for the establishment of a universal religion. A movement that has neither dogmas, nor hierarchy, nor law for the spirit, nor reign for the passions. And, under the pretext of liberty and human dignity, it would establish in the world, if it could triumph, the legal reign of fraud and violence." [81]

[80] Henri Delassus, *La condemnation du modernisme social dans la censure du "Sillon"* (Lille: Desclée de Brouwer, 1910), p. 56.

[81] St. Pius X, Encyclical *Notre charge apostolique*, nn. 34, 36.

A. The union of religions: an imperative born from the unification of the world

The texts below emphasize the union of religions presented as an imperative of the evolution of the universe and the union of peoples in the temporal sphere.

§ 108

Msgr. Ferdinand Klostermann, conciliar *perito* and adviser for the Pontifical Commission for the Apostolate of the Laity, advocated the union of religions, his departure point being the unification of mankind: "**Today man seems to be inside the flux of the evolution of the whole cosmos and is moving with an increasingly intense dynamism toward an end that is filled with mystery. Humanity,** notwithstanding all the tensions and dissensions, **for the first time feels like a single family, not only in theory, but in daily experience as well. For the first time also, the Church has the necessary conditions to truly be the Church of the world, to actually extricate herself from non-essential bonds with Europe and the West**, with this or that culture, people, or form of civilization **As a consequence, she will free herself from too close relations with the Western powers and their tutelage, creating possibilities for a genuine dialogue with Christians of various confessions and with the great religions, as well as possibilities for that spiritual universalism initiated by the final 'axial period' and crowned by the presence of Christ.**"[82]

§ 109

Auxiliary Bishop of Rome Clemente Riva explained that the Council wanted to approve religious liberty to answer the need for the unification of mankind: "**Catholics and all human beings should realize how much 'religious liberty is necessary, above all in the present situation of the human family.'** On the occasion of that declaration on religious liberty [*Dignitatis humanae*], the conciliar fathers, extending an urgent and paternal invitation to all men, warmly exhorted Catholics to consider the need for religious liberty 'with the greatest attention.' **The conditions presented by the contemporary world for the human family make this awareness absolutely essential.**

[82] Ferdinand Klostermann, "Il laico nella Chiesa," V.A., *I grandi temi del Concilio*, pp. 386-7.

"**Mankind is moving in two directions. The first is one where 'all peoples are becoming more and more united' and 'the distance is narrowing between human beings of different cultures and religions'** A fact that anyone can verify is that the fragmenting among peoples is diminishing. **Ever more numerous blocs of peoples are being constructed and unified.** Also, among such blocs, even amid notable hostilities and difficulties, there are increasing relations of thoughtful consideration, reciprocal understanding, and mutual influence."[83]

§ 110 Msgr. Gerard Philips, who wrote the final text of *Lumen gentium*, also considered unification of the world as an initiative to encourage Christianity to embrace ecumenical union. He wrote: "**The contemporary world is characterized above all by an evolution moving rapidly toward union, be it in the socio-economic terrain, the plane of technical progress, or that of cultural exchanges.** Despite the bitter rivalries that constantly set peoples against one another, humanity as a whole has never felt so much solidarity as today. However, the possibilities for material and spiritual interchange in themselves, even should they multiply *ad infinitum*, will never manage to make hearts beat in unison. **The total and universal unification of mankind will not take place except on a more elevated plane,** that of the saving grace of Christ. Parallel to the constant progress of temporal union, **religious unification becomes ever more necessary and urgent**

"**Even if a temporal order unified worldwide and the establishment of the universal divine kingdom of Christ remain two entirely distinct realities, one would have to be blind to deny the interaction that one exercises over the other. One need only consider the spread of ecumenism in the last years, due to the Council, and one will see the importance of this aspiration of Christian confessions for union,** even from the point of view of the earthly good of humanity and secular history. **The progressive unification of our planet has been an incentive for Christianity: the Council did not want to be left out of this healthful emulation,** without, however, stepping out of the boundaries of her religious sphere. It has its own message, a message of joy and love

[83] Clemente Riva, "Esposizione e commento," V.A., *La libertà religiosa nel Vaticano II*, pp. 257-8.

turned toward everything in the name of Christ, the Savior of all men."[84]

§ 111 The unity of the world would demand categorically religious changes, according to Fr. Bernard Sesboué. He wrote: "The relationship itself between unity and pluralism demands a revision , under the condition, however, that neither of the two terms are lost. **The aspiration to unity is,** moreover, **one of the most profound aspirations of humanity today. It is as necessary for us as the air that we breathe. If the Gospel of Christ were not presented as a firm promise of unity, if it were not placed at the service of unity and humanity, then it would have nothing more to say to the men of our times.**"[85]

§ 112 A famous name in contemporary Dutch theology, Fr. Piet Schoonenberg, SJ, Professor of Dogma at the University of Nijmegen, co-author of the *Dutch Catechism*, presented the dream of unity of mankind as a type of heavenly image: "Communion with God will be the 'all in all' (1 Cor 15:28). Implicit in this is a sense of community. **On earth we already know that humanity orients itself toward forming a world community, whose reflection gives us an image of final plenitude**. It is, however, impossible for us to conceive of it by ourselves, since that community will be characterized by the absolute absence of hatred. Even more, it will satisfy man in a way beyond the reach of our philosophy ."[86]

§ 11 It is appropriate to include the Jesuit Teilhard de Chardin on the topic of union of religions in function of the union of mankind and the evolution of the universe. With his characteristic language, at times incomplete and imprecise, mixing together scientific and spiritual terms, he affirmed: "**The consciousness [has awakened in man] of being linked to a world whose two halves (physical and mystical) are slowly being united, with the characteristic force of the world upon humanity, a force born from the coming together of the two halves.** Consequently, **the consciousness [has awakened] of having access to a hyper-milieu [elevated ambience] of life engendered by the encounter between a Christ**

[84] G. Philips, *La Chiesa e il suo mistero*, p. 73.

[85] Bernard Sesboué, *O Evangelho na Igreja*, p. 159.

[86] Piet Schoonenberg, "Creio na vida eterna," *Concilium*, 1969/1, p. 95.

who emerges [from creation] and a universe that converges [toward a single point]...

"With this we reach the very nucleus of the experience to which these pages seek to give testimony More than anyone else, **I know**, for having experienced it, **that which this** 'evolutionary sense' (or 'human sense') **simultaneously has of the involving, fortifying, and exultant. And I am absolutely convinced that it is only departing from and based on this new psychic element that the great spiritual edifices of tomorrow may be constructed (and, in fact, they will be constructed)**

"**Left to itself, I doubt that the consciousness** **of participating in the planetary flux of co-reflection would be capable of founding the type of religion** so ardently and so brilliantly **announced** by my friend J. Huxley **under the name of Evolutionary Humanism** **What would happen if, by a simultaneous adhesion to contemporary Neo-Christianity and Neo-Humanism, our minds should awaken, first to the suspicion, and afterward to the evidence that the Christ of Revelation is none other than the Omega of evolution?**"[87]

§ 114 Teilhard continued his description of the new progressivist religion: "Even though we still do not pay much attention to this, **question number one, which begins to be placed before humanity along its way to planetary organization, is a problem of spiritual** *activation* **What, except a religion, could represent this faith so hopeful of some coming consummation, in the most true and psychological sense of the term? A religion of evolution: This finally is what becomes more and more necessary for man to survive – and to super-live – from the moment he becomes conscious of his power and duty to transcend his self-humanization.**"[88]

Thus one can see how a Pan-religion, the goal of conciliar ecumenism, is presented as an imperative of unity that coincides with the secular unification of mankind in the temporal sphere, and the evolution of the universe.

[87] Teilhard de Chardin, "Le Christique," in *Le coeur de la matière*, pp. 105-6.

[88] *Ibid.*, pp. 111-2.

B. New man, new humanity, and the Pan-religion

§ 115 One of the central points of the progressivist utopia is the theory of the "new man:"[89] the long-awaited change of human nature that would take place in the final phase of evolution, supposedly close at hand. Here it seems opportune to describe some aspects of the theme in relation to the final goal of the union of mankind and establishment of a Pan-religion.

§ 116 The premise of the evolutionist doctrine of the "new man" is that man would not have a nature composed of two different elements, body and soul. The spiritual soul would not be a reality created by God and infused into each individual after his conception. Rather, it would be a natural emanation from the animal body, something similar to the vapor that rises from boiling water, and would represent a more advanced state of corporal matter.

Thus, Adam would not have been created, as Catholic doctrine teaches, from the "slime of the earth" with his soul infused by the "breath" of God (Gen 2:7). Rather, he would have emerged from some brusque change of state where a primate, by a qualitative leap in the evolutionary process, would have been transformed into man. His soul would have been born from the riches latent in the prior evolutionary stage.

§ 117 Analogously, as described above, the coming of Christ and His Resurrection would have constituted another great qualitative leap. In this new stage of evolution, vital latencies would have been activated, permitting man to rise to the stage of the divine-man. Christ would have been the precursor of this phase, realizing it entirely. In other men, however, this actualization is still *in germen*.

§ 118 That is, they hope that in the next stage – soon at hand – humanity will evolve decisively and, like Christ, enter the stage of perfection that He attained in His Resurrection. This man, thus become immortal and glorious, would be the "new man." And the "new humanity" born from this would be a utopian paradise that would "coincide" with what the Church teaches on paradise as the life of the blessed in heaven. According to the progressivists, heaven would only be a metaphor that refers to this final stage of the divinization of man on earth.

[89] Vol. VIII, Chap. IV; Vol. IX, Chap I.2.

It is clear that this progressivist doctrine, by "baptizing" religious immanentism and pseudo-scientific evolutionism with the name Catholic, is trying to fool the naïve. In fact, they are presenting the opposite of Church doctrine as if it were her real and original thinking.

§ 119 How would humanity reach this stage? When man would become conscious of the new stage in the redemptive evolution, this very consciousness would give birth to a general unification of mankind. Some imagine that this stage will only be reached after a catastrophe, an Apocalypse. Von Balthasar follows this school. Others, like Teilhard de Chardin, hope to attain it in the general euphoria of the unification of mankind. In further volumes this Collection will differentiate these various schools in more detail.[90]

By way of example, the citations below sketch a picture of the progressivist utopia that presupposes a Pan-religion in order to reach its final phase.

§ 120 Jean-Marie Domenach, director of the magazine *L'Esprit* and a founder of the review *Témoignage Chrétien*, expressed his hope that humanity would soon take the new qualitative leap: "The values launched by the democratic revolution of the 18th century have reached the whole world Thus, **humanity becomes conscious of itself as a totality in expansion. One can imagine, with Teilhard de Chardin, that the human species, united throughout the face of the earth, will finalize itself in some way, and that this phenomenon of *implosion* will give rise to passage to the new stage. Through its intellectual recourses, humanity is creating the conditions for its super-life. Moving away from natural determinism, it closes itself on its own thinking. And in this intellectualized milieu, in this 'noosphere,'[91] the passage from a phase of an unconscious biological evolution to a phase of spiritual evolution where humanity aspires to itself as a whole will take place.**"

[90] Vol. VII, *Destructio Dei*, Chap. III; Vol. VIII, *Fumus Satanae*, *passim*; Vol. IX, *Creatio*, Chap. IV; Vol. X, *Peccatum - Redemptio*, Chap. V.

[91] Noosphere (the sphere of the thoughts) is the term used by Teilhard de Chardin to express a hypothetical zone where all the thoughts of men would converge to exert influence on one another.

§ *121* Teilhard de Chardin presupposed the unification of mankind to reach the stage of the "super-human": "**The exit doors for the world, the doors of the future, the entry doors to the super-human, will not be opened just for some privileged few, nor for only one people chosen from among all the peoples! They will not open except by a push from** *everyone together*, **in a direction where all can gather together and complete themselves in a spiritual renewal of the earth.**"[92]

§ *122* Fr. Juan Ruiz de la Peña, professor of Systematic Theology at the Pontifical University of Salamanca, reduced heaven to nothing more than a "projection" of an anthropological desire for a new creation: "**Eternal life**, communion in the being of God, **will** also **be** *communio sanctorum* [the communion of saints]: the realization of a solidarity without limits of time or space, **the verification of the dream of a universal fraternity** On the other hand, humanity will finally see [in its final phase] the establishment of its dominion over the world. **The new creation [i.e., heaven] is the place conatural to this humanity, open to a creative power. Then, to work will be to rest, and to rest will be to work, so that action, always gratifying, will impress on the cosmos the form of the human spirit.**"[93].

§ *123* De la Peña concluded his study supporting the thesis of Feuerbach, the philosopher who inspired the thinking of Marx: "**The Feuerbachian thesis of heaven as the object of man's yearning for his own divinization** **is a valid thesis.**"[94]

These are but a few documents that present the outlines for the "new man" and the "new humanity" desired by Progressivism.

*

[92] Teilhard de Chardin, *O fenômeno humano* (Porto: Livraria Tavares Martins, 1970), p. 266.

[93] Juan Luiz Ruiz de la Peña, "O elemento projeção e a fé no céu," *Concilium*, 1979/3, p. 81.

[94] *Ibid.*

This Chapter presented the goal toward which ecumenism is heading, and showed that this aim coincides with a Pan-religion. To achieve this end, the roads being offered are Buddhism and Judaism. And the means to achieve the end would be an experimental, practical, and inter-confessional "communion" among the adepts of all the religions.

*

Part II has also reached its end. Supported by documents of theologians of indisputable prestige and importance, it showed how conciliar ecumenism – based on the Decree *Unitatis redintegratio*, the Constitution *Lumen gentium* and the Declaration *Nostra aetate* – profoundly clashes with the prior doctrine of the Holy Church regarding the unity of the Catholic Faith and unicity of the Mystical Body of Christ. It also demonstrated how ecumenism denies, in its essence, the militant and missionary characters of the Church, as well as promotes the utopia of a Pan-religion.

* * *

CONCLUSION

§ 1 Secularization and ecumenism ... with these two words the future will summarize the two principal initiatives of Vatican II. The tolerance that they establish toward error and evil will be named the principal trait of the spirit of the Council.

§ 2 In effect, these two initiatives set the tone conferred by the Council to the work of demolition of the previous position and doctrine of the Holy Roman Catholic and Apostolic Church. Considering the internal strategy of the progressivist attack, these initiatives could be called the two banners under which the armies that besiege the Holy City gather.

§ 3 Under the banner of secularization, the love of God is relegated to the shadows, and man is exalted. The sacral character of the Church is attacked. The intention of "razing the bastions" of the Catholic Church is proclaimed. "Putrifying with" the vices of the world and the auto-demolition of the Church's very structure are pointed to as ideals.

§ 4 Under the sign of secularization, these demands appear: a change in the Faith, the abandonment of Morals, and the inversion of the principles by which the Church always governed her relation with the temporal order. This new position, in its *first stage*, denies to the Catholic State the right of existence, and favors the Modern State, fruit of the Enlightenment and the French Revolution. In its *second stage*, it combats the Modern State, and favors a Socialist State. And finally, it aims to replace the latter – without denying its principles – with the establishment of a neo-socialist theocracy of a self-managing and tribal nature.

§ 5 Under the banner of ecumenism, the unicity of the Catholic Faith and the perennial nature of dogma are denied. The holiness and divinity of the Spouse of Christ are denied. The unicity of the mission of the Church as exclusive heir, vigilant guardian, and permanent witness to the treasures of Revelation left to man by the Word Incarnate is denied.

§ 6 Still in the name of ecumenism, the militant character of Holy Church, as well as her right to missionary expansion, are denied.

§ 7 Finally, in the Pantheon of ecumenism, the gods of the false creeds could all be adored alongside the true God, thus forming a Pan-religion that would supposedly fulfill the prophecy of Christ that one day there would be, under the aegis of the Catholic Faith, "one flock and one shepherd" (Jo 10:16).

§ 8 Therefore, in this Volume that seeks to analyze the spirit of the Council, it is impossible to avoid the conclusion that a deliberate *animus delendi* – desire to destroy – results from the initiatives of secularization and ecumenism.

§ 9 Considering what has been presented in this Volume, one sees that it is the intent of the Conciliar Church to tear down the bastions of the Holy City, reducing it to ruins – "*redegerunt Jerusalem in ruinas* (Ps 78:1). And in its place, they would like to build, independently of the true God, a new Tower of Babel at the service of man and the false religions.

*

§ 10 With this Volume the Collection concludes its exposition of the spirit of the Council.

Volume I, *In the Murky Waters of Vatican II*, showed how it was impossible to make a precise judgment on the letter of the conciliar documents, due to their deliberate and conscious ambiguity.

§ 11 To decipher this ambiguity, it would be necessary to know the spirit of the Council. Such an analysis was made in the next four next Volumes. Two Volumes were dedicated to the analysis of the *animus injuriandi* [desire to injure] of Progressivism against the Church, the Faith, and Catholic Morals. Volume II, *Animus injuriandi I*, showed the offenses made by the conciliar progressivists against the institution of the Church. Volume III, *Animus injuriandi II*, exposed the offenses against Catholic Doctrine.

§ 12 The two subsequent Volumes described the *animus delendi* [desire to destroy], the intent of prominent conciliar personages with regard to the institution of the Church and her doctrine. Volume IV, *Animus delendi I*, exposed the overall plan of the destruction of the institution of Holy Church, and its execution. In this work, Volume V, *Animus delendi II*, the two principal conciliar initiatives were analyzed – secularization

and ecumenism – whose aim is to destroy the Catholic Church and many points of her sacrosanct doctrine.

§ 13 Thus, after examining the *animus* of the conciliar theologians, as well as countless actions of the contemporary Popes, and after seeing that this *animus* counts upon the sympathy, or, at the least, the acceptance of the Conciliar Church, the necessary elements were found to adequately affirm what is this much-trumpeted spirit of the Council.

§ 14 The spirit of the Council, as adopted by this Collection, is defined as:

- **the spirit of tolerance toward evil and error;**

- **the spirit of hostility against the unity of the Faith and the unicity of the Catholic Church;**

- **the spirit of hatred for the militant, and missionary characteristics of the Church;**

- **the spirit of hatred for the sacred and hierarchical characteristics of the Catholic Church.**

§ 15 **It is a spirit of ferocious hatred and systematic destruction that the Holy Church has never witnessed throughout her History until our days. It was this spirit, however, that was presented at the beginning of the Council as a superabundant effusion of goodness and mercy...**

§ 16 The letter of the documents of Vatican II should be studied in light of this spirit.

§ 17 Under the protection of the *Madonna del Miracolo*, to whom this Work is dedicated, I hope in the next Volumes to analyze the fruits and thinking of the Council. With this I believe that a sufficient analysis of Vatican II in its principal aspects will have been made.

* * *

BIBLIOGRAPHY

ABLONDI, ALBERTO, "Meditando il Magnificat...," V.A. *L'annuncio del regno ai poveri*; "Messagio di apertura," V.A. *L'annuncio del regno ai poveri*. ACERBI, ANTONIO, *Due Ecclesiologie – Ecclesiologia giuridica ed ecclesiologia di communione nella 'Lumen gentium,'* Bologna: Dehoniane, 1975. ALBERIGO, GUISEPPE, "O Papado no Concílio Ecumêmico," *Concilium*, 1983/3. ALEXANDER VIII, Constitution *Inter multiplices* of August 4, 1690, DR 1322. ALLENDE, SALVADOR, Interview in *The New York Times, apud* Plinio Corrêa de Oliveira, "Religião a serviço da irreligião"; Statement on the Catholic Church assuming the principles of Socialism, *Ultima Hora*, November 12, 1970. ALMEIDA, FERNANDO FURQUIM DE, see Furquim de Almeida. ALMEIDA, LUCIANO MENDES DE, see Mendes de Almeida. ALVARENGA, CUNHA, "Eles não sabem o que fazem – Maquinações que expõem a riscos e angústias a causa católica," *Catolicismo*, December 1955. AMERIO, ROMANO, *Iota unum*, Milan-Naples: R. Ricardi, 1985. ANDREOTTI, GIULIO, interview by Gianni Valente, "A arte de mediar," *30 Dias*, July-August 1993.

AQUINAS, THOMAS (ST.), see Thomas Aquinas. ARNS, PAULO EVARISTO, Letter to Fidel Castro on the 30th anniversary of the Cuban Revolution, *O Estado de São Paulo*, January 19, 1989; Statement supporting Leonardo Boff against the Holy See, see Brazilian Episcopate; Statement on Nicaragua's Communist Revolution as his desire for Brazil, *O São Paulo*, March 7-13, 1980. ARRUDA, ROLDÃO, see J. B. Libânio. ATHANASIUS (ST.), *Symbol* of, *apud* Gregory XVI, Encyclical *Mirari vos*. AUBERT, A., *Le problème de l'acte de foi*, Louvain, 1950, *apud* L. Maldonado, *La nueva secularidad*. AUGUSTINE (ST.), *De haeresibus, apud* Leo XIII, *Satis cognitum*; *De symb. serm. ad catech*, PL 40, *apud* E. Dublanchy, entry "Église," *Dictionnaire de Théologie Catholique* (DTC); *Ennarr. in Ps. 103:17*, PL 37, *apud* E. Dublanchy, DTC; *Epistula 105, apud* Pius IX, Encyclical *Quanta cura*; *Sermo 94*, PL 38, 1346, *apud* E. Dublanchy, DTC; *Sermo 267, apud* Leo XIII, *Satis cognitum*; *De Civitate Dei*, Paris, 1854.

BALME, FRANCISCUS – CESLAUS PABAN, *Raymundiana seu documenta quae pertinent ad S. Raimundi de Pennaforti - Monumenta Ordinis Fratum Praedicatorum Historica,* vol. 6, *apud* J.M. Garganta, "Introducción general," to St. Thomas Aquinas, *Summa contra gentiles,* Madrid: BAC, 1953. **BALTHASAR, HANS URS VON,** *Abbatere i bastioni,* Turin: Borla, 1966; *De l'intégration,* Bruges: Desclée de Brouwer, 1970; "Dieu a parlé un language d'homme," V.A. *Parole de Dieu et liturgie;* "Escathologie," V.A. *Questions théologiques aujourd'hui; El problema de Dios en el hombre actual,* Madrid: Guadarrama, 1960; *Liturgie cosmique – Maxime le Confesseur,* Paris: Aubier-Montaigne, 1947; *Solo l'amore è credibile,* Turin: Borla, 1965; *Théologie de l'Histoire,* Paris: Plon, 1960. **BARBIER, EMMANUEL,** *Les infiltrations maçonniques dans l'Église,* Lille: Desclée de Brouwer, 1910. **BAUMHAUER, OTTO,** "Los cristianos en el mundo de hoy - II," V.A., *La reforma que llega de Roma.* **BAZOT,** *Tableau philosophique, historique et moral de la frac-maçonnerie, apud* H. Delassus, *La conjuration antichrétienne,* vol. 2.

BELLARMINE, ROBERT, see Robert Bellarmine. **BENEDICTXV – ST. PIUS X,** *Code of Canon Law* of 1917, Typis Polyglottis Vaticanis, 1918. **BETTO, FREI,** *Fidel e a Religião,* São Paulo: Brasiliense, 1985. **BOFF, LEONARDO,** Statement about the Communist States resolving the problem of poverty, *Folha de São Paulo,* July, 14, 1987; Statement about Communism achieving the Catholic goals for society, *Folha de São Paulo,* July 15, 1987. **BONIFACE VIII,** Bull *Unam sanctam,* of November 18, 1302, in Giorgio Balladore Pallieri – Giulio Vismara, *Acta Pontificia Juris Gentium,* Milan: Società Editrice Vita e Pensiero, 1946. **BORGIA, PIER FRANCESCO,** "Nomadelfia: la città dove non esistono ricchi e poveri, orfani e privilegiati," *L'Osservatore Romano,* October 24, 1991. **BOTTURI, F.,** "Oggettivismo e crisi della responsabilità," V.A., *Peccato e riconciliazione; alla ricerca della grandezza.* **BOZZO, BAGET,** "A longa viagem da baleia branca," Interview by Andrea Tornielli, *30 Dias,* July-August 1993. **BRAGA, MARIO,** "Papa diz a Sarney que reforma agrária não pode fracassar," *Jornal do Brasil,* July 11, 1986. **BRAZILIAN EPISCOPATE,** Letter of 20 Bishops to Cardinal Ratzinger supporting Bishop Casaldáliga, September 27, 1988, *Il Regno,* Bologna, November 15, 1988; Report of Cardinals Aloisio Lorscheider's and Paulo Evaristo Arns' trip to Rome to defend Leonardo Boff

against the censures of the Congregation for the Doctrine of Faith, *Folha de São Paulo*, May 10, 11, 13, 14, 20, 1985; *Jornal do Brasil*, May 13, 1985; *O Estado de São Paulo*, May 10, 1985. **BROGLIO, FRANCESCO MARGIOTTA**, "Il rebelli di Colonia," *Corriere della Sera*, January 28, 1989, *apud Adista*, February 9-11, 1989. **BRUNELLI, LUCIO**, "O inimigo é a Religião," *30 Dias*, January 1992. **BUONAUTI, ERNESTO**, *Le modernisme catholique*, Paris: Ed. Rieder, 1927. **BUTTIGLIONE, ROCCO**, "Cultura e Filosofia," *Antropologia e praxis no pensamento de João Paulo II*, Rio de Janeiro: Lumen Christi, 1985; *Il pensiero di Karol Wojtyla*, Milan: Jaca Book, 1982.

CÂMARA, HELDER, Letter to Roger Garaudy, *apud* Philippe de la Trinité, *Dialogue avec le marxisme*. **CAMPO, CARLOS PATRICIO DEL**, *Is Brazil Sliding Toward the Extreme Left? – Notes on the Land Reform Program in South America's Largest and Most Populous Country*, Foreword by P. Corrêa de Oliveira, New York: American Society for the Defense of Tradition, Family and Property, 1986. **CARDENAL, ERNESTO**, Interview by *Crisis* magazine (Buenos Aires), in *Movimento*, São Paulo, August 6-12, 1979. **CASALDÁLIGA, PEDRO**, *Yo creo en la justicia y la esperanza*, Bilbao: Desclée de Brouwer, 1976; Refusal to sign documents sent by the Holy See, *30 Dias*, Port. Ed., November 1988. **CASTRO MAYER, ANTONIO**, see P. Corrêa de Oliveira, *Reforma Agrária – Questão de consciência*; **CATECHISM OF THE COUNCIL OF TRENT**, see Council of Trent, Catechism. **CELAM – CONSELHO EPISCOPAL LATINO AMERICANO** [Latin American Bishops Council], *Medellin, 1968 – A Igreja na atual transformação da América Latina à luz do Concílio*, Petrópolis: Vozes, 1980; *Puebla, 1979 – La evangelización en el presente y en el futuro de America Latina*, Madrid: BAC, 1982.

CERETI, GIOVANNI, "Regno e conciliarità ecumenica," V.A., *Il regno di Dio che viene*. **CHARDIN, PIERRE TEILHARD DE**, see Teilhard de Chardin. **CHENU, MARIE-DOMINIQUE**, "O comunismo é uma idéia crsitã elouquecida?," V.A., *Os maiores teólogos respondem*; "Omelia tenuta nel corso della celebrazione eucaristica [of *Concilium* magazine's congress, Brussels, 1975]," V.A., *L'avvenire della Chiesa*; *Jacques Duchesne interroge le Père Chenu – Un théologien en liberté*, Paris: Centurion, 1975. **CIERVA, RICARDO DE LA**, *Oscura rebelión en la*

Iglesia, Barcelona: Plaza-Janes, 1987. **CIMI – CONSELHO INDIGENISTA MISSIONÁRIO** [Missionary Council for the Indigenous Peoples], Bulletin n. 22, July-August 1975; Bulletin n. 25, January-February 1976, *apud* P. Corrêa de Oliveira, *Tribalismo indígena: Ideal comuno-missionário para o Brasil no século XXI.* **CIVILTÀ CATTOLICA, LA,** Editoriale: "Dalla società perfetta alla Chiesa mistero," January 19, 1985. **CHILEAN TFP**, see Sociedad Chilena de la Defensa de la Tradición, Família y Propiedad. **COMBLIN, JOSEPH,** "La théologie catholique depuis le pontificat de Pie XII," V.A., *Bilan de la théologie du XXe siècle; Théologie de la Révolution*, Paris: Ed. Universitaires, 1970. **COMMUNIST PARTY OF CHILE**, Statement, *El Siglo*, January 27, 1970, *apud* Sociedad Chilena de Defensa de la Tradición, Familia y Propiedad, *La Iglesia del silencio in Chile*, Santiago: TFP, 1976. **CONCETTI, GINO,** "Soteriologia cristiana e culture odierne al Congresso Internazionale di Teologia," *L'Osservatore Romano*, February 9, 1984. **CONFERENCE OF LATIN AMERICAN MISSIONARIES (1990),** Final doument, *apud* V. Fedele.

CONGAR, YVES, *Chrétiens en dialogue – Contributions catholiques à l'Oecumenisme*, Paris: Cerf, 1964; *Église Catholique et France moderne*, Paris: Hachette, 1978; *Jean Puyo interroge le Père Congar*, Paris: Cerf, 1975; *La crisi nella Chiesa e Mons. Lefebvre*, Brescia: Querianiana, 1975; "L' ecclésiologie de la Révolution Française au Concile du Vatican sous le signe de l'affirmation de l'autorité," V.A., *L'ecclésiologie au XIXe siècle; Le Concile au jour le jour – Deuxième session*, Paris: Cerf, 1964; *Le Concile de Vatican II – Son Église, peuple de Dieu et corps du Christ*, Paris: Beauchesne, 1984; *L'Église Catholique et France moderne*, Paris: Hachette, 1978; "Le rôle de l'Église dans le monde de ce temps," V.A. *L'Église dans le monde de ce temps*; "Os grupos informais na Igreja," V.A., *Comunidades eclesiais de base – Utopia ou realidade?*; "Paul VI und der Ökumenismus," *L'Osservatore Romano*, September 23, 1977; *Pour une Église servante et pauvre*, Paris: Cerf 1963; "Salvación y liberación," V.A., *Teologia de la liberación – Conversaciones de Toledo*; "Theology's Tasks after Vatican II," V.A., *Theology of Renewal*; *Un peuple messianique*, Paris: Cerf, 1975. **CONGAR, YVES – GIULIO GIRARDI,** "1960-1970: Dez anos decisivos para a Igreja e o mundo," V.A., *Credo para amanhã.* **CONGREGATION OF BISHOPS**, *Monitum, apud 30 Giorni,* Portuguese ed., November 1988.

CONGREGATION FOR THE DOCTRINE OF THE FAITH, *Instrução sobre alguns aspectos da "Teologia da Libertação*, August 6, 1984, São Paulo: Paulinas, 1987; *Instrução sobre a liberdade cristã e a libertação*, March 22, 1986, São Paulo: Paulinas, 1986.

CORRÊA DE OLIVEIRA, PLINIO, *A Igreja ante a escalada da ameaça comunista – Apelo aos Bispos silenciosos*, São Paulo: Vera Cruz. 1976; "A I.O. no water shoot," *Folha de São Paulo*, October 3 1971; "Autodestruição, instrumento de lavagem cerebral," *Folha de São Paulo*, September 26, 1971; *Baldeação ideológica inadvertida e diálogo*, São Paulo: Vera Cruz, 1974; "Cruzada do século XX," *Catolicismo*, January 1951; "Entre lobos e ovelhas: novo estilo de relações," *Folha de São Paulo*, November 1, 1970; "Na 'noite sandinista': O incitamento à guerrilha," *Catolicismo*, July-August 1980; "Na I.O.," *Folha de São Paulo*, September 19, 1971; *No Brasil a reforma agrária leva a miséria ao campo e à cidade – A TFP informa, analisa, alerta*, São Paulo: Vera Cruz, 1986; "O show," *Folha de São Paulo*, January 13, 1977; "O show feito de três shows," *Folha de São Paulo*, January 29, 1977; "O fim dos três shows," *Folha de São Paulo*, February 7, 1977; "O lobo uiva em defesa do Pastor," *Folha de São Paulo*, March 22, 1970; "Sobre Pimen," *Folha de São Paulo*, September 12, 1971; "Religão a serviço da irreligão," Folha de São Paulo, July 11, 1971; "Toda a verdade sobre as eleições no Chile," *Folha de São Paulo*, September 10, 1970; *Revolution and Counter-Revolution*, New Rochelle,New York: Foundation for a Christian Civilization, 1980; *Tribalismo indígena: Ideal comuno-missionário para o Brasil no século XXI*, São Paulo: Vera Cruz, 1977; "What does self-managing Socialism mean for Communism: A Barrier? Or a Bridge-head?, *The New York Times*, December 13, 1983. PLINIO CORRÊA DE OLIVEIRA – GERALDO PROENÇA SIGAUD – ANTONIO DE CASTRO MAYER – LUÍS MENDONÇA DE FREITAS, *Reforma agrária – Questão de consciência*, São Paulo: Vera Cruz, 1960.

COUNCIL OF CHALCEDON, Declaration on no salvation outside the Catholic Church, *apud* Pius IX, Encyclical *Quanto conficiamur*. COUNCIL OF FLORENCE, Bull *Cantate Domino*, February 4, 1442, DS 1351. COUNCIL OF LATERAN IV - FOURTH LATERAN COUNCIL, DS 802. COUNCIL OF TRENT, Session 3, DR 793-4. COUNCIL OF TOLEDO 16TH, *Symbolum*, DS 575.

COUNCIL OF TRENT, *Cathechism*, trans. by J. McHugh and C. Callan, New York: Joseph Wagner, 1962; **COUNCIL OF VATICAN I**, see Vatican Council I. **COUNCIL OF VATICAN II**, see Vatican Council II. **CYPRIAN OF CARTHAGE (ST.)**, *De Catholicae Eccllesiae unitate, apud* Leo XIII, Encyclical *Satis cognitum*.

DAIM, WILFRIED, *Le Vatican et les pays de l'Est*, Paris: Fayard, 1971. **DANIELOU, JEAN**, Untitled. V.A., *Cinco problemas que desafiam a Igreja hoje*. **DANNEELS, GODFRIED**, "O inimigo é a Religião," Interview by Lucio Brunelli, *30 Dias*, January 1992. **DELASSUS, HENRI**, *La condemnation du modernisme social dans la censure du Sillon*, Lille: Desclée de Brouwer, 1910; *La conjuraion antichrétienne – Le Temple maçonnique voulant s'élever sur les ruines de l'Église Catholique*, Lille: Desclée de Brouwer, 1910. **DELHAYE, PHILLIPE**, see A. Sinke Guimarães. **D'ERCOLE, GIOVANNI**, Statement that the Holy See did not punish Bishop Pedro Casaldáliga, *Vida Nueva* (Madrid) October 1, 1988. **DHAVAMONY, MARIAUSUSAI**, see C. Geffré. **DÖPFNER, JULIUS**, *La Chiesa vivente oggi*, Bari: Paoline, 1972. **DOMENACH, JEAN MARIE**, "Le visage du monde contemporain," V.A., *Bilan de la théologie au XXe siècle*. **D'SOUZA, HENRY**, Statement against Capitalism, *L'Osservatore Romano*, October 7, 1983, Supplement. **DUBARLE, DOMINIQUE**, "Espiritualidade budista e o sentido cristão de Deus," *Concilium*, 1978/6. **DULLES, AVERY**, "Ecumenismo: problemi e possibilità per il futuro," V.A., *Verso la Chiesa del terzo millennio*.

EGAN, HARVEY, *What are they saying about mysticism?* New York-Ramsey: Paulist Press, 1982. **ENCARTA ENCLYCLOPEDIA ONLINE 2001**. **ENGELS, FRIEDRICH**, "Feurbach und der Ausgang der Klassischen Deutschen Philosophie," in *Marx-Engels Werke*, Berlin, 1962, vol. 21, *apud* Hans Küng, *Vida eterna?* **EYT, PIERRE**, "Igreja e mutações sócio-culturais," V.A., *A Igreja do futuro*.

FALCETA, WALTER, "Homilia faz defesa da reforma agrária," *O Estado de São Paulo*, October 15, 1991; **FAORO, ATILIO GUILHERME**, *Reforma agrária: terra prometida, favela rural ou kolkhozes? – Mistério que aTFP desvenda*, São Paulo: Vera Cruz, 1987. **FEDELE, VERONA**, *La sfida di Salvador – Il*

camino della Chiesa in America Latina, Il Regno, December 30, 1990. **FERNANDES, ANGELO**, Statement against Capitalism, *L'Osservatore Romano*, October 3-3, 1983, Supplement. **FEURBACH, LUDWIG**, *Das Wesen der Christentums*, Berlin: W. Schuffenbauer, 1956, *apud* H. Küng, *Vida eterna?*. **FLANNERY, AUSTIN**, *Vatican Council II - The Conciliar and Post-Conciliar Documents*, Collegeville, MN: Liturgical Press, 1975. **FLORIDI, ULISSE**, *Moscou et le Vatican*, Paris: France-Empire, 1979. **FONTAINE**, Speech in the Socialist Students' Congress, Liège, 1865, *apud* H. Delassus, *La conjuration anti-chrètienne*. **FURNO, CARLO**, Letter to Bishop Pedro Casaldáliga, *O Estado de São Paulo*, September 25, 1988. **FURQUIM DE ALMEIDA, FERNANDO**, Series of articles on the ultramontane Catholics of the 19th century - "Os católicos ultramontanos no século XIX," *Catolicismo*, February 1951 to August 1955.

GALLI, MARIO VON, "Diálogo con los protestatntes," V.A., *La reforma que llega de Roma*. "Misión si colonialismo," V.A., *La reforma que llega de Roma*. **GANTIN, BERNARDIN**, "John Paul II: artisan of communion and unity without borders," *L'Osservatore Romano*, October 16, 1988. **GARAUDY, ROGER**, *Do anátema ao diálogo*, Rio de Janeiro: Paz e Terra, 1969; *Parole d'homme*, Paris: Laffont, 1975; Statement on his relationship with Archbishop Helder Câmara, *apud* Philippe de la Trinité, *Dialogue avec le Marxisme?* **GARGANTA, JOSÉ M. DE**, "Introdución general," St. Thomas Aquinas, *Summa contra gentiles*. **GEFFRÉ, CLAUDE – MARIAUSUSAI DHAVAMONY**, Editorial, *Concilium*, 1978/6. **GEUSAU, LEO ALTING VON**, "La Chiesa, 'scandalo' del mondo," V.A., *La fine della Chiesa como società perfetta*. **GIRARDI, GIULIO**, see Y. Congar - G. Girardi. **GOYAU, GEORGES**, *L'idée de patrie et l' humanitarisme*, *apud* N. Webster, *Secret Societies and Subversive Movements*. **GREGORY XVI**, Encyclical *Mirari vos*, of August 15, 1832, in *Recueil des allocutions consistoriales, encycliques et autres lettres apostoliques citées dans l'Encyclique Quanta cura et le Syllabus*, Paris: Adrien le Clerc, 1865; see also DS 2730-1. **GROSSI, VITTORINO**, "La Chiesa preconstantiniana di fronte alla povertà," V.A., *L'annuncio del regno ai poveri*.

GUARDINI, ROMANO, *Der Herr*, Würgburg, 1961, *apud* H. Waldenfels. **GUIMARÃES, ATILA SINKE**, *Animus delendi I*, Los Angeles: TIA, 2000; *In the Murky Waters of Vatican II*,

Metairie, Louisiana: MAETA, 1977; Interview with Carlo Cafarra, Rome, February 4, 1983; Interview with Hans Küng, Tübingen, February 14, 1983; Interviews with Philippe Delhaye, Louvain-la-Neuve, February 28 – March 1, 1983; *Quo vadis, Petre?* Los Angeles: TIA, 1999; "O pacto de Metz," *Catolicismo*, March 1991; Series of six articles on the "Miserablist Church" and on the book *Casta Meretrix* by von Balthasar, *Catholic Family News,* January to June 2000; *The Biblical Commission on the Jews: Changes in Doctrine and New Anathemas*, Los Angeles: TIA, 2002; *The Universal Republic Bleesed by the Conciliar Popes,* Los Angeles: TIA, 2002. Guimarães, **ATILA S.** – **MARIAN T. HORVAT,** *Previews of the New Papacy*, Los Angeles: TIA, 2001. **GUITTON, JEAN,** "Guitton, lettere per l'aldilà," Interview by Ulderico Munzi, *Corriere della Sera*, February 9, 1995.

HENRIQUEZ, RAÚL SILVA, see Silva Henriquez. **HILARY OF POITIERS (ST.),** *Comment. in Matth. XIII, apud* Leo XIII, *Satis cognitum.* **HOLLAND, JOSEPH,** "Linking Social Analysis and Theological Reflection: The Place of Root Metaphors in Social and Religious Experiences," *apud* J. Hug, *Tracing the Spirit.* **HOLY OFFICE,** Letter to the Archbishop of Boston, July 8, 1949, DS 3866-72. **HORVAT, MARIAN THERESE,** see A. Guimarães – M. Horvat, *Previews of the New Papacy.* **HUG, JAMES,** *Tracing the Spirit*, New York: Paulist Press, 1983. **HUGO, VICTOR,** *Pendant l'exil – Actes et Paroles,* Paris: Jules Roulff, n.d., 2 vol.

IGLESIA DE SANTIAGO, CHILE, Archdiocesan News Bulletin, July 1969, *apud* Sociedad Chilena de Defensa de la Tradición, Familia y Propiedade, *La Iglesia del silencio en Chile.* **INFORMATIONS CATHOLIQUES INTERNATIONALES**, Paris, August 1972.

JOHN XXIII, Encyclical *Mater et Magistra*, of May 15, 1961, Petrópolis: Vozes, 1961; Encyclical *Pacem in terris,* of April 11, 1963, Petrópolis: Vozes, 1963. **JOHN PAUL II**, Apostolic Constitution *Pastor Bonus*, of November 20, 1982, *L'Osservatore Romano*, June 29, 1988; Apostolic Exhortation *Christifideles laici*, of December 30, 1988, *L'Osservatore Romano*, January 30-31, 1989, Supplement; Encyclical *Laborens exercens,* of September 14, 1981, São Paulo, LTR,

1983; Encyclical *Sollicitudo rei socialis*, of December 30, 1987, of December 30, 1987, *L'Osservatore Romano*, February 20, 1988, Supplement.

JOHN PAUL II: Audiences, Blessings: Audience with the Ambassador of Sweden, March 8, 1993, *L'Osservatore Romano*, March 10, 1993; Audience with the Brazilian President, June 30, 1980, Blessing the movement of Nomadelfia, *apud* M. Ponzi, *apud* P.F. Borgia; *Code of Canon Law* of 1983, São Paulo: Loyola, 1983; **JOHN PAUL II: Homilies:** Homily at the Mass for world peace at Bangkok's National Stadium on May 10, 1984, *L'Osservatore Romano*, May 11, 1984, Supplement; Homily at the Mass at Chiquinquirá on July 3, 1986, *Mensajes de S.S. Juan Pablo II a los Colombianos*, Bogotá: SPEC, 1986; Homily at the Mass at Belo Horizonte on July 1, 1980, *Insegnamenti di Giovanni Paolo II*, vol. 3. 2, 1980; Homily at the Mass at Recife on July 7, 1980, *A palavra de João Paulo II no Brasil*; Homily at the Mass at St. Luis (Brazil) on October 14, 1991, *O Estado de São Paulo*, "Pontífice defende reforma agrária," October 15, 1991;

JOHN PAUL II: Speeches, Statements: Inaugural Speech of his Pontificate, AAS 1979, vol. 71, *apud* CELAM, *Puebla – La evangelización en el presente y en el futuro de America Latina*; Speech to Academic representatives in Riga on September 9 1993, *L'Osservatore Romano*, September 11, 1993; Speech to Anglican hierarchs, *L'Osservatore Romano*, April 23, 1988; [Speech of John Paul II in Brazil] *A palavra de João Paulo II no Brasil*, São Paulo: Paulinas, 1980; Speech to Brazilian Bishops on March 21, 1996, *O Estado de São Paulo*, "Discurso do Papa dirigido a Bispos paulistas," March 22, 1996; Speech to the Cardinals, Curia, and Roman Prelature on December 21, 1993, *L'Osservatore Romano*, December 22, 1993; Speech to Catholic Teachers at St. John's Cathedral in New Land, Canada, *L'Osservatore Romano*, September 14, 1984, Supplement; Speech to the Cultural World in Seoul on May 5, 1984, *L'Osservatore Romano*, May 6, 1984, Supplement; Speech at El Tunal Park on July 3, 1986, *Mensajes de S.S. Juan Pablo II a los Colombianos*; Speech to the General Assembly of the United Nations on October 2, 1979, *Insegnamenti di Giovanni Paolo II*, 1979, vol. 2; Speech to Hungarians Bishops at the Vatican on January 28, 1993, *L'Osservatore Romano*, January 29, 1993; Speech to Indians of Latacunga, *L'Osservatore*

Romano, January 31, 1985; Speech to Land Workers in Oruro, *L'Osservatore Romano*, May 13, 1988; Speech to the orthodox in São Paulo on July 3, 1980, *A palavra de João Paulo II no Brasil*; Speech to the Pontifical Council for Interreligious Dialogue on December, 13, 1992, *L'Osservatore Romano*, December 14, 1992; Speech to Religious Leaders in Seoul, *L'Osservatore Romano*, May 11, 1984, Supplement; Speech to Workers in Modena, *L'Osservatore Romano*, June 5, 1988; Speech to the Workers in São Paulo on July 3, 1980, Speech to Youth at Vienna Prater, *L'Osservatore Romano*, September 12-13, 1983; Statements on admitting heretics and schismatics in the same ecclesiastical unity with Catholics, A.A.S., 64, 71, 1979, A.A.S.. 72, 1989, *apud* E. Yarnold; see **WOJTYLA, KAROL.**

JORNAL DO BRASIL, book review on *I tre temli dei presente* by Alessadro Natta, April 9, 1989. **JUSTIN (ST.)** *Apologia I pro Christianis; Apologia II pro Christianis; Cohartatio ad Grecos; Liber de Monarchia; Oratio ad gentes*, PG 6.

KANT, IMMANUEL, *Treatise on Perpetual Peace, apud* G. Spadolini, "A minha Europa." **KLOOTZ, ANACHARSIS,** *La république universelle, apud* H. Delassus, *La conjuration antichrètienne.* **KLOPPENBURG, BOAVENTURA,** *A eclesiologia do Vaticano II*, Petrópolis: Vozes, 1971; *Documentos do Vaticano II – Constituições, decretos e declarações* Petrópolis: Vozes, 1966, 5 vol. **KLOSTERMANN, FERDINAND,** "Il laico nella Chiesa," V.A., *I grandi temi del Concilio.* **KOLVENBACH, HANS PETER,** Interview by *Der Spiegel* magazine reproduced by *O Estado de São Paulo*, December 18, 1986. **KONIG, FRANZ,** "Il Concilio, sorpresa per il mondo," Interview by Silvano Stracca, *Avvenire*, October 16, 1992. **KUHN, HELMUT,** "La phenomenology," V.A., *Bilan de la théologie au XXe siècle*, Tournai-Paris: Casterman, 1970. **KÜNG, HANS,** *A Igreja*, Lisbon: Morães, 1969-70, 2 vols.; "La riforma liturgica del Concilio Vaticano II e la riunione con i cristiani separati," V.A., *I grandi temi del Concilio*; "Qual è il messagio cristiano?," V.A., *L'avvenire della Chiesa*; "Vaticano III: problemi e prospective per il futuro," V.A., *Verso la Chiesa del terzo millennio*; *Veracidade – O futuro da Igreja*, São Paulo: Herder, 1969; *Vida eterna?* Madrid: Cristiandad, 1983; Interview by A. S. Guimarães. **H. KUNG – PINCHAS LAPIDE,** *Gesù, segno di contradizione*, Brescia: Queriniana, 1980.

LANNE, EMMANUEL, "L'Église locale et l'Église universelle," *Irenikon*, 43, 1970, *apud* Y. Congar, *Le Concile de Vatican II*; LAPIDE, PINCHAS, see H. Küng – P. Lapide. LEKAI, LAZLO, Statement on Communism in Hungary achieving the goals of the Encyclical *Quadragesimo anno*, *Jornal do Brasil*, December 22, 1980. LÉGAUT, M., *Introduction à l'intelligence du passé et de l'avenir du Christianisme*, Paris: Aubier, 1970, *apud* Y. Congar, "Os grupos informais na Igreja." LEO I, THE GREAT (ST.), *Epistula 14*, *apud* Pius IX, Encyclical *Quanta cura*. LEO XII, Encyclical *Ubi primum*, of May 5, 1824, DS 2720. LEO XIII, Encyclical *Immortale Dei*, of November 1, 1885, Petrópolis: Vozes, 1954; Encyclical *Parvenu*, of March 19, 1902, Petrópolis: Vozes, 1952; Encyclical *Satis cognitum*, of June 29, 1896, Petrópolis: Vozes, 1960. LEONE, FRANCESCO, *La storia dei Partiti Politici Italiani*, Naples: Guida Ed., 1971. LEVI-WELLS, WILLIAM, Genesis of the section on the Jews in *Nostra aetate, La Domenica del Corriere*, July, 7, 1984. LIBANIO, JOÃO BATISTA, "Teólogo condena falta de democracia na Igreja," Interview by Roldão de Arruda, *O Estado de São Paulo*, April 21, 1996.

LIBRERIA EDITRICE VATICANA, *La visita di Paolo VI alle Nazioni Unite*, 1966. LOPEZ TRUJILLO, ALFONSO, "Nicaragua, Chiesa e sandinismo," *L'Osservatore Romano*, July 30-31, 1984. LORSCHEIDER, ALOISIO, Statement against Capitalism, *L'Osservatore Romano*, October 5, 1983, Supplement; Support for Leonardo Boff, see Brazilian Episcopate. LUBAC, HENRI DE, *Athéisme et sense de l'homme – Une double requête de Gaudium et spes*, Paris: Cerf, 1968; *Catholicisme – Les aspects sociaux du dogme*, Paris: Cerf, 1974; *La recontre du bouddhisme et de l'Occident*, Paris: Aubier-Montaigne, 1952; *L'Éternel Féminin – Étude sur un text du Père Teilhard de Chardin*, Paris: Aubier-Montaigne, 1968; "Teilhard de Chardin in the Context of Renewal," V.A. *Theology of Renewal – Renewal of Religious Thought*, vol. 1; *L'idée chrétienne de l'homme et la récherche d'un homme nouveaux*, Liège: La Pensée Catholique, 1948.

MADIRAN, JEAN, *Ils ne savent pas ce qu'ils font*, Paris: Nouvelles Éditions Latines, 1952; *Ils ne savent pas ce qu'ils disent*, Paris: Nouvelles Éditions Latines, 1955. MALDONADO, LUIS, *La nueva secularidad*, Barcelona: Nueva Terra, 1968; *La violencia de lo sagrado*, Salamanca: Sígueme, 1974. MARCUS,

EMILE, "O que é evangelizar?," V.A., *A Igreja do futuro*. **MARQUES, HUGO – ISABEL DE PAULA**, "Papa apoia denúncia de corrupção no Brasil," *O Estado de São Paulo*, March 22, 1996. **MARRANZINI, ALFREDO**, "Karl Rhaner ha avvicinato la teologia alle necessità spirituali dei contemporanei," *L'Osservatore Romano*, April 6, 1984. **MARSÍLIO, PEDRO**, Letter on the origin of *Summa contra gentiles*, apud M. Garganta, *Introducción general*. **MARTELET, GUSTAVE**, *Deux mille ans d'Église en question*, Paris: Cerf, 1984. **MARTIN, MALACHI**, *The Jesuits – The Society of Jesus and the Betrayal of the Roman Catholic Church*, New York: Simon-Schuster, 1987. **MARX, KARL**, Statement on human work, apud I. Mészáros, *Marx: A teoria da alienação*; *Das Elende der Philosophie, Werke*, vol 4, apud K. Papaioannou, *Marx et les marxistes*; *Die Heillige Familie, Werke*, vol. 2, apud G. Solimeo – L. Solimeo, *As CEBs – Comentários e Documentação*; *Le Capital, apud* K. Papaioannou, *Marx et les marxistes*. **MAYER, ANTONIO DE CASTRO**, see P. Corrêa de Oliveira, *Reforma Agrária – Questão de consciência*. **MAYRINK, JOSÉ MARIA**, "Padres aprovam moção em defesa dos sem-terra," *Jornal do Brasil,* February 7, 1996. **MENDES DE ALMEIDA, LUCIANO**, Public support for Bishop Pedro Casaldáliga against the Holy See, *Folha de São Paulo*, September 28, 1988. **MENDONÇA DE FREITAS, LUÍS**, see P. Corrêa de Oliveira, *Reforma Agrária – Questão de consciência*.

MÉSZÁROS, ISTVAN, *Marx: A teoria da alienação*, Rio de Janeiro: Zahar, 1981. **METZ, JOHANN BAPTIST**, "La teologia politica in discussione," V.A., *Dibattito sulla teologia politica*; "Los cristianos en el mundo de hoy – I," V.A., *La reforma que legga de Roma*; "Sulla presenza della Chiesa nella società," V.A. *L'avenire della Chiesa*; *Mas allá de la religion burgesa*, Salamanca: Sígueme, 1982. **MIFSUD, TONY**, "Lo sviluppo di un'etica della liberazione nei documenti della Chiesa a partire dal Concilio Vaticano II," *Concilium*, 1984/2. **MOINE, ANDRÉ**, "Échanges avec un croyant – De la main tendue au dialogue en vérité," *L'Humanité*, April 26, 1983. **MONTAGNE, HARVARD DE LA**, *Historia de la Democracia Cristiana – De Lamennais à Georges Bidault*, Madrid: Ed. Tradicionalista, 1950. **MORABITO, ROCCO**, Statement on repercussions in the Vatican on the book *A Igreja ante a escalada* by P. Corrêa de Oliveira, *O Estado de São Paulo*, April 8, 1977. **MOREIRA NEVES, LUCAS**, Statement favoring land reform, *O Globo*, "CNBB pedirá

votos para quem apoie a reforma agrária," April 27, 1996; *O Globo*, "A Igreja Católica cobra coragem do governo," June 28, 1996. **MORTIER, J.M.**, *Avec Teilhard de Chardin – "Vues ardentes,"* Paris: Seuil, 1967. **MOURIN, MAXIME**, *Le Vatican et l'URSS*, Paris: Payot, 1965. **MOUROUX, JACQUES**, "Sur la dignité de la personne humaine," V.A., *L'Église dans le monde de ce temps*, vol. 2. **MUNZI, ULDERICO** see J. Guitton. **MURY, GILBERTO**, Eulogies by communists of Vatican II, *apud* Philippe de la Trinité, *Dialogue avec le marxisme*.

NANTES, GEORGES, *Liber accusationis*, St. Parrès les Vaudes: CRC, 1973. **NATA, ALESSANDRO**, *I tre tempi del presente*, Turin: Paoline, 1989. **NEUNER, JOSEF**, "Seminário de investigação sobre textos sagrados não-bíblicos," *Concilium*, 1976/2. **NEMESHEGUI, PETER**, "Deus – Seus conceitos e experiências na Ásia," *Concilium*, 1977/3.

L'OSSERVATORE ROMANO, "Da Betlhem al Monte degli Ulivi," January 7-8, 1964.

PABAN, CESLAUS, see F. Balmes. **PALUMBIERI, SABINO**, "Vita nello Spirito nell'orizzonte di un mundo secolarizzato," V.A., *Lo Spirito Santo pegno e prinizia del regno*. **PAPAIOANNOU, KOSTAS**, *Marx et les marxistes*, Paris: Flammarion, 1972. **PATTARO, GERMANO**, *Riflessioni sulla teologia postconciliare*, Rome: A.V.E., 1970.

PAUL VI, Apostolic Letter *Altissimi cantus*, December 7, 1965, AAS, 1966, vol. 58; Brief *Ambulate in dilectione*, December 7, 1965, B. Kloppenburg, *Concílio Vaticano II*, vol. 5; Apostolic Exhortation *Evangelii nuntiandi,* of December 8, 1975; Encyclical *Populorum progressio*, of March 26, 1957; Apostolic letter *Octagesima adveniens,* of May 14, 1971. **PAUL VI: Angelus, Homilies:** Angelus, February 7, 1971, *Insegnamenti di Paolo VI*, vol. 9; Homily at the Mass in Bogotá on. August 28, 1968; Homily at the Mass in the Closing Session of Vatican II on December 7, 1965, *Insegnamenti di Paolo VI*, vol. 3; **PAUL VI: Messages, Speeches, Statements**: Message of January 1, 1968, CELAM *A Igreja na atual transformação da América Latina*; *O Credo do povo de Deus*, São Paulo: Paulinas, 1968; Speech in Mosquera on August 23, 1968, CELAM, *A Igreja na atual transformação da América Latina*; Speech at the Opening

of the Second General Assembly of the Latin American Bishops at Medellin, 1968, *Insegnamenti di Paolo VI*, Tipografia Poligata Vaticana, 1968; Speech to the United Nations on October 4, 1965, *La visita di Paolo VI alle Nazioni Unite*, Libreria Editrice Vaticana, 1966; Statement on admitting heretics and schismatics in the same ecclesiastical unity with Catholics, A.A.S., 64, 1972, *apud* E. Yarnold; Statement supporting Bishop P. Casaldáliga, *O São Paulo*, January 10-16, 1976.

PAULA, ISABEL DE, see H. Marques – Isabel de Paula. PELATRE, LOUIS, "Islam: la paura ingiustificata," Interview by Francesco Strazzari, *Il Regno*, March 15, 1993. PHILIPS, GÉRARD, *La Chiesa e il suo mistero nel Concilio Vaticano II – Storia, testo e commento della Costituzione Lumen gentium*, Milan: Jaca Book, 1975. PILARCZYK, DANIEL, Speech to members of Roman Curia and American Bishops, *Adista*, April 28-31, 1989.

PIUS VII, Encyclical *Diu satis*, of May 15, 1800, *Recueil des allocutions*. PIUS IX, Allocution *Si semper antea*, of May 20, 1850, *Recueil des allocutions*; Allocution *Ubi primum*, of December 17, 1948, *Recueil des allocutions;* Apostolic Letter *Multiplices inter*, of June 10, 1851, *Recueil des allocutions*; Encyclical *Quanto conficiamur*, of August 10, 1863, *Recueil des allocutions*, also DS 2865-7; Encyclical *Qui pluribus*, of November 9, 1846, *Recueil des allocutions*, also DS 2785; *Syllabus*, of December 8, 1864, Petrópolis: Vozes, 1960. Encyclical *Quanta cura*, of December 8, 1864, Petrópolis: Vozes, 1960. PIUS X (ST.), Apostolic Letter *Notre charge apostolique*, of August 25, 1910, Petrópolis: Vozes, 1953; Encyclical *Il fermo proposito*, of June 11, 1905, Paris: Bonne Presse; Encyclical *Pascendi Dominici gregis*, of September 8 1907, Petrópolis: Vozes, 1959. PIUS X – BENEDICT XV, *Code of Canon Law* of 1917, Typis Polyglottis Vaticanis, 1918. PIUS XI, Encyclical *Quadragesimo anno*, of May 15, 1931, Documentos sociales, Madrid: BAC, 1959; Encyclical *Quas primas*, of December 11, 1925, DR 2197; Encyclical *Mortalium animos*, of January 6, 1928, Paris: Bonne Presse, 1928. PIUS XII, Encyclical *Mystici Corporis Christi*, of June 29, 1943, Petrópolis: Vozes, 1960; Radio-message of Christmas 1949, Petrópolis: Vozes; Radio-message to the Katholikentag of Vienna, *Discorsi e Radiomenssagi di Sua Santità Pio XII,* Editrice Poliglòtta Vaticana, vol. 14.

PONTIFICAL BIBLICAL COMMISSION, *Il popolo ebraico e le sue Sacre Scritture nella Biblia cristiana,* Libreria Editrice Vaticana, 2001. PONTIFICAL COUNCIL FOR THE NON-CHRISTIANS, *L'atteggiamento della Chiesa di fronti ai seguaci di altre religioni,* Typis Polyglottis Vaticanis, 1984. PONZI, MARIO, "Nomadelfia: Preavviso e preannuncio di un mondo futuro dove tutti siamo chiamati," *L'Osservatore Romano,* May 19, 1989; "Il battesimo di un neonato nomadelfo per un stile di vita che non muore," *L'Osservatore Romano,* May 22-23, 1989. POUPARD, PAUL "Un Papa: Paolo VI – Un'Enciclica: *Ecclesiam suam,*" *L'Osservatore Romano,* August 6-7, 1984. PUEBLA, Message of – See CELAM. PROENÇA SIGAUD, GERALDO, see P. Corrêa de Oliveira, *Reforma Agrária – Questão de consciência.*

RAHNER, KARL, "A doutrina do Vaticano II sobre o ateísmo," *Concilium,* 1967/3; *El cristiano y sus parentes descreídos, Escritos de Teologia III,* Madrid, 1961, *apud* L. Maldonado, *La nueva secularidad; El fundamento sacramental del laico en la Iglesia, Escritos de Teologia VI,* German ed. 1965, *apud* L. Maldonado, *La nueva secularidad;* "Erlösungswirtichkeit in der Schöpfungswirklichkeit, *Sendung und Grade,* Innsbruck, 1959, *apud* L. Maldonado, *La nueva secularidad; Graça divina em abismos humanos,* São Paulo: Herder, 1968; *Grundsätzliches zur Einheit von Schöpfungs und Erlösungswirtichkeit, Handbuch edr Pastoraltheologie, II, 2,* Freiburg im Breisgau, 1966, *apud* L. Maldonado, *La nueva secularidad; La doctrina conciliar sobre la Iglesia y la realidad futura de la via cristiana, Escritos de Teologia VI,* German ed., 1965, *apud* L. Maldonado, *La nueva secularidad; Los cristianos anonimos, escritos de Teologia VI,* German ed., 1965, *apud* L. Maldonado, *La nueva secularidad; O dogma repensado,* São Paulo: Paulinas, 1970; "Religione assoluta?" V.A. *Incontro tra le religione; Sobre la possibilidade de la fe hoy, Escritos de Teologia V,* Madrid, 1964, *apud* L. Maldonado, *La nueva secularidad; Sobre la unidad del amor al prójimo y el amor a Díos, Escritos de Teologia VI,* German ed., 1965, *apud* L. Maldonado, *La nueva secularidad; Teresa of Avila: Doctor of the Church,* New York: Seabury, 1970; "Theological Reflection on the Problem of Secularization," V.A., *Theology of Renewal,* vol. 1. RAHNER, KARL – J.B. METZ, "Karl Rahner em

diálogo com Johann Baptist Metz," V.A., *Cinco problemas ques desafiam a Igreja hoje*.

RATZINGER, JOSEPH, Comments on the conciliar Catechism, *apud* Tommaso Ricci, "Rumo à reta final?," *30 Dias*, August-September 1990; "Il concetto della Chiesa nel pensiero patristico," V.A., *I grandi temi del Concilio*; *Fé e futuro*, Petrópolis: Vozes, 1971; "Liberdade e libertação," *Atualização*, September-October 1986; 'Preface" to *Il popolo ebraico e le sue Sacre Scritture*, see also Pontifical Biblical Commission and Congregation for the Doctrine of the Faith. REGNO E MESSIANISMO GROUP, Conclusions of its 1976 meeting, V.A. *Il regno di Dio che vienne*. RICCI, TOMMASO, "Rumo à reta final?," *30 Dias*, August-September 1990. RIJK, CORNELIUS A., "As relações judeu-cristãs e o uso dos livros sagrados de outras religiões no culto cristão," *Concilium*. 1976/2. RIVA, CLEMENTE, "Esposizione e commento," V.A., *La libertà religiosa nel Vaticano II*. ROBERT BELLARMINE (ST.), "Controversiarum" lib. 3: *De Ecclesia Militante*, c. 2, *Opera omnia*, Naples, 1857, *apud* Y.Congar, *Le Concile Vatican II*; *Christianae doctrinae latior explicatio*, Kempten, 1728, *apud* Y. Congar, *Le Concile Vatican II*. RODRIGO, MICHAEL, "Diálogo budista-cristão no Sri Lanka, *Concilium*, 1978/6. ROIZ, PERO, *Anchieta*, Salvador: Liv. Progresso, 1955. RUBIO, ALFONSO GARCIA, "Teologia da Libertação: Política ou profetismo?" São Paulo: Loyola, 1977, *apud* P. Corrêa e Oliveira, *As CEBs...*. RUIZ DE LA PEÑA, JUAN LUIS, "O elemento projeção e a fé no céu," *Concilium*, 1979/3. RUGAMBWA, LAUREAN, "L'arcobaleno nella Chiesa," Interview by Silvano Stracca, *Avvenire*, November 20, 1992. RUSSIAN SCHISMATIC BISHOPS, Statement praising the Communist Revolution of 1917, *30 Dias*, July 1988.

SALAVERRI, JOACHIM, "De Ecclesia Christi," *Sacra Theologiae Summa*, Madrid: BAC, 1958. SCHAYA, LEO, *L'homme et l'absolu selon la Kabbale*, Paris: Dervy-Livres, 1977. SCHEFFCZYK, LEO, *L'uomo moderno e il messagio evangelico, apud* Gino Concetti, "Soteriologia cristiana e culture odierne al Congresso Internazionale di Teologia," *L' Osservatore Romano*, February 9, 1984. SCHIFFERLE, A., *Marcel Lefèbvre – Ärgernis und Besinnung – Fragen an das Traditionsverständnis der Kirche*, Kevalaer: Butzon-Bercker, 1983. SCHILLEBEECKX, EDWARD, "Algumas reflexões acerca da interpretação da escatologia," *Concilium*, 1969/1; *Cristo, sacramento dell'incontro con Dio*, Rome: Paoline, 1970; *Gott*

mento dell'incontro con Dio, Rome: Paoline, 1970; *Gott ist Jeden Tag Neu – Ein Gespräch*, Mainz: Mathias Grünewald, 1984, *apud Orientierung*, January 31, 1985; "I laici nel popolo di Dio," V.A., *I grandi temi del Concilio*; "Introdução," V.A., *Cinco problemas que desafiam a Igreja hoje*. SCHOLEM, GERSHOM, *Les grands courantes de la mystique juive*, Paris: Payot, 1983. SCHOONENBERG, PIET, "Creio na vida eterna," *Concilium*, 1969/1; Untitled, V.A., *Cinco problemas que desafiam a Igreja de hoje*. SECRETARIAT FOR THE NON-CHRISTIANS, *L' atteggiamento della Chiesa de fronti ai seguaci di alter religioni*, Typis Polyglottis Vaticanis, 1984. SEGUNDO, JOSÉ LUIS, *Teologia da Libertação – Uma advertência à Igreja*, São Paulo: Paulinas, 1987. SEROUYA, HENRI, *La Kabbale – Ses origines, sa psychologie mystique, sa metaphisique*, Paris: Grasset, 1947. SESBOUÉ, BERNARD, *O Evangelho na Igreja*, São Paulo: Paulinas, 1977. SIEBEL, WIGAND, *Katholisch oder Konziliar – Die Krise der Kirche Heute*, Munchen-Wien: Langen Müller, 1978. SIGAUD, GERALDO PROENÇA, see P. Corrêa de Oliveira, *Reforma Agrária – Questão de consciência*. SILVA HENRIQUEZ, RAÚL, Advice to Catholics to vote for Communist candidates, *Ultima Hora*, December 24, 1969, *apud* Sociedad Chilena TFP, *La Iglesia del Silencio*; Eulogies of Communism, *La Nación*, February 25, 1962, *apud* TFP, *La Iglesia del Silencio*; *Memórias*, Santiago, Chile: Ed. Copygraph, 1991; Speech praising Communist Pablo Neruda, *Últimas Notícias*, August 21, 1969, News Bulletin of the Archdiocese of Santiago, July 1969; *apud* TFP, *La Iglesia del Silencio*; Support to Communism, *La Nación*, Santiago, February 25, 1962. SINKE GUIMARÃES, ATILA, see Guimarães. SMET, RICHARD DE, "La théologie en Inde," V.A. *Bilan de la théologie du XXe siècle*, vol 2. SOCIEDAD CHILENA DE LA DEFENSA DE LA TRADICIÓN, FAMÍLIA Y PROPIEDAD, "La autodemolición de la Iglesia, factor de la demolición de Chile," *La Tercera de la Hora*, Santiago, February 27, 1973; *La Iglesia del Silencio en Chile – La TFP proclama la verdad entera*, Santiago, 1976.

SOCIETY OF JESUS (JESUITS), Official statement of its 34th General Assembly: *Servidores de la Missión de Cristo*, March 21, 1995, Rome: Oficina de Prensa e Información. SODANO, ANGELO, Homily at St. Patrick's Cathedral in New York on October 21, 1995, *Bolletino – Sala Stampa della Santa Sede*, October 22, 1995; Speech to the General Assembly of the

United Nations on October 24, 1995, *Bolletino – Sala Stampa della Santa Sede*, October 26, 1995. SOLIMEO, GUSTAVO – LUÍS SOLIMEO, *As CEBs ... das quais muita se fala, pouco se conhece – A TFP descreve como são – Comentários e documentação totais*, São Paulo: Vera Cruz, 1982. SPADOLINI, GIOVANNI, "A minha Europa," *30 Dias*, August-September 1991. SPAE, JOSEPH, "A influência do budismo na Europa e na América," *Concilium*, 1978/6. Stracca, Silvano, see F. Konig and L. Rugambwa. STRACCA, SILVANO, see A. Rugambwa. STRAUB *De analysi fidei*, Innsbruck, 1922, *apud* L. Maldonado, *La nueva secularidad*. STRAZZARI, FRANCESCO, see L. Pelatre. SUENENS, LEO JÓZEF, "Cristianismo sem Deus?," V.A., *Cristianismo sem Cristo?*; "Discorso ufficiale d'apertura – Alcuni compiti della teologia oggi," V.A., *L'avvenire della Chiesa*. SYNOD OF THE BISHOPS, 1971, *Karol Wojtyla e il Sinodo dei Vescovi*, Libreria Editrice Vaticana, 1980.

TEILHARD DE CHARDIN, PIERRE, *Cahiers*, 2, *apud* H. de Lubac, *Athéisme et sens de l'homme*; *Le coeur de la matière*, Paris: Seuil, 1976; "L'Éternel Féminin," *Écrits du temps de la guerre*, Paris: Seuil, 1965; *Lettre à Maxime Gorce, apud* Philippe de la Trinité, *Dialogue avec le marxisme?*; "L'Evolution de la chasteté," *Directions de l'avenir*, Paris: Seuil, 1973; *O fenômeno humano*, Porto: Tavares Martins, 1970. TERTULLIAN, *Apologetica*, PL 1. THOMAS AQUINAS (ST.), *De veritate*, Turin-Rome: Marietti, 1949; *Summa contra los gentiles*, Madrid: BAC, 1953. TOMKO, JOZEF, "Riconciliazione e penitenza," *L'Osservatore Romano*, December 1, 1983, Supplement; *Peccato e riconciliazione – Alla ricerca della grandeza*, Rome: Paoline, 1983. TORNIELLI, ANDREA, see B. Bozzo. TRINITE, PHILIPPE DE LA, *Dialogue avec le marxisme – 'Ecclesiam suam' et Vatican II,* Paris, Cédre, 1966. TRUJILLO, ALFONSO LOPEZ, "Nicaragua, Chiesa e sandinismo," *L'Osservatore Romano*, July 30-31, 1984;

VALENTE, GIANNI, see G. Andreotti. VARIOUS AUTHORS (V.A.), *A Igreja do futuro*, Petrópolis: Vozes, 1973; *Bilan de la théologie au XXe siècle*, Tournai-Paris: Casterman, 1970; *Cinco problemas que desafiam a Igreja de hoje*, São Paulo: Herder, 1970; *Comunidades eclesiais de base – utopia ou realidade?* Petropolis: Vozes, 1973; *Credo para amanhã*, Petrópolis: Vozes, 1971; *Cristianismo sem Cristo?*, Caxias do

Sul: Paulinas, 1970; *Dibattito sulla teologia politica*, Brescia: Queriniana, 1972; *I grandi temi del Concilio*, Rome: Paoline, 1965; *Il regno di Dio che viene – Atti della 14th sessione di formazione ecumenical organizata dal Segretariato Attività Ecumeniche – Trento, July 7 – August 7, 1976*, Turin: Elle Di Ci, 1977; *Incontro tra le religione*, Verona: Mondatori, 1969; *L'annuncio del regno ai poveri*, Turin: Elle Di Ci, 1978; *L'avvenire della Chiesa – Il libro del Congresso*, Brescia: Queriniana, 1970; *L'ecclésiologie au XIXe siècle*, Paris: Cerf, 1960; *La fine della Chiesa como società perfetta*, Verona: Mondadori, 1968; *La libertà religiosa nel Vaticano II*, Turin: Elle Di Ci, 1967; *La reforma que llega de Roma*, Barcelona: Plaza-Janes, 1970; *L'Eglise dans le monde de ce temps*, Paris: Cerf, 1967, 2 vols.; *Lo Spirito Santo pegno e primizia del regno – Atti dela 19th sessione di formazione ecumenical organizzata dal Segretariato Attività Ecumeniche*, Turin: Elle Di Ci, 1976; *Os maiores teólogos respondem*, São Paulo: Paulinas, 1968; *Parole de Dieu et liturgie*, Paris: Cerf, 1958; *Peccato e riconciliazione – Alla ricerca della grandeza*, Rome: Paoline, 1983; *Questions théologiques aujourd'hui*, Paris: Desclée de Brouwer, 1965-6, 3 vols.; *Teologia de la liberación – Conversaciones de Toledo*, Burgos: Aldecoa, 1974; *Theology of Renewal – Renewal of Religious Thought*, Montreal: Palm Publishers, 2 vols.; *Verso la Chiesa del terzo millennio*, Brescia: Queriniana, 1979.

VATICAN COUNCIL I, Dogmatic Constitution *De Ecclesia*; Session 3, DR 1786; Session 6, DR 1812; Dogmatic Constitution on the Catholic Faith, Session 3, *Documentos Pontifícios*, Petrópolis: Vozes, 1953; Constitution on Revelation, *apud* St. Pius X, Encyclical *Pascendi*. **VATICAN COUNCIL II**, Dogmatic Constitution *Lumen gentium*; Pastoral Constitution *Gaudium et spes*; Declaration *Dignitatis humane*, Decree *Inter mirifica,* in *The Documents of Vatican II*, ed. by Walter M Abbott and trans. By Joseph Gallagher, Piscataway, New Jersey: New Century Publishers, Inc., 1966; *Documentos do Vaticano II – Constituições, decretos e declarações,*ed. by Boaventura Kloppenburg, Petrópolis: Vozes, 1966. **VERGOTE, ANTOINE,** "La presenza della Chiesa nella società di domani – Riflessioni Bibliche," V.A., *L'avvenire della Chiesa.* **VON BALTHASAR –** see Bathasar, H.U. von.

WALDENFELS, HANS "Palavra e silêncio no budismo," *Concilum*, 1976/2. **WALGRAVE, JAN**, "Relazioni sacro-storiche tra la Chiesa e i culti non-cristiani," V.A., *I grandi temi del Concilio*. **WEBSTER, NESTA**, *Secret Societies and Subversive Movements*, San Diego: The Book Tree, 2000. **WELLS, LEVI**, see W. Levi-Wells. **WILLEBRANDS, JAN**, Greetings to Schismatics recalling the kiss between Paul VI and Athenagoras, *L'Osservatore Romano*, December 14, 1983. **WOJTYLA, KAROL**, see R. Buttiglione, *Il pensiero di Karol Wojtyla*, and Synod of Bishops, *Karol Wojtyla e il Sinodo dei Vescovi*.

XAVIER DA SILVEIRA, ARNALDO VIDIGAL, *L'Ordo Missae de Paul VI: Qu'en penser?* Chiré-en-Montreuil: Diffusion de la Pensée Française, 1975.

YARNOLD, EDWARD, "La pluralité des formulations de la doctrine," *La Documentation Catholique*, September 2, 1984.

ZUANAZZI, G., "Freud, la morale e la colpa," V.A. *Peccato e riconciliazione: Alla ricerca della grandeza*. **ZWEIG, STEFAN**, *Triunfo e infortúnio de Erasmo de Roterdão*, Porto: Livraria Civilização, 1970.

* * *

INDEX

"CHURCH OF CHRIST" – **Against Catholic teaching**, Part II, Premise 1 §§ 1-19, Chapter 2 §§ 19-23. **Consequences of**, Part II, Premises §§ 11-13. **Progressivist concept that it is not the Catholic Church**, Part II, Premises §§ 6-10; Part II, Chapter 2 §§ 7-18.

CHURCH, PILGRIM – **Concept of**, Part II, Premises §§ 2-3.

CHURCH PROSTITUTE – **Concept of**, Part II, Premises § 4.

CHURCH, SINNING – **Concept of**, Part II, Premises §§ 3-4. **Defended in texts of** *Gaudium et spes*, Part II, Premise 2 § 2

CIVILIZATION – **Correct concept of,** Part I, Premise 1 Note 1

CULTURE – **Correct concept of,** Part I, Premise 1 Note 1

"COMMUNION" – **Based on false concept of the Eucharist**, Part II, Chapter 5 §§ 22-27. **Born from a symbolic act**, Part II, Chapter 5 § 12. **Fruit of ecumenical dialogue**, Introduction § 23, Notes 28-9. **Ignores that false religions do not have real faith**, Part II, Chapter 5 §§ 13-31.

COMMUNISM – **Agreement made with the conciliar Popes (the Pact of Metz)**, Introduction Note 16. **Attitude of Conciliar Church after Vatican II**, Part I, Chapter 5 Notes 126, 136. **Catholic-Communist political collaboration (***politique de la main tendue***)**, Part I, Chapter 5 §§ 131-136, Notes 127, 128, 135. **Conciliar Church supports class struggle**, Part I, Chapter 1 §§ 169-176. **Dominates Russian Schismatic Church**, Introduction § 15, Note 17. **John XXIII's support for**, Part I, Chapter 5 §§ 133-135. **Medellin Document (1968), Bishops use same language of**, Part I, Chapter 5 § 157. **Paul VI's role in the Communist victory in Chile** (1970-73), Part I, Chapter 5 § 156. **Progressivist support for its political-social struggles**, Part I, Chapter 5 §§ 131-147. **Progressivist support for its regimes**, Part I, Chapter 5 §§ 148-168, Chapter 6 Note 2. **Vatican II's failure to condemn,** Introduction § 15, Note 16d,e. **Vision of State: Common views shared with Progressivism**, Part I., Chapter 6 §§ 2,3; **points of difference with Progressivism**, Part I., Chapter 6 § 4. **Weakly condemned by the Conciliar Church**, Part I, Chapter 5 Note 28. **See Neo Socialist State.**